RENEWALS 458-4574

D1165627

EXODUS | ÉXODO

Bill and Alice Wright Photography Series

exodus | éxodo

WITHDRAWN
UTSA Libraries

WORDS BY **CHARLES BOWDEN** PHOTOGRAPHS BY **JULIÁN CARDONA**

UNIVERSITY OF TEXAS PRESS *Austin*

Publication of this work was made possible, in part, by Bill and Alice Wright, The Eugene McDermott Cook Foundation, Michael and Jeanne Klein, and a challenge grant from the National Endowment for the Humanities.

Copyright © 2008 by Charles Bowden and Julián Cardona
All rights reserved
Printed in China
First edition, 2008

Requests for permission to reproduce material from this work should be sent to:
Permissions
University of Texas Press
P.O. Box 7819
Austin, TX 78713-7819
www.utexas.edu/utpress/about/bpermission.html

♾ The paper used in this book meets the minimum requirements of
ANSI/NISO Z39.48-1992 (R1997) (Permanence of Paper).

LIBRARY OF CONGRESS CATALOGING-IN-PUBLICATION DATA

Bowden, Charles, 1945–
Exodus/Éxodo / words by Charles Bowden ; photographs by Julián Cardona. — 1st ed.
 p. cm. — (Bill and Alice Wright Photography Series)
Includes bibliographical references.
ISBN 978-0-292-71814-2 (cloth : alk. paper)
1. United States—Emigration and immigration—History—21st century. 2. United
States—Emigration and immigration—History—21st century—Pictorial works.
3. Border patrols—Mexican-American Border Region. 4. Border patrols—Mexican-
American Border Region—Pictorial works. 5. Mexico—Emigration and immigration.
6. Mexico—Emigration and immigration—Pictorial works. 7. Mexican-American Bor-
der Region—Emigration and immigration. 8. Mexican-American Border Region—Emi-
gration and immigration—Pictorial works. I. Cardona, Julián, 1960– II. Title.
III. Title: Éxodo.
JV6456.B68 2008
304.8'73072—dc22 2007052237

Library
University of Texas
at San Antonio

For Marisol
J. C.

For all my fellow Americans, past, present, and future
C. B.

contents

acknowledgments

I WANT TO THANK ALL THE MEXICANS who taught me the pain of leaving home and the struggle required to find a new home. This book would not exist without the willingness of Theresa May and Dave Hamrick of the University of Texas Press to tackle one of the most explosive issues of the day. Lynne Chapman, manuscript editor, and Marianne Tatom Letts, copy editor, have done their damnedest to save me from myself.

Years ago, Julián Cardona and I began stumbling toward this book as the flight of people from Mexico and other parts of Latin America seemed to rocket through our lives. There would be no book without Julián, who poured years into recording this unprecedented migration. Also, Clara Jeffery helped the cause by sending Julián and me out on a long *Mother Jones* story.

Mary Martha Miles once again went over my writing and helped to put it right. She believed in the book when I faltered, and I thank her for that belief.

Sam, as always, thought I was wasting my time, and his.

Naturally, I claim full credit for every error in this book.

CHARLES BOWDEN, SEPTEMBER 2007

AT THIS TIME, I must express my deepest gratitude to all who helped to make this project possible. Their contributions enabled me to bring this work into being and knowing them has enriched my life more than I can say. Thomas Kern and Daniel Schwartz of Lookat Photos started it all by inviting me to participate in *Borders and Beyond;* Marianna Erni and Ines Anselmi of Pro Helvetia, the Arts Council of Switzerland, worked tirelessly to coordinate the traveling exhibit and publish the book. Without the generous support of the Lannan Foundation and the unbridled enthusiasm of its president, J. Patrick Lannan, Jr., for rowing upstream, this photography project could never have been completed. Charles Bowden shared his profound experience of the desert and the border, as well as fine ideas and wine. Thanks also to Mary Martha Miles, who kept the lights burning always during my comings and goings. To Benjamin Alire Sáenz, who brought order and meaning to the first part of the project, and to the staff of the CUE Art Foundation in New York City for their warmth and expertise in hanging the exhibition. José Guerra, correspondent for *El Imparcial* in Hermosillo, and Gilberto González gave me a helping hand in Caborca, Sonora, at a particularly lethal time for newspaper reporters on Mexico's northern border. Francisco Castellanos of *Proceso Magazine* likewise offered help in Michoacán. And in Mexico City, my thanks to Alejandro Gutiérrez and to my friend and colleague Jesús Díaz. In Juárez, Bárbara Vázquez. My gratitude also goes out to the family who welcomed me in Sásabe, Sonora, though I promised for their safety not to mention them by name. In Altar, Sonora, my thanks also to Father René Castañeda and to Francisco García, director of the Casa de atención del migrante y el necesitado (CAMYN). Professor Altha Cravey in the Department of Geography at the University of North Carolina, Chapel Hill, opened the door to the everyday lives of Mexican immigrants in her community. Anita and Jonathan Treat have always welcomed me in Oaxaca. Sara Méndez, "el Wuero" Alejandro Sandoval, Rolando González, and Daniel Cardona, director of XETLA—*La Voz de la Mixteca*—opened the way into the village of San Juan Mixtepec. In Oaxaca, I am also grateful to René Ruiz and Beltrán Arenas of the Instituto Oaxaqueño de Atención al Migrante. In Mississippi, Victoria and Elvis Cintra plied me with delicious Cuban coffee and conversation after the devastation of Hurricane Katrina; both continue to work tirelessly to document abuses of immigrant workers in the region through the efforts of the Mississippi Immigrants Rights Alliance (MIRA). My thanks also to MIRA's director,

Bill Chandler. Jesus Gonzales, pastor of Mount Olive Lutheran Church in Metairie, Louisiana, shared his experience and contacts in the growing Mexican community in the New Orleans area. In California, I must mention Héctor Hernández and Fausto Sánchez, organizers of the St. John the Baptist Day celebration and the Festival Mixteco in Arvin and Lamont. In Los Angeles, Marisol Jiménez was my guide to the inner workings of the immigrants' rights movement as well as into the nooks and crannies of the city at the historical moment of the May 1, 2006, boycott and march. Carol Cruikshank and the staff at "Paso a Paso": Elvia Saavedra, Rose Rodriguez, and Margarita López allowed me to document their work with immigrant mothers in Eureka, California. The collaboration of José and Doreen Vargas, editors of *La Voz Hispana* of Dodge City, Kansas, has been invaluable. Likewise in Garden City, Gerardo Cajamarca, organizer for the United Steel Workers, gave me access to workers injured in the region's meatpacking plants. Leah and

Don Henry Ford provided hospitality in Seguin, Texas, and also shared their vision of a world ever more dependent on industrial, petroleum-based agriculture. Thanks also to my friend and editor Molly Molloy, librarian at New Mexico State University in Las Cruces, who provides valuable updates on migration and other border issues, as well as translations of my Spanish texts. My special thanks to Miguel Ángel Solís, Alberto Castañón Arellano, and Aracely Cortés of Imagen Virtual in Mexico City, whose expertise and patience was crucial during the printmaking process. Finally, I want to say *gracias* to assistant director and editor-in-chief Theresa May, assistant editor E. Casey Kittrell, manuscript editor Lynne F. Chapman, and production manager and designer Ellen McKie of the University of Texas Press, and to freelance copy editor Marianne Tatom Letts, for the passion and professionalism applied to this book. To all, my deepest gratitude, always.

JULIÁN CARDONA, MARCH 2007

EXODUS | ÉXODO

a short note

THE REVOLUTION OF 1910–1920 is the religion of the Mexican state and forms its main claim to legitimacy. Even the toppling of the ruling party in the election of 2000 by a conservative pro-business party has hardly altered this homage. In the United States, the revolution is barely remembered and functions as a cartoon of violence, rape and mayhem. But it was the moment when the Mexican people asked questions of themselves and of their government, questions that have never been answered nor gone out of date. The most forceful questions were asked by Doroteo Arango, better known as Francisco Villa, or Pancho Villa. He has been made into both a monster and a buffoon in the United States and all but erased from the revolution in Mexico. He is part and parcel of the Mexican migration because ultimately this flight from Mexico stems from the failure of the revolution.

Villa terrifies people who hold power. On November 17, 1910, Villa murders Claro Reza, a federal cop, at a meat stall in Ciudad Chihuahua and then rides into the Sierra Azul with fifteen men. Soon he leads an army, then is arrested and jailed, then escapes and flees Mexico for Texas. At ten o'clock at night on March 6, 1913, he recrosses the Rio Grande into Mexico with eight men. They carry nine rifles, 500 rounds, two pounds of coffee, two pounds of sugar, one pound of salt and a couple of barbed-wire cutters. They are almost immediately fired upon but they slip south. Villa sends a telegram to the anti-revolutionary governor of Chihuahua who has taken over since the murder a few weeks earlier of President Francisco Madero in Mexico City.

KNOWING THAT THE GOVERNMENT YOU REPRESENT WAS PREPARING TO EXTRADITE ME I DECIDED TO COME HERE AND SAVE YOU THE TROUBLE. HERE I AM IN MEXICO RESOLVED TO MAKE WAR ON THE TYRANNY WHICH YOU DEFEND. FRANCISCO VILLA.

In a year or so, the General has 40,000 men.
He is still out there, embodied in this new strange revolution called illegal immigration, an act by which poor Mexicans go from doom to a future, a movement which has enhanced the lives of poor people more than any policy attempted by either the U.S. government or the Mexican government.

People ask, why do they come here? People say Mexico has such low unemployment, so what is the problem? Consider this: you get up at 5 a.m. You live in a one-room shack and pay $59 a month in rent. Your address is on the outskirts of the world's second largest megalopolis, Mexico City. You share this shack with your woman, a niece and your child. At 5:30 a.m. you're on the bus, a ninety-minute ride for $2.45 a day roundtrip. You work in a tortilla shop for $1.64 an hour, eleven hours a day, six days a week. A gallon of milk at the store, the electricity that lights your shack, the fuel running the bus, all these things cost more than in the United States. Basically, everything costs more than in the United States—except labor. And there are other expenses. The water in the tap, should you even have running water, is not safe, so you must buy other water or drink soda. You never save a cent, and when someone in your family becomes ill, you cannot afford medicine. You have essentially no education because after junior high you must pay for books and schooling and so, depending upon your circumstances, you quit school sometime between age twelve and fifteen. You will earn in a year less than six grand and almost everyone in your country lives the same way—or not as well. You will never take a vacation. Or see any future that is different from all the days you have known. But someone, a brother, a cousin, a friend will go to the United States and you will hear of life there.[1]

Mexican civilization existed before the American people were even a thought. Americans have come to the game very recently, and like so many new arrivals believe they possess all the answers. At the moment, human beings are moving all over the planet to save their hides. Things have been upended, the moon rises at a strange hour, it is blood red, and dripping with hunger.

(1) More than ten million Mexicans have fled into a new country,
places like Dodge City, Kansas . . .

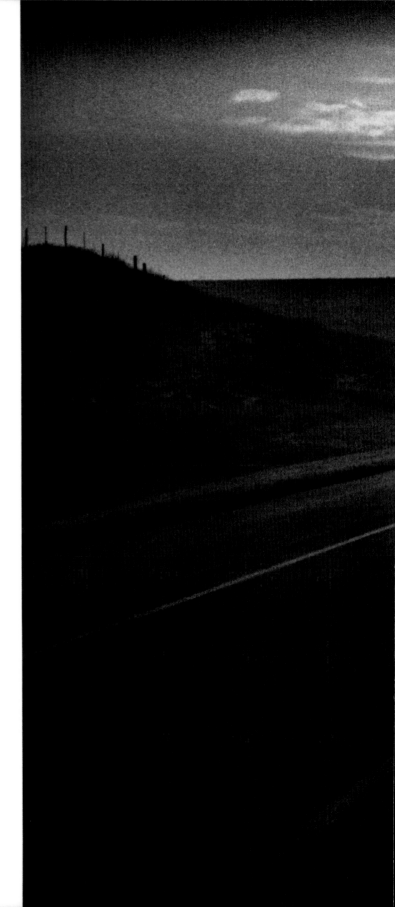

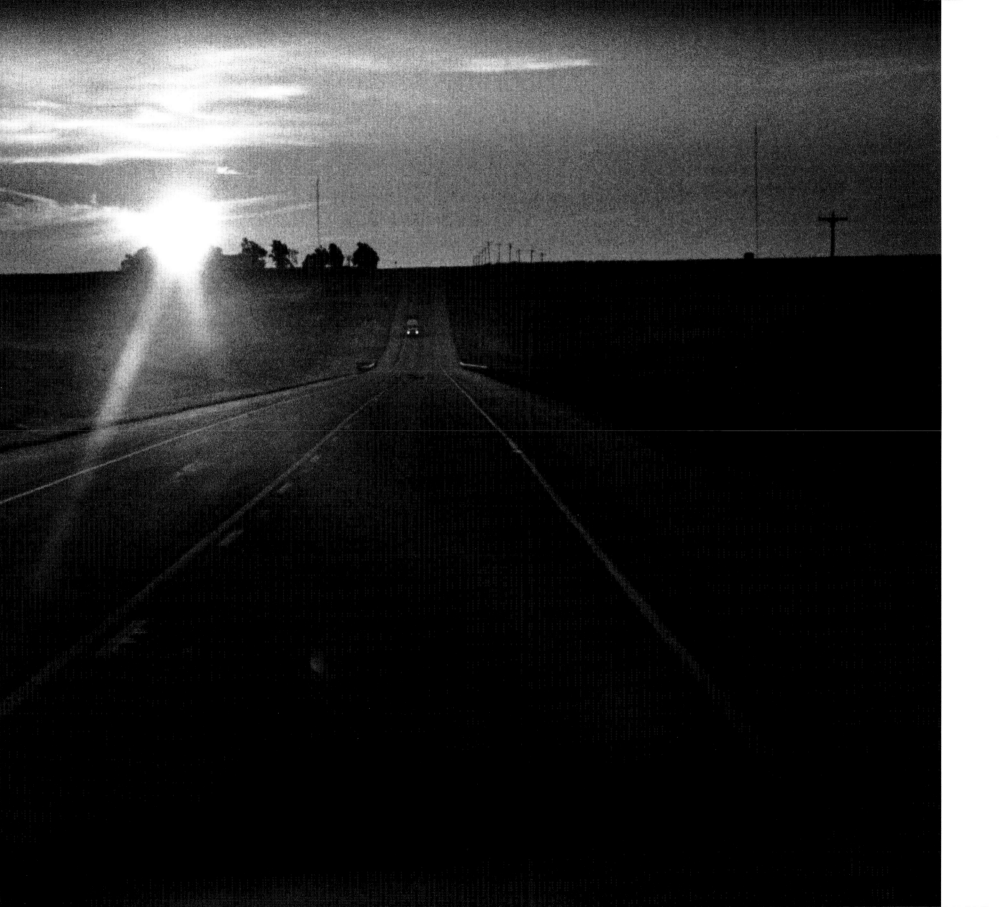

(2) *they come from a world of corn and labor . . .*

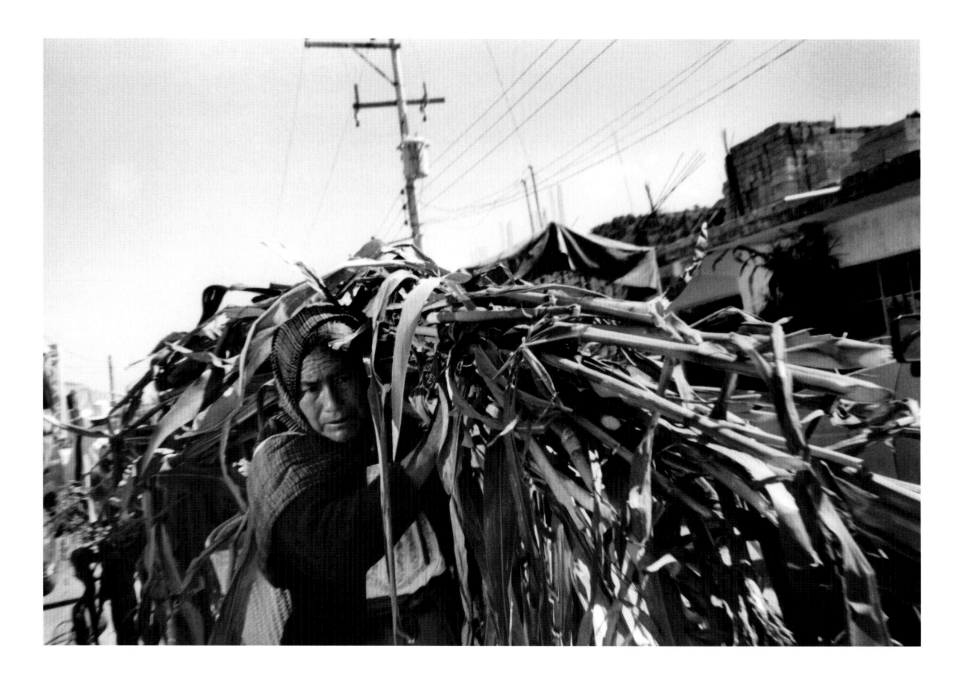

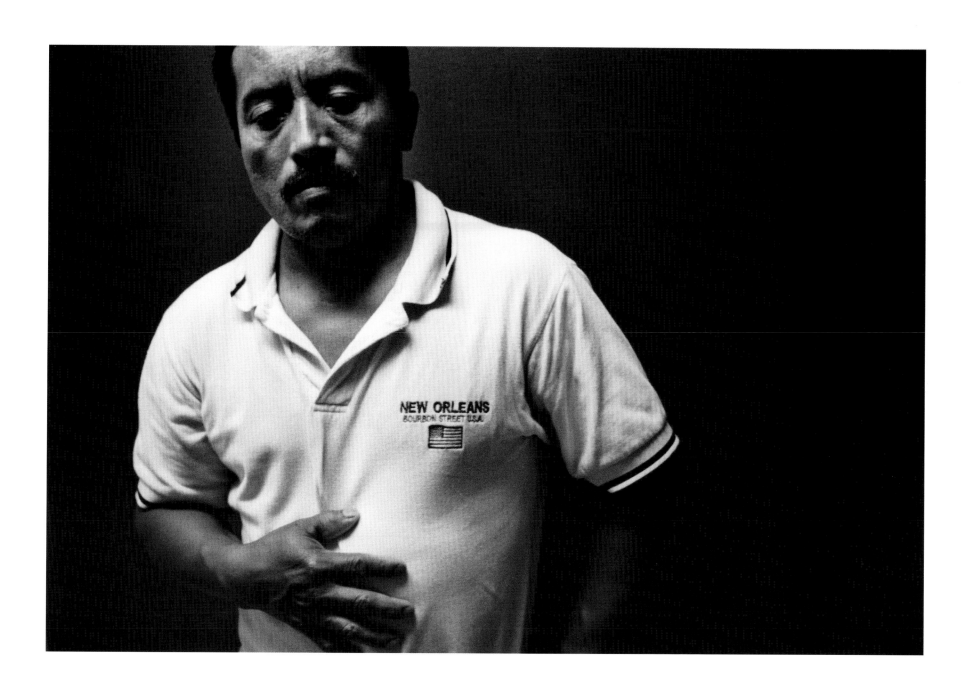

(3) *they come from Veracruz to rebuild dead cities like New Orleans . . .*

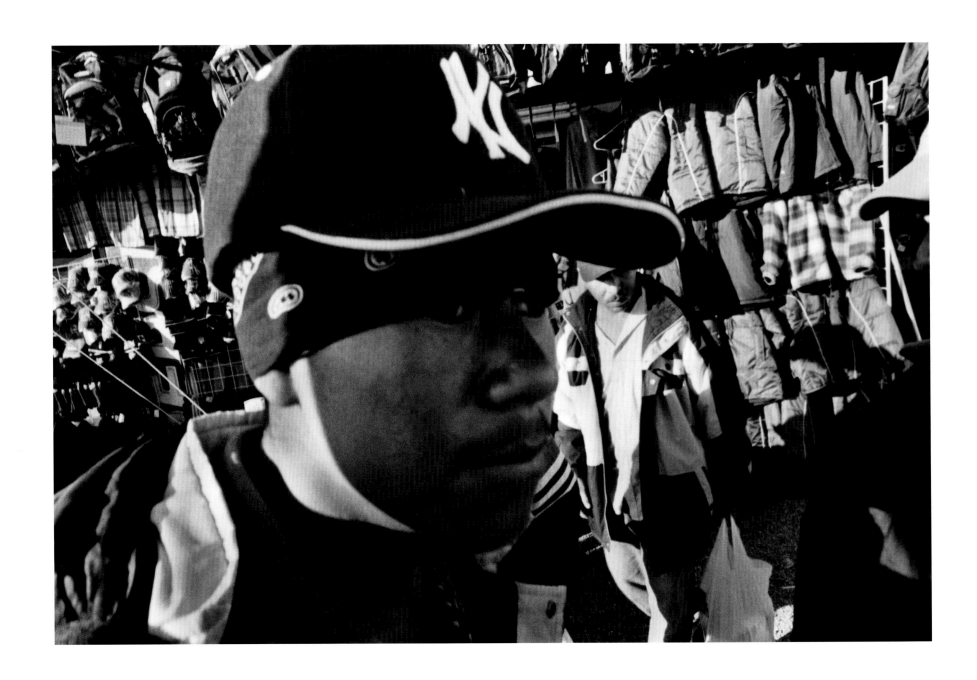

(4) *they buy black clothing in Mexico to go through a wire . . .*

(5) and ride through the desert to a dream . . .

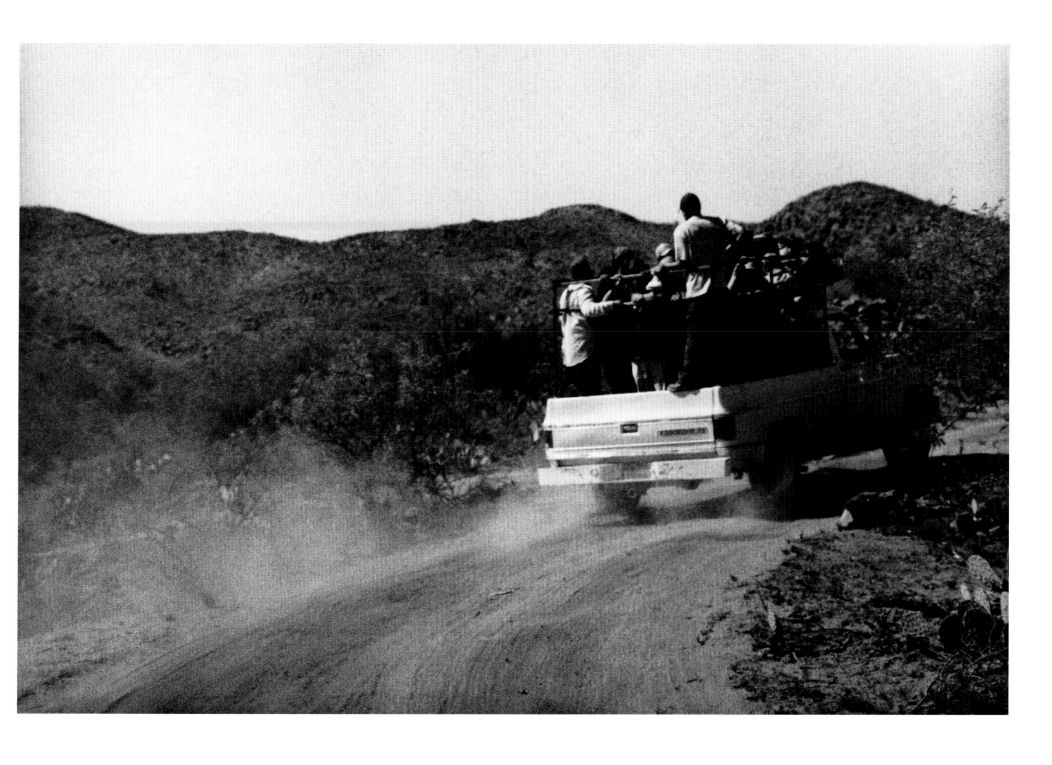

*(6) or they come from Central America and
run the gauntlet of Mexican cops . . .*

11

(7) *and enter the war zone of the border—*
a van bullet-riddled and abandoned on the Arizona line . . .

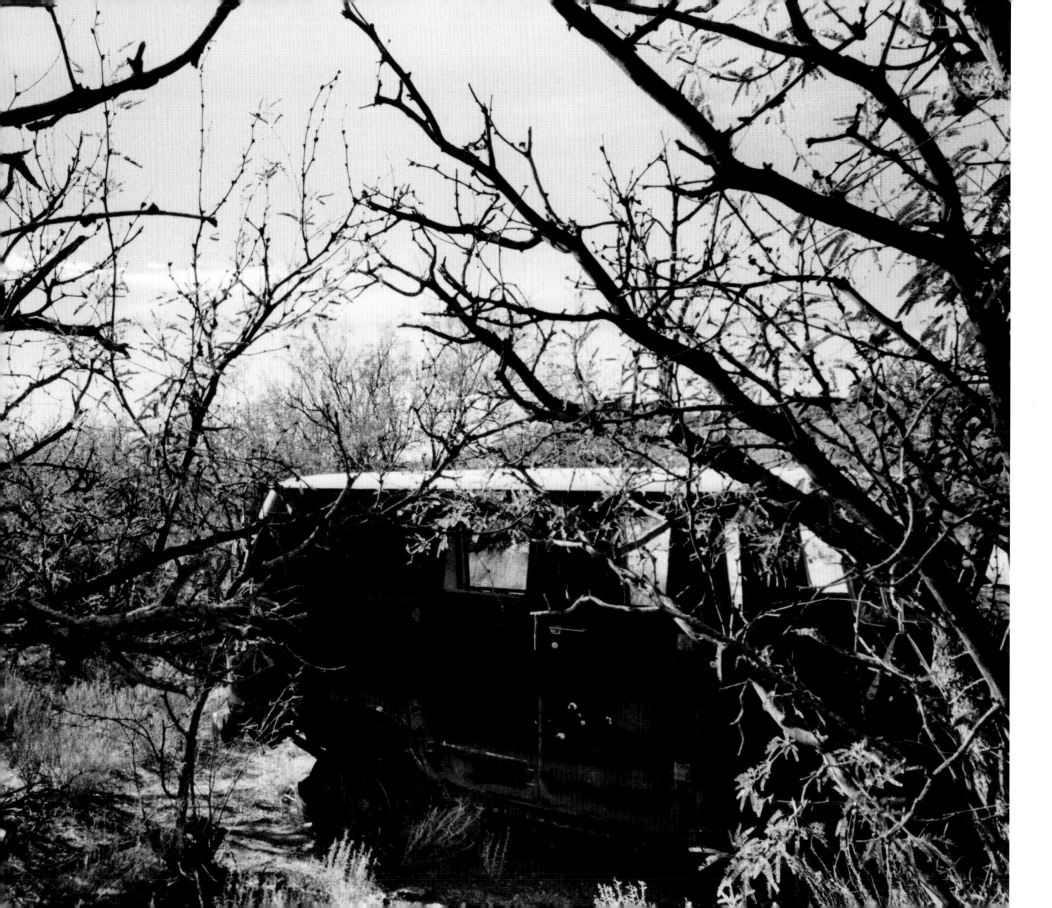

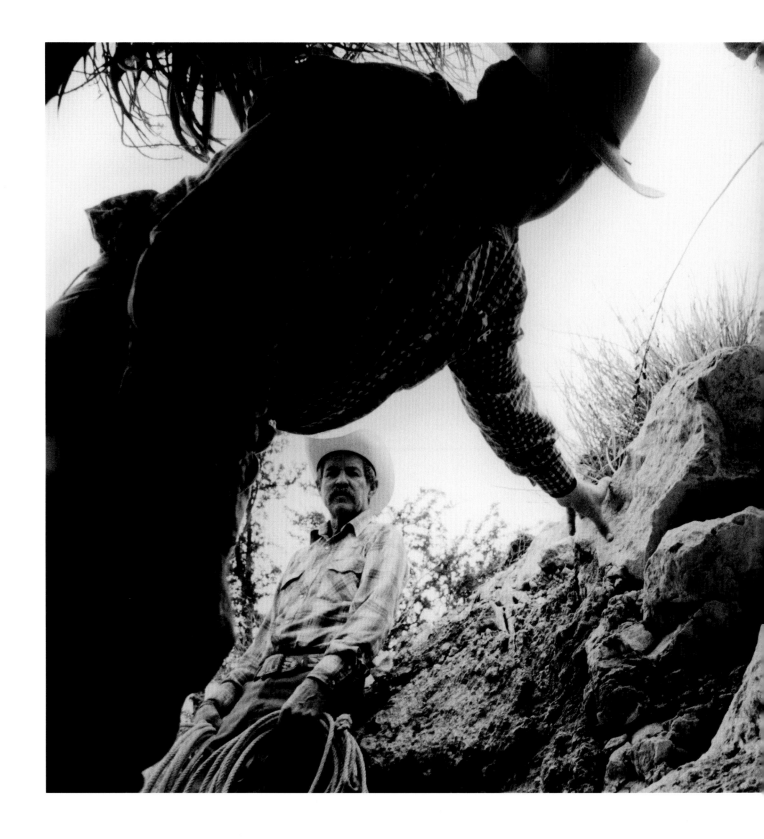

(8) *a hole on the line in Coahuila that held eleven tons of marijuana . . .*

(9) and the failed ruling class of Mexico surrounding their president . . .

(10) while in Juárez a woman walks home after her factory shift past outlaw electric lines feeding shacks.

part one

Sixty sorcerers were brought to Motecuhzoma;
they were old men, wise in the art of magic. The king instructed
them thus: "O elders, my fathers, I am determined to seek
the land that has given birth to the Aztec people, to discover
whence they came. . . .

Laden with rich gifts, the sixty sorcerers departed and some
time later reached a hill. . . . There they traced magic symbols
on the ground, invoked the demon, and smeared themselves
with certain ointments that they used and that wizards still
use nowadays—for there are still great magicians, men who
are possessed among them. One might ask: how is it that
they are not exposed? And I shall answer that is because they
conceal one another and hide from us more than any other
people on earth. . . . So it is that upon that hill they invoked
the Evil Spirit and begged him to show them the home of their
ancestors. The devil, conjured by these spells and pleas, turned
some of them into birds and others into wild beasts such as
ocelots, jaguars, jackals, wildcats, and took them, together
with their gifts, to the land of their forebears.

FRAY DURÁN, 1581

dreams and nightmares

AT NOON THE AIR BURNS—strike a match and toss it into a gallon of gasoline to get the feeling—and it stays this way into the night when the blackness wraps the body like velvet. For hours this air remains higher in temperature than that of the mammals struggling to stay alive. The ground rolls, a brown grassland dreaming of rain with clots of mesquite in green leaf. The mesquite tortures the mind. The dirt beneath the shoe may be 150 degrees, the skin roars with fire, the body feels baked and erratic, the one-gallon water jug in the hand long emptied and still the eyes stare at these thriving trees feasting off water 100 to 200 feet below the surface.

We go down to the line to do a radio program. Late at night we stop in the small Arizona border town of Sasabe and get a twelve-pack of beer with ice, then swing into a national wildlife refuge, the Buenos Aires, a patch of ground I have been roaming since childhood. At the gate going in, a Border Patrol vehicle lurks in the darkness. The refuge is overrun with smugglers and Mexicans and they have left over 1300 miles of new trails and over 200 miles of outlaw roads.

As we drive the dirt tracks of the refuge, a Border Patrol vehicle suddenly roars up and stops us. The agent is apprehensive. He has a right to be wary since spent brass from AK-47s now shows up on the ground of this sanctuary for masked bobwhite. I've found cars riddled with rounds.

He tells me I have no right to be there.

I tell him that is not true.

Then he changes his message and tells me it is very dangerous.

I do not argue and he relents.

After all, he works for people like me and so he spends his nights catching men and women and children walking through a desert toward dreams of jobs in places they largely know only as rumor. I have no ill feelings toward the agents, nor toward the people they hunt in the day and the night.

We park in the darkness a few hundred yards from the line. There is no moon and the hot blackness seems to stalk us with menace. We are poised in the largest corridor at that moment for illegal immigration in North America, the Altar valley sweeping up from Sonora to the west flank of Tucson sixty miles away. It is an empty habitat of the Sonoran Desert, an upland of grass and mesquite which as it flows north gives way to saguaro, creosote, and burning desert ground.

In the darkness, we drink beer and it is around midnight with nothing out and about but people fleeing into the United States and agents paid to stop them.

The tape machine comes on and then, the first question, "Where are we right now?"

And I say, "We're probably within 200–300 yards of the fence. It's invisible. It's like when you look overhead. There aren't any Mexican stars or American stars. It's like a great biological unity, with a meat cleaver of law cutting it in half. We're in an odd circumstance. We're in a national wildlife refuge, a sanctuary, and there's a thousand Mexicans out here scared to death and trying to make it into the United States, and there's a couple of thousand pounds of drugs moving around us and there's men with AKs guarding the drugs, and there's dozens, perhaps hundreds of Border Patrol personnel with the hairs on the back of their necks standing up all night. If you look to the north-northeast you can see the glow of the lights of Tucson, and they're gonna have to move constantly for three days to get there.

"It's sixty miles. How fast can men, women, and children in a unit travel? They can't move during the day much. After about 11 a.m., the heat'll knock 'em down.

"They follow the person in front of them. And they fall a lot. And they're afraid. They're afraid of the desert at night anyway. It's a different desert when you're being hunted. They've spent their lives as human beings. They cross the wire and they become deer, surrounded

by lions. The only thing you can really hear out here are insects and fear. Hundreds of square miles just crackling with fear. Soon, there will be a fence, car barriers, then towers with cameras. These people are risking their lives tonight to cross this desert and when they get to their Chicago or their Los Angeles or their North Carolina they will send money back to Mexico. You take a man, you put him 300 yards south of here, and he can't find a job, he can barely feed himself. You move him across this desert, you get him to an American city, Mexico no longer has to feed him, he becomes a money pump, like a private ATM that sustains their society. Oddly enough, moving human flesh, in a few years, is gonna be more lucrative than moving cocaine. It's the coming thing. Mexico has finally found a product that makes it money. Expelling its own citizens into a foreign country."

I stand in the darkness, in that pitch of night, and I realize I am tired and I love the taste of the cold beer on my tongue.

Then I'm asked, "Well, what's the solution to this problem?"

And I ask, "What's the problem?"

la gente

A visitor is excited by the opening up of Mexico and the new investment opportunities: "I trust that my general remarks about Mexico will lead the reader to believe that at the present time the country is passing with rapid strides from a state of anarchy and confusion to a condition of development and improvement. . . . Happily for the future prosperity of Mexico, the aspirations of the government and of the people toward so desirable a result are being furthered by their neighbors in the United States." The voice belongs to Thomas Unett Brocklehust, and he is speaking in the year 1883.

Or the General is talking to Doña Luz, a relative of the recently slaughtered President Francisco Madero. The General is in an odd mood because he's going to a baptism. Doña Luz is very pious and takes this opportunity to talk some salvation to the General.

"General Villa," she says, "you are a very sinful man; your hands are stained with much blood; in thought and act you have committed many other crimes. Put yourself in God's graces and He will pardon your sins."

"Señora Doña Luz," he quickly corrects her, "I have never killed anyone without reason."

She says, "I believe you, Señor General. But God says, 'Thou shalt not kill,' and He does not say with or without reason."

"Señora," Villa barks back, "to kill is a cruel necessity for men who are at war. If we do not kill, how can we conquer? And if we do not conquer what future is there for the cause of the people? Death is an accident in the course of our struggle, and we all either kill or die."

"Not all your deaths," she answers, "have occurred in war, Señor General."

"Señora," he says, "for me the war began when I was born. I am a man whom God brought into the world to battle with I do not know how many enemies.

"I have never stolen," he says. "I have taken from those who had much in order to give to those who had little or nothing. For myself, I have never taken anything belonging to another except in a situation of the most urgent necessity.

"It is the rich who steal," he continues, "because, having everything they need, they still deprive the poor of their miserable bread."

THE LINE HAS LONG BEEN a bristling matter. In the eighteenth century, Spain founded a series of presidios, frontier forts, to wall off the Apache and Comanche nations and their murderous raids into Mexico. Tucson, the city where I've spent most of my life, was founded in 1775 for this expressed purpose. The presidio system failed. A royal report in the late eighteenth century advised abandonment of most of it and letting the country north of this line be left to nature and Native Americans. This was hardly unreasonable. Texas spent forty years crushing the Comanches. Think of it this way: for four decades the

people of Texas were kept at bay by some other people of Texas, thirty thousand Native Americans from the high plains.

The Mexican War of 1846 lopped off half of the Mexican nation for the United States. Two things must always be remembered from that war. First, it was naked theft. Second, there were hardly any Mexican citizens in the stolen half, especially outside of California. Arizona, for example, had at most five thousand. Texas had barely been penetrated by Mexican settlement (the Comanche problem) and by the 1850s, to take one example, San Antonio was more German than Hispanic. For a spell, I lived in a hamlet near the line where the most distinctive buildings were those thrown up during the Mexican Revolution of 1910–1920 to protect the United States from bandit raids. Relics of that effort stud little communities all along the line.

la gente

General Villa has taken Saltillo as an act of loyalty to Venustiano Carranza, First Chief of the revolutionary forces. This in itself makes Villa irritable because he thinks Saltillo is of no importance in the revolution's goal of overthrowing the regime of Victoriano Huerta. His temper tantrums are beginning to alarm him. He gives up meat to see if that will help. It does not. Then at Saltillo he becomes ill because of his anger and his anger comes from a woman, Otilia Meraz. He met her at fiesta after taking Torreón. He makes her an offer and she accepts and to his delight he discovers she is very good in bed—"I discovered," the General acknowledges, "that she already knew much about love."

So he is at Saltillo with a woman who gives him pleasure when she tells him that Darío Silva, one of the eight men who crossed the Rio Grande with him on that lonely night when he invaded Mexico to begin the war against Huerta, is a former lover of hers. "I did not see how I could endure the revelation," the General confesses. "Instead of blaming the woman who told me of the past when there was no remedy for it, or blaming myself for taking a woman who had belonged to others, I blamed Darío Silva, and I obeyed my impulse to punish him and humiliate him."

He bans Silva from his table and makes him serve as the waiter. This goes on for days. Eventually the General cools and comes to his senses. He realizes Otilia is at fault, not Silva, and decides to beat her. "But," the General admits, "I recovered and contented myself with throwing her out and calling Darío Silva to assure him of my friendship."

NONE OF THE FORTS AND BATTLES and thefts had much to do with the fear of a migration. That is a recent concept—one that begins with the Oriental exclusion laws of the 1880s and blossoms in the immigration bill of 1924. In the nineteenth century, the United States fed off the surplus populations and cheap labor of Europe, all the unwanted people who came to a new land. People from Asia were shunned and outlawed, hardly surprising in a nation that had replaced slavery with the Ku Klux Klan, and severely restricted voting rights of people of color. Our Statue of Liberty has always needed a long footnote attached to explain the details of the contract we are offering.

Migrations have been occurring for thousands of years. Hadrian's Wall, the Roman effort to keep the savages out of what is now Scotland from the area of what is now England, began about AD 122. It failed after a few centuries. But what is forgotten is that at that time Scotland was not inhabited by Scots (they are a creation of later migrations) and England was not English, since that amalgam also was created long after the wall fell. Just as the Comanches who fought Spain and then Mexico to a standstill, and cost the Texans forty years of blood and treasure, did not arrive on the high plains until the late seventeenth or early eighteenth century. Before that time, they'd been grubbing out a living in the Rocky Mountains.

For almost 200 years, Mexico has struggled to achieve a just state through countless coups and revolutions. The failure of these efforts is played out on the border today.

When I was a child in the early 1950s, my father decided we should all get in the car and drive from Chicago to Mexico. We crossed at Laredo—I still remember looking out the car window from the backseat as the exotic landscape of semitropical scrub floated past my eyes. There was a man walking by the road, dark, with shabby clothing and almost no teeth.

I laughed at the man.

My father turned toward me and admonished me never to mock someone for being poor. I was taken aback by the anger in his voice.

Then came days and days of Mexico. I could not understand the poverty, the small houses and scant sign of money.

We lived in an apartment in a working-class neighborhood but I had never seen anything like this.

I wondered why they stayed there instead of moving, say, to Chicago.

Now I think we are seeing the future where the poor move because to stay in place is doom. Mexico is our one intimate brush with the majority of the planet where people have little or nothing and the future in their homelands promises even less.

la gente

General Francisco "Pancho" Villa, while still a boy, hides in the mountains and becomes a bandit. What Villa does is steal cattle, then slaughter them, jerk the meat, tan the hides, and then carefully descend to the towns and sell these items. Sometimes he steals money. Now and then he murders. He is in what we now call the teenage years. This life goes on until he is about thirty years old. He is the oldest son, his father is dead, and he misses his family very much. He is the head of his family but hides in the sierra from the rurales.

Word comes to him in his lonely hideout that his mother is dying. He saddles up and rides. When he arrives at a hill over his village, he looks closely.

The authorities are present and wait for him. His dying mother has become the trap. He sends a messenger down and asks for her blessing. She grants this wish. And then Pancho Villa sits on through the night hours looking down at his village and the lights in his mother's home as the deathwatch grinds on.

He does not curse. He does not write bitter words.

He weeps.

Villa has rough edges. His opponents send a man named Gaucho Mújica from Mexico City to win the General's confidence and then murder him. At first Villa trusts him and then he discovers his treachery. He tries to make his response appropriate and worthy of the commander of the Division of the North. He hits Gaucho Mújica over the head with his pistol and says, "So this is what you are, you good-for-nothing so-and-so. Well here I am, Señor."

"No, my General," Mújica says, "I did not come here to kill you although I told your enemies I would. Who would have the heart to kill a man like you?"

This is more than Villa can bear and he snaps, "Any traitor would. No man goes away alive if he comes to kill me face to face, but a traitor, yes, or several traitors together, if they catch me unarmed."

Ah, the General remembers this all so clearly and he explains, "When I tired of beating him—he was bloody and humble by now—I sent for a rope and with my own hands tied him, putting the pistol on the floor. The men who had brought him carried him away, and then and there took him off my train and shot him. I did this in anger." The American representative, Carothers, witnesses this temper tantrum and advises the General to put an account in writing of Mújica's confession, since the man was an Argentinean and technically covered by international law. And the General does that.

I SIT ON THE COUCH in the house in the sand dunes on the west edge of Juárez. The building glows a nice pink. As I walked up the path to the door, I noticed three men trying to get warm around a barrel of burning wood. The older one, somewhere in his forties with a black moustache, made me with his eyes, passive but searching eyes. He has to be the husband and father, I think. One of his daughters is dead.

Another of his daughters goes around town painting black crosses on pink backgrounds so that people will remember the dead. His wife told the attorney general of the state that she wanted justice, that she had the right to ask for this even though she comes from humble people. That was in the past, when her daughter had been missing only a few days. She was seventeen, María Sagrario González Flores. She worked in an American-owned factory making parts for cars. She played guitar on Sunday at mass.

She was buried out of the church where she played music.

I come for the war, the war publicly discussed as about free trade, money, goods and services, assembly lines and trucks and imports and exports, kilos of dope, bundles of money and fast women and long Saturday nights spiked by booze and cocaine, the coke to fuel the fire that eats the booze, the booze to blur the memory of the week, the fast women to stroke as the fire roars and then banks, the straps to fall off the shoulders, the scent to grace the air, come for the war, factories sprawling out on the flats, cardboard shacks clawing up the hills, brown people pouring out of buses and entering the gates of the mills, *cholos* loping down the lanes, girls bent over assembly lines in dull smocks and then the shift ends, they leave and vanish, sometimes vanish forever, sometimes coming back freshened up by rape and strangulation, a breast sliced here and there, come back with lips curled, teeth gleaming, eyes rotted out—and what are the dead girls but tiny details, the bones so small, tiny details, insignificant numbers in a commerce of billions, footnotes in a vast folk migration north to the line, and beyond that they are nothing, yes, nothing, the girls are simply numbers in a ledger called the fortunes of war.

Paula Flores sits on the couch in the pink house, dogs mill about, fleas bite me as I listen to a mother talking in a flat voice of a dead daughter, of justice, a mother with almost vacant eyes talking of love lost and of the days and nights when God seems to have turned His back on her family.

The fence separating nations is maybe 500 yards away and the lights of America twinkle over there while here darkness falls like lead. In Paula's world, water is bought off a truck and stored in a barrel. In Paula's world, electricity is stolen from power lines and snaked in cords across the sand to the shacks.

Paula Flores went on after her daughter's murder to found an organization called *Voces sin eco*, Voices Without Echo.

la gente

In 1910, 98 percent of the rural Mexican people were landless and 127,111,824 acres had been gobbled up by the government and largely sold to foreigners—North Americans, for example, owned 21 percent of Mexico. Tallies indicate that seventeen Homo sapiens owned 40 percent of all the soil, water, minerals and beasts in Mexico. In 1910 one Mexican family, the Terrazas, is said to own one-third of Chihuahua. Don Luis Terrazas is the closest thing to God most people are likely to meet. He comes from a shrewd and fierce clan that has sharpened their instincts for generations by warring with raiding Apaches. His cousin Joaquín becomes so addicted to this electric form of hunting that he squanders his life killing Indians. Don Luis tends to business, although, like his cousin, he is in love with the huge, fierce landscapes of Chihuahua.

He is a little man, barely five feet tall, but he thinks big. He begins with a small butcher shop in Ciudad Chihuahua when his father dies in the cholera epidemic of 1849. He rises at 5 a.m., he eats his simple breakfast at six and he works all day and into the night. He does not waste time on the ladies but remains faithful to his wife and fathers fourteen children. He attends mass. His delights are those of a country boy. He loves to watch horse racing, chicken pulls, roping, variations on bulldogging.

In 1871, he buys a wool textile mill called La Industrial. From 1870 to 1907, he buys up haciendas—La Cañada, San Lorenzo, San Miguel de Babicora, San Felipe, Labor de Trías, El Carmen, San Pedro, Tapiecitas, San Luis, El

Torreón, Las Hormigas, San Isidro, San Diego. Some are small, some are huge. By 1910 he is said to own seven million acres or seventeen million acres, depending on who is counting. Besides this cattle ranching he is into sixteen businesses worth about 27,350,000 pesos (at the time the peso is two to the dollar). The neighboring gringos across the river in Texas brag of the huge King Ranch, a spread of 900,000 acres, a mere cottage industry to Don Luis.

There is a story that goes like this: Don Luis is asked if he is from Chihuahua and he replies, "No, Chihuahua is mine." Another tale involves an American cattle buyer who telegraphs one of Don Luis's ranches and asks, "Can you supply five thousand head?" The brief reply is "What color?"

When the revolution explodes under his chattel and family, Don Luis ships his deeds, titles and financial papers out of Chihuahua—this requires sixteen boxes. Campesino soldiers grill meat over open fires on the floors of his former homes, strange hands ransack his wife's wardrobe. Don Luis himself is now in his eighties and he crosses 300 miles of desert. He sees several priests trudging grimly through the dust and he dismounts and offers them his vehicle. They climb in his automobile and the old man begins walking across the desert. He crosses into safety at Ojinaga.

One of his sons, Luis Jr., is kidnapped by the General. It is said that the son is periodically hanged from a beam in an effort to convince him to divulge where the family's gold and jewels are buried. The General apologizes that Luis Jr. is "slightly tortured." He explains his strategy simply—"Cuando se amarra el becerro, la vaca no anda lejos. When the calf is tied, the cow won't wander far." The General wants money for his army and he asks for a million dollars in ransom or three hundred thousand dollars—reports vary. When the money does not come swiftly, Luis Jr. hangs from the beam.

The General is not foolish in his requests. In 1913, three years into a bloody civil war, the Terrazas estates branded 85,000 calves. For two years, the General seeks his money, periodically dangles the son from a beam, and takes his war into the vast holdings of the Terrazas family. The plan pretty much works, although it is said that Luis Jr.'s mind is permanently broken.

The General basically took away this family empire with his gun and theoretically divvied it up into tidbits of 62.5 acres. And then the revolution won, the government came back wearing posters and slogans, and the big money emerged from its cave and life resumed at its earlier ebb.

In 1911, the General meets Francisco Madero, the provisional president of the revolutionary cause. Villa is impressed. He thinks, "He is a little fellow but he has a great soul. If all the rich in Mexico were like him, there would be no struggle and no suffering, for all of us would be doing our duty."

And then the General thinks some and he asks himself, "And what else is there for the rich to do if not to relieve the poor of their misery?"

IN JUÁREZ AT LEAST three thousand people have been murdered or disappeared in a decade. No one knows or will ever know the actual number.

On the east side of town, sunflowers bloom—multi-headed wonders—and each flower has eighteen yellow petals and a rich brown center. Police stand around by the idle backhoe and small holes in the earth mark their search. Right by this vacant lot, cotton flourishes in a small field, the bolls white and lush with lint. An irrigation ditch runs by one side and here the cottonwoods loom large and the channel is rank with tall, green grasses. Five came out of the ground here. Three more were found later, bones scattered in the field. The whole place is circled by police tape saying *Peligro*, Danger. Two major streets, Victory and the National Army, form an intersection here, each six lanes wide and the air is a steady hum of traffic. Just across the artery is the fine brick building of the Association of Maquiladoras (AMAC), the border factories owned mainly by Americans. Across the other road is a new upper-class subdivision surrounded by a tall stone wall.

A few hundred yards away is the country club of lakes (Misión de los Lagos). The fairways have concrete paths for the carts, and the club and the mansions are patrolled by guards. Hills rise just beyond the opening

holes and the small houses of the poor and lower middle class crawl up the dirt knobs. The sunset is a dying globe perfectly framed by angry clouds, a movie finish to the day.

At the intersection by the cotton field where the bodies were found, two men work. One bends while the other stands on his back and juggles. They wear the makeup of clowns, sad clowns. They are very poised, unruffled by the streams of cars, adept at doing their trick and then racing from car to car idling at the red light. The dead girls probably made $40 to $50 a week in the *maquiladoras*. The clowns do better.

I make notes in the bar of the country club, and I am not welcome. The club's floors are well-oiled Saltillo tiles, and wrought iron frames the terrace. On the silent television, the Discovery channel explores honey bears. The head of the Juárez cartel is said to live in this gated community but this is not a question to be asked. When the forensic pathologist of Juárez had her daughter and husband slaughtered this past summer, she noted that in this city only the dead can speak freely, even eagerly, to her expert eyes. The living, she continued, are too afraid to speak.

Claudia Iveth González is twenty, stands 1.62 meters, has light hair, brown eyes and light skin. On October 10, she is wearing a beige jumper, a sleeveless blouse and blue tennis shoes with the trademark Guess. She has worked for four years at Lear Number 173 making wiring for cars. The plant is at the corner of Reforma and the Niños Héroes.

AROUND 6 P.M. ON NOVEMBER 9, the authorities tentatively identify the body from a strand of hair and from a bone contusion on the little finger that distinguished Claudia in life. It is now after 6 p.m. on the 9th and people are still piling into the rust-red house in the Juárez barrio overlooking the bright lights of El Paso. Maybe twelve or fourteen stand in the small living room where there are two sofas, a wooden floor-to-ceiling case for the stereo and television and baby toys,

a big bed and a bassinet. The yellow walls almost shout from the bright overhead light. In the kitchen, another dozen or more people stand and talk. It is now a quarter to seven and the word is spreading. An older man, drunk and clutching a quart of beer, stumbles in, hugs an old woman and then melts into the crowd. A light blue child's dress with a Mickey Mouse face hangs in the doorway leading to a bedroom.

No one cries. The men are mainly silent, the women speak softly and wear pink ribbons with Claudia's name, a tribute just created today at the insistence of cousins from El Paso. She is somewhere past number 300, or maybe number 58, depending on who is counting. For the police, she is maybe number 58.

Claudia's sister, Mayela, who is twenty-four and has worked for eight years at Delphi making parts for General Motors (her black diploma plaque for four years' work hangs on the wall), says the police were useless. They told her that Claudia was a loose girl, was crazy and had probably run off with some boys. She did not run very far from Lear Number 173 and apparently lost interest in running near the cotton field and the inviting ditch with rampant sunflowers.

The mother, Josefina, forty-seven, came north from Torreón forty-four years ago. Her three daughters and one son were born in Juárez. She wears a dark blue Adidas jacket, a very short purple skirt, nylons, and low heels. Her face is smooth and rich with grief, her black hair long and straight, hanging down her back. She sits on the bed in the front room and suddenly begins to weep as she softly speaks. The women listen but do not touch her. Josefina's voice whispers for several moments and then she grabs some center in herself, the face smoothes again, the tears fade and the room returns to being a throng of people and small children, the adults focusing on the kids underfoot and cajoling smiles from them.

There is a pattern to talk when death walks into the house, and it is not denial and it is not despair. The men keep largely to silence. They

have failed in a primal sense. Someone has had his way with their woman. The women at first go to where they feel comfortable, that talent for smoothing over the rough edges of life, for making a baby stop crying, for draining the anger from their men, for keeping life on an even keel. So the women make small talk and smile, and briefly now and then mention that Claudia is dead and that this is very sad, but in the main, the women maintain so that the house can endure and so that this nebulous but real thing we call family can exist.

She was twenty with young hips promising children and a new family, with young eyes looking for someone to call a husband. She had clean white teeth and red lips and smooth skin and a fine scent. She is still here and still alive here at this moment, the bones and snatches of hair are distant reports from some cold room where strangers examine her remains. So the men are largely silent, the house purrs with small talk of the women, everyone dotes on the small children, and the younger women, those in their teens or early twenties, they simply watch, their well made-up eyes clear and sharp and yet blank as television screens in lonely motels.

Within hours, at latest by early tomorrow morning, the rituals of death and burial will smooth the way for everyone. But now in this first hour, everyone is on his or her own and improvises. It will not be simple: the authorities refuse to release the body for at least fifteen days and will not conclusively state their identification of the remains until the coming Wednesday. But a major step has been taken: the family now can say the word *death* out loud.

By eight the first wave of knowing is over. A four-month-old baby gurgles and stares and takes in the scene. The remaining women make pink ribbons and carefully write Claudia's name on each.

The people from El Paso begin to leave, the wait and search at the bridge could take hours, of course. By eight the red house is almost empty, and very quiet. A black and white teddy bear stares from the bed in the living room. In the side bedroom, Christ and the Virgin of Guadalupe watch from the wall, plus a framed poster supporting the Dallas Cowboys. The floor is layers of linoleum tiles that are white, black, yellow, green, tan, blue and whatever could be found, and in the center of the room where the tiles are worn away, the cement stares like a black eye. On the walls, a row of large portraits of two- and three-year-olds, one of them Claudia staring out from a bed at age two, her tiny feet splayed and her mouth not quite smiling at the camera. Two decals, Tweety Bird and Felix the Cat, have been pasted on the glass. Over one sofa, a collage of family images: the ancient patriarch and wife, her in a black dress, him in a white suit and hat, and then radiating out, a soldier from long ago, young women with men, marriages, a fête with the girls in new dresses and the brother in a tuxedo at his ninth-grade graduation—all holding wine glasses. One image is of a U.S. soldier, Josefina's brother, who fought in Vietnam and now lives in El Paso.

Claudia lost touch and the authorities explained she ran off, that she was loose and crazy. That is, until a day or so ago, when she returned from the fields and the ditch.

For a month, her sister Mayela has led searches in the desert, going to the traditional places where some of the 300 or the 58 have reappeared in the past. But this cotton field by the fine roads and rich houses was not such a place. Mayela failed to look there and was apparently outfoxed by her loose sister.

By the doorway leading to the bedroom stands a two-foot doll still in its box and staring through the cellophane front. The skin is white bisque porcelain, the hair auburn ringlets, the gown ruffles, as is the hat. The second thing to be remembered is that on this Friday evening of November 9, men stand on the corners of Juárez juggling and doing tricks for change, but that is not what catches the eye. It is the men clutching dozens of roses and selling them to lovers idling at stoplights, the bursts of blood red, the fumes of exhaust, the hands reaching through the lowered windows for testaments of love.

In the corner of the front room, a child's tea set is ready for a party. Four-year-old Karla, the daughter of Mayela, ambles over, her hair in pigtails, her smile both broad and shy. Claudia was her *tía*, her aunt. She does not wear a pink ribbon but instead clutches a small plastic toy car. At times, she holds it to her eye and pretends it is a camera and clicks off shots of the evening when everyone piled into her little house and milled around under the very bright overhead light.

SHE WAS LATE. On October 10, Claudia was to work the second shift at Lear Number 173. She arrived at 3:42 p.m., two minutes late for her place on the line. The doors were locked and she could not get in without the permission of her superiors. It is unclear how long it took to achieve this permission, twenty or thirty minutes it seems. When permission came, Claudia was gone and no one has come forward to explain her disappearance after she toiled for four years on the wiring of American automobiles.

No one saw anything. Across the street at the burrito stand, La Cabaña, the sign portrays a mountain cabin surrounded by pine trees. The brother and sister who work there each day from 9 a.m. until 7 or 8 p.m. say they saw nothing. They have a clear view of the entrance to the plant and also of the bus stop where Claudia would wait for her ride. They say she never ate there—her family says she ate there precisely twice over the years. Later, a guard at the plant said that he saw Claudia board a bus. When Josefina asked him about this after October 10, he denied ever making such a claim. A patron of La Cabaña also saw her board a bus, but the brother and sister who run the stand cannot remember his name. The plant itself has five security cameras on the exterior with roving lenses. No film has ever been offered for investigators even though the entrance where the guard made her wait for being late is always filmed. The police have never questioned the brother and sister at the burrito stand.

The brother at the burrito stand says the neighborhood is infested with thieves and *cabrones*. Over the course of an hour, he greets everyone who passes by with a familiar hello. His sister explains that even though she was working at 3:42 p.m. on October 10, she could hardly notice Claudia being kidnapped since the area has so many people walking past. And finally, Claudia, who allegedly boarded a bus and then disappeared, had no money for a bus. She tried to borrow money for her return fare on the morning of October 10 from a girlfriend. But the friend had no money to loan.

Twenty-four hours after Claudia disappeared, Josefina came to the burrito stand asking about her daughter. A flyer with Claudia's photo and description is still taped to the wall of the business.

AT LEAR FURUKAWA NUMBER 173 the building is beige, like Claudia's jumper, with a deep rust-red trim, like her own home. The factory is surrounded by a block wall ten feet high and this is topped by a cyclone fence over six feet high and this is topped by three strands of barbed wire. It is Saturday, November 10, thirty-one days after Claudia vanished and Juárez huddles under a cold rain. An abandoned white van by the plant has a sticker saying: ¡NO MÁS VIOLENCIA! EXIGIMOS SEGURIDAD. On the ground a wet newspaper has photos of skeletons from the recent Day of the Dead and a headline reading: EN HONOR A NUESTROS MUERTOS. Grackles babble in the trees.

On the gate of the plant, a large white sign warns: Safety Starts Here/ Remember Someone Is Waiting For You Healthy And Safe. A black company flag sags on a pole in the rain. The two Juárez newspapers state that the eight girls were strangled and had their throats cut. The authorities also state that the cause of death is yet to be determined. The Bishop of Juárez laments the murders. Yesterday, according to the papers, four women barely avoided being abducted in three separate instances.

At the burial site with the sunflowers, the rain falls gently and one lonely cop waits in a white car. No digging or looking is going on. At the corner stoplight by the killing ground, a man sells *El Diario*, the local newspaper, and also, copies of the film *Titanic*.

IT IS SATURDAY, November 10, 3:07 p.m., and Josefina sits in her house and talks softly. She wears a red velour blouse, a plaid jacket, light blue denim pants, and black snakeskin boots. She has single pearl earrings and no makeup. On each hand are two rings, one huge. She shows photos of Claudia at age five or six.

In the kitchen is a calendar advertising a downtown seafood restaurant and a cheap copy of Leonardo da Vinci's *The Last Supper*. Two philodendrons grow on a table. There is a stove, refrigerator and washing machine. The countertop is butterscotch-colored tile. The loudest sound in the house is the ticking of a clock.

Claudia did not dance, did not party, did not have a boyfriend, did not go out except to work. Claudia liked to do this: listen to music (Backstreet Boys) and follow the Dallas Cowboys games on television. She would be twenty-one this coming February. She planned to use her December bonus from Lear to buy a television for her bedroom. The bedroom itself is Claudia's final portrait. A stereo with a tape player, a large dresser with a mirror, the surface holding a hairbrush, a tube of toothpaste, some shampoo, and hairspray (no clutter of eye makeup, perfume, or lipsticks). On the walls, cheap lithographs of Christ and the Virgin of Guadalupe, plus that large Dallas Cowboys poster. On the armoire in the corner are dozens of stuffed animals (bears, wolves, monkeys, rabbits, one saying I LOVE YOU on its chest). Claudia and Mayela collected them. A CD hangs off the light chain.

It is the room of a girl who worked from 3 p.m. to 2 a.m. five days a week and did not go out. Friends would say to her, come, have some fun, but she would refuse. She worked.

When she disappeared, the Lear plant gave no aid, but now that she is soundly dead they have offered to help with the burial costs. Also, she had life insurance and her brother and two sisters are the beneficiaries.

Josefina slowly brightens as the afternoon crawls along. She remembers talking with the fat guard at Lear who had two stories: 1. That Claudia signed the book at the gate and then crossed the street. 2. That she signed the book at the gate and then stayed by the fence at the guard house and somehow magically vanished. Several of Claudia's friends from the first shift at Lear say they saw her by the gate waiting when they left work.

Karla, the four-year-old niece of Claudia, comes into the room holding a section of *El Mexicano*. The headline says: Identify Two Corpses. The child wears gold earrings and beams as she waves the newspaper.

Josefina holds a picture of Claudia. Her hair streams down her back almost to her waist.

Josefina says, "Juárez, well, we are not secure here. You can't even trust the police."

Mayela says, "Juárez is, how do you say? A city that ridicules people, a place where they do with us what they want."

Both women began to notice the murder of females in Juárez around 1990. They have never noticed the pink telephone poles with black crosses painted around the city by Guillermina González's group.

When Claudia vanished, Mayela only felt that her sister was not okay. She could not face that she was dead.

Mayela's baby is on the bed, and Karla plays with it. Mayela's husband reads the newspaper packed with stories about the eight new dead girls.

Mayela explains that the Santo Niño was a gift from Claudia's grandmother, the Virgin of Guadalupe was from Josefina, the Dallas Cowboys poster was from a girlfriend who worked in the maquila.

Josefina tries to mimic the way Claudia would cheer at the Cowboys games on television. Her brother had a vision of her on the Saturday or

Sunday after her Wednesday disappearance. He was sitting in the front room on the sofa and a woman would pass him going back and forth from the bedroom door to the kitchen door. She had long hair trailing down her back and he could not see her face. His body shook. Since then, the brother always keeps a light on at night.

Josefina tends the house and the children of Mayela. Back in 1994 or 1995, she and Claudia worked at the same maquila. Claudia would have been thirteen or fourteen then. After three and a half years, Josefina quit but Claudia kept working, eventually going on to Lear Number 173.

Outside the rain is ending and sun is peeking out at the city.

la gente

It is January 4, 1913, and a North American manager of Mexican holdings writes to a U.S. senator about what is happening in the republic. He decides to draw a kind of picture. He notes that about a year before, he visited a ranch owned by Americans. It was during the harvest time and the wheat was being threshed. The owner sold the wheat for $1.50 a bushel. His 240 laborers were paid twenty-four cents a day for twelve hours' work. They cut the grain with sickles and the visitor was disturbed by this fact. He asked why don't you cut the grain with a binder "like a live Yankee." The owner replied that his way of cutting wheat cost less than the twine would for a binder. On this wheat ranch there is a company store. It pays more in taxes than the whole 10,000-acre ranch. So the man writes to the United States senator who is trying to sort out this sudden trouble to the south.

YEARS LATER, I'M BACK IN ANAPRA, the barrio on the fence where Paula Flores sat on a couch and talked to me about her dead daughter. But now it is no longer a fence, it is an iron wall, a section of the long walls to come. Behind me a dead dog bloats in the sun with flies buzzing. There has been rain and the barrio is mud. The wall itself ends just where the slope begins that leads up to the giant statue of Christ watching over the twin cities. Beyond this gap spreads a pond of runoff. A Mexican man and his toddler step through the gap and stand briefly in the United States as two Border Patrol vehicles watch them. Then they stand back. They have proven they can move at will.

Just to the west, where the slum of workers ends, a new barbed-wire fence with concrete posts blocks the dunes from more squatters. Here and there along this barrier are gun towers. So far, two of the poor have been mowed down for trespassing. This land is claimed by one of the richest families in Juárez and the family's gunmen guard the dunes where a new port of entry from the U.S. has opened. The rich intend to get richer off the ground that will soon erupt with all the commercial establishments that flock to new border crossings.

This new barbed-wire barrier, of course, is within Mexico, and it is hardly discussed because mentioning some things here gets a person killed.

Everything feels normal. The lanes of mud, the shacks, the glitter of the U.S. a few feet away, the new barrier to keep Mexicans off the suddenly valuable dunes. There once were train robbers here who robbed the freights passing less than 100 yards away on the U.S. side, robbed them hundreds of times a year. And then that story passed beneath notice.

I remember standing here about ten years ago with three young kids from Oaxaca who lived in a cardboard shack. They'd planted tiny trees in the sand even though all their water was bought off a truck and stored in a barrel. All three worked full-time in some multinational factory.

Since then, things have changed. Anapra has filled with more shacks. The fence has become a steel wall. The jobs have dramatically migrated to China, where human beings will work for less. Now the barren sand dunes to the west are worth money and fenced off from the poor.

SOME COME TO THE CITY of the *fresa* dream. Like any dream, it is beyond their reach, but it drifts through the dusty *calles* of the city like the breath of spring, holding them in its spell.

Six girls crowd around a long table in the public market of Juárez. They sit near a stage surrounded by small cafés offering stewed pork, roasted chickens, barbequed beef and the usual tacos. All order the special—platters of beans, rice and stewed meat with tortillas at about two bucks a throw. Nearby stalls sell folk magic. A skinned, dried rabbit hangs from a stick, a cloak cradles the statue of a skeleton. A ten-year-old girl floats by from the kitchen with an apron that says "A man's got to believe in something. I believe I'll have another drink. —W. C. Fields."

It is Sunday. The band, *Reyna de Chiapas*—a sax, a trumpet, a trombone, a drum and a marimba—plays "Mi linda esposa," a song about an old man looking at his gray-haired wife and remembering when they were young and their bodies burned with heat. The faces of the young girls glow. They are sixteen, seventeen, and eighteen. Six months ago they arrived in Juárez, a city of two million, leaving behind a village of several hundred in Oaxaca, a poor, mainly Indian state a thousand miles to the south.

"Everyone in the pueblo was talking about Juárez," one of them offers, "so we came here."

And they come, not simply toward something but away from nothing. They work five-and-a-half days a week for maybe forty dollars in an American-owned maquiladora, one of hundreds of border factories sited here to feed on their cheap labor. They shop in stores that charge almost the same as those in the U.S., and thus they enjoy First World prices on Third World wages. They are part of a movement busily digested and explained and denounced by sociologists and economists and the editorial writers and the church. This workforce is about 55 percent females, and mainly young.

They have their tricks. The group at the table has a small camera that they take turns carrying. Today, it dangles from the wrist of one young girl wearing a T-shirt that says in bold type: Venezia Italia.

Often, a group of them—say ten—will throw some money in a pot so each weekend one girl can take her turn and go off for a night of dancing and dreams on the fun money.

Today, the girls wear dark plum lipstick outlined in black, heavy makeup on the eyes, sparkle blush on the cheekbones, and brilliant blouses atop micro-minis or long floor-length dresses with slits up the side that show some leg. They step out of shacks without running water and they are spotless and their clothes shimmer.

la gente

There are so many stories about the General, more stories than documents, more stories than witnesses. More stories than there were days in his life. We have a wealth of stories—and don't forget the movies too. Stories come down that the General cannot be trusted with matches. He is at heart a pyromaniac according to these tales. He is in Jiménez and desires to tie up the González family and then torch their house. He is in Satevó and speaking to a grandmother, Lugarda Ruiz. The General desires to burn her but none of his companions has matches. She is said to have expressed her contempt by flinging a matchbox she had in her apron pocket and saying, "Here you are, bandit; don't let it stop you." They say that later all that remained was a heap of ashes. Through her close friend, he sends a message to Margarita Guerra, a Parral schoolteacher now living in Chihuahua City. The General says, "Since you are Margarita's comadre, send word to her that I'm on my way to Chihuahua, where I intend to burn her. . . ."

One of his wives has a tale about the General's interest in women. She is in a quarrel with him. She has grown tolerant of his habit of showing up with a load of children he has had by other women and then leaving them with her to be raised. After all, many men have their little quirks. But one day she loses her

temper over his constant love affairs. The General says, "You're crazy if you believe I'm gonna care for all them girls who keep writing to me and sayin' that they love me. I wouldn't have time to answer 'em."

He calls out to his secretary to get the latest batch of letters and his wife plucks one from the pile. It comes from Oklahoma and reads, "General: I am eighteen years old, the owner of so many acres of land. I have not parents and wish to elope with you. But if you are married, then let me know who the bravest of your men is, and I will marry him."

OUTSIDE THE MARKET in the city center, the telephone poles bear black crosses crudely painted on a pink background. A young girl working in the maquilas cannot promenade on a warm spring day without constantly passing these blazing headstones of pink.

Years ago, when a criminologist for the Juárez police department first noticed the growing number of dead girls, he was ignored. Two years further on and several dozen more bodies later, mothers were holding vigils outside the mayor's office. In the United States it was news: women in Juárez were suddenly seen as being twice as likely to be murdered as women in New York City. In Juárez, little happened. A few arrests were made. The killings continued. In February 1998, when a deputation from the Mexican congress arrived to look into the record-setting death toll, the city responded by running a warning newspaper ad featuring a young guy with his face covered by a black bar over the words, "Single man looking for young female worker who likes to party every weekend until the early hours of the dawn." Since then, the United Nations has issued a report condemning the violence, the FBI has investigated, and still the killings continue.

Some think one or several serial killers are on the loose—a theory exploded by an FBI forensic study (one requested by the Mexican authorities) that found nothing linking the murders except dead girls. Some think it is the work of teenage gangs. There is a belief held by some that the sons of the rich are doing the killing. Others think it is

the punishment exacted by Mexican men on girls who threaten them by seeking to escape the traditional world and ancient roles for women. And every now and then an implausible urban legend is born. One held that the killings are the work of a band of bus drivers working for a convicted killer who, in an effort to prove that he himself is not the culprit, paid them $1200 for every girl they raped and killed. For a while, the police thought this was a fine explanation.

And some think, and I am one of them, that the murders come from the heart of the city itself, a blood price exacted for what Juárez is: the fourth largest city in Mexico with less than 1 percent unemployment, over 300 maquiladoras—the largest concentration in the country—and abundant poverty.

Whatever the cause or causes, girls began dying and became an issue here about the time NAFTA was passed in 1993, an economic treaty that spelled the death knell for tariffs. And the girls continued to die as Mexican wages have plummeted.

The Oaxacan girls are swept away by music the band is now blaring, "Dios Nunca Muere"—God Never Dies—and it is so good to be alive and carrying a camera and eating a plate of food that they cannot stop smiling. A week or so ago, another girl was found charred in a brick oven. The police said that a bus driver on a lonely route raped and killed her.

SHE HAS HAD ONE DREAM since she was six years old. She will become a lawyer because she wants to help people like her father who is always being charged with robbery and then hiring lawyers and these lawyers take his money and do nothing. Yanira Segovia is eighteen, three months in Juárez from her home in Zacatecas, and determined to have a career. She is a small-boned woman under five feet with rings on her fingers, black hair, and shiny eyes. She weighs eighty-five pounds. She says, "I want to have fun. And save a little for school."

The workday begins with an alarm at 5:30 a.m. and she reaches over and silences it for another thirty minutes of rest. Then she showers, gulps down some milk and fruit, throws on her makeup—the eye shadow and liner, the lipstick and liner, the scents—maybe ten minutes for the makeup. Then she catches the bus at 6:30 a.m., makes one transfer, and in half an hour is at the University of Juárez, where her classmates are mainly from the city's miniscule middle or upper-middle class. She has just begun her five-year coursework for a law degree. Classes each weekday run four to six hours, then it is home again to her uncle's house, a brief rest, and the 2:30 p.m. bus to the maquila where her shift begins at 3 p.m. She works nine hours, five days a week. The bus home comes at 12:30 a.m. and she gets back to her bed at 1 a.m. She sleeps, if she is lucky, five to six hours a night. On Saturdays, she takes English classes.

"I am fine," she says shyly as she tests this strange language.

We are on her street, a dirt track up a hillside. The sun glares on a collection of black tar paper shacks and block houses crawling willy-nilly up a steep rock pile. Juárez is clotted with these shantytowns, instant communities of cardboard shacks on bleak dirt hills. This is the landscape of the new urban planners—teenagers clawing out a life in Bombay, Mexico City, Sao Paolo, and the mega-cities in China.

Yanira is always tired. She has never been to El Paso, in plain view from the hill and less than a mile away, and cannot imagine the United States.

"I don't think about anything beyond being a lawyer," she explains. "I take life as it comes. When I sleep, my dreams are the same reality as my life when I am awake. I wake up tired. I almost never use my imagination. I do not want to imagine things. I want a home, a home just for me. It will be large, very large and colored pink. There will be many rooms and a large garden with grass, trees, and flowers. . . . Maybe I will marry. But I will not marry before I become a lawyer."

She lives the fear. The factory is safe, she notes, but the people are unsafe. Once she came home on a Friday night with her weekly wages in her purse. The corner of her eye caught cholos—gang members—in the darkness. She crossed the street, they followed. They took everything.

"I felt it was normal," she says of her robbery, "because it happens all the time."

The pink poles with black crosses do not touch her, she does not understand their meanings. She has heard of the missing girls but says softly, that can happen to anyone. On Friday night she goes with well-heeled university friends to the disco Amazonas. The club has a huge, tinted-glass façade framed by a waterfall. Inside there's a jungle motif—mosaics of fish, monkeys and birds on the floor, fake vegetation draping the walls and two huge serpents twining up the Greek columns behind the bar. Simply to enter is to feel like a success and she must wear something that says Gap or Guess or Tommy Hilfiger or the like. Juárez stores sell cheap knockoffs with the right labels. On forty dollars a week the discos are beyond her reach. But the young men with money who throng the disco looking for young country girls, they pay for her. Girls who go to such upper-middle-class discos are called *fresas*, strawberries.

Yanira explains, "It is style, a state of being."

I ask my photographer friend Julián Cardona what will happen to her.

He listens to my question with surprise and says with a flat tone, "She will be crushed by Juárez within a few months. She will never finish law school. And she will never leave."

GUILLERMINA GONZÁLEZ'S SISTER, Sagrario, was kidnapped on her way home from a maquila and murdered in April 1998. Guillermina is twenty-two, very attractive, and works as a hairdresser and cosmetologist. Every other weekend she and her friends paint a silent protest, and they make it pink because Guillermina feels it is the symbolic color of women. She is the one behind the poles with black crosses. She also once worked in a maquila.

"Making things for you," she notes with a smile.

She intends to paint every pole in this city pink with a black cross until she makes the government so angry it will react. Already hundreds and hundreds of such poles dot downtown Juárez (which eventually are erased by the city in a burst of downtown remodeling). She stands on the sidewalk by a busy street as Juárez roars into the delights of a Friday night. The winds have stopped, the air is thick with heat.

Guillermina never goes to discos now.

"There are more important things," she says firmly.

She wears cheap earrings, long dark nails, a red top, bare midriff, tight black slacks, platform shoes. She deals with the fear of being a young, fresh-looking woman in Juárez.

She says, "I always look them in the eye. I try to appear strong. I show no fear."

She carries protection in her purse, but she will not speak of this.

"That's my secret," she smiles.

When she talks of her refusal to be afraid, her left hand strokes a small dog on the couch, her legs are on the floor, and her voice is clear, businesslike, and monotone. But time passes, it is getting on toward eleven, and of course, there is the matter of that night, April 15, 1998, the night Juárez forced the pink poles with black crosses to the surface. Now she has her legs pulled up firmly against her chest, her arms across her knees, and her voice is soft, very soft, like velvet.

"My sister, Sagrario," she continues, "was very happy but very responsible. She was very serious and contained. She was never angry. She played the guitar in church and taught catechism. She wanted to study computers and learn English."

It is once again 8 p.m. on April 15, 1998 and Guillermina is working at the maquila when her brother Chuy calls, alarmed that Sagrario is not yet home. The family had only come up from Durango, a ranch and farm state just south of Chihuahua, a year and a half before.

"There was no work," the mother offers matter-of-factly.

When the father arrives home from his shift at nine, he takes the brother and goes out into the night looking, checking at bus stops along Sagrario's ninety-minute route to and from work. Then they go to the hospitals. Guillermina gets home at 1 a.m. and there are lots of cars and people at the plywood hut. She immediately goes back to the maquila, gets her sister's I.D. photograph, has copies made, and then all of the family begins hitting buses, cabbies, anyone who might have seen this girl who ended her shift at 3:30 in the afternoon when there was light everywhere in Juárez and no dark corners.

The next morning the family goes to the cold comfort of the city and state police, but the authorities in these cases think the girls are just out on a fling or are, well, loose.

Then, finally, comes the official investigation and it is very simple and direct. The police investigate Sagrario. What kind of a girl is she? Does she like to party? The police come to the house in the dunes four or five times and grill the sisters about their missing sister. Sagrario returns to her family on April 29. They find the body more than twenty miles down the river. She has been stabbed three times in the chest, twice in the back and strangled by someone's bare hands. The body has been out in the weather too long to determine if she has been raped. The police tell the family that when she was found, she never looked more beautiful, that she was ready for a night, for a party.

Here Guillermina falls silent. She stares down at her feet and pulls her knees ever tighter against her chest. Her mother tugs at the corner of her white overblouse and slowly rolls the edge back and forth between her fingers.

Outside, the wind rises and sand beats against the plywood walls. They are all painted pink, every wall, inside and outside. And now the sand eats into the pink.

Guillermina says, "Alguien debe pagar por esto. Someone will pay for this."

PATRICIA MONREAL TALKS against the beating of the Indian drums outside her window, a steady beckoning to a return to the ancient fires. It is a holy day and mass has just been said at a wooden altar thrown together in the dirt street. A fiesta begins with young men from the Juárez barrio dressed as Indians performing traditional dances.

She is the community organizer. She is thirty-five and her hands move with emotion as the words come and her eyes are bright, the voice steady yet lyrical.

She deals with the byproduct of the maquila, latchkey children of single mothers running wild, toddlers without day care, the twelve- and thirteen-year-old girls working illegally. She and the people of this barrio have gotten the government to build a free day-care nursery for the women of the neighborhood who work in the maquilas, one of only four in an entire city of two million souls.

"People coming from the *campo*," she begins, "are glad to have work. But to come and think you will earn a good home and get an education is an illusion. Work, school, buses, few can do it. The maquilas have given women the possibility of supporting themselves as mothers and daughters. But it has cost a lot. This new woman is trying a new pattern created by the maquilas and living relationships made by maquilas."

Patricia Monreal can talk for hours about the girls of the maquilas and never mention one word: unions. Such organizations are tame here, government-controlled or absent.

The streets take a toll: the leading cause of death in Juárez is diabetes, followed closely by violence, then heart trouble and cirrhosis of the liver. Some maquilas are now giving self-defense classes for the girls. An activist group faked and taped an attack on a woman in the city center and the daily paper, after viewing the video, notes that the faces of many of the people mask surprise, anguish and even terror but no one gives help.

Outside, the fiesta grows, the drums ever more insistent.

She says, "The maquila is the rhythm of the city. There is no social structure which can survive this rhythm of production. The girls will be destroyed human beings living that rhythm. For the girls in the maquilas, there is no future. If you tell these girls this dark vision, it is too much for them, for their understanding."

IT IS FINALLY FRIDAY. Tomorrow is, at worst, a half-day shift. Feel the fine fabric of the dress, admire the young face in the mirror.

They come streaming out of the plants on Friday afternoon, an army of young women who have brought their finery to work. This is the carnal tongue flicking out and ever hopefully tasting the night air. Scent rises off the young girls.

The wind has died and now Juárez awakens under the sweet stench of raw sewage—the fragrance of money in a boomtown. Tonight, Yanira will not go out and dance. She has been dropped from law school for missing too many classes because of her factory job. And as a matter of course, she has been dropped by her fresa law school friends. Her father wants her to return to Zacatecas. But she refuses. She is sad, her dream seems over. Her tiny body has somehow managed to shrink even more. Guillermina, with her carefully applied cosmetics and her smooth face and fine bones, she stays home in the pink plywood house in the dunes.

In El Patio, a huge dance hall for maquila workers who lack the confidence for a place like Amazonas, men wear good cowboy boots, tight Levis, flaming cowboy shirts and straw hats. The cover is three dollars, drinks two dollars, and at least 500 people clog the dance floor and the surrounding mezzanine as a ten-piece band plays tropical music. They are singing about El Cochi Loco, the Crazy Pig, a dead *narcotraficante* still famous for his valor. He once borrowed a backhoe and buried a group of enemies in a trench. They were alive and standing as they

went under. The song is hypnotic, a thundering bass under the repeated phrase, El Cochi Loco, El Cochi Loco.

The images of the young girls smolder on the mirrored columns rising from the dance floor. Lights play across their young, yearning bodies, green lights, blue, red, and a wandering white blaze of a spotlight. To hell with death, to hell with pink poles and black crosses, to hell with managers and lonely bus rides, and to hell with the endless shifts. The faces with the darkened lips and highlighted eyes, the cool, young faces all say the same thing: every man in this building wants me.

At the door, bouncers search some guests for guns. No one can speak in the deafening sound and everyone is a mask, a blank face shored up with great dignity. They do country steps within this electric cauldron.

A couple off to the side moves slowly, the man tall in his Stetson, surefooted in his fine leather boots. But the girl moves on yet another level. Her blouse is rich with red, her long, white skirt erupting with roses. Her hair rises on her head in the crown of a contessa and then trails down her slender back. Worship me. The face is blank, no smile, the eyes glazed and almost unblinking. A few hours ago, she was a cog in a machine for forty bucks a week. Tomorrow morning, she will be scurrying around El Centro for a week's supplies and then to the *mercado público* where cheap restaurants beckon and old men play the music of Chiapas. Outside, the city is spiked with pink poles and black crosses. El Paso glows across the river as distant and as cold as a star. But now, in here, the body heat rises.

la gente

He is a boy on the run and he cuts across a pasture to avoid the hacienda where he may be recognized and arrested. A stranger stops him and accuses him of trespassing. Then rides his horse against the boy's and strikes him twice. Pancho Villa fires and kills the stranger instantly. He climbs down and takes the

dead man's pistol and cartridge belt. He thinks, "If he had not given me cause, I would not have killed him." When the dead man's horse proves difficult to catch, he shoots it for its saddle and rifle.

"Always pursued, always in hiding," the General explains of his younger years. "I distrusted everyone and everything. At each turn I feared surprise and ambush. Since we stopped so often in Chihuahua, I bought a house to stay in while there. It was an old one, but large, at No. 500, Tenth Street. It had three adobe rooms whitewashed with lime, a very small kitchen, and a large pen for my horses. I myself thatched the roof of the corral and built the stables, the water trough, and the hayrack. I would not exchange that house, which I still own and have rebuilt in a modest manner, for the most elegant palace."

Early on in the revolution, Villa gives a brief speech to a trainload of foreigners scurrying away from Ciudad Chihuahua. "This is the latest news," he notes, "for you to take to your people. There shall be no more palaces in Mexico. The tortillas of the poor are better than the bread of the rich."

It is the height of the revolution and the General is cutting a fine swath of death through the center of Mexico. He has set one of his wives up in a fine house in Cuidad Chihuahua and begun gathering the children he has bred off his many other wives. One is a son named Agustín. His wife dresses the child in a beautiful red outfit and has a crown embroidered on the cape. Then the General sees the garment on his boy and flies into a rage. He demands it be taken off. Then he rips the vile royal thing to shreds. He permits the boy to wear a charro *outfit.*

THE CITY CLAIMS YANIRA. The anxiety grows in her eyes and her face becomes increasingly blank.

At one point, one of Paula's daughters, Guillermina, the one who painted black crosses on pink backgrounds in memory of all the murdered girls, said wistfully she thought of returning to the state of Durango because she was certain that in the churches there God was nearer at hand. Later, she simply gives up and marries and lets it all go.

(11) *Illegal labor builds mansions in North Carolina . . .*

(12) *rather than sell limestone in Oaxaca* . . .

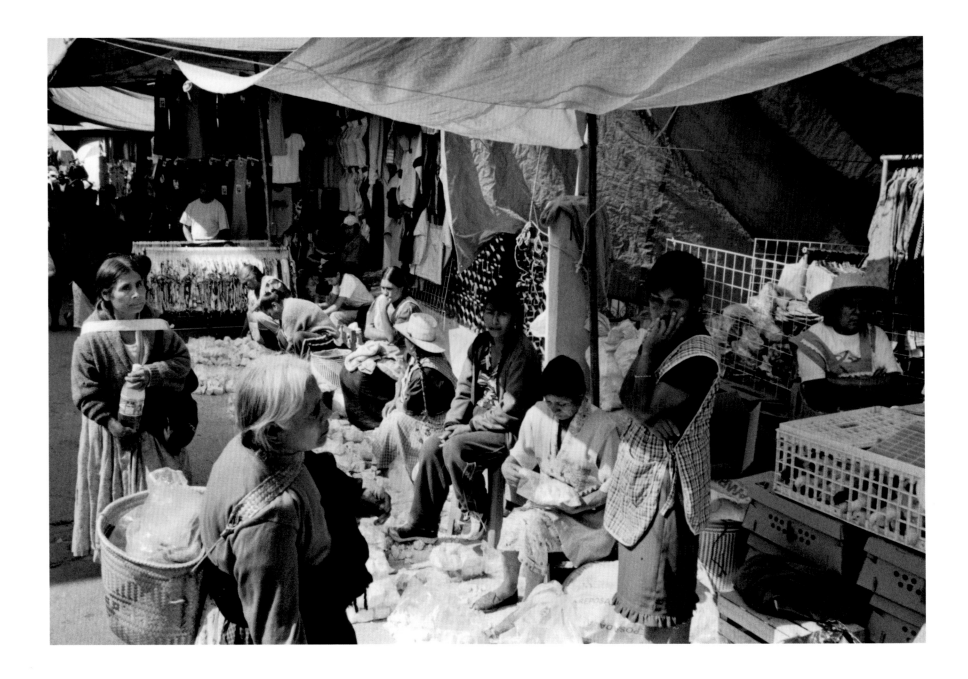

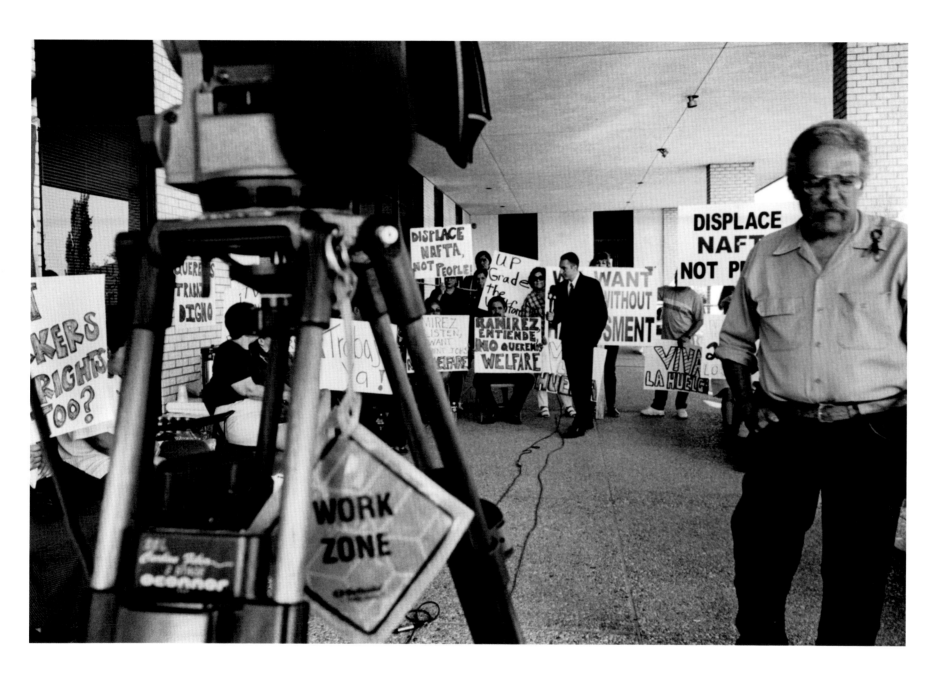

(13) *and the jobs flee U.S. places like El Paso,*
where all the blue jeans marched south to cheap labor . . .

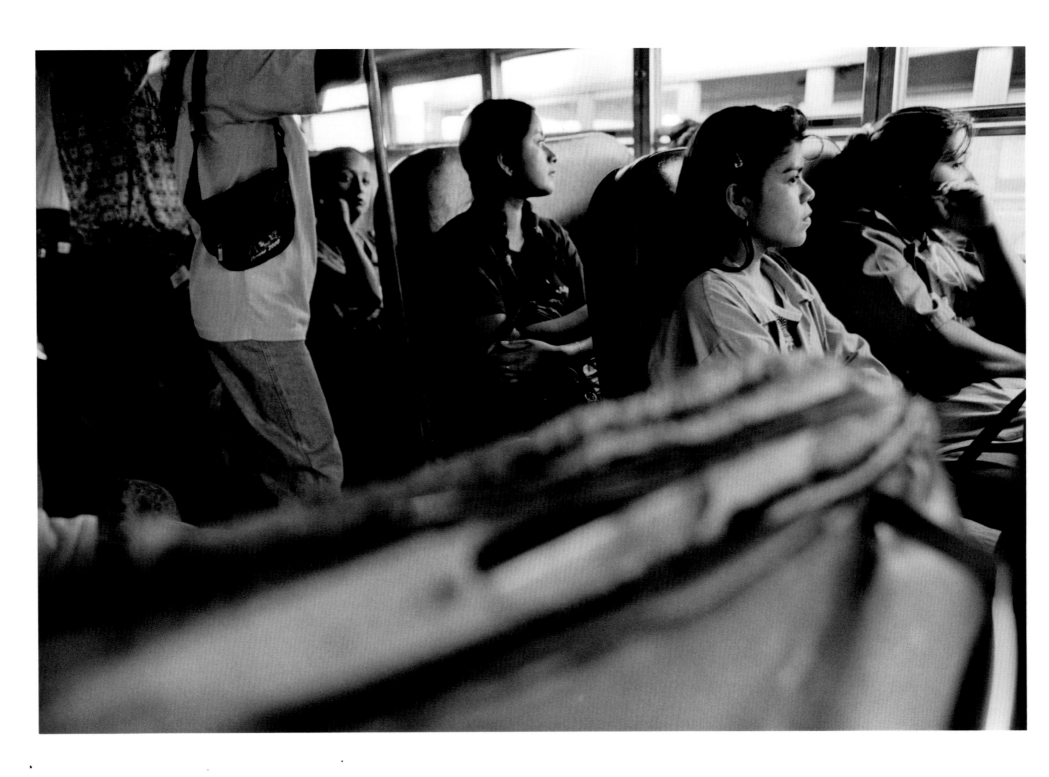

(14) *where teenagers ride a bus after the third shift . . .*

(15) *or a man from Nayarit with no work waits for dusk*
to go through the wire . . .

(16) *or Central Americans face Mexican cops as they stream north . . .*

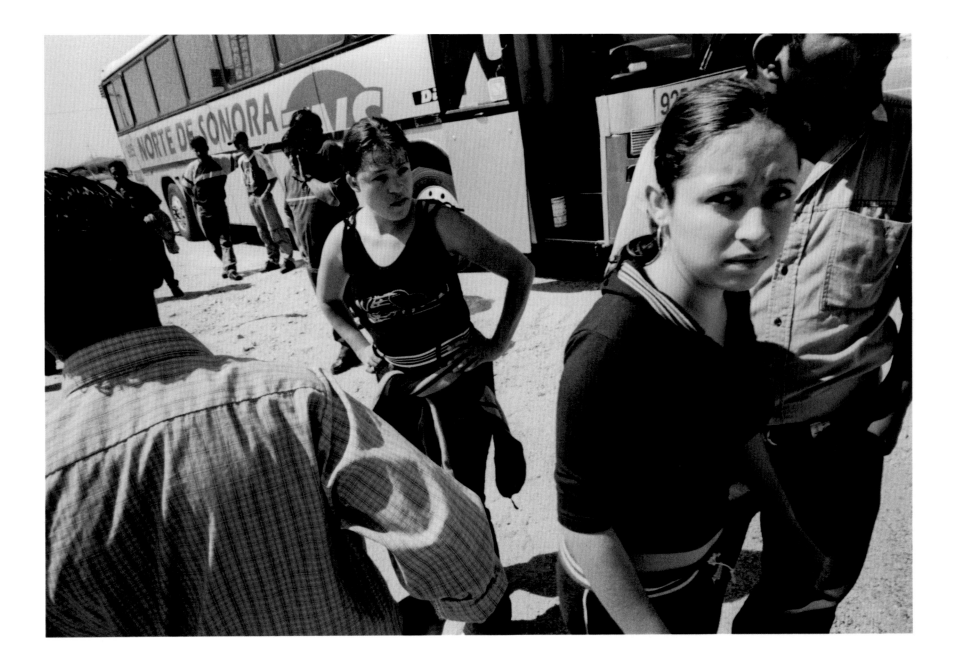

(17) *rather than be this woman working two machines in Juárez for $5 to $7 a day . . .*

(18) *while the Mixtec Indians in Altar line up for money transfers from family in the United States . . .*

(19) *or finally they leave and get in vans like these*
arriving on the line at Sásabe, Sonora . . .

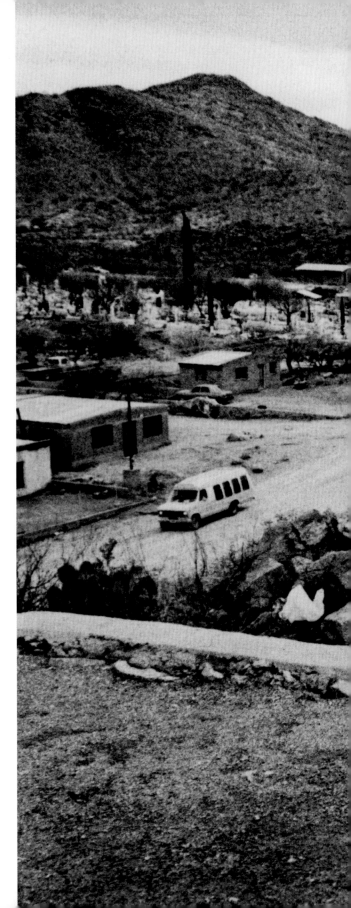

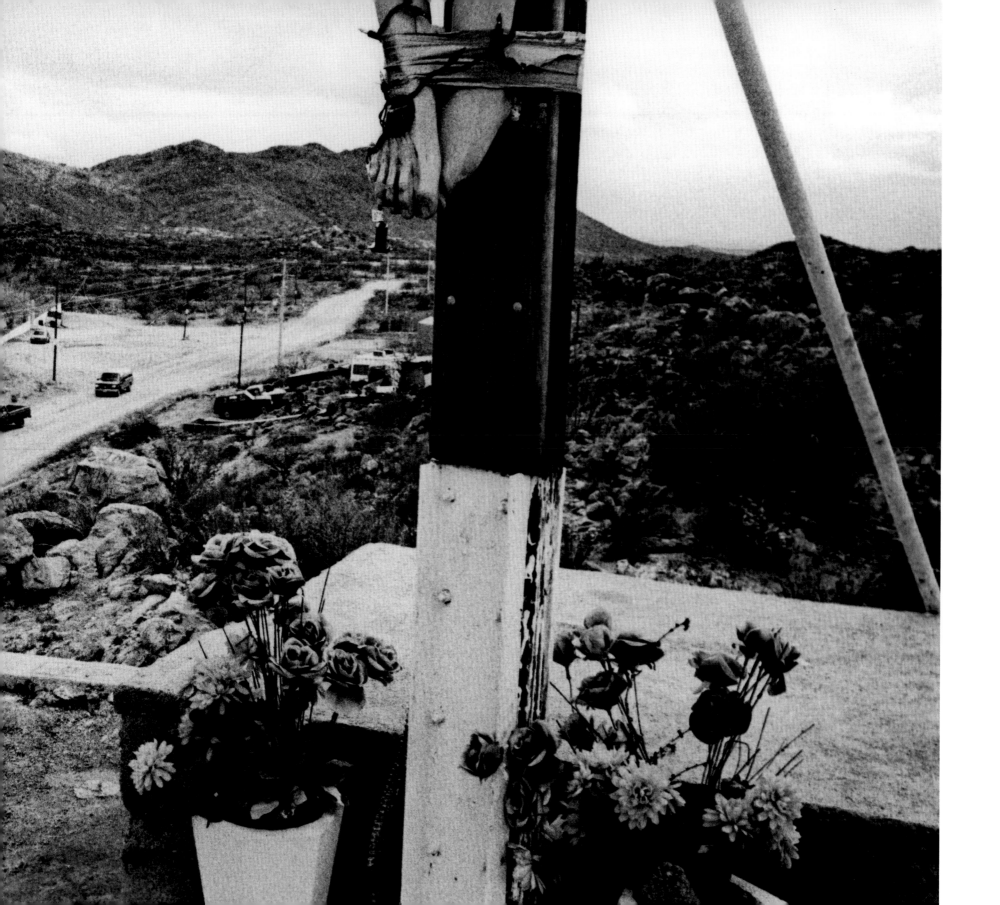

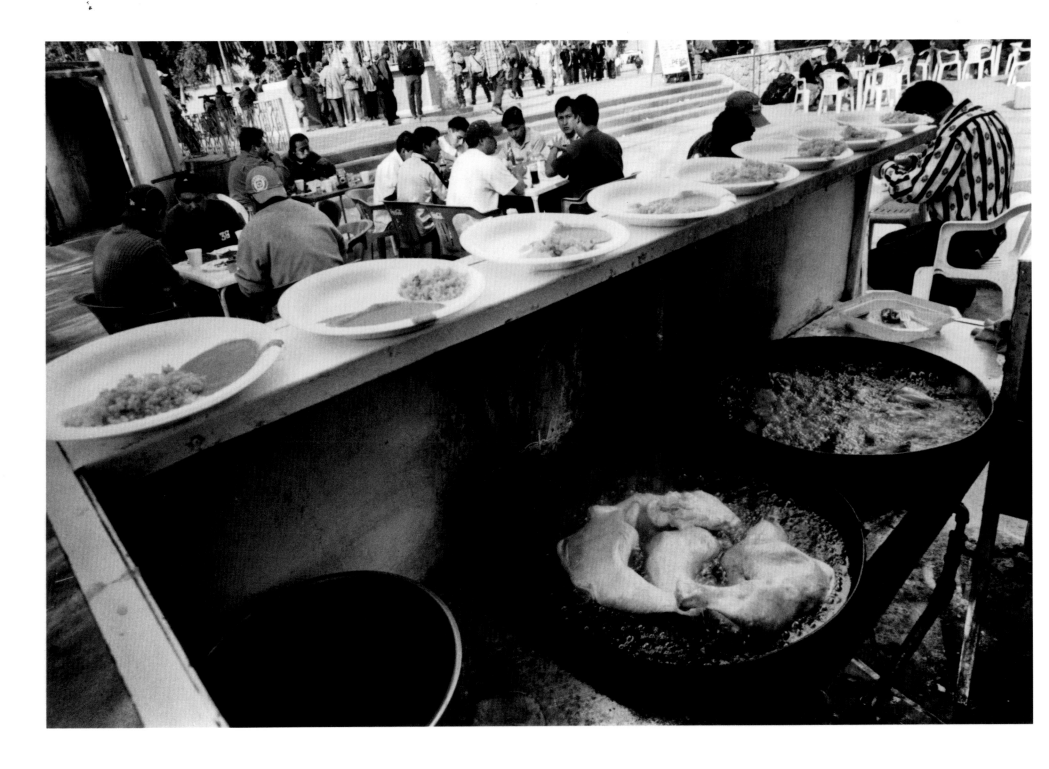

(20) *and eat cheap meals while they wait to cross . . .*

(21) *so that they can become this couple in North Carolina*
in their new apartment . . .

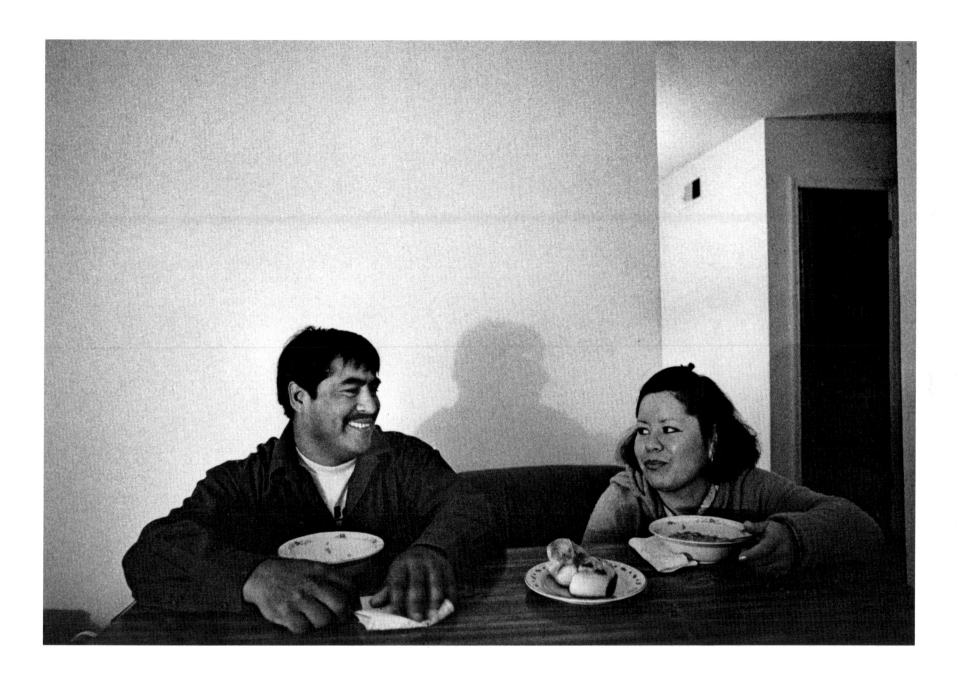

(22) *or send money home to Oaxaca for a new home they will never live in . . .*

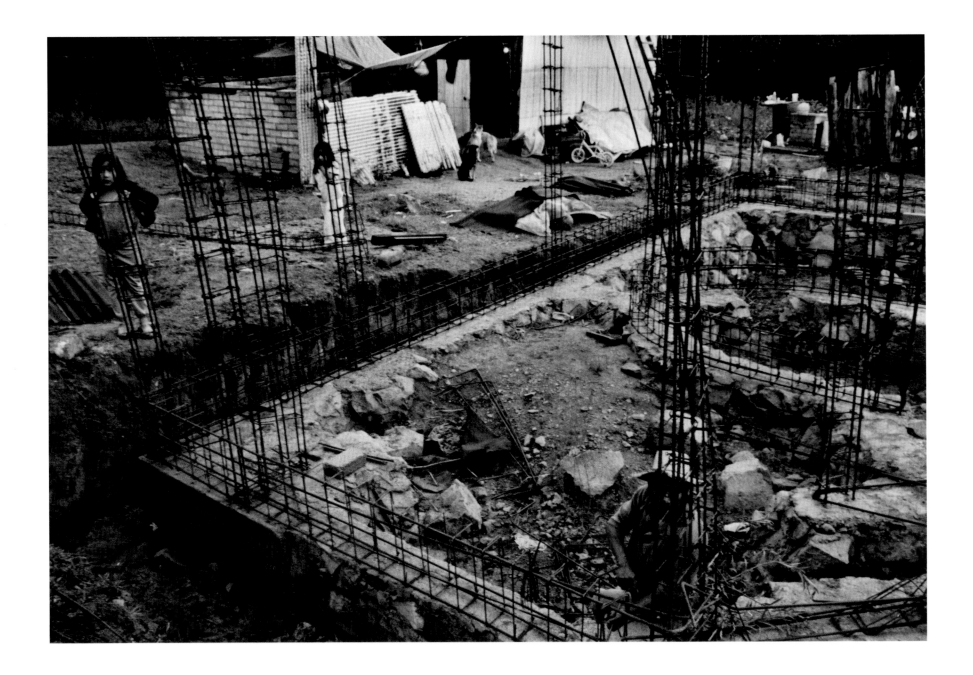

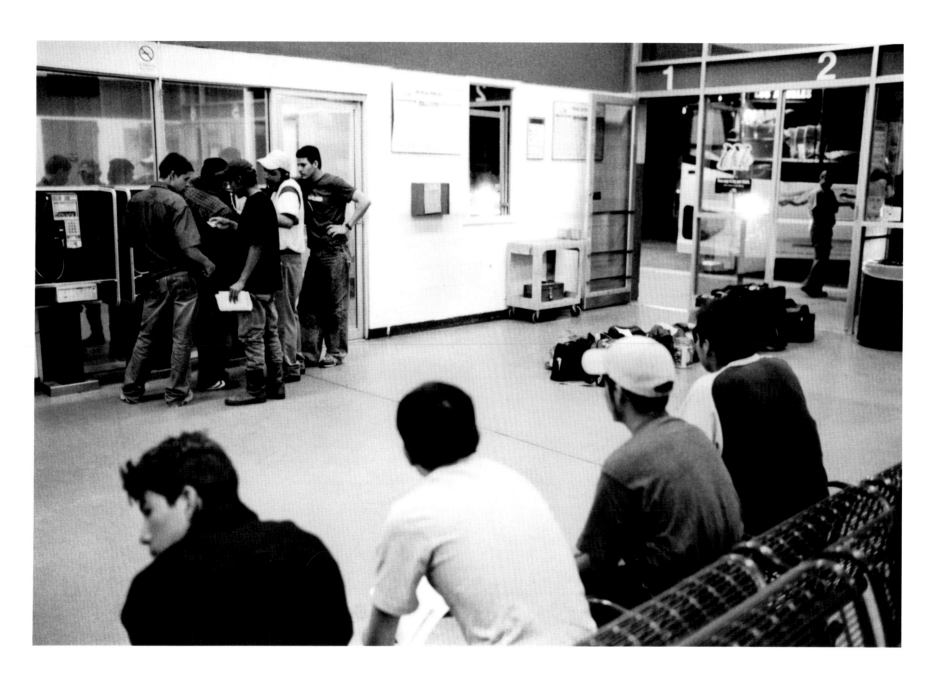

(23) *or stand in a Tucson bus station huddled as they call home from their illegal journey . . .*

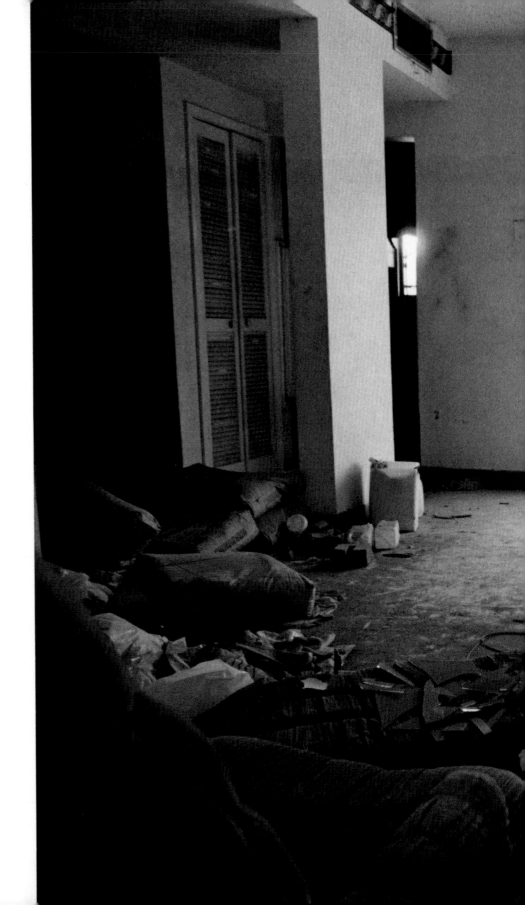

(24) *and flee places like the House of Death in Juárez where cartel members murdered and buried twelve people with the full knowledge of U.S. Homeland Security . . .*

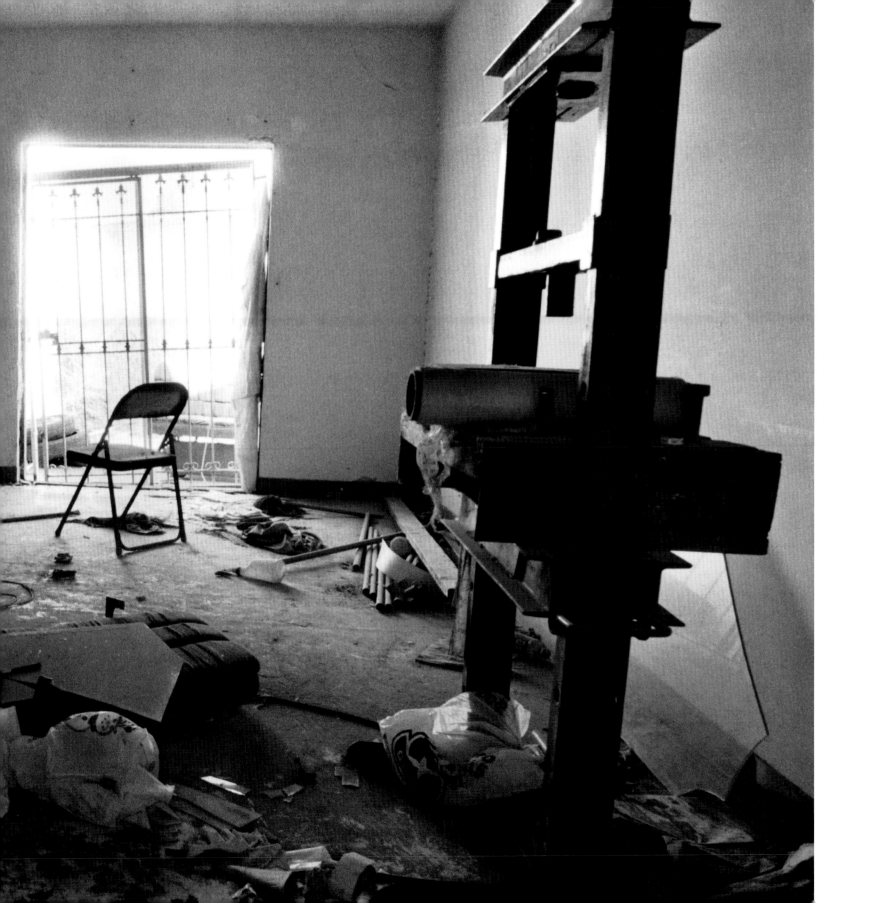

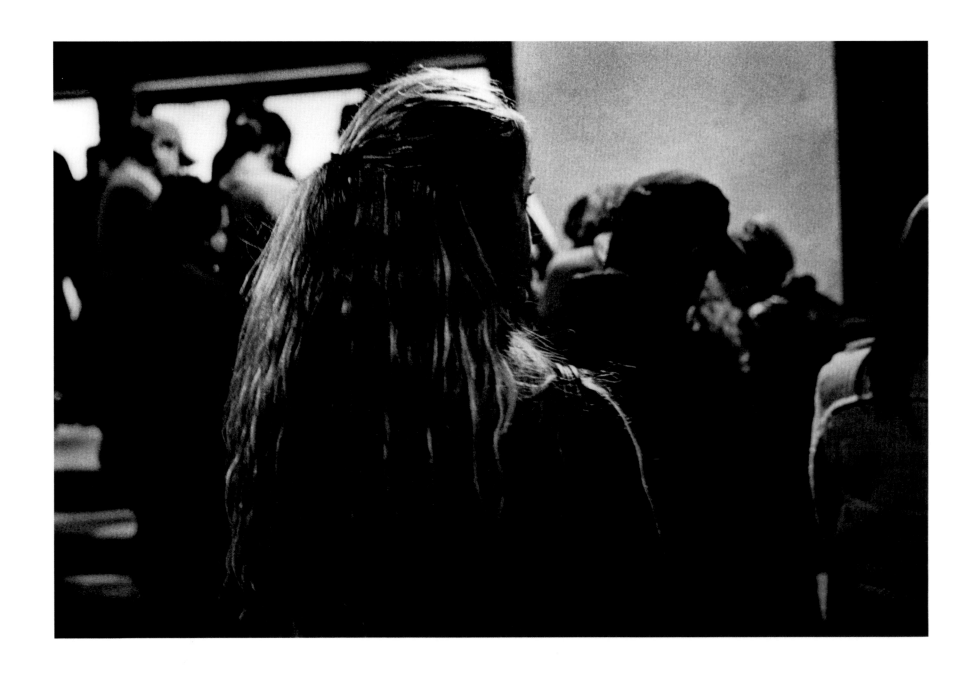

(25) *or the pain of this woman at the Juárez morgue*
looking for a disappeared brother . . .

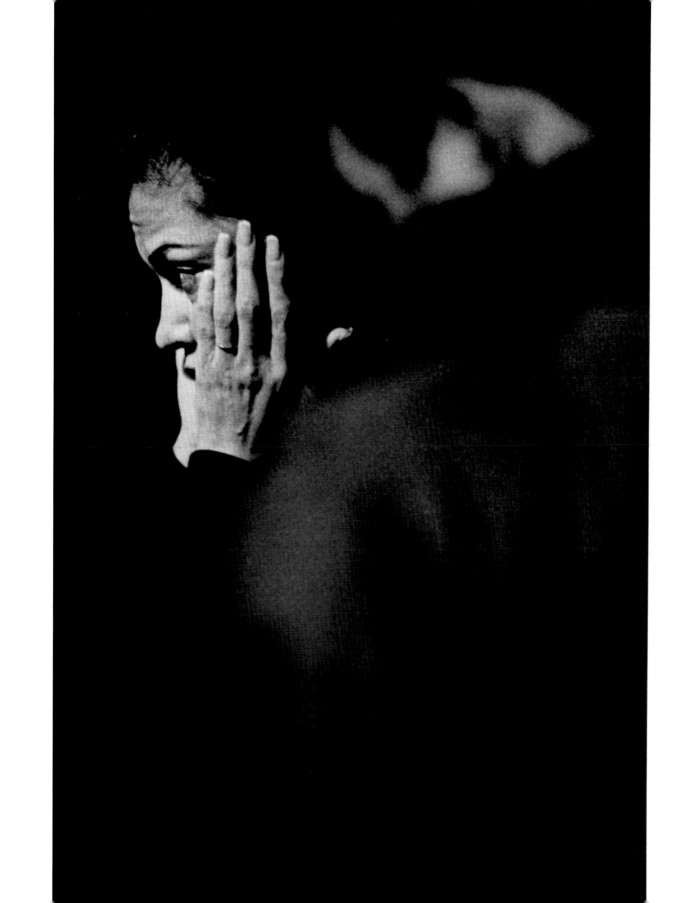

(26) or this woman in the morgue parking lot . . .

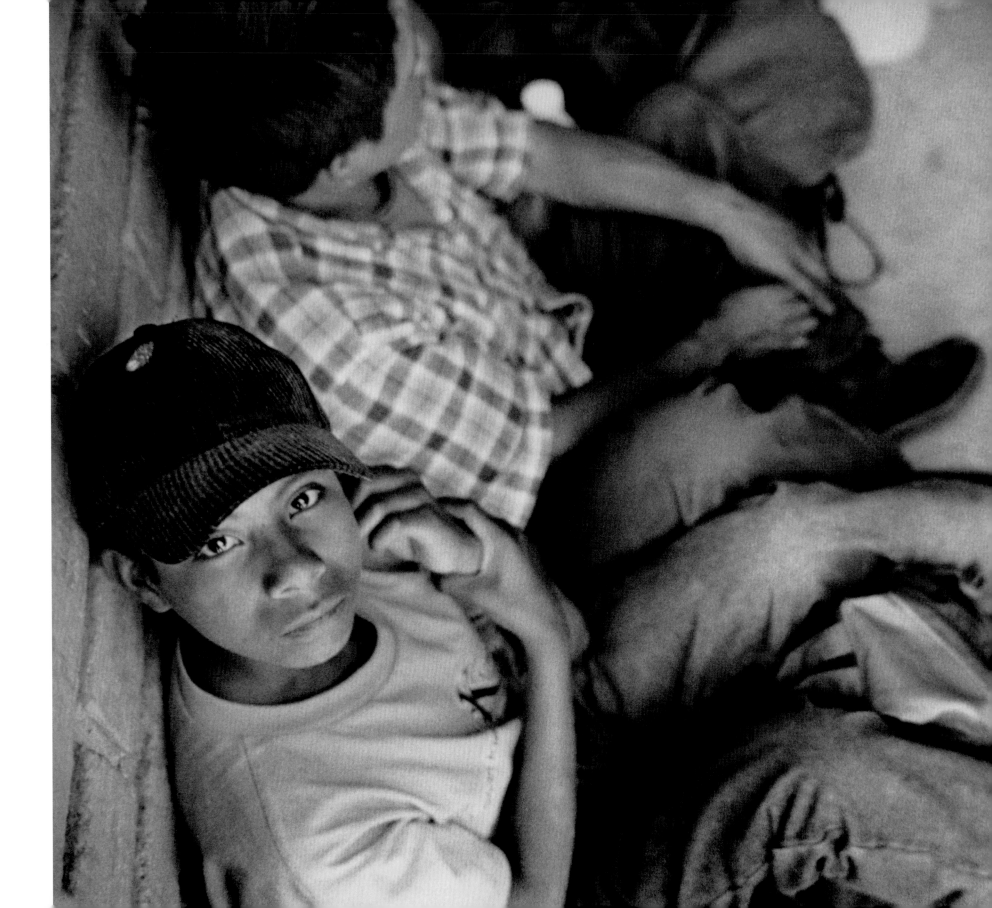

(27) *or this 14-year-old illiterate boy in Sásabe, Sonora,*
waiting to go north . . .

(28) *or an Ecuadorian child held in Sonora after crossing the ocean to get to the U.S. . . .*

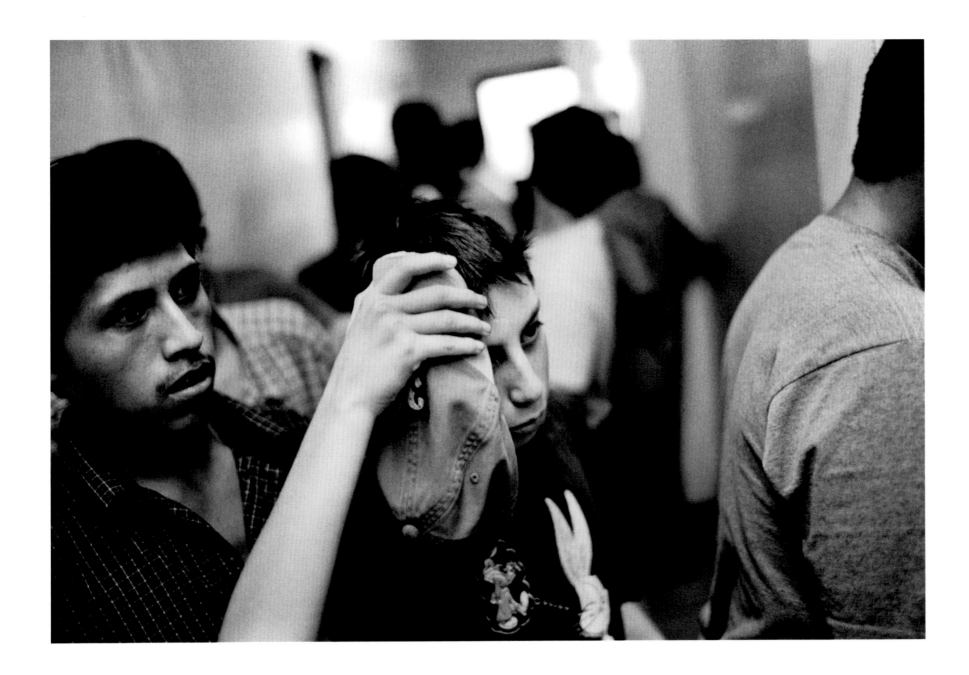

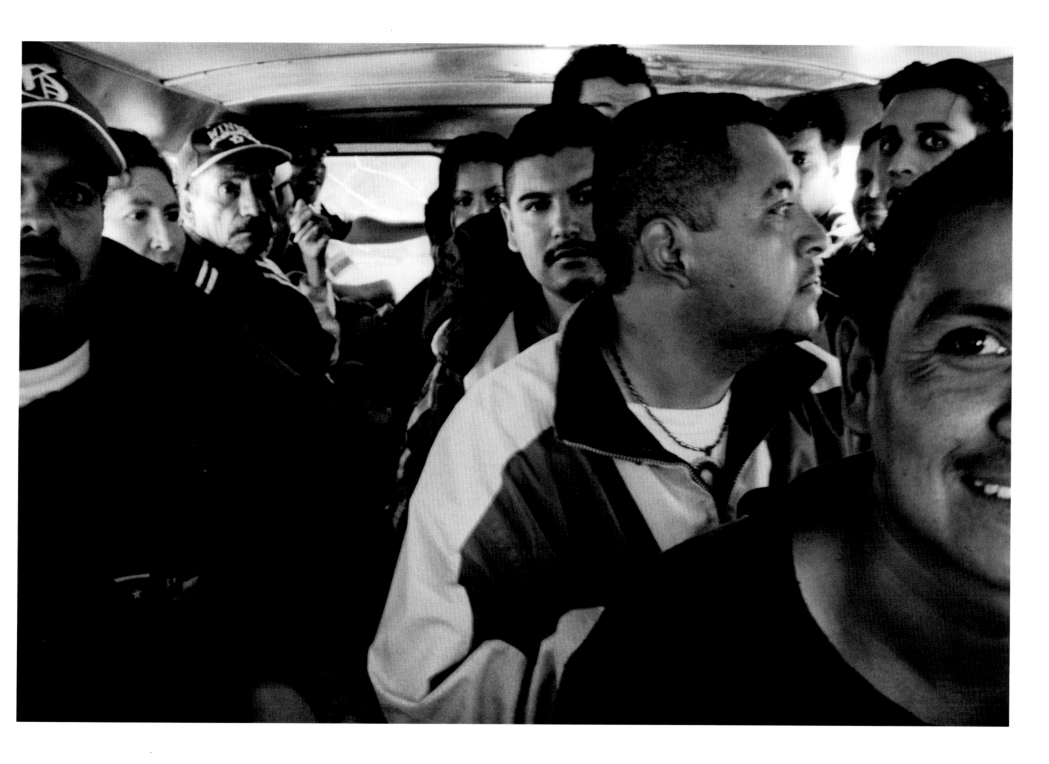

(29) *finally to ride in a van to the wire . . .*

(30) or to stay in Juárez like Paula at the funeral
of her murdered daughter . . .

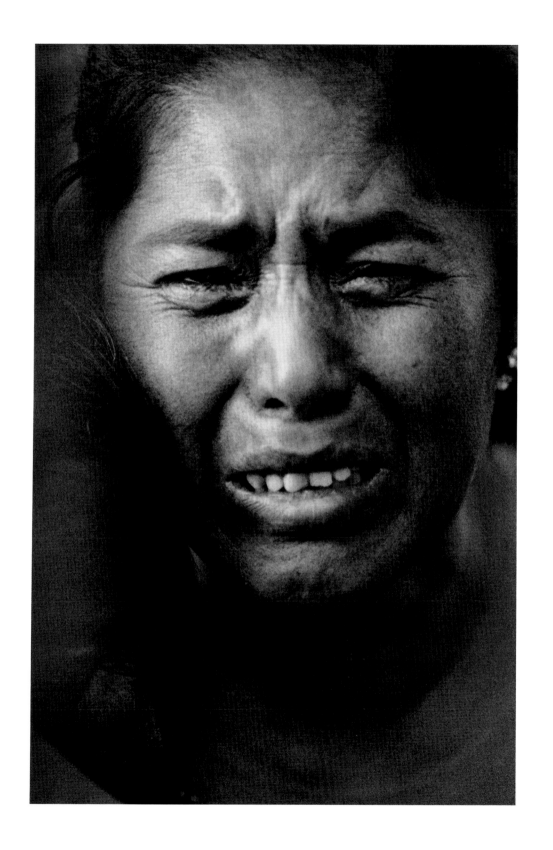

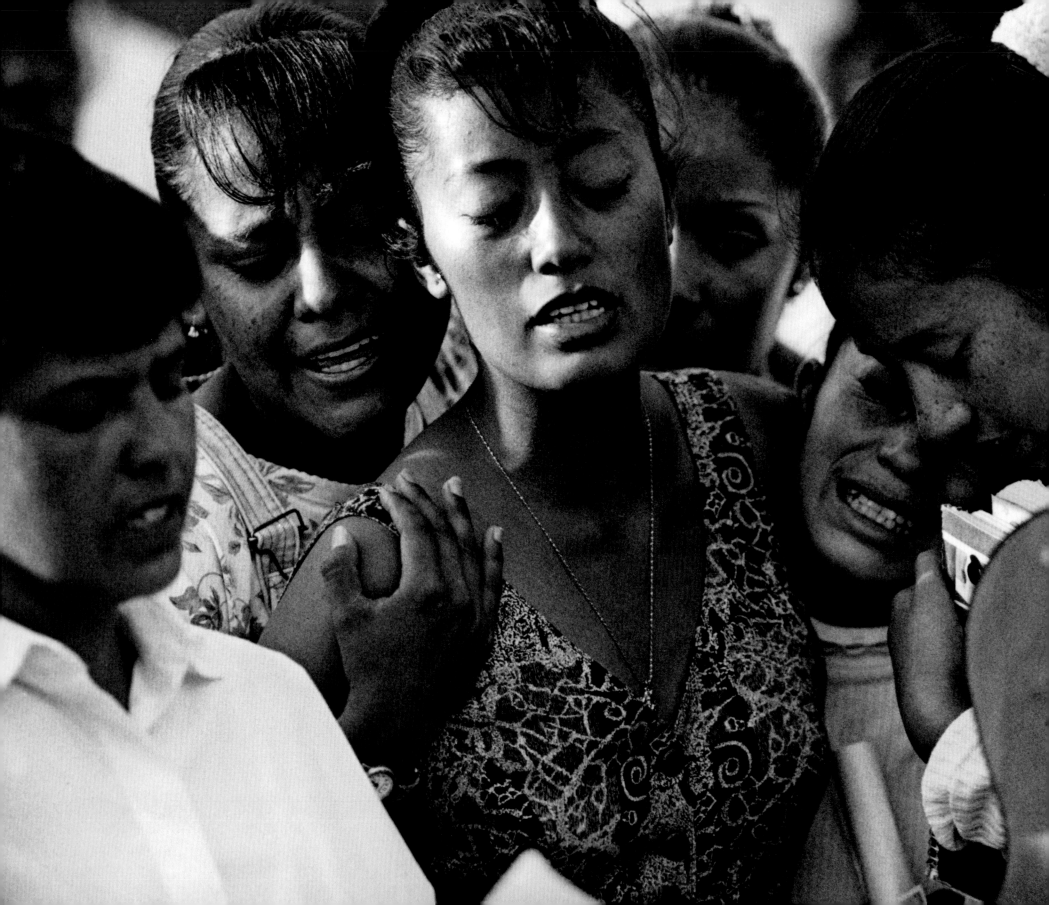

(31) listening to the music of grief sung by her daughters . . .

(32) *while Voces Sin Eco searches for dead girls in the desert by Juárez . . .*

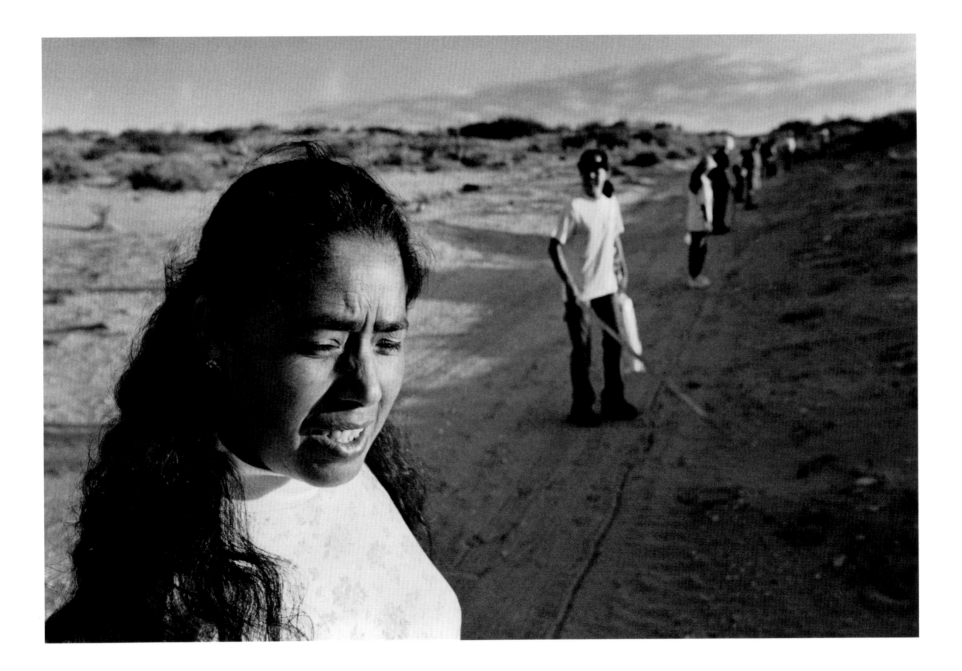

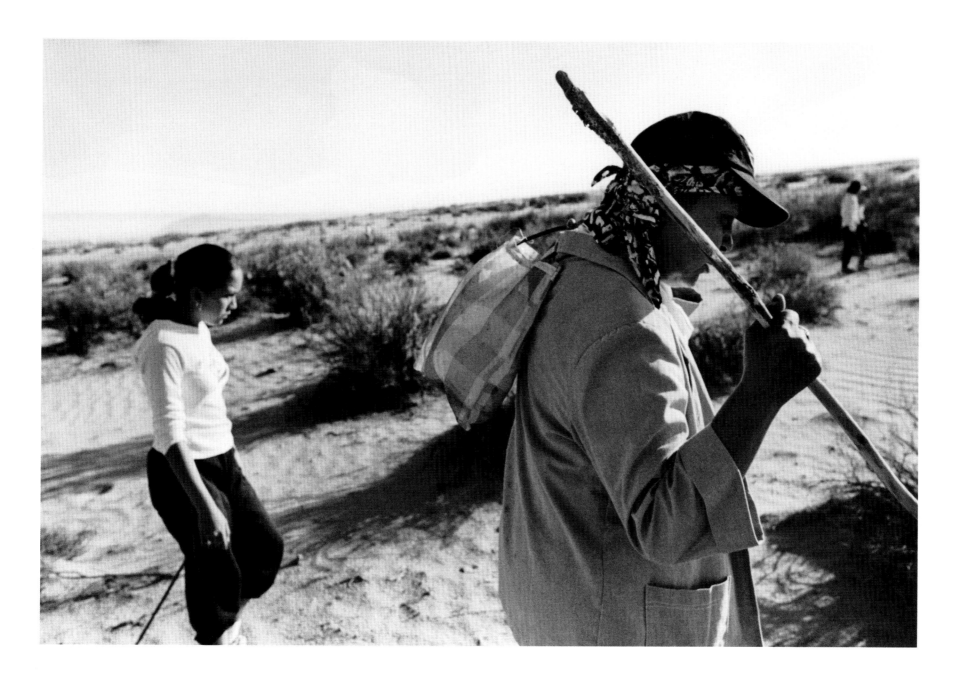

*(34) and other mothers with children wait
to cross into Arizona . . .*

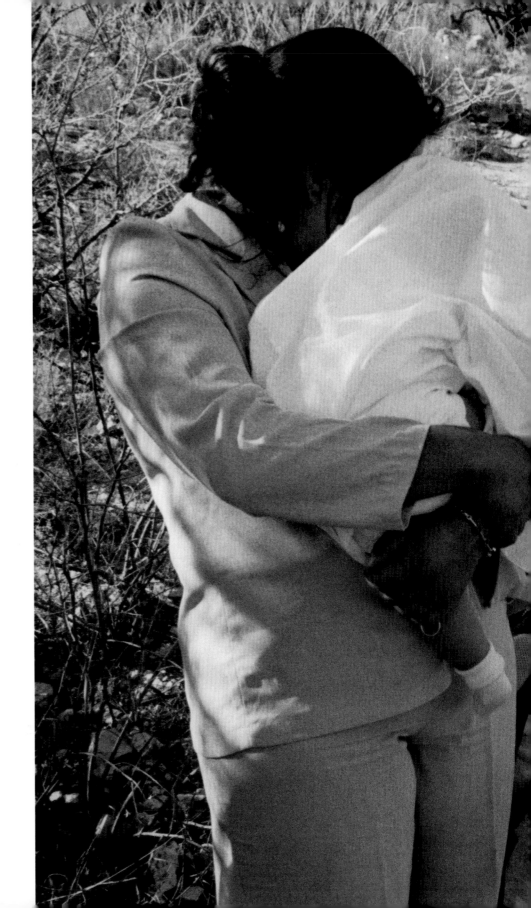

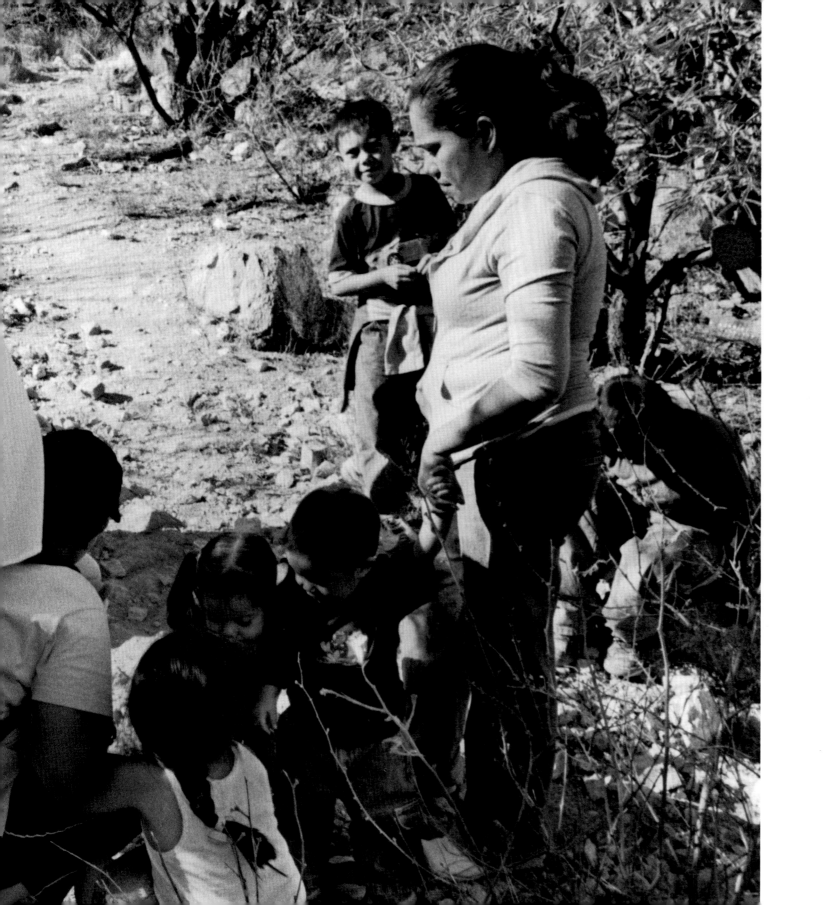

(35) *Evangelina's own daughter vanished several years ago and now she puts up flyers demanding justice and visits the coffin of another murdered girl, Liliana . . .*

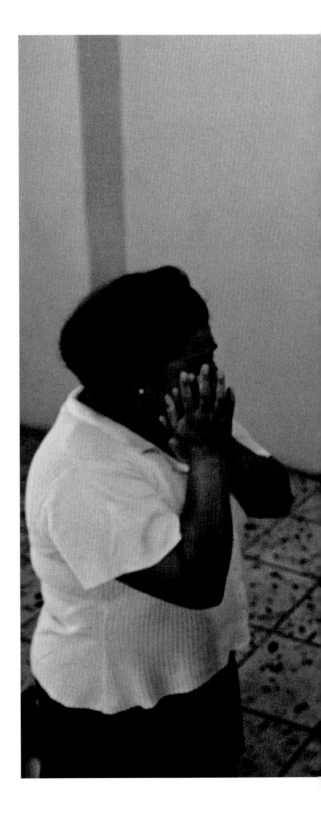

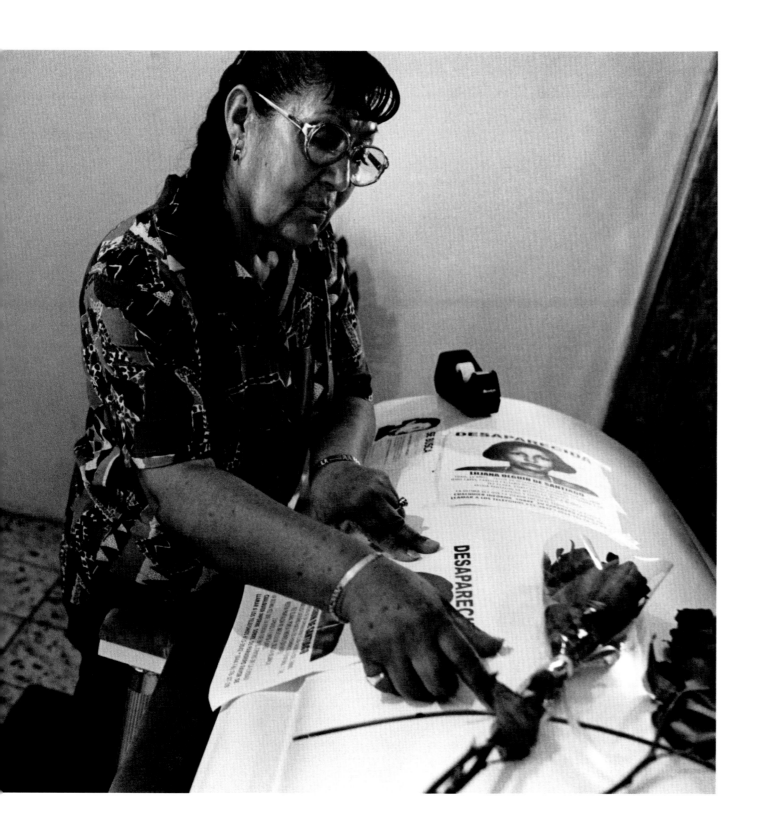

(36) and on the U.S. side, Border Patrol agents detain illegals near Bisbee, Arizona . . .

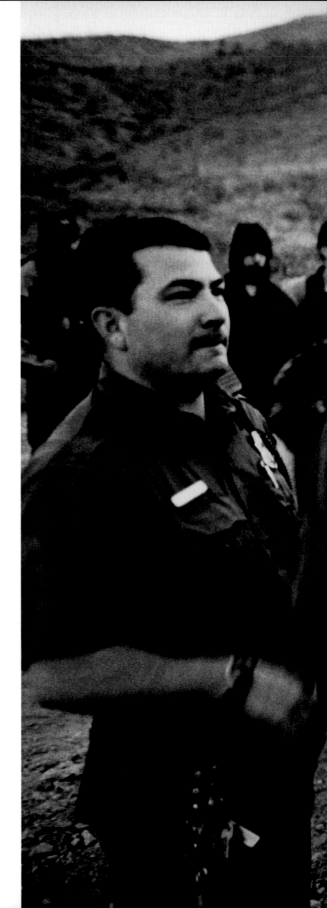

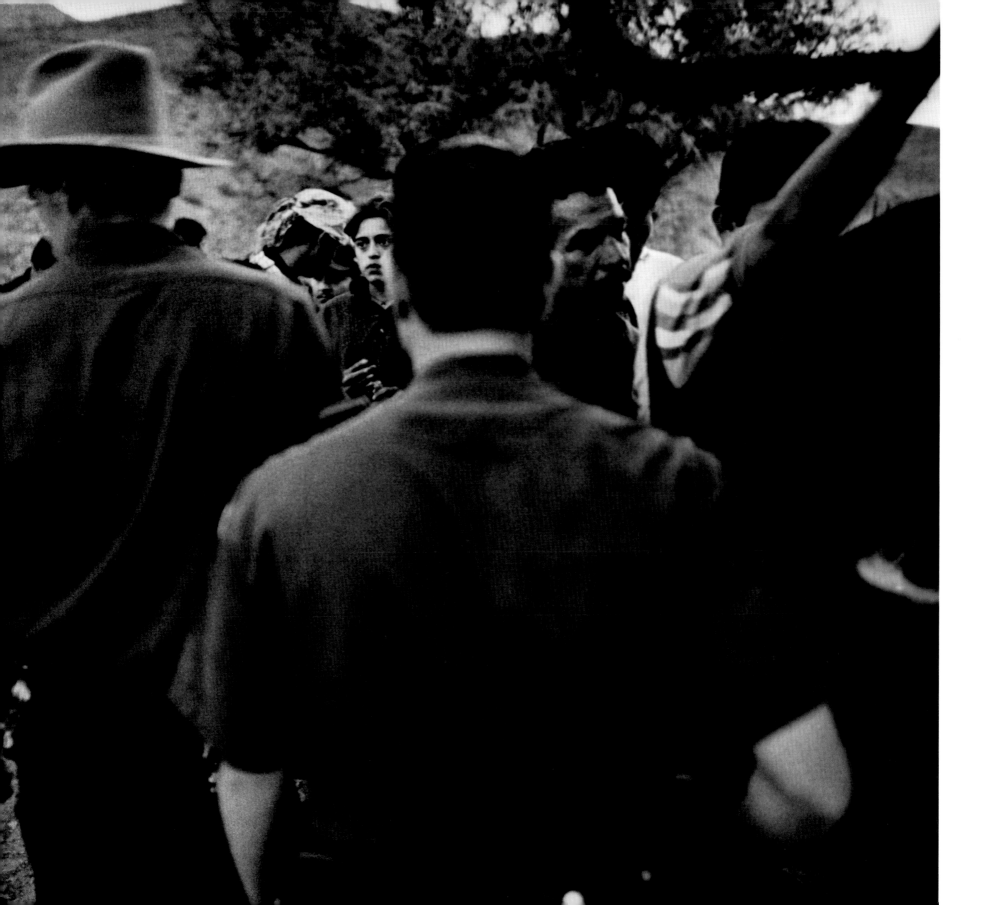

(37) *while to the south in Altar, Sonora,*
migrants pray before crossing the wire . . .

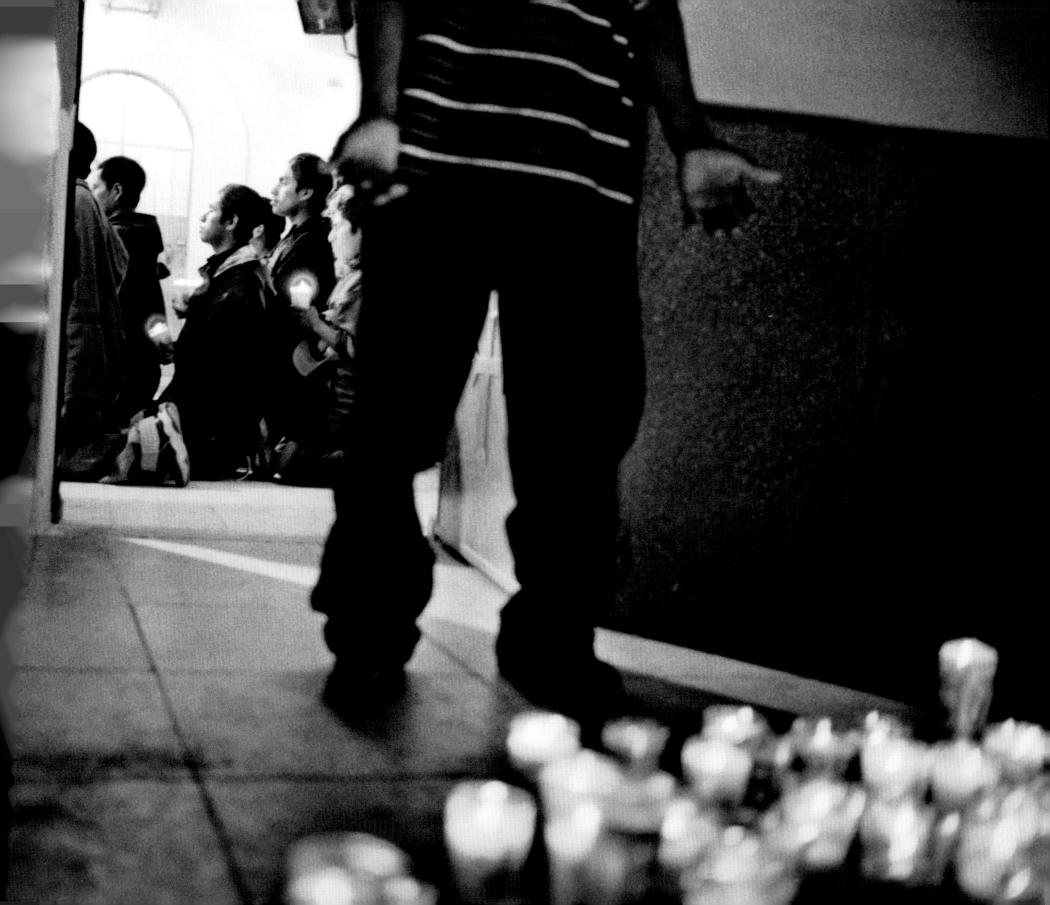

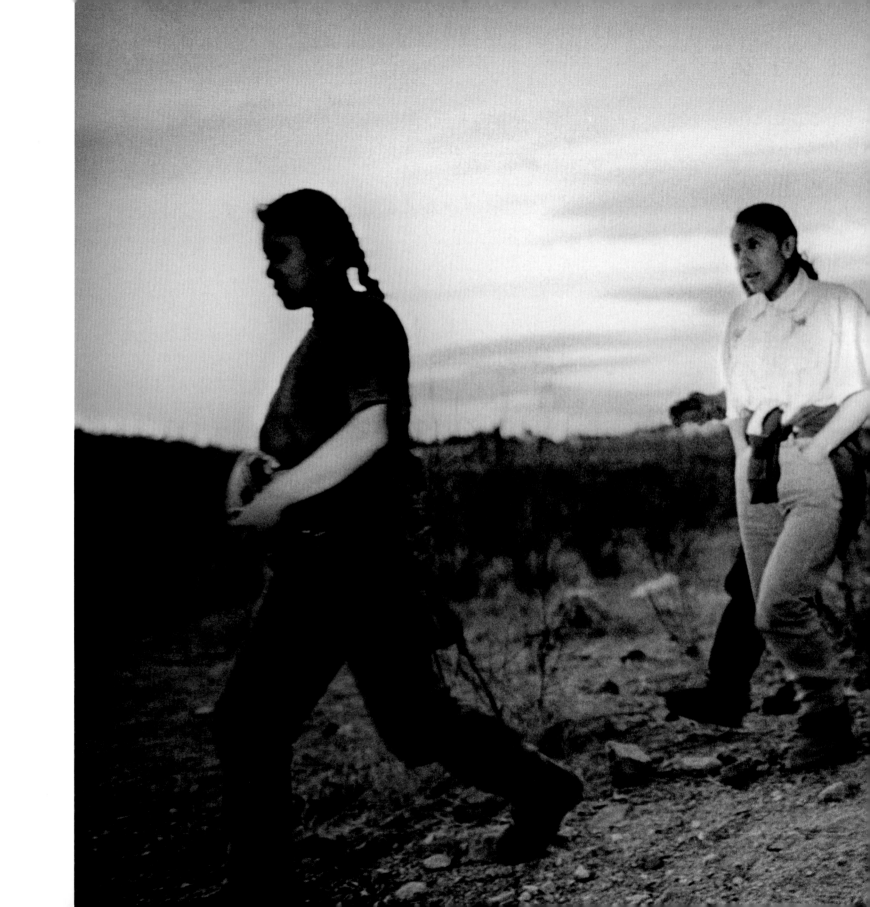

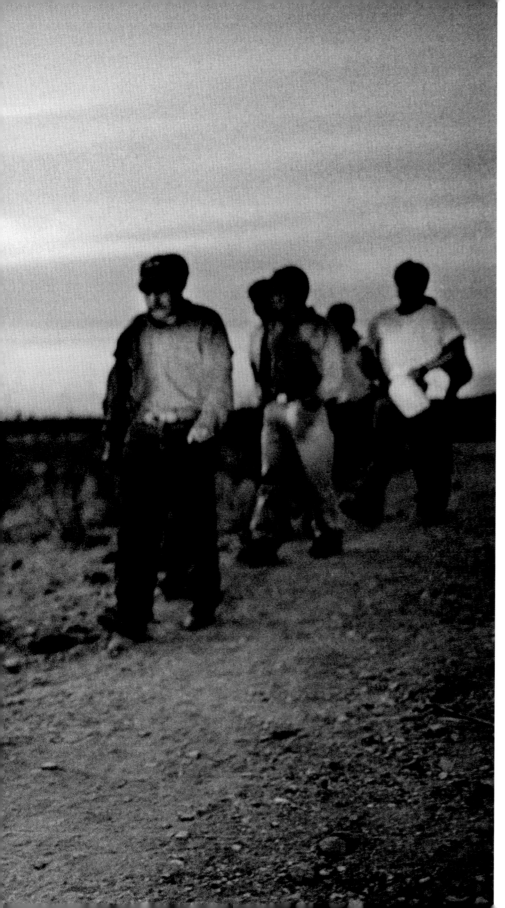

(38) *where they move into a new world with darkness . . .*

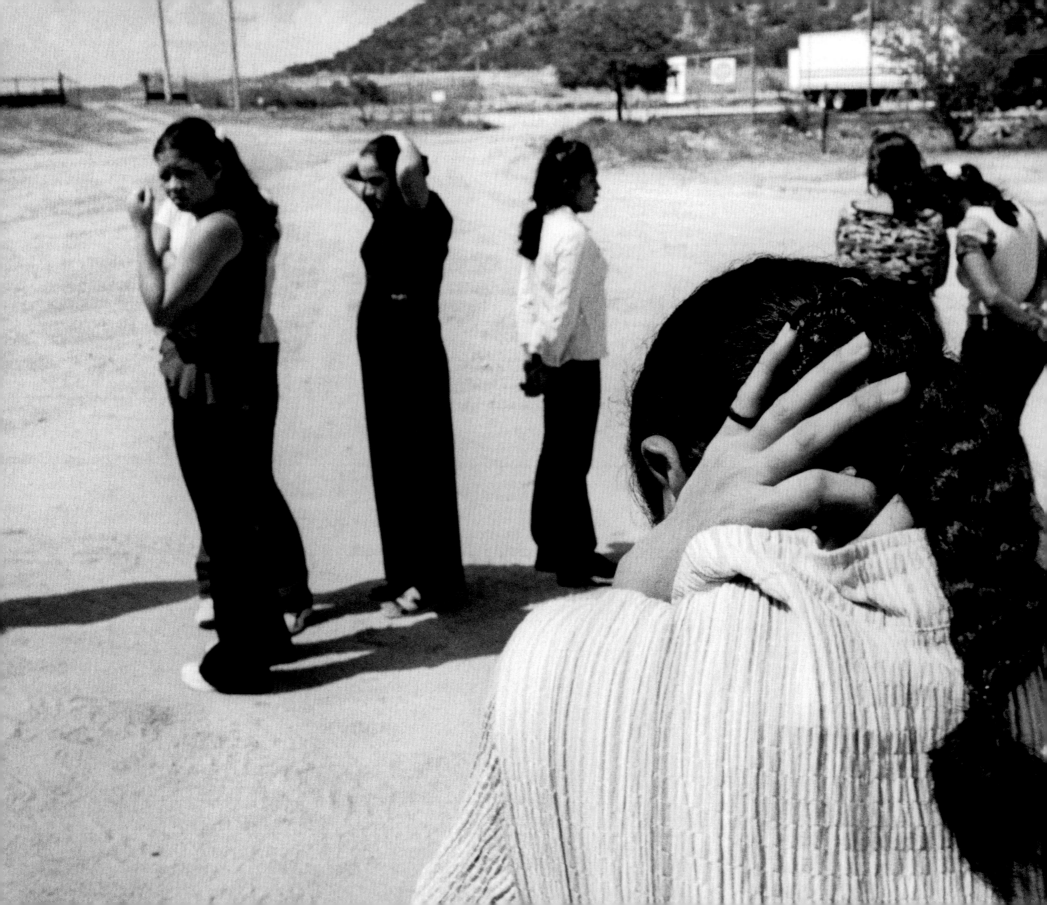

(39) *and some do not make it—Central American women,*
three pregnant, caught in Sonora . . .

(40) *and a group moves into Arizona as night falls . . .*

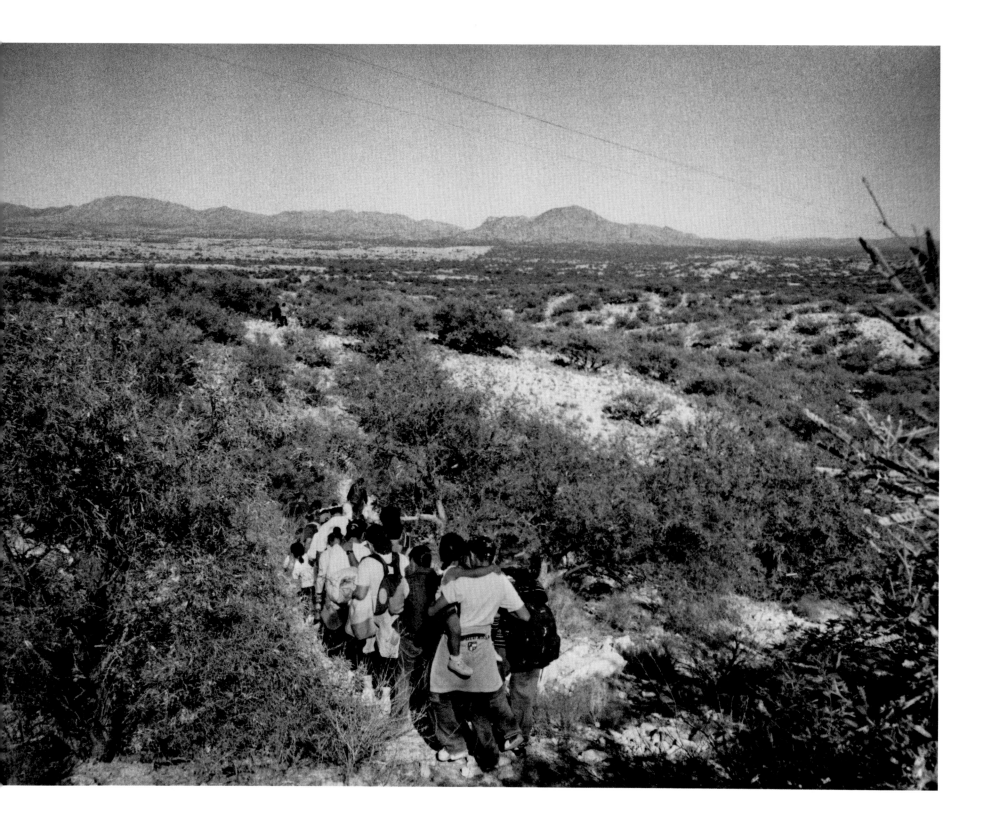

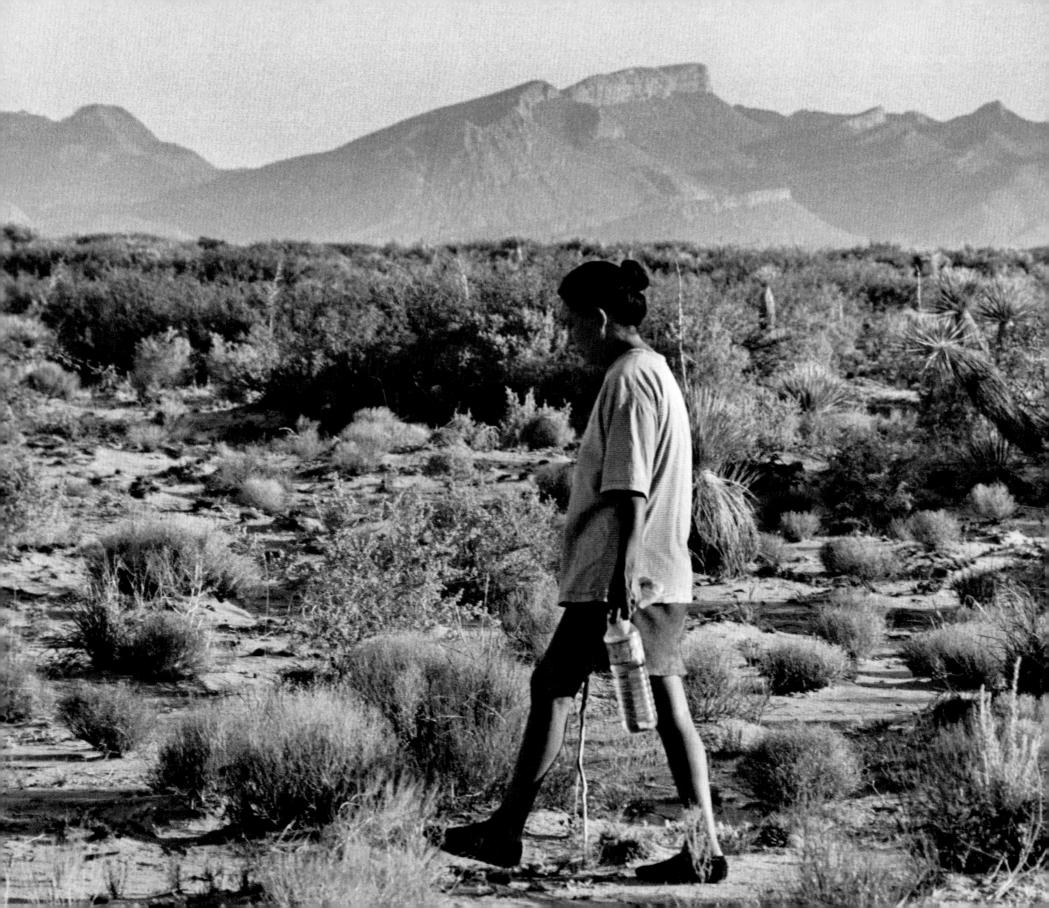

(41) *and a mother looks for her vanished daughter outside of Juárez.*

part two

When the festivities had ended, Motecuhzoma seated himself in the supreme place, the Divine Seat, the Place of the Gods, and the war captives were brought out. All of them were sacrificed in honor of his coronation (a painful ceremony), and it was a pathetic thing to see these wretches as victims of Motecuhzoma. It had become as common among these people to sacrifice men on feast days as it is for us to kill lambs or cattle in the slaughterhouse. I am not exaggerating; there were days in which 2000, 3000, 5000, or 8000 men were sacrificed. Their flesh was eaten and a banquet was prepared with it after their hearts had been offered to the devil.

When the sacrifice was finished and the steps and courtyard were bathed in human blood, everyone went to eat raw mushrooms. With this food they went out of their minds and were in a worse state than if they had drunk a great quantity of wine. They became so inebriated and witless that many of them took their lives with their own hands. Under the strong influence of these mushrooms they saw visions and had revelations about the future, since the devil spoke to them in their drunken madness.

FRAY DURÁN, 1581

what's your name?
who's your daddy?
is he rich like me?

THE BIRDS CAN NO LONGER BE TRUSTED. Homeland Security suspects a duck or a goose, perhaps that rare swan, will bring plague to our shores and slay our citizens.[1] The ice is melting, also. The polar bears are slated to die, the seas are guaranteed to rise and flood our coasts. The skies have mutinied and new monster winds whip off the ocean. We have already lost one city and there is concern about the storms of future summers. We worry about nuclear weapons that are not controlled by white people. There is a fear of biological agents. The government eavesdrops often, sometimes within the United States, and the officials say this is necessary for our protection. The enemies can be anywhere and appear as almost anything. This is called terror and this means war.

I am in a place of beauty. The desert spreads a skin of mesquite and cactus under a blue sky. My life has been spent wandering such ground and for me it is safe and sure. Years ago, a friend of mine would sleep in the arroyos outside the city but when he came into town, he always packed a gun because the straight streets and grim faces of the city made him feel unsafe. Of course, he had tasted a bad war in Southeast Asia.

What one sees in this ground depends on what one brings here. In the 1840s, John James Audubon's son wandered through on the way to the gold rush in California and of course, for such voyagers, the desert was simply a barrier to be crossed on the way to some Big Rock Candy Mountain. In the 1850s, an American adventurer led an expedition to a Mexican town about fifty miles from where I now stand—he failed and had his head lopped off. And for centuries, this patch of earth has been home to the Tohono O'odham, a desert tribe that feels this place is the center of all that matters. Now it is part of the Tucson Sector, a Border Patrol designation of the most transgressed portion of the boundary lines of the United States. And for thousands each day, it has become a place of terror, of all the fears we felt as children in the dread of the night.

So I have watched the meaning of my ground change as we have changed ourselves.

The boy sits by the road on a dirt embankment about four miles north of the border. His clothing is dark, his shoes casual. He wears a cap and a daypack. His eyes are glazed with fear. He is the face of yet one more official enemy. And he is lost and afraid. He's been trying to flag down Border Patrol vehicles but he says they pass him by. He is seventeen and afraid to give his name. He is afraid of the desert. He is afraid to talk of the *coyote* he hired. He is not afraid of the United States Border Patrol but he cannot seem to get their attention.

The night before, he left Sásabe, Sonora, a border town less than ten miles away.[2] He was hauled along the fence to the west and then started walking north in a group of about thirty. A chopper with searchlights appeared in the night, his group scattered and he could not find them again. A twenty-six-year-old woman from Chiapas died near this spot last summer, one of the four or five hundred that now perish each year in this new version of the Middle Passage. But he knows nothing of that. What he fears is the desert of night that he just endured.

His father in Florida paints houses and knows the boy can get work. So he has brought his son north from Veracruz, guaranteed a smuggler $1700 for his passage to Florida, and then in the darkness all went wrong.

The boy wonders if his coyote will return for him.

I tell him, not likely.

He wonders if he can make a phone call using Mexican money.

I tell him, no.

I point north to an Indian village just 500 yards away. I give him twenty bucks and say go there, give them the money, they will let you call your father in Florida. Of course, he will be picked up by the Border Patrol in the next few hours, dumped back in Mexico, and tomorrow or the day after that he will join a new group of migrants, probably with the same smuggling organization, and move toward his future, again.

Depending on the sector of the line, an estimated 10 or 20 percent of the Mexicans moving north give up after being repeatedly bagged by the Border Patrol. Or they do not. On the line, all the numbers are fictions. No one knows how many people are coming north. No one knows how many give up and return to their villages.[3] Only two facts are certain: the apprehensions by the Border Patrol (during one week this particular April, the agents bagged 12,000 people in the Tucson sector, for example).[4] And the exportation of human beings by Mexico, which now reaches, officially, a half million souls a year.[5] Or double that. Or triple that. The only reduction of poverty in Mexico, since the ruling party was swept out of power and the winds of change arrived, has been achieved through two tactics: the exportation of brown flesh to the United States, and the money those people send home to sustain the people that their government ignores.[6]

Everything else is talk. And bad talk.

la gente

He does not want to go to the constitutional convention at Aguascalientes in October 1914. The General knows his limits and he is at sea in this world of lawyers and intellectuals and politicians. But the delegates insist and so he makes a brief appearance and says a few words: "I cannot guide or enlighten you in any way, and you will hear the words of a man who comes before you with a total lack of culture. But if there are men of sound mind here who under-stand the meaning of patriotic duty and brotherly feeling, Francisco Villa will not make these men ashamed of him. Señores, I ask nothing for myself; I joined the struggle only to do my duty. I want nothing in benefit of my person or in payment of my services. I want everything for the good of the people and the relief of the poor. I tell you, I want to see this country happy and safe, because I have suffered much for it, and I refuse to allow other Mexicans, my brothers, to suffer what I have suffered, or the women and children to suffer what I have

seen them suffer in the mountains, the fields, and the haciendas. In your hands you hold the future of the country, the destiny of all Mexicans, and if that is lost, the entire responsibility will lie upon you people of law and knowledge."

As the General speaks to the delegates, he weeps.

THERE ARE NO HONEST PLAYERS in this game. People seem to cut the cards to fit their ideology. More Mexicans come north than either government admits. They do drive down wages.[7] They do take jobs.[8] They do commit crimes—give me the name of anyone who wins the lottery and moves to a poor neighborhood for safety. And they cannot really be stopped.[9]

They are no longer migratory workers. They are refugees from a collapsing economy and a barbarous government[10] and their journey is biblical and we should call it Exodus.[11]

They say Mexicans take jobs Americans refuse to do. This is probably true in some instances. But I know that in the mid-1960s, slaughter-house workers earned twice the current wage for such toil. Now such jobs are held by Mexicans.

This is an old story, one Americans seem to love to forget. Imagine this scene: a giant steel mill. The work gets increasingly dangerous, the wages keep sinking and the jobs, once taken almost completely by U.S. citizens, are given over to immigrants. The hours increase from eight to twelve a day, and finally run eighty-four hours a week. The migrants, lacking language and skills, take such murderous work. They comfort themselves with the notion they will only toil in such a hell a few years and then go home with the money. This seldom happens since expenses eat into income. Where is this steel mill? Just outside of Pittsburgh in 1892, when the Carnegie steel interests bring in armed forces and scabs and destroy all vestiges of unions. The workers are poor men from Eastern Europe, used as cannon fodder as the industrial engine of the United States is built with human blood. Andrew Car-

negie, now remembered, if at all, as a pioneer philanthropist, writes on the eve of the violence, "Advances in wages or cost at present time of course impossible. . . ." Carnegie is worried about competition both foreign and domestic and so insists he is powerless to alleviate the misery of his workers. He is, in his own eyes, simply a cog in a giant global economy.[12]

There is another point I should tell you before we continue. The solutions in political play are idiocy.

Worker permits? Well, the demand at this moment for such permits must be at least enough to cover the twelve million illegals in the U.S. today and this will climb each year by at least one more million.

Open the U.S.-Mexican border? Mexicans would be trampled to death by Asians storming up the open route and also by other Latin Americans, you know those folks the U.S. government calls OTMs, Other Than Mexican.

Employer sanctions to make illegals unemployable? Fine, then Mexicans go home and Mexico erupts and we have a destroyed nation on our southern border and even greater illegal migration. In the fall of 1910, the Mexican Revolution exploded in a nation of fifteen million souls. One out of eight or twelve or fifteen died. But 892,000 fled to the United States during the revolution. Now there are 106 million Mexicans. Do the math.

That wall? Take a walk through the 1951 miles of desert, mountains and scrub, a zone legally traversed by 350 million people a year, and this legal traffic makes it the busiest border in the world.

There are piles of studies on these matters, studies that prove illegal migration benefits the United States, studies that prove it does not benefit the United States, studies that show it enhances the GDP or has little or no contribution to the GDP. There are plans to manage this migration and plans to stop it dead in its tracks. There are proposed solutions. And of course, there are claims that we don't really need a solution because mass migration is natural for a nation of immigrants and as American as apple pie.

Pretend you are watching a fast film of our past. It will look like this: For centuries, the area now called the United States lacked labor as the European settlers expanded into land taken by force from Native Americans. Immigration was not only tolerated but sought—parts of the South, famously, required convicts in order to establish a population. Mexico invited U.S. citizens into its isolated colony of Texas in a desperate effort to—well, build a human barrier against the possible theft of this vast territory by the United States. With the industrial boom ignited by the Civil War, cheap European labor became a key for the establishment of new fortunes. For decades, unions were crushed or tamed by hordes of cheap immigrants who drove down wages. The human suffering inherent in this migration is all but forgotten today. Just as the United States really remembers no labor history, it has kept only a sugarcoated version of the great movement of the poor to this new nation in the nineteenth century. In 1924, the new immigration bill shut down this vast movement—something much simpler when the migrants required boats in order to cross an ocean. Just as the migration itself was easier to accommodate when vast tracts of the republic were largely empty. But no one who dips into the literature left by the survivors of this movement can escape the savagery of it.

Today, we cling to our hallowed past as a nation of immigrants, make a fetish of our Statue of Liberty (also a migrant from France), and pretend that what happened then can continue even though the nation is now 300 million and the planet is surging past six billion souls. In the past, immigrants drove down wages and were often specifically recruited for that purpose. In the past, immigrants were brutally used. But in the past, we were building mills. Now the mills, thanks to enhanced transportation, are fleeing to where poor workers can be found. We live in an age of the migration of capital as much as of labor,

if not more. And yet we cling to a fantasy of our past in facing our present and future. We pretend we can go to our ancient pantry and find the solution to our current woes.

But in the end, you don't get to pick solutions. You simply have choices and by these choices you will discover who you really are. You can turn your back on poor people or you can open your arms and welcome them into an increasingly crowded country and exhausted landscape.

I believe this country already has too many people and that the ground under our feet is being murdered and the sky over our head is being poisoned. I find these beliefs pointless when I stand on the line.

For thirty years I have, at random moments, helped Mexicans sneak into the United States in full knowledge that I was breaking the law. There are things I have done that I regret. These acts are not on that list.

MESQUITE CLOTS THE LAND HERE and 100 people moving fifty yards away would be invisible. On the ground by the highway, clumps of one-gallon water bottles mark where coyotes picked up migrants. Nearby trees lining the arroyos hide temporary camps where men and women and children waited for rides.

Thirty years ago, I was in almost this exact spot with an old Indian man who still raised crops in the desert based on capturing the summer rains, a tactic called *ak chin*. He'd sleep in his field at night on a cot. He had ropes racing out from beside his bed and linked to suspended tin cans he'd rattle in the darkness when he heard coyotes—the real and native canines of the desert—come for his squash and melons. Now that old man is dead, his field abandoned and no one does traditional agriculture here. The tribe has moved on to welfare, the riches of casino gambling and smuggling illegals and drugs.

One day, after I left that old man, I found two Mexicans wandering in the desert with gallon jugs of water. They had been walking to the upper Altar valley where they could work on a farm. But now they were crushed by the summer heat and looked at me with broken faces. I put them in my car and drove them almost 100 miles to their destination without a thought. Now, I won't drive a frightened boy 500 yards to a phone because I'm worried about getting busted by the Border Patrol and facing huge legal expenses.

I am standing in the stream of the largest migration on earth. And it is not seasonal labor. The people walking north all around me are not going home again. This is an exodus from a failed economy and a failed nation. When the dust settles it will influence the United States more than the Iraq war. The Iraq war is simply the inevitable and latest consequence of a passion for imperial rule. But the migration is the result of the failure of both American economic policy and foreign policy. The war is who we were, the migrants are who we will be.

For a century the United States has tolerated various non-democratic rulers in Mexico if it resulted in a stable state sharing an almost 2000-mile border with us. When Porfirio Díaz ruled as a dictator, we celebrated him.[13] When the revolution came, we tried to corrupt it and repeatedly invaded. When a new dictatorship ruled Mexico and disguised itself within a single party for seventy years, we celebrated it. When the students were butchered in Mexico City in 1968 in the Plaza of the Three Cultures on the eve of the Olympics, we focused on gold medals and ignored the murders. When Mexico became a narco-friendly state in the 1980s, we denied this fact.[14] When NAFTA proved ruinous to most Mexicans, we denied this fact.[15] And now as millions flee this charnel house, we pretend it is simply a mild structural readjustment of globalization, something that provides us cheap labor and grows that thing we call our economy.

Mexico has its own history of failure. From the time of the conquest,

the Spanish empire sputtered outward, with its basic fuel being the discovery of buried minerals, gold and silver. During the three centuries of rule by Spain it failed to achieve any equitable distribution of wealth and became a place of the very rich and the vast numbers of poor. The first Mexican Revolution of 1810–1820 created an independent nation but hardly broke this pattern. The American wife of a diplomat in the 1830s kept a diary that had many entries about street mobs in the capital and how they kept breaking into the ambassador's residence.

Modern industrial life with railroad and factories began with the dictatorship of Porfirio Díaz in the late nineteenth century. It traded the nation to foreign investors in order to obtain capital, attempted to crush the Indians within it, refused to share the wealth and was vaporized in the revolution of 1910–1920. This revolt devastated the nation to such an extent that it was not until 1940 that the economy even reached the level of 1910.

For seventy years, one ruling party of the rich operated the nation. It collapsed in utter failure in 2000, but only after negotiating NAFTA as a last stab at survival. In the final decade or so of the regime, national industries were sold to a handful of rich Mexicans, the rights of collective farmers were obliterated, reduction of tariffs destroyed Mexican agriculture and industries, and the poor were left to their own devices. They came north rather than die in place.

That is how we got to the present.

la gente

Luz Corral seems to live on and on and finally in the late 1940s she issues a small book about her marriage to Pancho Villa. She seeks to prove she was his only legitimate wife and she seeks to prove that the General for all his gales of rage was really a kindly man. She is an old crone hobbling around the house Villa built for her in Ciudad Chihuahua and named Quinta Luz. He planted

this home in a poor neighborhood. She scratches with her pen, "I am sitting close to the window, while the glow of the dying winter twilight faintly pierces the window panes. Vapors that herald the advent of spring begin to rise from the land and the potent breath of newly born life pervades the atmosphere." It begins this way with a prim and hopeful tone. Señora Corral de Villa insists on being a lady.

But with the General, such a tone is difficult to sustain. Ugly and unexpected moments keep occurring. The pen moves on and suddenly Señora Luz Corral de Villa is writing, "Some time later I learned my husband's body had been beheaded. The news was more shocking to me than words can tell. Who, I asked myself once and again, was the wicked creature that has profaned Pancho Villa's tomb? Someone, allured by the advertisements published in American papers offering a 50,000-dollar reward to whomever would produce that head, had accomplished the incredible thing. . . . Whoever the criminal was, may eternal curses fall on the man!"

William Benton is an Englishman who runs a large ranch in Chihuahua. When the revolution gnaws at the flesh and bones of Chihuahua, he begins to lose cattle to its hungers. In a rage—and he is known to be a touchy kind of man—he goes to see General Villa and complains of his treatment. This is all well and good, but then Benton is said to pull a gun. The General orders him executed for this display of bad manners. There are many versions of what follows. According to one, Rodolfo Fierro, the General's most bloodthirsty assistant, gets the assignment. He has Benton dig his own grave, clubs him over the head with a shovel, and then pitches him in. Most likely, Benton is buried alive. Later, His Majesty's government inquires about the whereabouts of Benton. The General is informed, has the body dug up and properly shot. This repair job fails to pass muster with the experts and there is a lot of bad talk after that about the General.

One night years later in the revolution, the General and Felipe Ángeles are arguing again. Ángeles is the educated officer from the army of Porfirio Díaz who has gone over to the revolution. The General recalls Francisco Madero, the

initial match that lit the dynamite of revolution, and he says Madero was a fool because when he had a chance to execute one foe, he did not do it. Ángeles cannot abide this statement and says, "Don't call Madero a fool for those reasons. In Juárez he acted as a patriot and in Veracruz he respected individual rights."

Villa snaps back, "Yes, General, and look at what happened to him and what is happening to all of us."

The General will not keep his silence. He is the ignorant and coarse man normally denied a hearing at important meetings. And yet the General tends to make a lot of sense when the odd document pops up that records his thoughts and words. On this matter of Madero and whether or not the famous martyr made mistakes, on this issue, Villa is on fire.

"Listen, General," he says to Ángeles. "I'm going to tell you the prophesy I made to Maderito during the banquet which took place in the customs house in Ciudad Juárez in 1911 at the moment of the revolution's triumph; I attended because he asked me to, but already I felt a deadly hatred for all those elegant dandies, perfumados. They had started in with the 'espiches,' and that bunch of politicians talked endlessly. Then Madero said to me, 'And you, Pancho, what do you think? The war is over; aren't you happy? Give us a few words.' I didn't want to say anything, but Gustavo Madero [the president's brother], who was sitting at my side, nudged me, saying, 'Go ahead, chief, say something.' So I stood up and said to Francisco Madero, 'You, sir, have destroyed the revolution.' He demanded to know why, so I answered, 'It's simple: this bunch of dandies has made a fool of you, and this will eventually cost us our necks, yours included.' Madero kept on questioning me. 'Fine, Pancho, but tell me, what do you think should be done?' I answered, 'Allow me to hang this roomful of politicians and then let the revolution continue.' Well, seeing the astonishment on the faces of those elegant followers, Madero replied, 'You are a barbarian, Pancho. Sit down, sit down.'"

Once, two woodcutters come to the General's camp in the sierra and say they wish to join his forces. He suspects they have been sent to murder him. So he has one strung from a tree to see if he can frighten the truth out of him.

But the man dies in this bit of play. His fellow general, Felipe Ángeles, watches and tells Villa he has made a terrible mistake. The General thinks about this and says to his men, "Listen, boys, a mistake has been made, just like General Ángeles says. So you better hang the other man, because if he is not our enemy right now, he sure will be after this."

The second woodcutter takes this new statement in good stride. He turns to Villa and announces, "I see, General, that I cannot lie to you and I am going to tell the truth. We came here to kill you." He tells him that two more killers are on the way. The General checks this out and when he finds it to be true he gives the man his freedom.

FANTASY POSSESSES MANY MINDS in the United States. Some people say there are many cultures and they all have equal value. Others say there is really only one ultimate culture, something very close to American economic and political practices, and every culture is slowly but surely moving toward this culture. But regardless of these two professed views, there is a silent consensus that other nations and cultures can be remolded at will and made to conform to vague ideas called the global economy or free trade or democracy or human rights. And that history is a kind god, and this god is progressive and striving onward and upward.

These silent but potent fantasies erupt whenever the United States faces resistance in places it considers undeveloped.

In Europe, the European Union has driven Romania like a hog toward market and dangled the possibility of full membership in return for privatization of the nation's economy and for cleaning up corruption. Some see this as the way of the future. But the U.S. has nothing to offer Mexico as an incentive to clean up its act. Besides, Mexico loathes U.S. intervention after having half its territory taken as spoils of the Mexican War and having been invaded by the U.S. during its early twentieth-century revolution.

The U.S. must deal with a nation where, according to the former National Security Director under President Vicente Fox, Alejandro Gertz Manero, only 1.5 million out of 4.5 million crimes are even reported and only 8 percent of the reported crimes are even prosecuted. He also estimates that 60 percent of the economy is illegal.[16] In 2002, the United Nations reported that 50 to 70 percent of Mexican judges were corrupt and that 7 percent of Mexico's GDP was lost to corruption.

In 1970, Mexico's national debt was $4 billion. In 2004, it was $170 billion. Meanwhile, NAFTA has flattened agriculture and China has gutted the maquiladoras on the border.[17] Mexico has become a machine that manufactures poor people and the U.S. has become a dumping ground for this surplus humanity. Reform of corruption is part of the litany of every Mexican politician. Their success is demonstrated daily by the thousands crossing the line and fleeing into the U.S.

The Third World has finally said hello and this time even a wall may not keep it silent or at bay.[18] For several decades now our politics and our economic theology have outsourced not only American jobs, but also the reality most people on this planet endure.[19] We buy clothes made by children and comment on the good price. Oceans have largely sheltered us from the consequences of our actions. We stumble into a Vietnam, leave, swear we will never forget it, and then change the subject. A September 11 stuns us, not simply with its violence and barbarism but also with the hatred of us that propelled those planes into our lives. And so we launch a war on terror and declare there is no need for further discussion.

But what is happening on our southern border is no longer really happening there. It has penetrated our entire country and the border is simply a point where we watch the world race toward us at flood level. The issue is not securing a broken border, any more than the real issue in New Orleans is building a better levee. Storms are rising at sea and they will come ashore and the walls and levees are simply points where we taste their initial force as they move inland.

We have entered the future even as we pretend it is simply a version of our past.

And some of us protest this future. The border has become a theater for vigilante actions and they come and go with different groups and names but all wearing the same uniform of fear and dread. There are dates that get noted, then forgotten, a desire to note sequence, create a history, have everything organized. That's fair, but feeble. History cannot contain what is happening—history is a custom to kill off the raw experience, to tame and make it safe. What is happening is not safe. Raw wounds seldom are safe.

We have a history of fear. In the 1790s Congress throttled free speech for a spell to silence recent radical immigrants from France and Ireland. In the 1840s, riots against the Irish erupted in Philadelphia and Boston and this anti-immigrant hatred continued until the Civil War—when the Irish in New York expressed their ire at the draft by murdering black Americans who had toiled on this ground for generations. California raged against cheap Chinese labor and passed successive bills barring their employment, a legal move that resulted in the importation of Mexican workers by the railroads. Also, this spawned the federal Chinese Exclusion Act of 1882, and the creation of a counterfeit-document industry enabled thousands of Chinese to continue to migrate. The rage against migrants from southern Europe was replaced in World War I by legislative assaults against German immigrants. World War II brought the Japanese internment. This is a tapestry of fear and scorn, one in which one immigrant group has often denounced the other. The anti-Chinese campaigns in California were dominated by Irish immigrants. No one has a bloodline free of this passion. Earl Warren, as the liberal Republican governor of California, hailed the imprisonment of Japanese Americans during World War II. J. Edgar Hoover as head of the FBI opposed it—the same Hoover who had stood at the docks gloating when the fabled Red Ship deported radical Americans following World War I.

During these waves of fear, the arguments against migrants are almost always the same: they don't speak the language, they are clannish and morally depraved, they will subvert democratic institutions, they drive down wages and so forth. And these arguments always have some basis in fact.

But the point is that these protests are recurring, and if immigration is claimed to be as American as apple pie, so is the hostile reaction to it. It is part of our flesh and blood.

ROWS OF TRAILERS UNDER A PACIFIC SKY. Redwoods older than God live in groves nearby. A woman walks down the lane with a toddler smuggled north, the men are off working in the logging industry or perhaps raising flowers—tulips, irises, daffodils, hyacinths. A mother leans over a bassinet where her new baby, an American citizen, beams upward and wears a T-shirt with the handwritten message "Daniel I Love You Mam," and this is followed by two hearts. They come from Oaxaca, Jalisco, Michoacán, and wind up here in Eureka in northern California. They know little English and many speak little Spanish because they are Indians who until recently lived in the mountains of Mexico and went generation after generation without seeing a city.

Celerina makes tortillas every day in her trailer. She crossed at Sásabe in Arizona three or four years ago with three small children. It was very hot and very hard, she remembers. She came from a village in Oaxaca. But now she is here, embedded in a new village of metal while her husband works and the future unfurls itself before her eyes.

A tree falls, a man dies in northern California and then suddenly the place left behind is the place to be. Women in a Oaxacan village make tortillas on the *comal* over a fire for three days in preparation of the funeral observance. Others make *mole*. A line of brown faces over the open coffin, the mother grabs the arm of her son's corpse in grief and

lifts it for one last gesture of life. The feet of the mourners are clad in sandals and the band—drums, saxophone, tuba, clarinet, trombones, a wail of brass—plays over and over one song, "God Never Dies." The Zapotec women clutch bundles of mums and irises, yellow and white flowers, the coffin moves up the mountain to the Campo Santo, the band still playing, the sax in the hand of the dead man's daughter, a dog leading the procession. He was thirty with family and then the tree fell. Dozens of candles burn in the night over the fresh earth of the grave. Fog settles into the mountains, seven waterfalls slide off the rock in the area and two worlds are briefly one. So many have left this part of Mexico that the shipment of bodies back from the United States is now routine at the airport and they are picked up by the families like any other package.

In California's Central Valley near Bakersfield, Mixtec women with flowers swarm around the shrine of San Juan. The statue came from Oaxaca and on the saint's day, the men wear the masks of devils and dance, the ceremony learned somehow centuries ago from black slaves. At the end of the mass, the saint is removed from the church and a procession accompanies him as he is taken to a Mixtec home. This is the home ground of John Steinbeck's *Grapes of Wrath*, and after that, of Buck Owens and Merle Haggard, and now it is graced by a new music as new Americans join the ground.

KYLE, THIRTY-SEVEN, wears a camouflage hat and a green T-shirt. He's a man of some heft and does not smile easily. He's getting ready for a patrol at a ranch house about forty miles north of Sásabe, Sonora, a small border town of several thousand. It's early April and the Minutemen are bivouacked just above the Buenos Aires National Wildlife Refuge. The year before, he took part in the initial action in southeastern Arizona, an event of media brilliance that recalled guerilla-theater masterpieces of the 1960s. With only a handful of people, mainly

retirees (one day I counted 127 minutemen and women staring down 1.7 miles of the border fence from their lawn chairs), the Minutemen, outnumbered by print, radio, and television media, captured the imagination of many Americans and danced across television screens for weeks. Their leader, Chris Simcox, came across as a smooth-talking John Wayne defending a new Alamo. I liked them and felt I had stumbled into a Woodstock based on canned food, beer and spleen. Mexican cops had shut down the border the Minutemen faced in order to avoid any unseemly incidents, told the coyotes to take a holiday from people-smuggling, and so the entire month was tenting, talking, lawn chairs and not much else.

I remember at that time watching the Minutemen and groups opposing them do demonstrations on the street in Tombstone, Arizona, a tourist town where people come to indulge in dreams of the Old West when homicide was sport. I grew bored with the piety of the speeches and walked a block to a bar full of ancient bikers out for their own fantasy of being outlaws. No one in the bar was aware of the Minutemen. That night they were a sensation on national television.

The next year is different. The Minutemen issues (a rising tide of illegals, the cost to the U.S. in social services, the crunch of wages because of this cheap illegal labor, the lawbreaking, and so forth) have become legitimate talk on the floors of Congress. Like so many outsider movements, the Minutemen have had their thunder stolen by the mainstream pols. But still they come and they have announced at least 400 will guard this little slice of America forty miles north of the line.

Kyle's here to "protect the American dream, live in a free country, own a home and make a decent living without tyranny."

And it is not always easy. The year before, he was out one night on post alone and it scared him. This is normal. The Mexican migrants I encounter who have spent a night in the desert alone also report being scared.

Kyle owns a kind of janitorial service in the Phoenix area and in a few days that city will host a march by illegals protesting the bill in Congress that would make them felons, deny them a chance for citizenship and possibly deport them. He says a bunch of his employees have told him they are going to skip work for the march.

He begs to differ.

"You can't," he offers, "legitimize fifteen million to thirty million lawbreakers. There's some people here who plain shouldn't be here."

Just then, Chris Simcox ambles up.[20] He's dressed in black and holds a hacksaw in one hand (he's been cutting PVC pipe) and a cigar stub in the other.

Simcox is a natural American genius at publicity. And he has a very good mouth.

"We're going to grow," he explains, "until we equal the number of Border Patrol if we have to. We have seven thousand members and next year we'll have fourteen to fifteen thousand. We have Americans here taking jobs that the government won't take. Try and remove us."

He speaks darkly of an incident like Tiananmen Square should the authorities try to remove Minutemen from their stations on the line.

He loves the marches by illegals and their supporters that have been erupting around the country.

"It's already backfired," he says. "We couldn't ask for a better situation—hundreds of thousands showing no respect for this country. The silent majority is not out there yelling and screaming."

I stroll around the corner and see the tally board. One day the morning shift sighted ninety-two illegals and bagged thirty-four. The midday shift saw eighty-three and caught fifty-nine. The night crew sighted fifty-four and nailed twenty-three. These numbers stun me because they mean that, unlike last year, the coyotes have so many customers they cannot afford to abandon routes known to have Minutemen plopped in their path. Imagine rush hour, and you see the reality. Of

course, bagging the quarry means calling the Border Patrol to pick them up. The Minutemen are punctilious about the niceties of law and what they are doing—armed patrols against lawbreakers are legal.

They are the inevitable consequence of illegal immigration, part of a new page in American Nativism. They are neither alarming, nor unfriendly, nor relevant.[21]

There are two groups of people I know who have little consequence for Mexicans sneaking north through the desert. The Minutemen with lawn chairs and muskets and the human rights groups plopping down random water stations and patrolling to rescue Mexicans who have gone down. The chances of an illegal bumping into either group are about the same as winning the lottery.

Forty miles south of the Minuteman camp, I hit the drag road, a dirt track along the line swept by the Border Patrol looking for the footprints of men, women and children heading north. The ground is littered with castoff water bottles, clothing, food cans, shoes, gloves, backpacks. The Buenos Aires National Wildlife Refuge, covering about 185 square miles, is being slowly obliterated by Mexicans trudging north toward work and Mexican drug smugglers roaring north toward our appetites. There are over 1320 miles of new trails, and over 200 miles of new roads. Plus abandoned cars, some decorated with bullet holes.[22]

The place was created in 1984 to save the masked bobwhite, a bird extinct in the U.S. and barely clinging to life in Mexico. What killed off the bird was settlement in both nations. Now it is being slowly stomped to death in its last refuge.

I load my truck up with trash from illegals and head out to the main gate. There are two empty Border Patrol trucks sitting there. The agents have gone off on ATVs hunting Mexicans.

Two kids sit nearby. The girl is twenty-two, her brother sixteen. They've been trying to flag down Border Patrol units that roar down the nearby highway but no one will stop.

They came up from Oaxaca. They're Zapotec Indians but they don't feel that way. Their parents moved to Oaxaca City and since they've not been raised in an Indian pueblo, they see themselves as city kids, as Mexicans. For sixteen days, they've been on the road.

First they took the bus up to the border. Then they paid a coyote $800 to guide them across. The first time they got caught and deported. The second time they got separated from their group and they say they have now wandered the desert for four days. I don't believe them about the four days, they look too clean, but clearly they are broken in spirit.

They're headed toward friends in Madera, California, a spot outside Fresno. But for now, they want to go back to the border. They need to reconnect with the smuggler (who usually includes three attempts in the price), make a call to their people in California. And they need to eat and drink. The boy, despite warnings about the trash I've collected off the migrant trails and pitched in the back of my truck, grabs from this garbage a bottle with some pop left in it and guzzles.[23]

He weighs maybe 110 pounds and she is not likely to be more than eighty-five. They are both small-boned and the skin is dark and shines with life. The smiles are full and flash from their faces. Both move with the light tread of cats. An hour ago I found a shawl out in the desert of a pattern and style only made in Yucatán. Everyone is moving. I hear in my head that ancient band, Buffalo Springfield, singing of some minor dustup on Sunset Strip and the voices say, "Hey, people, what's that sound? Everybody look at what's going down."

More than forty years ago, when I was a boy starting to notice the way those girls moved when they walked, I camped on a street in Durango with my old man in a bread van he'd converted into a camper—a slab for him to sleep atop cases of beer, a Coleman stove, and the floor for my bunk. It was hot and he opened the back doors and tossed a canned chicken into a pot for his notion of a meal. Soon

a gaggle of kids gathered with hungry eyes. The old man stood there with his hand-rolled cigarette and then started giving out cans of food—potatoes, chickens, corn, beans, Spam, hash, all the staples of his menu. When he was done and all our food was gone, I asked him why. He said nothing but opened a quart of lukewarm beer from the reserve he slept on. I knew he'd come up hard but it was years before I understood what he knew and what he taught me that night.

I give the girl forty dollars and tell her to hide the money because Sásabe is not an easy place. She and her brother climb in and I take them to the border crossing and wish them good luck. The guys on the U.S. border station watch them climb out and walk into Mexico.

They ask me if they worked for me and I say no, that they are two kids from Oaxaca sneaking into the United States, that they said they'd wandered in the desert four days and were very thirsty and hungry.

They tell me what I have just done is illegal and could cost me a lot of money and put me in jail.

I say I know that fact.

They look at me with sad eyes and wave me on.

It's not easy for anyone in the future.

THE OTHER NEVER LEAVES, I can pretend, but still I look over and there is the other, that creature my country aunt mentioned when she came for a Chicago visit long ago and complained about the way black people smelled on the streetcar, something about their choice of cologne or perfume, and she objected and wrote them off and they were the other, the person beyond the pale, outside the clan, banned from the tribe, and this was never explained but simply stated and you leave home and move into some other worlds, change comes, you tell yourself you grow, but still somewhere over the horizon, just out of view, lurks the other, that person or tongue or batch of customs, that color or dress that is wrong and pushed away.

As a child I'd go down to Maxwell Street, a Chicago thieves' market, once the turf of tough immigrant Jews, and then, as they prospered, a swirl of Gypsies, Italians, Poles, Mexicans, a laundry list of nations, salami hanging off racks outside, the buzz of flies, cries of hawkers, the street all people, and cars are banned, and in the window of Smoky Joe's the wardrobes of pimp dreams, hats at an angle and the colors on fire, men pushing carts with ice-cream sandwiches, the old man tugging me along, and then buckets of menudo steaming the Chicago air, the basket of tamales wrapped in corn and how can anyone eat that? Women with paint on their faces, the Greeks slicing meat and then wrapping it into some kind of funnel, horseradish on the breath, pastrami and corned beef, pizza and loaves cut in half and stuffed with beef, the faces all yellow and brown and black and every other shade, babble of tongues, kids my age with ancient eyes at little stalls, and back at the flat my old man keeps a print of Grant Wood's mother, for God's sake, and some oils by an unknown of Holsteins feeding a lush pasture, but here he feels at home, wandering the street, striding through the mob and no one looks like him and he doesn't seem to notice or care, his hand clutching some bundle of bread and corned beef, his eyes feeding and this rush of sound never leaves the ears alone, the voices, shouts, yells, cries, pleas, announcements, and over it all music spilling out of radios, the country and western of a dozen nations all telling of work and low pay and Saturday and ain't my old lady fine?

Down the block in my neighborhood lives a kid who says he is Bohemian, wherever that place might be, and the Irish are everywhere, also Swedes—their wooden barrel of herring down on 79th Street, the Jews with shops, those Germans baking and peddling pastries, Italians with jars of pickled things and bread with hard crusts, and the kid in elementary school who explains to me that his people eat squid and I ask what is a squid, and he can't really tell me except for the texture and then for supper my German mother cooks a tongue and we slice it and smear it with horseradish and the world seems American again.

There are block committees to keep out the blacks, and if a Catholic or Protestant marries one another it is hell for sure. Gangsters are honored, the older men point them out and speak with respect, and one Saturday night in a local bar one man bites off the ear of another, but that is all right, they are both our kind.

I think something has been lost in the warehousing of people in suburbs, in the endless electronic maze where we sit in caverns called homes and stare at screens, and that is not simply the notion of the other, but also the physical presence of the other, the breath in our face with onions and garlic, the barbeque sauce floating off the ribs, the chitlins piled up for sale and pig's ear ready at the market. We became proudly multicultural but never brush against each other's lips. We tread carefully around ethnic slurs but never shake hands with the people basking in our piety.

In the debate about immigration there is always a silence about this other, the person who looks different, prefers strange foods, speaks a foreign language. And this silence operates on both sides of the political aisle.[24]

Chopper spinning the sky over an Indian village while Border Patrol vehicles race to the site, park, and then agents tear into the brush, all the while the chopper pivots and dips down like a border collie herding sheep and somewhere off two or three hundred yards away in the brush men, women and children rush in panic, the dust rising in their faces from the twirl of the blades, the men on foot pounding toward them, and I lean against my truck by the road watching as if I stood on some other planet where a man is legal and safe in his property and privacy. Or I'm rolling down a road in New Mexico, that thin ribbon of asphalt that skirts the border and runs through ranches and tiny hamlets when I see the lights swirling in my rearview mirror, pull over, the agent suddenly standing by my door asking for proof of identity, asking me why I am on a state highway in the United States, and where have I come from and where am I going and for the past hour I've seen nothing but National Guard units camped on hilltops and staring south, met nothing on the road but Border Patrol units and the sky is blue, the sun warm, and the feel of heaven is in the air and then I am released until the next time.

I hardly know a stretch of the 2000-mile line not clawed by human trails or outlaw roads, gates shattered, fences down, fires on the mountains from careless fires left by illegal men and woman and children in their march north. It will be 100 years and the imprint of this migration will still be naked on the ground, the heaps of abandoned plastic jugs sighing forever in the desert winds.

When it is all settled, when the other becomes us and then mans the ramparts to keep yet others out, this war will linger and slap us in the face if we walk our land.

There are so many things not to be spoken of. One is the trash. Another is the maiming of the land. There is the matter of fires. The abandoned vans littering the wildernesses that are no more. Of course, the bones of those who failed in their journey. And a miniature police state of endless stops, of highway checkpoints, of guns pointed, of papers demanded, of vehicles searched.

Smoke rolls off the mesquite fire, I'm thirteen, maybe fourteen years old and my mouth burns from chili as the men dance on the pounded dirt with deer heads tied to their skulls, drums steady and it is 2 a.m.—white clocks have been murdered here—as the tribesmen take themselves through their understanding of the passion of the Christ in the desert city where I live just north of that line, stars wheeling overhead, women bent over pots on the coals, fresh scent of tortillas in the night air, and the smoke wafts over me and cures me like a ham hung on beam, all the skin is brown here, a man collapses and crawls twenty, thirty, forty yards and then drapes himself on a big cross planted in the ground, no one looks, no one says a word, the drums beat.

The tribal members are all immigrants. Long ago during the wars to kill them, they fled Mexico and came here without papers and time has ignored this breach of law and now they simply are and no one asks for papers.

The headman has nodded and so I am allowed to sleep on the ground and then awaken and the drums fall still at times and then resume, also the flute, cut from cane, just one hole, the flute wailing and wandering above the drums. I get such a flute. The man is ancient, he'd fought in the wars against the hated Mexicans. He sits, rubs the joints of the two pieces together, then spits, rubs this on the cane and they slide into a unit and the sound comes forth. Then he hands it to me.

The other never really leaves any one of us but it can be moved as we advance on the nightmares hiding within ourselves. Like race hatred, facing the other is very American. We are a bastard race but we must have time to accept the new faces that will, as always, become our own.

la gente

When the General sends one of his wives to the United States in order to sit out his next bout of killing, she pleads with him to come north also—"Let us go to a country where we can live peacefully." The General will have none of such whimpering. "I will forgive you for all you have said, because I can see love in your words, but I will never stand for people saying, to your shame and that of the children, 'Francisco Villa fled across the border to hide his own cowardice and dishonor in a foreign country, maybe with the money he stole in Mexico.'" Ah, he is getting angry and the General in anger is not a pretty sight. He seems to seize control of his emotions after a moment and he continues, "Sooner or later you will know that your husband is dead, but dead in Mexico." He pauses, then rolls on, saying, "I tell you something more. If after my last

cartridges are burned, I see my life is in danger, I'll use my last bullet on myself that my enemies may not have the pleasure of killing me."

In the early 1920s, some Hollywood producers come to Villa and ask him to star in a movie about his life. He insists on script control and carefully signs each page of the approved screenplay. Then the boys get down to haggling over the money. The General brings them up short with his terms. "I do not want anything for myself," he explains. "I'll work in the picture on the sole condition that the company builds a big agricultural school at Santa Rosalía, where my fellow citizens may receive an education. This school is to be cared for in everything for five years and the building cost will be one million dollars. After this time it will be the property of my country's government. But the school is not to be named after me: in fact, it will not be named after anyone, you just call it 'Escuela de Agricultura.'"

The movie is never made. The school is never built.

The General is a lover. One day he brings his most recent wife a present. He says, "I bought this guitar for you, Güera, 'cause I wanna hear you sing that song you hooked me with." She strums and sings,

Down in the ocean's darkening depth,
With none to watch but God and the sea,
A thousand kisses for your lips I'll have,
A thousand words of love for you to hear.

Years later she recalls this moment and adds, "As for me, I cannot forget that his love filled my life and that it was through the bandit—as he was called by those who could not understand the longing in his heart—that I became a mother."

IF YOU ANNOUNCE IT, they will come, but no one knows just how many may turn up. On February 6, the local Spanish-language radio stations promoted a protest at Senator Jon Kyl's Phoenix office. The

senator had tossed some tough provisions into an immigration bill. Twenty thousand people showed up. Now, after the massive marches in Chicago, Los Angeles, and Dallas, Phoenix joins a national network of marches on April 10. The organizers say they hope for fifty to a hundred thousand. The city simply waits, silent, a bit worried and at the same time curious. It has the feel of that moment when the lottery winner is announced and everyone looks frantically at their ticket. Just how big will *la gran marcha* be?

Outside Mel's Diner, the parade route sleeps in the early morning light. A hand-painted banner hangs off an apartment building: CITIZEN-SHIP IS A PRIVILEGE, NOT A RIGHT. Posters of a blue and white ribbon line the street, the symbols of a Catholic group that hopes to meld with the marchers. Men unload cases of water at aid stations along Grand Avenue and cops mill at various points waiting for whatever will happen.

Inside Mel's, a hash house decorated with American flags and slogans ("Let Freedom Ring"), the owner talks in Spanish with three young, illegal guys about some remodeling and each wears big decals with the march slogan, *Somos América*, We Are America. The back room is wall-to-wall cops chowing down and plotting how to handle the marchers. The customers, buzzing about the event, are black, white and brown. One black guy pretty much sums up their attitude: "As long as they do it right, it's okay." But this is a low-key, working-class crowd, the kind where a hefty white guy sports a T-shirt that features four drunks and the message, Weapons of Mass Consumption. The radio plays Simon and Garfunkel singing "Scarborough Fair."

Frank, forty-seven, the Mexican American counterman, sounds the only dissent. He's pissed by the display of Mexican flags in the earlier march on Kyl's office. He's got huge tattoos on each arm and a quick mouth that says, "They got more rights than we do. They got cars, cell phones. I was born here, worked all my life, I can't get no car. They talk about how wonderful Mexico is, well, kick their ass back there then. I take the day off, I lose my job. They ain't gonna pay my rent."

He rolls on how his mom's neighborhood is overrun with illegals living seven to ten to a house. Then he turns to a customer and instantly shifts into Spanish. Across the street, in the 9 a.m. light, someone has torn down the banner hectoring about citizenship. And there are growing numbers of cops.

But mainly, Phoenix waits. No one expected those 20,000 people at the senator's office in February or the huge turnouts from marches in other cities. No one expected all those Mexican flags, a sign of identity for migrants but a flashpoint for puzzled residents. And no one has any real notion how many kids will leave school, how many men will walk off the job, how many mothers will show up with babies and toddlers.

Phoenix has always been a city where Mexicans were present, but not accounted for. Fifteen years ago, I was talking to the publisher of the city's major lifestyle magazine and when I mentioned Mexican Americans as an element of the city who were absent from his slick rag, he looked puzzled and suggested there were a few around doing gardening.

For the last few years, the metropolitan area has been growing like a weed and murdering the desert with subdivisions. And since the 2000 census the largest part of Arizona and Phoenix's growth has been illegal migrants. Home invasions have exploded as rival gangs steal migrants from stash houses. And yet, until the turnout at Kyl's office, Phoenix feasted on golf, traffic jams and sun and remained largely oblivious of a secret city within the city. And so today, you can almost hear the city hold its breath and wait and wonder just how many souls will emerge from the shadows.

Around 10 a.m. at the march origin point in the state fairgrounds, bands and speakers entertain only five or ten thousand people. They are all ages and they are all brown.

It is difficult to give simple categories such as legal and illegal. Pedro Pascual, thirty-two, is from Guatemala, has been in the U.S. sixteen years, has some kind of papers and he holds a pole on his shoulder with a huge American flag. He says simply, "We will see if we have the energy." María Torres comes from Guanajuato, the same state as Mexico's President Fox, and one of the key sources for migrants. She's illegal, has been here four years, and wants "to get legal because I came here to succeed." But the real feel of the growing crowd is summed up by Sandro García. He's been here fourteen years, was brought north by his farm-worker dad. He has some kind of papers. Next to him is his wife, and she's illegal. She holds the child, a girl Sandro calls "Pretty Girl," and the child is a U.S. citizen by birth. Technically, this family has one illegal but as a state of mind, they are all migrants, all living and working in a kind of shadow world. And they all are festooned with small American flags.

Police and media choppers hover overhead. The crowd chants, *Sí se puede*, Yes, we can do it. A burly young guy has an American flag sprouting out of his hat and a huge tattoo on one arm that says HECHO EN MÉXICO, Made in Mexico. All this is watched by Pete Rosales. He did Nam in 1964 and 1965 and has a big scar on one leg as a keepsake of that frolic. He's been watching the crowd since 7:30 a.m. "to make sure they get it right." And getting it right for him means no more of those damned Mexican flags and lots of people so that gringos will stop treating Mexicans as second-class human beings. He needn't worry—few arrive at the fairgrounds with Mexican flags and those few are pounced on by organizers and asked to put them away.

At 12:25 p.m., the march steps off and it is now huge. The opening wave is staff wearing yellow T-shirts and locking arms across the five lanes of Grand Avenue and the generous tree-lined sidewalks on each. I've seen flash floods roar down desert arroyos, the wall of brown water churning and tumbling. Now I see one made from human flesh.

For over two hours, La Gran Marcha sweeps past me. The people fill Grand Avenue from building to building. There is no space for spectators except on rooftops. The lines flooding the street are at least sixty people across. Each line takes one to two seconds to pass me and features three to four baby strollers. The water station next to me is gutted in fifty minutes flat. And still they keep coming. In two hours, I see maybe ten Anglos, one black, and no more than thirty Mexican flags. And at least 50,000 American flags, flags fluttering from poles, flags held in hands, festooning cowboy hats, sprouting like decorations from manes of black hair on the heads of mothers pushing strollers. The signs are almost all the same, WE ARE NOT CRIMINALS, WE ARE AMERICA, TODAY WE MARCH, TOMORROW WE VOTE. A herd of Prussians could not be more organized and on message.

Cops stand around chatting and devouring popsicles in the heat. There is nothing to do, La Gran Marcha has a life of its own. By the time the people finally reach the grounds of the state capitol two miles away, they are still forming up at the fairgrounds. The newspapers will say the march drew maybe 100,000 people. I wish I had access to the newspaper's drugs, since 100,000 people swept by my post in the first hour. The mayor's representatives will say simply that all they know is that marchers walked by their office for three hours. At 4 p.m. at the capitol grounds, pols have been haranguing the crowd for at least an hour and yet marchers are still arriving. No one seems to pay much attention to the yapping from the podium. La Gran Marcha needs no speeches. The torrent of people is the statement.

When it is over, there will not be a single reported incident. Nothing but at least 200,000 people peacefully walking down the street of the city that ignores them. And I never see a single can of beer. This is the largest gathering of human beings for any reason in the history of Arizona.

I loathe marches and have felt like a fool every time I've been in one. But I am stunned and feel my eyes almost misting up at times. I have never experienced a march of this size without a whiff of tear gas in the air and the music of sirens. The faces are what do me in. In part, it is the determination of those thousands of young mothers pushing baby strollers through the heat. In part, it is the squads of teenagers all wearing stickers that say WE ARE AMERICA. But mainly it is the men in their thirties and forties and fifties, men with the hard bodies of *campesinos* and the hard hands of brutal work, men with blank faces who march and yet feel foolish for the act of marching because such things are for women and children and not for men who should be at work earning money for their families, and yet they are here, and they want to be here, but it does not feel natural or quite right to them.

A man pushes a baby stroller as his wife walks next to him. American flags on small sticks erupt from her hair. He sports a shaved head, a white T-shirt, and on the back he's written with a felt marker, WE ARE YOU FRIENDS.

For weeks afterward, the state press is largely silent about the march. It was too big and it put people in the street that had been invisible. They are here, they work, they have children. And now what? Deportation begins to sound like a pipe dream. And the scale of the migration suddenly seems larger than people had imagined. After all, this is the nation that could not get 100,000 of its fellow citizens out of New Orleans and to safety.

YELLOW DOGS LAZE in the afternoon of the plaza. Altar, sixty miles of dirt road south of Sásabe, is home to 18,000 people, and a way station for 500,000, 600,000, 800,000 souls a year who pass through on their way to El Norte. No one knows for certain the actual number and hardly anyone really wants to know. But you can go to the bank with one fact: more Mexicans move through Altar and into the United States each year than the U.S. government admits enter across the entire 1,951-mile border. Altar is the beginning of the lie and the beginning of the pain.

At the moment, Holy Week in April, a holiday during which Mexicans make a desperate effort to be home with their families, at least two thousand people are passing through to the border each day. This is like Americans deciding to go to the office on Christmas Day. A month ago, an undercover Border Patrol agent surveyed the traffic and pegged it at five thousand a day. A visiting novelist, Phil Caputo, noticed the twenty-odd stalls selling black daypacks, black T-shirts and clothing, and figured it for a migrant Wal-Mart. Two things happen to visitors in Altar: first stunned silence and then a search for some metaphor to wrap around the dusty town with sixty miles of dirt road south of the American line. On the east edge of the community is one such effort, a boarding house for migrants (three bucks a day for enough space for one sleeping body) named *Éxodo*, Exodus. There are dozens of such flops in town.

Here is the basic script: you get off a bus you have ridden for days from the Mexican interior, increasingly from the largely Indian states far to the south. This is the end of your security. On the bus, you had a seat, your own space. Now you enter a feral zone. With money, you can buy space in a flop for $3 a night, get a meal of chicken, rice, beans, and tortillas for about $2.50. You stare out at an empty desert unlike any ground you have ever seen. Men with quick eyes look you over, the employees of coyotes, people smugglers. On the bus, you were a man or a woman or a child. Now you are a *pollo*, a chicken, and you need a *pollero*, a chicken herder. The price to get from this point to distant spots in the U.S.—North Carolina, Los Angeles, Chicago, and so forth—is at the moment $1700 and rising. Within three months it will pass $2000 and continue to rise. American Homeland Security is good for people smugglers. And this cost does not cover getting to the border

or crossing the border or food or a place to stay. It only covers getting from a stash in Tucson or Phoenix to some destination in *Estados Unidos*. You pay to learn how to be a chicken.

You will never be safe, but for the next week or so, you will be in real peril. If you sleep in the plaza to save money, thugs will rob you in the night, or if you are a woman, have their way with you. If you cut a deal with a coyote's representative (and 80 to 90 percent do), you still must buy all that black clothing and gear, house and feed yourself, and then one day when you are told to move, you get in a van with twenty to forty other pollos and ride sixty miles of bumps and dust to "La Línea." Each passenger pays ten to twenty dollars for the van ride—the price varies but keeps edging upward. The vans do not move with less than seventeen, prefer at least twenty, and do, at a minimum, three trips a day.

Thirty miles below the border, you will face a checkpoint set up by Grupo Beta, the Mexican force supposed to help pollos. Here are signs warning of venomous creatures and high desert temperatures. And the officials are under an orange ramada, one with a crudely painted single word, *gallo*, rooster. The vans stop, the bodies are beat up but the tires, always, are excellent. You will be sitting inside, possibly on an iron bar so that dozens of pollos can be packed in. The men of Grupo Beta will count you—everyone gets a cut in this business. The head of the state police in Sásabe Sonora, the town just ahead on the line, takes in $30,000 a week.[25] You are worth a little money now, though you are penniless, unemployed, and frightened. Two years ago, a friend of mine did the ride and counted fifty-eight vans in one hour. Early this year, a group of American reporters stood at the checkpoint and counted 1296 people in 180 minutes.

You have entered a Middle Passage and it ends at the stash house. In between that bus from the interior you disembarked from in Altar and the stash house in Tucson or Phoenix, almost anyone could rob you or kill you or rape you. And many will try. At the moment, you are worth a few hundred dollars, almost like an oil future. But you must get to the stash house before you are worth real money and worth protecting. And you must do it by force of will. In this sector of the line, the 300-mile-wide Tucson sector, four or five hundred of you will die, most in summer. Others will die and rot in the desert and go uncounted. A year ago, a woman from Zacatecas went down and died in late June. Her father came up and searched for weeks to find her body in the desert, a valley of several hundred square miles. In his quest, he stumbled on two other corpses before finding the remains of his own child.

At dusk on the line, you will go through the wire with twenty, thirty or more Mexicans. There will be a guide. You will carry a gallon of water and that black daypack. The temperature in summer could be 110 or 115 degrees during the day. You will walk anywhere from ten to sixty miles, depending on the route and what you have agreed to pay. There will be rattlesnakes, cactus, trees. And almost no signs of people or their homes. Everything will have thorns and rake your skin as you stumble through the darkness. You will keep up or be left behind. If you are a woman, you have a fair chance of being raped. And you will most likely never speak of these nights again so long as you live. You will have children and grandchildren and teach them many things. But if you are like the others who have passed this way, these nights will remain your secret.

A major strand of the largest known human migration on earth is passing through this section of the Arizona desert day and night in silence. No one is really counting the people, no one is really recording their journeys. They are items on back pages of border newspapers. Their Ellis Island is not marked on the map. Somewhere between Altar, Sonora, and Tucson and Phoenix, new Americans are being made and their souls are being forged in a burning desert. Soon, they and their descendants will number thirty million. And this vast silence is likely to be the savage part of their repressed history.

On the plaza at Altar, pollos sit in rows. They wear dark clothing, have daypacks and gallons of water by their side. They are waiting for their van rides. A mile to the west, two new motels have risen, one mainly for pollos, the chickens, the other for polleros, the chicken herders. A tourist would have a hard time finding lodging in Altar.

Everywhere around Altar, new houses are coming out of the ground. The nicest run two to five thousand square feet, have fine windows and doors, good walls surrounding the lot, and flowering trees and shrubs. These belong to drug traffickers, sharks that swim in the same sea as the migrants and find that thousands of pollos mask their own hikes with backpacks full of dope. They tend to carry AK-47s as well as water bottles. The going rate for moving marijuana across the fence is ten dollars a pound—which means one night hauling a 100-pound pack can mean a thousand dollars.

There is a fantasy that drugs and migrants are separate matters. Both are often moved by the same organizations and both come north to satisfy American hungers. Sometimes the two commodities flow together, and sometimes they are kept separate on the ground lest a group of poor people draw too much attention to a route and jeopardize a shipment of high-grade heroin. But the networks are generally the same people because both commodities are about the same thing: billions of dollars of profit. And both mock the pretenses of Homeland Security. And both are relentless flows. They satisfy elements in each political party, those seeking people who will work for low wages and those seeking highs.

He's wearing a black Thunder Road chopper cap, is thirty-six, from Veracruz, and claims he and his mother and sister are on the way to Tijuana. He's almost certainly lying. No one sits on the plaza here dressed in black save pollos. Or the guides that haul them. But almost no migrant admits to being a pollo or a pollero. In part, this is fear. Once I walked two blocks, sat on a curb and watched eight people in a line at a pay phone (pollos try to report in to relatives despite Mexico's phone rates, among the highest in the world).[26] Outside a flop, another half dozen pollos sat on a bench. I took my notebook from my pocket, flipped it open, and started writing. Every one of them fled.

Besides this fear of poor people far from home and suddenly facing a new and dangerous world, there is another reason for this deception. Shame. No one likes to admit their own nation has no place for them and that the nation they seek to enter holds them illegal and will try to hunt them down like animals. So the man from Veracruz says, "The United States? I have no papers for crossing."

Nearby are two guys from Guerrero in the regulation pollo black. They are Indians and plan to go to Taylor, Texas. They say they have friends there—pollos always say they go to friends, not family, another act of caution.

One guy is nineteen and he gives the basic biography of a pollo: "I have friends there. I have never been in the U.S. before. I plan to spend two years, a couple of years, and then go back to Mexico. There are no jobs in Guerrero. Why even go to school? When you graduate there are no jobs. Last week, in the state capital I saw 300 young schoolteachers demonstrate because they could find no jobs. I work in the fields. I can grow beans, corn, and squash."

His eyes are anxious and he cannot seem to smile. He has heard there is work in the United States. He has heard Americans think people such as him steal jobs from them. But he does not believe this because "people who have been in the United States tell me Americans don't work in the fields."

He says he has two worries—dying in the desert, and not finding a job. He's heard of the recent big marches and thinks people have a right to march.

"Why," he asks, "won't the U.S. let us work and then go home? We don't want to do anything bad to America. In my village, 20 percent of

the people have gone to the U.S. and in the state about 50 percent have gone. I've been in Altar two days waiting to cross."

He and his friend have no money and so they will cross without the help of coyotes.

He says he does not want to fail.

This story plays out of mouth after mouth in the plaza. There is no work in Mexico. Do you know where Oregon is? Do you know where Tennessee is?

Juan Hernández, a dark Mixtec Indian who has already been caught once by the Border Patrol, explains, "There is no work, no rain, nothing to do in the fields. We are very poor there. I don't know what the U.S. is like. I am about to give up. But a part of me wants to try again."

Already twenty to thirty people from his village have gone to the U.S.

In the stalls, black T-shirts say Retired Army, or U.S. Navy. They sport huge American flags, or soaring bald eagles. Racks hold medallions of Jesus Christ and Jesús Malverde. One was said to be a carpenter, the other a bandit hanged in Culiacán, Sinaloa, in 1909 and now a favored *santo* of narcotraficantes. Amid the stalls, a line snakes out of the telegraph office where people wait to get money orders for the next leg of their journey. Against the side of the church is a sign: God Is Love.

There are two sounds: pigeons, and the low rumble of vans as they load pollos. The humans of the plaza are all but silent as they brace themselves for their new lives. Or deaths. Inside the church, pollos often light one-dollar votive candles before heading into their desert passage.

Francisco García is around forty, has smooth skin, black hair and moustache and the slack gut of a man who does not work in the fields. Until recently, he was the presidente (boss) of this municipio (think something the size of a U.S. county). Now he works for the Catholic Church running an aide center for migrants six blocks off the plaza. Those defeated by the desert and the Border Patrol come here for food and shelter. And then they head north again—García knows one migrant that tried twenty-five times before he got through. He thinks at least 90 percent of the migrants get through.

He explains that the traditional economy of Altar was cattle and farming. Now it is pollos and drugs. Almost all the people in the pollo industry—the people running phone services and boarding houses, the coyotes—come from outside Altar. This is a common thing in the people-smuggling business all along the border.

"Altar," he offers, "is not only a path for migrants but a path for drugs. The migrants are like a curtain that hides the money of the drug business."

He dreads that the illegal migration might end, or move elsewhere. He dreams that migrant workers are made legal and that Altar becomes a kind of hiring hall and hub for American businesses. Regardless, he does not think the United States can successfully close the border.

He describes the people-smuggling business as like a string of beads on a rosary with each bead a self-contained cell. In the Mexican south, there are men recruiting pollos, then there are other men rounding them up and shipping them on buses to, say, Altar. Here another cell plants them in flophouses and arranges van rides. Sixty miles north, another cell moves them through the wire. At the end of their desert trek, they brush against the next cell, one that loads them in vans and takes them to stash houses. Here a key representative of the coyote arrives, copies down names and phone numbers and destinations, makes the calls and tells of the charge. Sometimes these people double the price from what had been earlier agreed. After forking over half the fee, the pollos are loaded in vans according to their destinations in American cities and towns. On arrival, another key figure appears,

some blood kin of the coyote who pockets the rest of the money. The coyote remains in the shadows, he says, an intelligent, cunning, and mysterious figure.

This year García thinks 800,000 Mexicans will pass through Altar on their way to El Norte. The sign behind his desk advises that Jesus, Mary and Joseph were migrants and were looking for a better life.

Down at the plaza, people line up at the public restroom (three pesos a visit). A Red Cross clinic in the trailer of a semi-truck treats a woman who is losing the nail on her toe. She claims she hurt it in her house. This seems unlikely. She is dark and from Acapulco. Her name is Alicia Soriano, forty-nine, and her face is awash in pain as the doctor clips off her nail. She has no one with her. Most likely she was separated from her man and family in the desert and walked and destroyed her foot. She is alone now in a strange town with blood gushing from her toe.

Outside, buses keep arriving and unloading people from the south with dark daypacks and dark clothing and anxious eyes. Two mannequins stare at the pollos. One is a woman wearing a white bonnet and the mask of a Zapatista. The other is a man wearing an Australian bush hat and a rosary. Two pollos stop at a stall just before climbing into a van and buy foot powder. Vans depart more and more frequently. They will haul Mexicans until at least 8 p.m., then shift to the three or four hundred Central Americans who are generally moved in the dark of the night. They will be moving through the wire, if everything goes according to schedule, on Good Friday.

Where the road leaves Altar and heads north into the dust of the desert stand three crosses. One says "Children," the next "Family," the third states that "2800 have already died on this journey and how many more must die?" The town priest put them up. Each year he came out one Sunday and said mass. Then he was shipped to the Vatican so he'd stop making such a fuss over this matter.

THEY WORK CONSTRUCTION in the hardwood forest and build mansions for people who speak a different language. North Carolina is one of those places that never saw it coming and now it is studded with new colonias of migrant Mexicans. On the weekend, open-air markets erupt and look like those in rural Mexico.

A man works on his car out on the streets. He came up from Honduras and paid $5000 to get to North Carolina.

A couple lives in a house. The man came north through Sásabe. He stood under a tree there and tore off his Mexican clothing and then changed into the garments supplied by a coyote so he would look American. I've stood there while men and women morphed into their new costumes.

He works construction and has brought his woman north through Tijuana. He's been here a year, she has been here a few months. She cleans apartments, the work goes very fast because strong chemicals are used—she has had to sign a waiver that says she will not sue if the chemicals harm her. They rent a house, they work all the time.

Everyone has dreams and they think of their former homes. But they will not be going back, except in their dreams.

THEY SOMETIMES DIE TRYING to get here and yet a part of them never wants to come. This tone in the song is very old. Paul Taylor wanders the new Mexican barrios of the Chicago area in the late 1920s and early 1930s. He is a sociologist. He finds a camp made out of old boxcars where the laborers live surrounded by gardens, pigs, chickens, cats, and dogs. He speaks to a woman, the mother of four children. One of her boys has had his eye pecked out by a chicken, the baby is bow-legged. The boxcar feels dark and dirty to Taylor as the woman begins to talk.

She says, "My husband has been in this country ten years. He spent many years in Missouri, working on the railroad. I knew him before he

left Mexico and we always wrote to one another. Our family was not friendly with his. They would not let us get together down there. Seven years ago, he came back to Mexico because things were bad here. But they were worse down there so we got married there and came here. All our children were born here in the United States. It is four years since we have been living in this camp. Before, we lived out in Iowa. There were few people from Mexico along the tracks; they were mostly in the cities. I feel very lonely and sad out there. Here, there are more people from Mexico and I have someone to talk to and visit with.

"It is very nice here but I miss the *vida alegre* of Mexico very much. I long to go back and enjoy the fiestas and *ceremonias* of our country. We seldom leave our camp here. I do not care for the movies so much. They are nice but I cannot read the titles in English. My husband knows a little but sometimes we miss the meaning of things and we are lost. We have very few people who speak English coming here. At times some of our friends from el pueblo come over for a nice cool Sunday to spend the day with us. But I wish I were back in Mexico."

It all sounds familiar, blood of my blood. My great-grandmother spent almost every minute of her life in a German colony in Iowa. When she died at ninety-six right after that war in Korea, she had learned not a single word of English. And she missed many things from some country she called old.

la gente

Enrique Creel, who is related to the Terrazas clan, a governor of Chihuahua at the turn of the century and a card-carrying member of the plutocracy that devours Mexico under Porfirio Díaz, puts his finger on a throbbing part of the land's heritage in a lecture he gives in 1928: "The inhabitants, principally those of the countryside, are more developed and more strong than those of the South of Mexico. . . . There are towns . . . where a growing number of the inhabitants can place ten shots from a rifle in exactly the same spot."

Enrique Creel once made a wish list of what Mexico should and should not be: "Dangers—1. Hatred of religion. 2. Hatred of capital. 3. Hatred of foreigners. 4. Civil war. Corrections—1. Peace. 2. Justice. 3. Love of capital. 4. Love of work. 5. Respect for property."

THEY HAVE WIT. The $5 bumper sticker says "Señor Fox, the King of England Didn't Like the Minutemen Either." About 100 Minutemen have gathered forty miles north of Sásabe, Sonora, for Operation Secure Our Borders. They fall into three clumps: young guys in their twenties and thirties and old guys reaching up into their eighties. And women. They generally all wear guns and are friendly and media savvy. Their explosion onto national television in the spring of 2005 has made them see the press as their best weapon.

Simcox is off barnstorming around the country but in a few days he will unleash his new idea: have the Minutemen build some fences on private property along the line to demonstrate that the U.S. government could easily stop this brown invasion of America.[27] First, there will be a six-foot-deep trench backed by some coils of concertina wire and then a fifteen-foot-tall steel mesh fence with the top angling toward Mexico. Behind this will be a dirt road and video cameras so that anyone on a home computer can watch for pollos. Across the road will be another fifteen-foot fence and then more coils of concertina wire. The group figures the whole deal will only run $125 to $150 a foot.[28]

So far this month, the Minutemen have spotted 877 illegal immigrants, called the Border Patrol and bagged 370. Thursday night they were sitting around outside their loaned ranch house when forty pollos came by on bicycles riding down the paved state highway. The headquarters has a big sign announcing MEXICO IS NOT ONE OF OUR STATES. Just to the south of the old ranch house, they've parked tents and campers and various RVs. It has a good feel because the boys ambling around with their guns and intensity have finally found meaning in their lives.

Line Bravo runs two miles and is periodically studded with Minutemen who stand on the roofs of their vehicles with binoculars and radios and hunt prey.

Just past the end of Line Bravo is an old stock tank. Bob Kuhn parks here. He's past seventy, did his stint in World War II and Korea and last year was Chris Simcox's bodyguard. Bob is originally a land surveyor out of Colorado and Nebraska, a family man who has worked hard all his life, and now he lives in Arizona and devotes time to the Minutemen and also to a machine he's designed that will make electricity for free. He tells me he'd love to go to Altar and see all those coyotes and pollos but alas, M-13, a Central American gang, has put a $50,000 reward out for his head. He heard this through the underground.

We walk about 300 yards, come up a slight rise and then it slaps us in the face. The dump site. The mess flowers like an ink stain over the desert and the ground is literally black with tossed daypacks and clothes and underclothes. I've spent days cleaning up dump sites on the Buenos Aires National Wildlife Refuge just to the south and never seen one remotely of this scale. I'm sure U.S. intelligence satellites can watch Mexicans molt into Americans at this place.

Bob and I fall silent. The ground feels haunted. There are hundreds, thousands of daypacks. I pick up a dark blue brassiere with lace, the straps torn by wear. The woman must have been very small and very young. There are panties everywhere along with spent bottles of water, electrolyte mix, fruit juice, chilis, razors, toothbrushes, canned fish, all manner of soaps and foot powders, rolls of toilet paper, a canister of Three-Minute Quaker Oats, shoe polish, Brut underarm deodorant, a toenail clipper, a spool of thread, a bottle of Vick's Formula 44, hair gel, a thick Spanish-to-English dictionary. I pick up an eye shadow case, the cells of color barely touched. The woman had a choice of white, opalescent pearl, Prussian, taupe, Naples yellow, rose lavender, slate, raw sienna, viridian, rose lavender deep, broken viridian and chocolate taupe. And possibly work in America. Mexican airline and bus tickets are scattered about. Aurelio Pérez, a child, got aboard a bus at night, for example.

A deck of Tarot cards is scattered on the ground. Antonio Hernández Salinas has forgotten his high school records—he was studying math, English and ethics in the state of Hidalgo. Tucked in the pocket of one daypack is a letter in Spanish with the block printing of a seven-year-old, probably a girl. She wrote, "for my father, dad I love you too much for giving me so Much from Yourself and I wish you a Good trip in the Airplane When you Travel to the united states and god take Care of You in the airplane."

I sit on the ground for an hour or two. Ravens and hawks come by, the wind rustles the trees. Tied to one daypack is a small stuffed dinosaur named Sugarloaf and made in Indonesia. There's a dirt road a short way to the north. The pollos come here, and they've walked about two days to reach this spot, and they meet the next phase of their lives, smugglers who have brought American clothing so they will look normal. They rapidly strip naked, bras, panties, Levis, blouses, shirts, everything is cast aside. Hurry, hurry, they are told. And so a good father who lies to his little girl can sometimes forget that letter he has been carrying to help him find the will to cross the desert.

Then, decked in clean clothes, the pollos crowd into vans and are taken to stash houses in Tucson and Phoenix. I've stumbled on their Ellis Island where their past slips from their grasp and their new life is hastily pulled onto their naked bodies.

I compulsively ransack daypacks for forgotten mementos and I feel very unclean. It's Saturday of the Gloria for the pollos and tomorrow will be Easter and the resurrection. I can't quite explain my feelings to myself but I sit there on the dirt and think we are going to pay for putting people through this.

la gente

The weapons keep crossing from the U.S. to Mexico as if the border did not exist. Mexicans need modern rifles and wide belts filled with cartridges. An American happens to be in Douglas, Arizona, on the line and he asks some members of the Tenth Cavalry how this came to pass in the face of a strict U.S. embargo.

"Nothin' strange about that. If you was workin' for $20 a month and somebody come along and offered you $25 to turn your head and look the other way for fifteen minutes, would you do it?"

The American is intrigued so he asks the soldier how the man would feel if he was ordered to cross the line and invade Mexico.

"Hey, mister, we'd like nothing better—Mexico City, then on to Panama. Ten thousand men is all we need."

"Yes," the American replies, "then another half million to police the country."

The General crosses the border, raids Columbus, New Mexico, kills many North Americans and then rides south once again. Ten thousand American soldiers pursue him into the dust of Chihuahua and the stone of the sierra. We can never forgive the General for this moment. He spills our blood, he violates our fantasy of protection and isolation from the tumult of these other worlds. People still wonder why the General did this thing. In Mexico to this day they sell a poster of the General on his horse and the words say: General Pancho Villa, the Man Who Dared to Invade the U.S.A.

Pablo López rode with the General on that raid on March 8, 1916. By May of that year López is the prisoner of another revolutionary faction and about to be put up against a wall. He refuses to talk to North American reporters but then discovers one is Irish and concludes that the Irish are a revolutionary and anti-imperialist people. So he talks.

He lays out his thinking this way: "My master, Don Pancho Villa, was continually telling us that since the gringos had given him the double-cross he meant not only to get back at them, but to try and waken our country to the danger that was very close to it. Don Pancho was convinced that the gringos were too cowardly to fight us, or to try and win our country by force of arms. He said they would keep pitting one faction against another until we were all killed off, and our exhausted country would fall like a ripe pear into their eager hands. . . . Don Pancho also told us [our President] was selling our northern states to the gringos to get money to keep himself in power. He said he wanted to make some attempt to get intervention from the gringos before they were ready, and while we still had time to become a united nation. . . . So we marched on Columbus—we invaded American soil."

Then time is up for Pablo López. He makes one last gesture: he requests that no North Americans be allowed to witness his execution.

THE MOUNTAINS RISE TO THE WEST of Columbus with tongues of creosote licking up the slopes. A sister range frames the valley to the east and just in front of my gaze is Mt. Riley, a remnant volcano of almost 6000 feet. The only sound is wind and there is not a single footprint. Yucca stabs the horizon here and there, and clumps of cholla, yellow fruit glowing on the barbed arms, dot the landscape. Pink and yellow wildflowers beam from the black rock.

The rattlesnake slides in front of me across the sand in the Potrillos mountains along the New Mexican line near El Paso. More than two million people live within an hour of this spot but hardly anyone ever comes here, maybe a few thousand a year, if that. There is talk of making this empty ground a 155,000-acre wilderness. There is also talk of building a section of the proposed 700-mile wall on the border to slash through the flow of life here—think of severing one of your arteries.

Dennis Jennings, fifty-three, fit and decked out in camouflage pants and a fine black cap that says Minutemen Civil Defense Corps, thinks about big game. He's part of a group of twenty volunteers prowling the high desert around Columbus, New Mexico.

In the past eight days, he reports, "We got six."

He means Mexicans sneaking into the United States to work.

During the day, he and his friends kill time doing what he calls "recon."

They're not alone—the area is crawling with Border Patrol and National Guard units, the latter busily building car barriers (a low-slung line of iron rails on posts to stop hard-driving smugglers). On hills here and there are military trucks with racks of launchers for Patriot missiles—the tubes empty for now.

Desert willows grow near the pure-water tap in the patio of the mayor's office at Columbus, New Mexico. The faucet is the town's only safe drinking water. For almost a century the community of 2000 has clung to one moment in 1916 when Pancho Villa raided, the U.S. grew irate and sent General Pershing and an army into Mexico to show the flag and hunt down the bandit chief. George Patton, a young officer then, bagged two Mexicans and brought them to camp tied like deer to the fenders of his car. Villa was never even sighted.

Now news organizations come here to taste the problem called illegal immigration. The governor of New Mexico demanded the demolition of part of a Mexican village fifteen miles to the west that is used as a staging area by migrants. Some local ranchers pop up on television and Minutemen swing through to defend the nation.

Eddie Espinoza, forty-two, grumbles about it all. He's the mayor—Navy veteran, New Mexico park service veteran, and local boy. He says there is no problem here except for the posses of law enforcement. He says two of the ranchers who complain about Mexicans moving north, well, he thinks their father would be ashamed of them since the family money was made off the sweat of Mexican laborers. But mainly, he thinks everyone is talking nonsense.

"You want to shut down the border?" he rumbles. "You need to put a man every five yards for 1951 miles. You're not going to stop it."

He says all the barriers hardly matter since what is driving the migration is the economic failure of Mexico.

He says of the border, "There is nothing alarming. Everyone makes it alarming."

His wife is a Mexican national and his in-laws run businesses just across the line in neighboring Palomas. He raises his children to be proud of their roots. He is about paving streets and getting the town ball field built. He is determined to have a high school rise up out of the local ground.

"It's not a war zone," he snaps. "To bring the National Guard in, that's so farfetched it is unreal. I go to the state capital and tell them what it is like here and what it is like in Mexico and the officials look at you like you don't know what you are talking about."

As for the proposed big steel wall that is supposed to separate his town from neighboring Palomas, Chihuahua, he thinks, given the slope of the land, it will create a kind of lake when it rains and this could help raise wells in the Mexican town.

The Potrillos area is about thirty miles from both downtown El Paso and downtown Columbus and is the creation of volcanoes—forty-eight cones dot the landscape and a huge maar crater gapes just to the east of it. The ground is sand and lava flows, the black rock called *malpaís*, badland, in Spanish. When the rains are decent, some people run cattle in here. There are a few cinder mines also. But basically, this huge tract has been left to itself and now it is the finest surviving piece of Chihuahuan desert in New Mexico.

The Boeing Corporation just had a man visiting Columbus to see if it might be a nifty spot for the proposed multi-billion-dollar virtual wall—a high-tech array of ground sensors and cameras. All this is heady stuff for a small town where no one can drink the tap water and where houses can be had for fifty grand.

Hardly anyone in Columbus ever goes into the Potrillos mountains. It is that wonder that occurs here and there along the arid border, a *despoblado*, a place without people.

Just across the line sprawls Palomas, an isolated desert community of 10,000 people facing Columbus. The streets are dirt and full of deep potholes. The air is dust, businesses bleak and failing. In the plaza, pollos, Mexicans ready to go north in the night, are sprawled on the ground asleep. They all wear black and the nearby store sells pollo gear—black daypacks, black pants, black shirts, black caps. Going to El Norte is night work.

Fine new pickup trucks with dark tinted windows are parked here and there. Palomas is a branch campus of the Juárez drug cartel—in 1999 one of the outfit's private burying grounds was unearthed here. And then there are the people-smuggling entrepreneurs. Outside of that there is dust, poverty, and sullen dogs patrolling the calles.

The Minutemen I talk to in Columbus never come here. But then, I can't recall ever meeting a Minuteman who visits Mexico.

Manuel and Marta Acosta run a kind of shelter for migrants in Palomas. They've gone north themselves for work—Marta once was unknowingly bought by some guy in Grants, New Mexico as a sex slave. Now they are devout evangelicals and they hand out food, clothes and a piece of their concrete floor for wayfarers. The house is cold, the kitchen a pile of dirty dishes waiting for the water to finally come on again. She and her husband try to rescue migrants in the desert, but right now they can't afford the gas.

She says people are afraid of the Minutemen (they have guns) and the National Guard (in Mexico the army is an outlaw organization—the Juárez cartel, for example, often contracts with the army to disappear people). For a spell, her husband put out water barrels on the line for migrants. But then he caught hell from locals who sell water to migrants. And he also caught hell from local drug guys because the big

flagged barrels drew attention and, like all drug smugglers, they don't like attention out in the desert. So the barrels had to go.

Marta whispers about the mafia and how no one can do anything about them. She means the drug industry, the big silent hole in any discussion of Mexico or the border.

The Potrillos mountains, she says, "are dangerous, there is no shelter there, just empty desert." And so the human traffic goes to the west of Columbus where there are farms and water. Traffic is now down, way down, because of all the U.S. law enforcement. A year ago, it was 1000 people a day, now it is maybe thirty she thinks.

As for the proposed wall, Marta sees it as "just one more obstacle."

Marta's voice asks softly, "There's so many jobs in the United States, why do Americans do this to people?"

Mount Riley scrapes the sky just to the south, and off a way to the north is Aden crater and its lush black lava flow. Hawks hunt around me, harriers flying low and dodging mesquites, red tails circling high above with death in their talons. Clouds of yellow butterflies descend on damp patches of earth.

I've just run into the Minutemen again this morning and they've now bagged another fourteen just west of Columbus—twelve men and two women. Dennis asked me if I thought there was a conspiracy afoot to keep the truth of illegal immigration from Americans. I said no. At a neighboring table in the café, nine National Guardsmen ate breakfast and talked about how much car barrier they would weld today.

For the moment, I revel in looking for melanistic lizards, reptiles so adapted to the black lavas they have also become black. Marta is off in her cold house waiting to help someone. She's sitting in a freezing room with cracked walls, one saggy couch, two old stuffed chairs, six blue plastic chairs and a big hole in the wall where the stove pipe once went for the wood stove that no longer exists, while outside the two vans she and her husband use for rescuing migrants are broken and slumber in the dirt yard.

I think of Alima McMillan. She works as an EMT with the Columbus fire department, and in her spare time rescues Mexicans battered by the hard trek through the desert. She is indifferent to all the fences because she says, "if people are willing to cross sixty miles of desert on foot, a fence is not going to stop them." Of course, given a choice she'll take the electronic virtual fence because it won't fuss with wildlife and will be just as useless against Mexicans as a solid metal fence.

She tells of a recent rescue. A truck crashed in neighboring Palomas and spilled eighteen people out on the road from the deep south in Mexico. They'd been hauled north to work in the local onion fields—the Columbus area is noted for sweet onions. She and her EMT colleague went over because Palomas was overwhelmed by the mayhem. And she'd never seen people like the migrants. Their hair was falling out, their guts were swollen from malnutrition. And the skin, she can hardly wrap words around that skin except to say it looked dead and as she treated the wounded their skin felt like something she could pull off at will with her fingers.

She has seen photographs of people like that in magazines from famine hellholes in Africa. But she'd never faced an entire truckload of starving human beings heading north to work. She could hardly imagine them standing, much less doing labor.

Her voice grew soft as she told her tale and then it simply trailed off.

I CAN'T TELL YOU MUCH of anything but this. He came up in the gangs of his American barrio and then at nineteen, he caught a break and became a drug dealer. His operation is smooth, reaching down to his suppliers in northern Mexico and far into the interior of the United States where people need his product to calm their minds. But now he's shifting into people smuggling like so many with his background. The networks he knows are now full of violence as narcos kill small coyotes and swallow their routes and pollos.

For the moment, he helps out at stash houses. His connections in the drug business also move people and so he does odd jobs for them as a favor. He'll go to Costco and buy cases of Campbell's Soup, and say, a half dozen can openers. Then he'll go to the stash house. A pistolero will be there to guard the pollos so they cannot be stolen. This man will have a chair and sit with his gun. He is generally ignorant and cheap and a throwaway human being.

The man with cases of soup will carry them in and hand out the can openers. The house will be rented and in a nice neighborhood. There will be no furniture and such houses are changed often. What he remembers of his work is two things: how bad the houses smell with twenty, thirty people crowded in them. And how nice some of the young pollo girls look.

But he insists he resists all temptation. He sticks to *doscientas*, maquiladora girls brought up from the Mexican factories just across the line to decorate parties. They are each given 200 dollars and for that, he tells me, the girls will "give you that massage that sends you to heaven."

He is a very intelligent man. His favorite magazine is *GQ*. He dreams of owning a Cadillac Escalade.

But that smell in those houses, he repeats, it is terrible.

He is in a hard business. Recently, a man sat in a local café and offered $50,000 for anyone who would murder the man's boss, who happened to be his uncle. His uncle heard of this offer and came down to the café and pistol-whipped his nephew half to death, all the while shouting, "How could you insult me so? I am worth more than $50,000 on a contract."

I ask him how many guys he came up with in these businesses are still operating or even alive. He falls silent for a minute or two. He cannot think of many, he replies.

We talk for hours. He laughs easily but not for a single second does he ever express sympathy for the pollos. After they get off that bus, and

start north into the United States, they cease to have full human rights and fall between two worlds.

And people such as him wait in this space between the pollos' past and the pollos' possible future.

He is not a bad man. The Border Patrol agents are not bad people. Homeland Security people are not bad people. The Minutemen, the *polleros*, the human rights folks putting water bottles out in the desert, well, I've met them all and they are not bad people.

As for you and me sitting in our homes and reading about it and thinking and watching that television, the jury is still out.

THERE IS A PLAN NO ONE TALKS ABOUT very much, one that floats over the horizon like an approaching storm at sea. In this business dream, the Pacific ports of the United States will be shifted south to new massive anchorages in Mexico even though this increases the shipping distance by 30 percent for all the Asian tonnage. These new ports will be linked by major train and truck arteries, NAFTA Corridors, to the cities of the United States and Canada. Mexican trucking companies will be bought (and are being bought up now) by American firms and then Mexican truckers will deliver the freight and freely drive all U.S. highways. In this plan the shipping of the United States leaves union ports and the long-haul trucking leaves union drivers.

An enlarged I-35 will reach north from the sister cities of Laredo/Nuevo Laredo 1600 miles to Canada via San Antonio, Austin, Dallas/Ft. Worth, Kansas City, the Twin Cities and Duluth, and I-69 will originate at the same crossing and streak north to Michigan. Each corridor will be about 1200 feet wide. Six lanes will be dedicated to cars, four to trucks, and in the middle will be rail and utilities. The goods will come from new Mexican ports on the Pacific coast. At the moment, at least five such corridors are on the drawing boards.

Five men sit at the truck stop about twenty kilometers below the Rio Grande at Laredo/Nuevo Laredo on the Texas border. They, or their sons or grandsons, will someday be shock troops in the NAFTA Corridors. Just a few hundred yards from where the men eat and smoke, the major highway coming from the Mexican south forks. One road leads into Nuevo Laredo, the other arcs west and connects with a trucking center on the U.S. side by means of the World Trade Bridge. This new bridge and dedicated truck highway are an early link in this NAFTA Corridor. At the moment, 5800 trucks enter and leave this border crossing a day, a trickle compared to the traffic that will pour north once the new ports, rails and roads come on-line by 2025.

Their small lunch is finished, an empty liter of beer stands before one driver, and at the moment, they smoke and laugh and talk.

"The longest distance I drive," says a guy about thirty in a black T-shirt, "is from Ensenada to Cancún, 4500 kilometers. Five days and six nights alone. Tomatoes. The company won't pay for a second driver."

Ah, but how can a man stay awake and drive for five straight days?

The table erupts in laughter. The man facing the empty liter of beer smiles and says, "Professional secret."

The younger man in the black T-shirt offers one phrase, "Magic dust."

There are more smiles and mention of "special chemicals."

And then they are off, a torrent of words and quips and smiles, and a knowing discussion of that jolt when a line of cocaine locks in. They are all family men who run the highways at least twenty-five days a month and they are adamant about two things—that no one can run these long hauls without cocaine and meth and now and then some marijuana to level out the rush. And that the biggest danger on their endless runs comes from addicted Mexican truck drivers, which means all truck drivers.

The men earn about $1100 a month. In Mexico, the cost of living is roughly 80 or 90 percent that of the U.S. The only real bargain in

Mexico is labor. Many other items cost more than in the U.S. Mexican telephone rates are among the highest in the world, and a sack of cement or a board foot of lumber costs more than in any American town.

None of the drivers at the table has driven in the U.S. save for short crossings where they dump the load and instantly return on special routes like the World Trade Bridge.

But they think about those U.S. highways. One man says, "If you let us in, we will kick their asses and they will lose their jobs."

The man with the empty beer explains, "We make almost nothing—less than 300 dollars a week. I work forty-eight hours nonstop. I drive 2400 kilometers per trip and get no time for turnarounds."

"If you drive to Mexico City," another driver adds, "you are robbed, for sure. Police are the first to rob you. If you report a robbery, the police try to make you the guilty person."

And now the table is rolling, about the bad equipment they are given, about the fact that the owners often stall them on payment, about how there is no escape from the job, that they all know drivers who are still out there on long hauls at seventy, how they have all been robbed and hijacked, have all killed people with their trucks and, given the nature of Mexican police, have all fled such accident sites, that they are all doomed to spend their lives on an asphalt treadmill.

The men talk with smiles of the *cachimbas*, which means fireplaces. In earlier days on the road, there would be wooden shacks with fires going, roadside brothels. Mexico now has four-lane roads for many truck routes and stouter buildings but the term cachimba has stuck for truck stops where women and drugs are freely available.

One man says, "Don't print that, if you do, all those American truckers will want to drive down here."

A woman costs about $20 and drugs are like dust in the air. A Mexican trucker can get anything at a cachimba but decent food. They all agree that the most beautiful women are on the west coast route that snakes through the narco state of Sinaloa.

"The worst thing," one says with some bitterness, "is not being home. We all have two or three Sanchos," meaning strangers who sleep with their wives when they are gone.

FRANCISCO SAMUEL ANGUIANO is around forty years old and he is out of sorts as he lingers at a truck stop in Santa Ana, Sonora, about sixty miles south of the Nogales, Arizona, crossing.

He was robbed the night before at a truck stop in Caborca, a narco town on the Mexican federal highway that links Baja California with the Mexican mainland. He points to the hole in his dashboard where his CB radio and regular radio once rested. He is on his basic run from Tijuana to Mexico City. Normally, he is allowed seventy-two hours for this route, but sometimes he does the express run of forty-eight hours and then he gets no sleep at all.

"I have twenty years' experience," he adds. "Here you make the rules and take a lot of amphetamines."

But he tries to live cleanly and so he personally uses massive vitamin doses and various power drinks of caffeine and herbs to keep him rolling. A crucified Christ hangs in one corner of his cab and when he drives he stares at portraits of his wife and three children to keep him moving. On the seat beside him is a laptop computer—he is constantly monitored, and for security reasons, he is never told what his cargo is. He drives at least 130,000 miles a year, is almost never home, and earns maybe $1100 a month. And he is very intelligent and once planned to be a lawyer before the reality of the Mexican economy put him behind the wheel of a semi.

He has been robbed before and tries to be ready for such moments. He hauls out a small baseball bat and his knife. He demonstrates how he can do a karate kick to the head while seated behind his steering

wheel. He is a small man in jeans, blue shirt, and cowboy boots and he repeatedly shows me this practiced kick to within an inch of my head.

Then he brings out his infrared binoculars. At night they prove useful, he explains. He stares out through them, and if he sees a federal police roadblock, well, then he pulls over and tries to find a way around the cops lest they also rob him. He also carries two sets of identification because you never really know whom you are dealing with out there on the road. He's been hijacked twice. He points to the photographs of his family and says, "They give me the energy to keep going. If you are alone, no one helps you. It is you and your truck."

"I have never driven in the U.S.," he says, "but I want to because of the economy that exists there. I look at my family, I keep working, but driving in the U.S. would be better."

He adds softly, "The hardest part of my job is staying alive."

But he stays in Mexico.

"There are many reasons," he explains, "mainly life itself. It is good to go to the U.S. but I think we Mexicans are better than the American truckers because we can drive any terrain and Americans drive easy highways on flat land. American truck drivers cannot make a truck speak. I can. I take care of my truck, always clean it. In Rambo, Sylvester Stallone had a headband. We don't wear those but we are more dangerous than Rambo because we are Indians. We can sense things.

"My theory is . . . start talking. I'm here, listening, looking. We are Indians. The U.S. has always disqualified us. Why? We are more professional than them. A fat driver is not good. But here in Mexico, we could fuck them. Let an American driver try these highways and he will kill himself.

"The American drivers discriminate against us and they don't know we are better drivers than they are. They will never let us in the U.S. because we are the best."

He keeps a gallon of water and a liter of apple juice on the floor where he can reach them.

IN NUEVO LAREDO, I stand in front of the yard of Trans Mex Swift, an American-owned Mexican trucking company. The traffic of the World Trade Bridge roars past. In less than an hour, four truck tires explode. Mexican truckers are not coddled with good rigs or good tires. One semi pulls over. Both tires on the left rear back axle are gone and the trucker stares at rims resting on the pavement. One tire, he explains, went about 150 miles ago, but he had no money with which to buy another one. Now both are gone.

But she waits by the fork in the road where the lanes spin off to the World Trade Bridge.[29] The first little capilla appeared five years ago at the interchange. Now there are three more chapels, each large enough for a man to enter. Trucks idle on the shoulder of the highway as men approach La Santísima Muerte, Most Holy Death. She stands in front, about seven feet high, and wears a cloak of black. Or of white. One means death, the other hope. She is the saint for drug dealers and for truckers and for anyone else who understands that the game is not on the level and help is necessary for survival.

La Santísima has no flesh and the skull and bony feet and hands reach out from her cloak. One hand holds a huge scythe, the other the world. She looks like death but promises a chance at life to those whirling in a world of death.

In Nuevo Laredo, 260 people have been slaughtered in the last sixteen months as a byproduct of the drug industry. In February 2006, two men entered the daily newspaper, sprayed the office with machine pistols (the lobby still has over twenty bullet holes), cut down a staff member, threw a grenade in the editor's office and then left after 180 seconds of commentary.[30] The paper decided to cease publishing stories on the drug industry. When four cops were executed on a downtown

street that spring, the news was broken by Mexico City papers, 700 miles to the south. Yesterday, a cop guarding the comandante's house was mowed down.[31] The paper buries this story in the back facing a feature on a honey cooperative created by local women. Like every place on the border, the pathway of drugs also has space for the pathway of migrants.[32]

A trucker about thirty stands before La Santísima, his lips moving and his voice very soft as he speaks to her.

He says, "She is just like us, except she has no flesh. She can speak to God. She has helped me many times."

Once he saw her standing by the road. She saves him when the highways are wet and saves him from wrecks and saves him from police and saves him from the many faces of death.

He enters the main *capilla* where more images of La Santísima wait. He lights a cigarette and leaves it burning for her. The altar is rich with candy bars and fruits and money.

He explains, "I have believed in Santa Muerte since I was thirteen years old. If I tell you of her favors to me, I will never cease talking. I have a shrine to her in my house and offerings of rice, tomatoes, wine, apples, corn and bullets."

A man about forty climbs down from his truck. He wears black dark sunglasses and a gold chain. He stands before La Santísima and softly speaks to her as he sprays her body with perfume. An expensive two-seater sports car rolls up. The two occupants do not get out but sit in their machine a few feet from La Santísima praying as the air conditioner roars. No one looks at them because everyone knows how expensive sports cars are earned here.

She first came to public notice during the late 1990s in Tepito, the thieves' market of Mexico City, a zone of thirty-seven blocks festooned with contraband, whores, addicts, live sex shows in the evening and violence. The priests were alarmed but could do nothing about La Santísima because she exuded tolerance. Women went to her to be safe from AIDS and to ensure their clients remained docile. Men sought protection from bullets. She spread north to the line and then spilled over into the ragged neighborhoods where migrants hide from view in the cities of America. The anthropologists pounced and concluded she had erupted from the long dormant virus of Aztec death worship.

I think she is the saint of NAFTA. The trade agreement first kicked in in 1994 and within a year the numbers crawling through the wire began to spike. Within three years, La Santísima entered the minds and hearts of those broken on the wheel of life and of this new notion called free trade. NAFTA crushed peasant farmers who could not compete with the torrent of cheap agricultural products flowing from American agribusinesses.[33] Trade with China, Mexico's introduction to the global economy, swiftly wiped out traditional industries—toys, serapes, shoes and so forth. Then the border plants, the maquiladoras where Mexicans assembled goods for American corporations, closed up shop and hightailed it to China where men and women work for one fourth the wages of Mexicans. Juárez, almost the poster child of free trade, lost 100,000 jobs to China in two years, for example.

In Nuevo Laredo near the Rio Grande and the fence, a market stall sells statues of Christ, the Virgin of Guadalupe, Emiliano Zapata and La Santísima. Santa Muerte outsells all the others combined and the black La Santísima, the one symbolizing death, is the best seller. Governments, trade agreements, policy statements seldom reach this place. But La Santísima does. The woman running the stall says La Santísima arrived in her life three years ago.

She holds the whole world in her bony hand. She listens. She knows. She touches more human behavior than the Border Patrol or Homeland Security or DEA. For years, she succored the souls being displaced and then hurled north, listened to their fears and hungers while politicians talked about slight adjustments in the global economy, while oth-

ers spoke of guest worker programs, as some babbled about pathways to citizenship, as growing numbers rumbled about building big walls on the line, and still others explained the need for workers to perform tasks beneath the notice of native-born Americans. All this while, like the illegals themselves, she remained largely invisible to those who believed themselves to be in control. Most Holy Death is the face of the migration, one kept safely off camera, one never invited to be on the cable talk shows, one worshiped by men and women who scorn presidents.

Across the river in Laredo, Texas, a 2800-bed, $100 million super-jail will soon be built for illegal immigrants. It is part of a jail boom. A little over twenty years ago, Immigration and Customs Enforcement (formerly INS and now ICE) did not have a single cell in Texas. Now 7000 new bunks are in the works, part of 40,000 new cells nationally for ICE.[34] The more Border Patrol agents, the more apprehensions and the more detentions and the more cells.

Most Holy Death and ICE now face off down by the river.

la gente

In this land of machismo, a warrior woman keeps visiting to give the men the courage for the necessary gore. Sometimes she is Toci and sometimes she is Tonantzin and then in 1531, on the former temple site of these two goddesses, she comes again and says she is the Virgin of Guadalupe. Juan Diego, an Indian, sees her and she gives him roses and her skin is as brown as his. By 1571, she is at Lepanto where the Spaniards defeat the Turks. By 1810, she is revolution itself when a follower of Father Miguel Hidalgo defends the first Mexican revolution as merely a defense of Our Lady of Guadalupe. Other rebels declare she has become their plan, their banner, their laws and their institutions. When the Yaqui Indians rise up in the 1830s, her banner leads their troops. She becomes María Insurgente and the women of Mexico see her as their bridge to war. It is a bridge that they have long crossed and will cross again.

In the carnage of the various tribal groups that occupied time in that age before Cortés and the conquest, women fought at times in the ranks. During the time of King Moquihuix of Tlatelolco (1469–1481), the men in combat were temporarily pushed back and so the king ordered a group of women to strip and form a squadron. The record reports, "They were made to attack the Mexica, who were fighting furiously. The women, naked with their private parts revealed and their breasts uncovered, came upon them slapping their bellies, showing their breasts and squirting milk at the Mexicas."

In 1914, a federal army flees Pancho Villa at Ojinaga. When it crosses the Río Bravo it contains 3557 men, 1256 women, and 554 children. The Americans are baffled by this arrangement.

Each year the fiesta of the Virgin of Guadalupe, María Insurgente, comes round, the processions march through the cities, towns, and villages and very old drums seem to beat.

THE CATHOLIC CASA DEL MIGRANTE sits on the bank of the Rio Grande. Men can stay here for three days, women sometimes for six days. Then they are expelled into the furnace breath of Nuevo Laredo. The Casa is seldom open for use by migrants. The woman who answers the door says come back in five or six hours when a priest will stop by. For blocks near the Casa, men are sprawled on the sidewalk. She looks out at them and explains they are not migrants and so not her concern. She is lying. The men are short and dark and have streamed here from Central America. The minute they step into Mexico they become illegal and so they have been hunted for days and weeks as they have moved toward the line at Laredo, Texas.[35]

The migrants speak softly and slowly come out of the shadows of the street like ghosts. They are from Honduras, Guatemala, El Salvador. They refuse to give their names and insist on giving their stories. A bunch of migrants sit on a pile of old lumber. One man from Honduras wears a T-shirt that says Tommy Boy. He's never been to the U.S. but

he says he has some friends in Houston. He thinks half the population of Honduras has already left. He finds Nuevo Laredo very hard because he can find no work.

He is New York bound. He believes the U.S. is the land of opportunity. "But," he continues, "it is very hard to reach. I work hard in Honduras but it is difficult to earn anything. If I go to the U.S., then I can build a home in Honduras. I have spent thirty days getting this far, and this cost me $1500. I have seen others robbed. I have no money left for a coyote. I will try to cross by myself but it will not be easy because of *la migra*. I will do anything. But I know nothing but the fields."

As the men speak, more and more gather. They beg for money for food and I fork over $25. A boy in a New York Yankees cap says, "I usually work construction. I left home a month ago. I am heading for Los Angeles."

First, he illegally entered Guatemala from Honduras. Then he entered Mexico illegally and boarded the fabled train of death where migrants hop freight cars. This part of the trip is very cold and many cannot hold on to the cars. The boy saw six dead bodies by the tracks. In Empalme Escobedo, Guanajuato, the police appeared on horseback with lariats and roped men around their necks. Some die from this experience. Also, he continues in his soft voice, the taxi drivers are treacherous. They take your money and then dump you by the road in the countryside.

"The U.S.," he believes, "must be better. I'll make enough money to build a little house back home. We are all single here. There is no money for marriage.

"I fear la migra, fear being caught and deported. We have already suffered. If we are sent back to Honduras—no jobs, no money—how can we survive? When I find enough money for water and food, I'll cross."

Someone has spray-painted on the wall behind the men, BAR HONDURAS.

The Rio Grande is maybe half a block away and lush with trees. On the opposite bank are homes in Laredo, Texas. From the Bar Honduras, they look like mansions. The men sit and stare out. They wear the refuse of the United States—a Salvation Army sweatshirt, a jersey from a U.S. pro football team. They all agree that about fifty to 100 Central Americans wade the river here each day, 100 to 200 on Saturday and Sunday. They first started appearing here about three years ago and now they are a thread in the tapestry called illegal immigration.

They face a few problems. There is no work in Nuevo Laredo and so their chances of earning money are close to zero. A coyote charges about $1600 to $2000 for passage to San Antonio, 150 miles to the north. Houston costs $200 or $300 more. The walk to San Antonio is five to six days. This information comes from Antonio Canales, a man in his late thirties from Juárez, Mexico. And he speaks with some authority since he is employed by a people-smuggling organization. He is one of two Mexicans hanging around and watching the Central Americans. He says the local police control all the routes down to the river and if you do not pay them, they beat you or kill you.

He himself guides groups across, up to fifteen people at a time. Thousands cross each day, he says, and there are moments when he sees 200 people in the river. More cross at night. Of course, there is a charge for real service. A Mexican who pays $2500 to $3000 will be put up in a cheap hotel and led across the Rio Grande to the United States. A Central American must pay $4000 to $5000 for the same service. Those from South America (mainly, Peruvians, Bolivians, and Brazilians) must fork over $10,000 to the organization. The business, he rolls on, is controlled by Mexican Americans and they seem never to be arrested.

As Canales speaks, the Central Americans sit in silence. Some braid cords so that they can secure one-liter water bottles to their wrists. One fishes out a photograph of himself and says, "I am a tailor." He

has an address in Houston and wonders if he can find work there. The air hangs with humidity, the heat is rising and at times the only sound comes from the buzzing of flies.

This is not the problem, this is the solution. Economies collapse in South America or Central America, and well, they come to Nuevo Laredo. NAFTA crushes Mexican agriculture, the river awaits. Americans feel the blues, and well, the kilos are coming north. In the U.S. Congress, they have time and so they can talk of the problem. Here, as elsewhere on the border, hundreds of thousands of people have fashioned answers out of things as simple as braided cord to tie an empty pop bottle to the wrist. The three major Mexican border towns on this stretch of the river, Nuevo Laredo, Reynosa and Matamoros, are each pumping at least 100,000 people a year north. And these people ask for essentially nothing. They'll walk five or six days to the work. They'll find work on their own. They'll locate housing. They need no job training. And they don't complain much.

Luis Ángel Ramírez Nevárez, twenty-four, could be a poster child for this can-do attitude. Last year, he left El Salvador and headed north. Somewhere in the Mexican state of Veracruz, he fell off the freight he had hopped, shattered a leg and mangled one arm. His one forearm now looks strange—as if the bone had decided to make a sharp turn, reconsidered, and finished up with a U-turn. His fingers seem pretty useless on that hand but the arm functions. In January, he arrived in New Orleans because he had heard they needed workers.[36] He did painting and stucco, ten hours a day, five or six days a week, for ten bucks an hour. Things were looking up for him even with his mangled limb.

Then, as he walked to his job, he was scooped up by the Border Patrol and pitched into Mexico. Now he waits for dark. He's heading back to New Orleans. He's with another guy who also worked there. His case is a little different. He has temporarily left his job as a roofer in New Orleans to help his brother cross and join him in the work. But now his brother has found a job in Mexico and prefers to remain there. So Luis and his new friend will go north again and return to New Orleans. Both are refugees from the cratered economies of Central America. And both now occupy the space left by the evacuees of New Orleans.

Everything else is details. The cops that may kill you when you cross, the Border Patrol that will hunt you when you climb out of the river, the five or six days of walking through scrub forest to San Antonio, the passage to New Orleans in a nation where you have no legal standing, all this seems like the flies swirling around the men. Irritants but not real obstacles. In New Orleans they will earn at least $500 a week. They can be stopped. But not by much shy of death itself.

The street is still, blocks of men sprawled and leaning against walls. Here and there Mexicans watch them, various predators that idle into a group and then seem to vanish. A snow-cone man peddling a bicycle cart comes by. He says he normally plies the area of downtown, about twenty blocks away. I ask him why he is here, since the Central Americans have no money. He says with a smile, ah, I have three or four special customers in this area and so drop by. And I think drugs, since domestic consumption of items like cocaine has exploded in Mexico as the price has fallen. Another guy with fair skin, nice clean slacks, good shoes and a clean, pressed shirt listens in on the migrants. He contends he is also a migrant but this is hard to believe. Just as Canales, the people smuggler, keeps hanging around to keep an eye on things.

The feel of the migrants' world is in the area. The brutal border crossing from Guatemala where Mexican gangs and Mexican cops operate like wolves, the ride on the train of death, the cops in that town in Guanajuato with lariats, the long haul to Nuevo Laredo without papers through siege lines of avaricious federal, state and local police. And now this street and the river. You cross without paying and you can get

killed. You stay here, you are doomed. But over there, in some city you have never visited, you are told you are worth $500 a week. If you can take that one-liter water bottle, plunge into the trees by the Rio Grande, make it to the other side, and walk five or six days while hunted by la migra, you will be in another world where a house and a woman can become part of your life.

So everyone here speaks softly, leans against walls, and waits for dark.

I climb into my pickup and suddenly the men come to life. They flock around the truck, press against the windows, ask for money, ask for talk, ask in a sense to exist. They have found their guest worker permits. They are on the path to citizenship. It is all down by the river. They only have to clamber down the bank here, wade in and take it.

I WILL NEVER KNOW HOW IT FEELS. There is that time in Asia, on the island with beautiful beaches and fine resorts, a Muslim island where Osama bin Laden is seen as a great man, and when I get off the small plane at the airport, I am the only Anglo in a crowd of brown people reaching out for my bag and my money. I hire a man who speaks English and tell him my errand. He is disturbed by my desire, but he lives in one room with his woman and child and a single burner for cooking and there is no money, none at all, and so he says yes. It takes a few hours. No one will help but then we find them, hiding on the grounds of an international organization, living out under the trees like our ancestors in Eden, men, women and so many children, all huddled and reeking of fear.

They tell me the islanders try to kill them.

They tell me they have no money.

They tell me their women are not safe.

They tell me they cannot go back because there is no place to go back to.

They tell me they cannot go forward because they lack the money for guides and bribes.

They tell me to help them.

Women tug at my sleeves, children grab at my pant legs, I am in a sea of people, hundreds it seems, all doomed on an island where they are hated because they are Muslims of an unacceptable style, Shia in a Sunni world, Iraqis in Indonesia.

I have to tear myself away when I leave, I can still feel them clawing at me.

When I get in the car with my guide, he tells me they are lying, that no one harms them, that it is all false, an effort to libel Muslims such as himself.

I will never know how it feels.

I see them vanish into nothing as the car speeds away from the men pursuing us in the street.

THE OLD WEST IS NOW A NEW WEST. Dodge City was once a trail head full of wild Texas cowboys, and lawmen like Bat Masterson and Wyatt Earp. The men of the new west work in slaughterhouses. They lose fingers and hands, slowly learn English and buy pickup trucks and then have scenes from their villages in Mexico painted on the tailgates. Dodge City is now tacos and mercados and brown people celebrating September 16, Mexican independence day. At least half the population is now Latin and men line up and drink beer and watch match races between horses. Norteño music roars at fiestas, women wear traditional dresses to keep some feel for their past, and a young guy leans against his truck, beer in hand, with a Mexican eagle screaming from his big belt buckle.

THE IMMIGRANTS ARE ILLEGAL because there is functionally no way for them to be legal. To tell them to go to the back of the line is to tell them to go off and die. The immigrants are part of the global

economy—their very flight has in part been created by the movements of capital and trade that have surged through their obscure worlds like fire. They are the unforeseen product of this economy and because their existence was unforeseen, they are invisible to the proponents of this economy. No one invites them to Davos and to the World Trade Organization meetings.

And if the arrival of poor people in the United States does not drive down wages, then surely there is a Nobel Prize to be earned in studying this remarkable exception to the law of supply and demand.

ESPERANZA WAITS TABLES IN LOS ANGELES. At night she sits and watches a video of her new house in her pueblo in Oaxaca. The home has a tile floor, a huge sala. It is the result of a dream of prosperity. She has never visited this fine residence. Through family, she arranged for the design and construction and then her mother sent her videos for her pleasure. The building is three years old. No one lives in it, and no one may ever live in it. There are similar fine homes popping up in obscure Indian villages across the Mexican south. The owners cannot afford to visit these homes because the border crossing has become more difficult and more expensive. But still they pump money into their dreams and sit in various American cities staring at screens displaying their distant shelters.

The case can be made that it is absurd to build a dream house you cannot even visit, much less live in. But that is the nature of dreams—there is always a case to be made against them.

In August 2003, José Manuel Hernández picked up a brush in Seguin, Texas, about forty miles east of San Antonio. He went to the east wall of his brother's tire store and began to paint a huge mural of the Virgin of Guadalupe. He had a wife and one-year-old son. The Virgin had deep meaning for him. A few weeks later, he was picked up by the Border Patrol and deported. Now he lives in Durango, Mexico.

The painting still shouts brilliant colors on the wall of his brother's store. Out front are racks of tires and an American flag—José Manuel's brother became a legal resident in 1995. José Manuel's boy is now four and of course, he is an American citizen.

On May 1, the brother, José Antonio, shut his tire store for the national day without a Mexican and went into San Antonio to march.

la gente

Of course, the General knows that war is hard. He is one of the men who have made it harder than ever. At Torreón, he addresses his beloved troops before the battle: "Muchachos, we are here to take Torreón. Did you come here under my command to waste my arms or to use them against the enemy? I drag nobody into battle, even in defense of the people's cause. But neither do I let anyone desert in the face of the enemy. You who are ready to fight will step forward. The rest of you will stay where you are. I promise you won't have to face the enemy because you will be shot on the spot."

Everyone steps forward.

He has a history of loving discipline and being a fanatic on efficiency. Early in the campaign, they capture some federal prisoners. "I formed the sixty prisoners in files three deep," the General notes, "and had them shot in that formation, to save ammunition by killing three with one shot. We threw the hundred-odd bodies into a well at the edge of town."

The General sees the girl in Jiménez and he wants her, all of her. He says, "Conchita was beautiful of body and eyes and coloring. I was attracted and soon fell in love with her. It happens Conchita's aunt was always coming to talk with me about the vicissitudes of life and the great need in which they found themselves. And one time, the aunt said she knew of my love for Conchita and added, 'It is a pity that you are married, Señor General!'"

But the General leaps into this matter and he says, "It happens, Señora, that marriage is one thing, and love is another."

The aunt is determined to close the deal and she comes again to the General and she asks, "Very well, Señor General Villa, Conchita loves you but she is ashamed thinking that if you are married you cannot honorably take another woman. But I want her to be happy, and I shall try to convince her that her affection is pure because God wills it."

And the General listens and promises to provide for Conchita and honor her, because as he admits, "I was longing for that Conchita."

He beckons her to his next battle station, Guadalupe, Zacatecas, and the General dispatches a special train to bring her and her friends. He meets her at the station and he feels she is warm to him—"I felt that she belonged to me, and put my arm around her in a protective manner."

But after a few days her emotions shift and she hides in her room and weeps constantly. The General is distraught and confides in his secretary, Luisito.

His confidant says, "I do not think this woman loves you, my General."

"Very well," the General replies. "There may be women who do not love me. But if this one came to me, and I accepted her, why does she regret her acts and look on me as the cause of her unhappiness? I love her, Luisito, I really love her."

"You are a married man, my General."

"Yes, Luisito, but marriage is one thing and love is another."

"For some women there is no love without honor, my General."

"Isn't it honor enough that Pancho Villa, being married already, chooses a woman and loves her and wins her and cherishes her? Marriage, Luisito, is contracted only for fear that love will end, and you can be sure that it is no honor to a woman for a man to be true to her only because religious and civil laws compel him. A man honors every woman he loves and protects with his affection."

"Your wife is in Chihuahua, my General."

"Good, Luisito, the honor of my marriage is there and the honor of my love is here."

The General and Luisito talk for a very long time and go round and round. Finally, the General blurts out, "I wanted to be certain I was not to blame and I wanted Conchita to stop looking at me in horror."

THIS IS AN EXODUS, *éxodo* in Spanish. That means the people coming north are leaving their villages forever, whether they can admit this fact to themselves or not. This is not migratory labor. Hardened borders simply deepen this fact until you wind up with a waitress in Los Angeles looking at her dream home in Oaxaca that she cannot afford to visit. Coyotes in Mexico now earn at least $10 billion a year.[37] Expect this to increase as Congress passes new legislation to add yet more teeth to the jaws of the border.

The tired and frightened men and women crawling through the wire soon become founts of money sent back home and commonly wire transfer $50 to $300 a month. This is the largest transfer of wealth to the poor in the history of the Western Hemisphere, and it dwarfs all the American gestures of aid and all of the revolutions that have filled the plazas of Latin America with tired statues. Remittances to Mexico now are estimated to be over $20 billion a year, a figure as great as or greater than that earned by Mexican oil or tourism and rivaled only by the drug trade.[38]

Such money props up a corrupt and declining regime and at the same time is a dagger aimed at the heart of the status quo. Here is the size of the dagger: the money shipped home by Mexicans working in the U.S. is at least the cash equivalent of peddling a half million barrels of oil a day at $70 a barrel.[39] This could vanish almost overnight if some fabled pathway to citizenship occurred. When Germany enacted a legalization bill for Turkish immigrants in 2000, about half the remittances they sent home vanished by 2001. A similar pattern happened in the late 1980s after the U.S. offered amnesty to illegal Mexicans in 1986.[40] In both instances, families reunited and the motive for remittances ended.

Presidents come and go in Mexico and nothing changes. But any gesture by the U.S. toward either exclusion of illegal migrants or acceptance could be catastrophic for Mexico.

This is the largest teach-in of American values in history. Somewhere between ten and twenty million illegals are experiencing law enforcement without massive corruption,[41] contract law, the joys of homeownership, the existence of real public schools with real textbooks, the pleasures of freedom of speech and freedom of the press and recently, in the marches and demonstrations, the strong drug of dissent. Beneath the Mexican and other flags in the demonstrations, beneath the Spanish language signs, a deep shift is taking place as strangers in a new land become part of that new land. Hurling these people back into the nations they have fled would be like the Germans sending Lenin into Russia during World War I to see what mischief he could conjure up. American employers have inadvertently created the most affluent and politically active generation of poor people in the history of Latin America. Sending them home would detonate the nations they have come from.

This migration is not a byproduct of the global economy, it is as structural as children sewing clothing in Bangladesh. As long as resources decline and capital flows dislocate traditional economies, as long as overpopulation remains a taboo expression, as long as corrupt governments loot the poor in the developing world, global trade will produce shock waves of migrants.

la gente

The General is riding his horse near Mexico City and a small child of seven dogs his steps. The General in a moment of whimsy snatches a section of sugarcane from the child's hand and chomps off a bit. He laughs and gives the boy two pesos and asks, "What will you do with the money?"

"I will take it to my mother, Señor."

"You have a father, too?"

"A father, too."

"Does your father send you to school?"

"No, Señor."

"Why not?"

"Because I help him with the work on the farm, Señor."

"Well, go and tell your father that Pancho Villa says to send you to school tomorrow or I will find him and shoot him."

A man comes to Villa's house and says, "Señor General Villa, I am the father you threatened to shoot because my son was not going to school. If I send him to school, who can gather corn for him to eat?"

The General has had enough. "I know nothing about your corn, Señor," he says, "but you can be sure that my men will hunt you out and shoot you if that son of yours and his brothers do not go to school. Don't you know that we are fighting the revolution so that every Mexican child may go to school? If the greed of the rich deprived you of schooling, as it did me, and so you are unable to support yourself or your family, then steal, Señor, steal whatever you need to send your son to school. If you steal for that reason, I will not shoot you, I will reward you; but if in not stealing you allow your son to stay away from school and follow the road of misfortune and crime, I will shoot you for that."

And then the General hands him 500 pesos and sends him on to his destiny.

FIVE DAYS AFTER KATRINA MADE LANDFALL, I walked into an Italian bistro in Houston on Interstate 10. The cluster of surrounding motels had counters piled high with flyers from churches offering aid. The restaurant was packed with evacuees from New Orleans and they all had stories. One black man told me he'd spent eighteen years as a janitor in a complex near the Superdome. Now he planned to stash the wife in some Houston rental and then head back to grab what he saw

as fine jobs that would sprout from the soggy ground as reconstruction got underway.

The bistro itself probably sat 200, and every chair was taken by evacuees. They were easy to spot with their dazed eyes, disheveled clothing and sudden fellowship that crossed race and class lines. But what struck me about the entire scene was the staff toiling in an open kitchen. Except for the hostess and the guy manning the cash register, the entire service crew—cooks, dishwashers, busboys, waiters—were short, dark, Indian-looking people from the Mexican south. I doubt many had papers that were in order.[42] And so I sat at the bar and dined amid the constant ringing of cell phones, and the constant chatter of evacuees as they were fed by other evacuees from the collapse of a Latin world. One group was helpless, the other group was, probably for the first time in their lives, in control of their lives and fortunes.

It was a tiny blip on the screen called migration.

Eight months later, I was in a fashionable bar on South Congress in Austin, a strip for hip tourists who ooze money. I was looking at some photos of Juárez, shots of murders and rapes, when a middle-aged guy sitting next to me said, "That's my town."

Miguel had just sold his fine home there, he went on to explain.[43] He'd kept some ranches and things—I didn't pry—but he was getting out. He thought he'd buy a condo in El Paso for openers. He had two sons in Austin going to college. He was part of the power in Juárez. One of his family had once sold a ranch to Amado Carrillo, the then-head of the Juárez cartel. He was deeply involved in Mexican politics and the names of the elite that run Juárez tripped easily from his lips.

But he was bailing out on Mexico, part of an invisible flight of middle- and upper-middle-class people who have visas, come across and then simply do not go home. He said the violence was too much, the economy was too bad and there was little hope of change. Like the Indians I saw toiling in the Houston Italian bistro, he'd made a decision and marched north. But then Miguel was hardly a surprise—after all, the publisher of the Juárez daily newspaper lives across the river in the United States for safety reasons and has his children in U.S. universities.

A few days before, I was staying at a ranch an hour south of Austin. Martín, the hand, had papers. His son had just arrived from Nuevo Laredo illegally. A little later, a call came in from a Mexican man I knew. He'd been a major drug smuggler, then done nine years in a U.S. federal prison. Now he was in Shreveport, Louisiana, running a construction crew and credentialed with phony documents. Before that, he'd been in Houston doing the same thing. His son was arriving the next day at the wheel of a truck. The boy was legal, one of those anchor babies born in the U.S. as a kind of family stakeholder.

All this is the basic noise of the line, a kind of constant thrumming that is missed by census takers and ignored by policymakers. But it is the real policy.

While I was staying at that ranch, a local guy came out to spray the buildings for termites. He'd spent his life in nearby Gonzales, a town of 7000 where the Texas revolt from Mexico began. He asked me what I was doing there.

I said, "I'm a friend of the owners. I'm down here writing about migrants."

He looked puzzled for a moment and then asked, "When you say migrants, do you mean wetbacks?"

"Yes."

"Well, what do you think we should do?"

"You might as well ask me what I think we should do about hurricanes."

He chewed on that a moment, and then offered, "That's what I think. Nothing can stop them. I've seen guys deported on a Friday and they're back here at work on Monday."

He was a white man who'd spent his life in a town that was a mix of Anglos, Mexicans and African Americans. And he had that ease about such matters. So the talk soon turned to barbeque and deer hunting.

Almost twenty-five years ago, on the night of June 21, I crossed the line illegally with a friend and plunged into the empty desert that holds the legendary El Camino del Diablo. This desert of thousands of square miles has no living water, air temperatures that cross 120 degrees and soil temperatures that reach 160 degrees. It is the bone yard of countless migrants. I was a newspaper reporter then and agitated because a group of seven Mexicans had died in the heat the summer before and this slaughter had been a tiny item in the papers. So my friend and I and a bunch of Mexicans entered the United States illegally and streamed into this unpopulated death zone and in one night walked forty-five miles. It all but broke me and I can still remember the pain that radiated through my body and how around midnight in the 100-degree heat my mind began to melt into some zone of delusions.

I thought then that the problem was manageable and that a newspaper story would trigger simple reforms—water stations in the death zone, a public information campaign to steer migrants away from that stretch of desert, and so forth. Maybe there would be investments in Mexico, some kind of Marshall Plan, and the whole matter of economic inequality would be resolved.

But the world turned over, nothing much addressed the facts of Latin American poverty, and the future was sketched by people on foot, people ignored by those who sit in offices in the various capitals. The major investments in Mexico were made by drug dealers. The major answers to poverty were made by poor people walking north.

THE MAIN STREET HAS NO CARS, none moving, none parked, on the paved street. Nor are there people. This is the deserted village, one of many such places, this one is in Michoacán.

These far departing, seek a kinder shore,
And rural mirth and manners are no more.

Two lines from Oliver Goldsmith's "The Deserted Village," a poem written in 1770 to record the death of the rural England and Ireland. Now it is the silent song of much of rural Mexico, where the land no longer can provide a living and so the men go north. The women of Santa Inés, Michoacán, come out in the evening and sit on chairs in front of their houses and look at the town where the men are gone. Now and then a teenager will sit on the curb of the main street and wait for cars that never pass by. Red tile roofs, lonely electric poles, a ninety-two-year-old woman sitting on a chair with an expressionless face. Outside of town stands a mansion built by a migrant who has gotten papers. He returns each December for a week or two to visit the home that will never be his home.

I CANNOT REMEMBER the first time I felt the pain of sorrow on the line. There is a face, smooth, eyes bright, a young face yearning for a better life and the thought comes that with a little help, a small sacrifice, some dollars, this face can light up with a future. Then a glance takes in the faces behind the face, and the faces stretching into the distance behind these faces. Resolve collapses. There are too many and there seems to be a factory, some dark, possibly satanic mill, manufacturing these faces in an endless stream of production.

Maybe it was the dog by the dump on the outskirts of a small coastal town in Baja California years ago. I'd gone into the dunes looking for arrowheads because a local barkeep who made a massive tequila sunrise told me they could be found there poking out of the sands. Giant cardon cactus cluttered along the beach and the bay was still and warm with the breath of Eden.

I'd come with a woman, and our days were sun and sea, the nights velvet with alcohol, flesh and swaying of palms overhead.

That day, near the dump, a small dog suddenly appears and begins to follow us. It is affectionate, bright-eyed. She wants to take it back to the States. I say no, it probably has an owner. She persists. I say no, the need is endless, Mexico is filled with hungry dogs looking for homes.

So we left it and then had a fight that night.

These moments never cease, they keep coming almost in a file, shuffling past and testing me. Naturally, I fail the test.

But the test itself is what is in question. The tendency to focus on the boy lost in the desert, the Mexican in Altar desperate to get to a job in the United States, the children battered by the heat of a June night. Pick a single tragedy and feel bad and say this must stop. The solution then becomes private and personal, just as our people faced the Depression by giving men out of work a plate of food by the back door and ignored the failure of an economy and the assumptions of that economy.

The blood on the line is merely the seepage from a global wound of people without futures, without work, without food. After forking over money for a meal or feeling bad, the wound keeps seeping, in fact growing, as the numbers increase and that column of hurt shuffling past stretches ever farther into the horizon.

Until the number of human beings is faced—say it just once, that forbidden word, overpopulation—and shrinkage of mineral deposits, fuels, trees, clean water, animals is admitted—well, then nothing will happen but this self-indulgent pity game, the various rock festivals where in drunken stupor the contact high of relieving the poor can be tasted in between hits on the sacred pipe.

There is another matter, the heads rolling on the floor. It is summer in a nightclub in Michoacán and men enter with a sack, then open the bag and out roll the severed heads. The dancers become still as the faces roll, thunk, thunk, thunk, across the disco floor in the Light and Shadow. A hand-printed sign is left for instruction: "The family does not kill for pay, does not kill women and does not kill innocents. The only ones who die deserve to die, and all the people know that this is divine justice."

Sometimes the heads are found in the plaza of a city. Sometimes in the garbage dump. There is the House of Death in Juárez, a condominium I once visited where a dozen men were murdered by local drug merchants and the state police and then buried in the yard. There are grenade and rocket attacks in various cities, the cowed reporters and editors one can visit in any Mexican town and city who do not write of drug murders lest they also die.

This is not a breakdown of order. This is the new order.

All the Juárezes and Laredos continue as before, the stores open on time, the trucks roll, the people go about their business, and heads grin from the ground.

The future caresses our faces and it is murder.

A man sits in a cell in Brazil. An interview appears that claims to be this man's voice. Some think it is an imaginary conversation. Some feel a chill and are certain it is true. The man is the head of a gang, *Primeiro Comando da Capital*, one that operates freely in Brazil's prisons and in its streets. Once, as a show of power, the gang slaughtered over 100 people in Sao Paulo over the course of a few days.

What the man says in the interview is never said on the U.S. border but is on everyone's lips.

He says, "It's you who's scared of dying, not me. In fact, you can't come here and kill me here in jail, but I can send people to kill you out there. We're man-bombs. In the slums there are 100,000 man-bombs. We're at the core of what is beyond solution. You guys are in the right, and I'm in the wrong, and in the middle is the frontier of death, the only frontier. We're already a new species, a wholly different animal from you."[44]

la gente

The General tries and tries but he cannot bring himself to trust politicians. In fact, he seems to hate them. He is busy crushing the federal forces of 5000 men at Paredón when hunger hits him and he breaks with some friends and has lunch under some mesquites. His men bring two captured officers to him, and without interrupting his lunch, he tells them to shoot them. One officer expresses his contempt for Villa but the General is determined to enjoy his meal and for once controls his anger. The other officer falls on his knees, weeps and begs for his life. The General just keeps on eating.

Then one Jesús Acuña, a lawyer and politician who has briefly attached himself to Villa's army as an observer, speaks up. "My General," he says, "spare us the sight of these deaths. We are eating; we are happy over our morning triumphs. Is it right to spoil our satisfaction with such sights?"

The General's voice rises as he responds, "Why are you afraid to see the laws of the revolution carried out? You chocolate-drinking politicians want to triumph without remembering the blood-drenched battlefields."

The officers are duly shot and the General continues dining as the bodies sprawl on the ground near his picnic.

General Hugh L. Scott is the commander at Fort Bliss, Texas, and in 1914 he sent the General a pamphlet detailing the Hague Conference Rules of War. The General is puzzled by the little tract. "What is this Hague Conference?" he asks. "Was there a representative of Mexico there? Was there a representative of the Constitutionalists there? It seems to me a funny thing to make rules about war. It's not a game. What is the difference between civilized war and any other kind of war? If you and I are having a fight in a cantina we are not going to pull a little book out of our pockets and read over the rules. It says here that you must not use lead bullets, but I don't see why not. They do the work."

It is early in the revolution and the General stops at a well at Rellano. There are so many men and horses that the water is soon exhausted and so a soldier is let down into the hole and fills the water jugs. Villa and his officers, one of them being Francisco Madero's brother, drink the cool water with gusto. All at once the soldier down below shouts, "Let me out. Let me out. Pull me up." When he climbs out of the well, his face is fear. He says, "There are seven dead men down there. I won't go down anymore." Madero's brother says he is going to vomit and the General laughs heartily.

The General is used to being alone. He has years of experience of banditry and such a life lacks many social moments. Still, there is solitude and then there is solitude. In his prison cell in Mexico City, he discerns these distinctions. He tries to handle stir by turning the enormous blocks of time to use. After all, he is a fanatic on not wasting time. He studies typing and accounting, "two things," he thinks, "that are useful in the world of business." But still solitary confinement eats at his guts and he admits it. "They were holding me incommunicado," he remembers. "This I endured with resignation, wishing to leave a good record in jail, as I had done in war. But I suffered not from the solitude, for I was accustomed to that, but from confinement and the silence. There is a difference between the solitude of the sierra, with arroyos and the mountains all around, and that of a jail, where the walls let you see no one but yourself, and each day's rest is more exhausting than the most dangerous action.

"One day I asked the judge if it was true that some books can hold us under a spell when we read them. He answered yes. I said, 'Señor Judge, if you can get me one of those books, I will be grateful, especially if it is about soldiers or war.' He brought a book called The Three Musketeers, and I found great consolation in it."

HERE IS WHAT THE GOVERNMENTS apparently do not know. The woman left a village in Oaxaca. She crossed the Arizona border. She arrived in Eureka, California, and settled. She is thirty, has five children. She knows the name of her village in Oaxaca but cannot name any place near it. She does not know where she crossed into Arizona. She knows Eureka and its Oaxacan community but nothing else of

California and the United States. Two of her children are U.S. citizens. She has no identity beyond her family and her kitchen. She answers to no pathway to citizenship, nor is she up on the global economy. She is what all the politicians are talking about and yet she understands not a word they say.

Another woman in the same community says, "I do not feel safe here." She is afraid to leave her house because of the police. She is overwhelmed by a new world and so she concentrates on cooking in her home. She has come to the United States because the tightened border increasingly means the men hardly ever return home to Mexico.[45] And so she huddles in northern California where the men toil in the lumber industry or tend plants in nurseries.

Or, Martín now has papers. He began crossing twenty years ago to jobs in south Texas. The first time, a coyote took $200 and then vanished. A second time, he walked for days through scrub, reached the promised van and then was seized by the Border Patrol. Once he found work, toiled thirty days in the melon fields, and then found the farmer had called the Border Patrol so he could avoid paying his illegal laborers. All this is told in a soft voice under a live-oak tree, the stories often punctuated with laughter. Martín has family now, a house, a job. And wears a baseball cap with a raging eagle and an American flag.

His son-in-law came through the line about seventy days ago. He called a number in the United States from his village in Mexico. The man sent a guide to bring him across the river. He spent two days in the coyote's house waiting. Then the man came and said put on this soccer uniform. The man said, if they ask you where you are going, you say, "San Antonio." If they ask you if you have papers, you say, "Yes" in English. They practiced these simple answers.

Then they rode up to the U.S. checkpoint about ten miles north of the border. The Border Patrol agent asked the two questions, got his answers, and waved them through. In San Antonio, the guide took back the soccer uniform.

The man has done this same stunt at least fifty times in the past year at the same checkpoint. Sometimes he moves two people, usually one. They must be young and look fit. For this he charges $2000. He never fails. You can believe the guide is unusually lucky or you can believe U.S. agents are on the take. Martín's son-in-law never asked nor does he care. He can make a good living working in the fields in Texas and that is all he cares about.

Victor has been here for years. He tends a stable of horses in south Texas. His wife is American, and he is raising the boy of another Mexican who is going to be in a U.S. prison for a long time. Victor works across the street from a county jail but none of the cops ever bother him. He is a lean and dark man and he is about work. For six years he worked in Juárez right across from El Paso, first in an RCA plant and then doing construction. He never thought of crossing. And then he began hearing from friends in his native village about the good jobs they'd found in the United States. And so he came here and put down roots.

He says he had a dream recently and in that dream he was in Mexico. He awoke terrified and thinking, "How will I get together enough money to pay a coyote and escape Mexico?"

THEY STARTED SHOWING UP A FEW WEEKS after Katrina at the Shell station at Lee Circle near the New Orleans Superdome. For a few months, there would be three or four hundred a morning, a land-office business in soft drinks and snacks for the gas station. Now it's down to 100 or so a day—Mexicans and some Central Americans looking for work. This is one of the informal hiring halls of a new city, a place evacuated by longtime residents, and being repopulated and rebuilt by evacuees from sinking worlds south of the Rio Grande. No one knows

how many Mexicans and Central Americans have swarmed in since the hurricane. One estimate guesses at least 100,000 in the Gulf region. In the 2000 census, New Orleans was 3 percent Hispanic.

At 7 a.m., men mill around. A truck will pull in, men amble over, an offer is made and then some men climb in for a day of work.

Eddie is a licensed paint contractor who's been doing painting in the area for eighteen years. He figures illegal labor has cost him a half million dollars in lost jobs in the past eighteen months as their cheap labor undercuts his bids. But he is not too upset about it because he is getting plenty of work in the ruined city and because "I never fault a man for wanting to earn his own dollar."

Lamar Montgomery, the gas station owner, also has kind feelings about the illegals that hang around his station. They've never, he notes, caused him a bit of trouble. The looters that sacked his place right after Katrina, well, bitterness seeps into his voice as he remembers finding his business smashed and beer taken. The beer irks him since he figures it was hardly survival rations in a natural disaster.

Carlos Banda has been coming to the Shell station at Lee Circle since January. In his native Coahuila, he earned maybe $20 a day doing construction. Here he takes down $100 to $150 a day and works at least six days a week. His rented room costs him $300 a month. He sends home $800 to $1000 a month to his wife and three sons in Mexico. He wears a Dallas Mavericks cap and if someone puts amnesty or citizenship on the table, he'll take it. He's forty-four now and been coming north for almost fifteen years in order to survive—he figures he's crossed fifty to 100 times. The first time was a little rough, with days of walking. But now, it is hardly a bother to him. In the beginning, he worked as a hand on ranches but then he learned of wages in the cities and started doing construction in Dallas and Houston. Since he's been in New Orleans, he's been picked up twice by the Border Patrol (they were looking for someone else, he says) but they instantly let him go. He notes that

they sweep Lee Circle every Monday and Tuesday. He says he has no problems and that he likes New Orleans very much.

Some of the men milling around at Lee Circle are from Central and South America but when asked they all insist they are Mexican since this means they can only be deported back to the U.S./Mexican border. A few blacks hang around looking for work and most have cans of beer. The Mexicans and Central Americans all drink supercharged bottles of caffeine-laced drinks. When black contractors roll in, they seem to only hire blacks. White contractors seem to only hire Latinos. The tension between the two groups hangs in the air. A row of young black guys and girls sit over against the wall of a building. They stare with contempt at the Mexicans waiting for work.

Now the city is largely empty, the black residents evacuated from the ruins and a new tribe descends.

A mile or two away, on Claibourne, is another hiring center. Here dozens of men mill around a gas station while street vendors sell them tacos and coffee. Many are Central American, but all deny this. One who by accent is clearly from Central America wears a Hecho en Mexico cap just in case. Another sports a T-shirt announcing "U.S. Polo Team."

Contractors pull in, haggle and then leave with a truckload of workers. Suddenly, a black BMW convertible arrives and a white man in shorts gets out. He offers the men $8.50 an hour and is greeted with laughter. He ups the deal to $100 a day. No one moves. Finally, at $120 a day three men get in his car.

Out in St. Bernard Parish, the slab east of New Orleans where destruction was close to total, with only two houses spared flooding, Jesse Melendez, forty-three, cuts a deal with a plumbing contractor in the parking lot of the town's only open grocery store. He'll get him Mexicans for a commission of $100 each. The contractor gives him his phone number.

Melendez goes to Ft. Worth for his illegals. He loads them into his van, plies them with beer, and then brings them home. Normally, he's a roofing contractor but he's just finished a four-month jail stint and does not return to work for two days.

The jail stint irks him since the cops nailed him for drunk driving and he insists he was pretty sober—the ice chest full of beer in his van was for his roofing crew. He lets them drink from 3 p.m. on.

Melendez is native-born, Puerto Rican in ancestry, and feeble in Spanish. He's a wiry man and well-decorated with tattoos. He's keen on Mexicans.

"There's a shortage, big time," he explains. "They bust ass—work hard and consistent."

He says crack has been a problem since Katrina, so he avoids junkies. But these Mexicans, he rolls on, really work and send money home to their families.

He pays them $120 a day on his roofing crew. He can't find any other labor, but if, say, a black would do roofing for him, he'd only pay him $60 or $65 because he finds them less hardworking.

"I got nothing against niggers," he notes, "everyone should own two."

Melendez has lived a frisky life—he's got eleven kids and the woman with him has eight. He's spent a lot of time in the local jail, mainly for fighting.

"I'm a known street fighter," he offers, "and everyone wants to try me. You got it on your mind, I got it on my mind."

But at the moment, his mind is on Mexicans. While he was in jail this last time, a friend hired his Mexican, overworked him and burned him out. Now it is time for replacements. He gets his van back from the shop today, and he's off to Fort Worth to resupply.

In St. Bernard Parish, he explains, the sheriff keeps the Border Patrol out and should they sneak in, local law enforcement makes sure to warn the Mexicans. In fact, he adds, that's why the grocery reopened—otherwise contractors had to drive their Mexicans out of the district so they could buy food, and they might get a better offer while they were shopping.

Basically the Mexicans are kept out of sight and sleep many to a room in the houses they are reconstructing. Melendez is convinced that the reason St. Bernard Parish is rising from ruin faster than New Orleans is that locals understand the care and feeding of Mexicans.

There are a lot of ways to get rid of what is happening at Lee Circle or on Claibourne or in the wheelings and dealings of Jesse Melendez. You can call it racist or exploitation or you can pretend it is not happening. But it is happening—more Mexicans and Central Americans arrive each day, they come from countries where they could barely eat but they soon laugh at someone who offers them $8.50 an hour. They are protected from U.S. federal law enforcement by U.S. local law enforcement. They work very hard and earn $500 to $700 a week.

They are back where they started: they left a ruin and now inhabit a ruin. Almost all of the damage left by Katrina is still visible. Destroyed cars line up like corpses under the freeways downtown. The drive into central New Orleans is ceaseless destruction. What is taking place in New Orleans is simple and brutal in its meaning: a city abandoned by Americans is being occupied by people who risk their lives to reach it. There could hardly be a better demonstration of the difference between life in the developed world and life in the collapsing world.

The supply of labor for New Orleans is limitless. This is one of the facts of the migration. Coyotes never run out of pollos—if pollos are apprehended, the Border Patrol drives them directly back to the border and to the coyote, a fact that drug dealers might envy when they lose a shipment. They are a labor force that delivers itself to the market, asks for no pensions or benefits, and figures out how to house itself.

It is a future of brutal work, toxic materials, bad housing, and constant wariness of federal agents. The dead of the region, buried in stately vaults because the high water table precludes a normal grave, enjoy better housing. Ray Nagin, the mayor of New Orleans, complained that his city was being overrun by Mexicans. It's a fair bet that they outnumber black residents. But no one really knows the current population of New Orleans. It is a work in process, a new kind of place for a new world.

I KEEP RETURNING TO the destroyed city because I sense the future whispers from the rotting houses. I've been coming here since childhood and as I walk the streets I can hear my dead Cajun aunt at my ear, see the houses of her people on stilts in the swamps, the water smooth as glass, the cypress huge with life. New Orleans cannot exist either in memory or in the moment without scents, that dampness springing forth from the earth, the rotting leaves, the vomit from the crowds last night on Bourbon Street.

For almost 300 years, the city hugged the bank, flooded, and endured and then came a wave too great, the levees shattered and now there is stillness, a silence that is worse than death, because this is the place the music came from. This is the ground of permanent funk and suddenly the whorehouse piano is still, Jelly Roll Morton has washed away and Louis Armstrong's horn chokes on silt.

The migrants come here and this is seen as new blood, a new beginning. Futures can be spun from the misery of these homeless men who have fled their villages to toil in the demolition of destroyed houses in New Orleans.

But the city itself slumbers, then tosses as if swept by a bad dream, then slumbers some more. The sun burns bright, the air is soggy, and the people sleepwalk. She sits at a table in the private school and she asks me if the city will come back. Her parents, her friends, the parents of her students, all of them talk of leaving. They are the white professional people who live on the dry land of the Garden District and uptown, the ones who evacuated and came back to intact homes. But to tattered lives. There are so many things she now knows and does not want to know. The storms forming in the Gulf, she does not want to know of them. One more storm, she offers, and then trails off. Her students walk on thin ice with their lives. Their parents talk of pulling up stakes and the students, who spent the better part of the last year scattered about the country separated from home and friends, cannot bear the talk of the parents.

She has been stunned to hear her friends, educated liberal friends, she notes, openly talk of how the big wind cleared the city of them, how it is a better place now with them gone. She at first could not believe what she was hearing. And now she cannot even listen.

Do you think, she asks, the city will come back?

A man tells me he retired after thirty years on the police force, two days before Katrina. He was going to pull up stakes, get out of the Big Easy. Been raised in the Lower Ninth, then bought a house in Gentilly, a fine house constructed by a shipwright. That one made it okay—the water only came up to windowsills and so nothing to do but pull out some moldy sheetrock, redo wiring and so forth. The one in the Lower Ninth, well, it is gone for good. Now he lives in Mid City, the murder gallery of the ruined New Orleans, and has the Gentilly house rented and is slowly putting his exit plan together. He says it does not matter where you are in New Orleans, the killers go everywhere because, well, you know they have cars.

Two things this country's in denial about, he offers. Drugs and sex. The drugs are everywhere and ain't going away. And hell, every time one of his fellow cops pretends to be a fourteen-year-old girl on the Internet, then 300 guys show up.

Reverend Jesus Gonzales is feeling fine.

He said the Mexicans are now growing in number as work opens up. He sees Mexican barrios forming, something that has never happened before.

He brokers deals with workers, has lawyers in to help workers defrauded by contractors, houses them illegally in his church. He has an old man watch the church since the Mexicans will obey a *viejo*. He insists on no drunkenness but if a man does come in drunk, he is to be taken to a bed and no one must talk with him. The kitchen must be kept clean—when the men failed at this, he locked up the kitchen for a week.

Still, he realizes all they do is work—on average they last eleven months before they get homesick. But they're only gone a week or two before they come back. They've gotten used to the life and the money. So a while back, he took them to a ranch the church has out in the country. They roasted meat, played soccer, had wheelbarrow races. It was very good, the reverend says.

He is in the future.

There is life of a sort to be found amid the ruins.

la gente

The General is willing to tackle this stuff called religion. He admits, "I am not bothered by the threats of hell." He is traveling with a priest to the baptism of a child where Villa will become the padrino, *the godfather. The priest seizes on this fact to insist, "Señor General, as you have consented to contract the duties of godfather, you do recognize the laws of our Catholic Church, as God disposes."*

What? The General unleashes his thoughts, he will not be tricked by some crafty padre.

"Señor," he corrects him, "to contract the duties of godfather does not imply recognizing any laws in this world or any other. Men are compadres by virtue of the bonds of friendship and custom. That is, if a man consents to take on himself the tutelage of the child of another in case the other man fails or dies, this is not because of religious doctrine but because the duties that unite us with our fellowmen require it, and this is true although the believers believe something else, seeing that the Church intervenes in these deeds to sanctify them. However, I do not deny belief in God. I affirm it and certify to it since it has comforted me and all men in many of life's crises. But I do not consider everything sacred that is covered by the name of religion. Most so-called religious men use religion to promote their own interests, not the things they preach, and so there are good priests and bad priests, and we must accept some and help them and prosecute and annihilate others. The bad priests, Señor, like the Jesuits, are the worst men in the world because it is their duty to teach what is good by means of sacrifice but instead they dedicate themselves to the fulfillment of their passions in ways that are evil. I think they deserve greater punishment than the worst bandits in the world, for the bandits do not deceive others in their conduct or pretend to be what they are not, while the Jesuits do, and by this deception they work very great hardships on the people."

The General says this with his belt stuffed with pistols and his chest wrapped with bands of cartridges, always ready to move from talk to action.

The General is building his big house in Ciudad Chihuahua but he really pays attention to only one room, a place he calls "Heroes Room." The walls are a hodgepodge of Aztec decorations, portraits of Miguel Hidalgo, Morelos, Vicente Guerrero, Francisco I. Madero, the boy cadets who defended Chaplultepec from the invading North American army, Statues of Liberty and Justice add to the effect and the General's fallen comrades are also painted—Aquiles Serdán, Abraham González, Trinidad Rodríguez, Toribio Ortega. The General is so obsessed with this room of heroes that his wife thinks she can slip in a new room and he will never notice: a chapel.

He is showing General Álvaro Obregón his soon-to-be new home when he stumbles on this chapel and he blurts out, "It seems to me, General, that the priests have got my wife by the skirts. I'm afraid they're gonna spoil her."

Then he turns to the general contractor and says, "Have all this torn down."

The General has been ill with fever. Sickness knocks him down from time to time, as do his explosions of anger. He is fighting under General Huerta, it is early in the revolution, and they are allies under the command of President Francisco Madero. And then Huerta decides to have the General shot at Jiménez over the matter of a horse. At first Villa does not grasp the obvious.

"As we skirted the wall," he recalls with a sigh, "I saw what for the first moment I could not believe. They had formed a square and I was to be shot. The dizziness left me. Anger possessed me. I had given my fellow soldiers no reason for wishing my death, but apart from that, it was contrary to all regulations for them to shoot me without a hearing. I was not a traitor or an enemy or even a prisoner. Why did they do this?"

And then Villa began to sob. He is a famous weeper who breaks down without warning. He never disguises this part of his emotional makeup. The General later thinks about this incident and recalls, "I could not continue for the tears that choked me. At the time I hardly knew whether I was weeping from fear or from mortification, but I see now it was because of the wrong they were doing me. In my opinion I have never shown any signs of cowardice or avoided danger, however great, though there have been times when death was so near I was sure I was performing my last act."

They make him stand at the foot of a cross and he just keeps weeping. The General throws himself to the ground and begs. Finally, his dismayed firing squad allows him to be brought into Huerta's presence. He is still weeping. The execution order is revoked and Pancho Villa is put on a train for that prison in Mexico City.

THERE'S BEEN A CHANGE in the weather.[46] Huge storms keep rising up from the seas. There has been a change in the economies and huge numbers of people are in motion. Barriers matter little to either force. Every man in Lee Circle has a story of a river crossed, a desert walked, a coyote hired. In Honduras, for example, papers can be bought for $1500 that will satisfy U.S. ports of entry. In Texas a soccer uniform magically fools a Border Patrol checkpoint fifty times in a row. In Arizona, a huge dump site of clothes and daypacks somehow evades U.S. law enforcement even though the area is clogged with agents in vehicles, ATVs and small aircraft.

Every effort to stem the migration simply reroutes it around the new barriers and raises the fees paid to coyotes. Walls have a way of breeding tunnels. The way to understand illegal immigration is to think of the debts young Americans pile up in order to get a college education. The debts are seen as bearable because the return in future income more than covers them. That is what $1500 for phony documents looks like to an illegal, that is what a couple of grand for a coyote means to a man seeking work. You can bear a lot of expenses if it means you suddenly leap from earning a few dollars a day to 100 dollars a day.

Southern Louisiana has a history of evacuees. Four thousand French settlers arrived here after their brutal eviction from French Canada by the British in the eighteenth century. Black slaves were sold by the early eighteenth century. The Americans arrived by force of arms for the battle of New Orleans in 1815 in Chalmette. The global economy is old hat around here. Henry Wadsworth Longfellow wrote a poem largely unknown to the men milling in Lee Circle:

> *A band of exiles, a nation scattered, bound by common belief*
> *and misfortune.*
> *Men, women, and children guided by hope . . .*

Now people flow into an abandoned city, one that had been losing people for decades, but also to vanishing ground. The bayous of southern Louisiana are vanishing into the sea because of human alterations of the sediment flow of the Mississippi River.[47] In the eight hours of Katrina, Plaquemines Parish, just south of New Orleans, lost 30 percent

of its land. Cameron Parish, the state's largest, is all but abandoned. By late spring of 2006, only twenty-five schools were reopened in New Orleans. Housing starts are running around zero. The city's Democratic wedge of votes that swung elections is now evacuated to Texas and other states. And no one, drunk or sober, has any faith in the strength of the surviving levees.

Think of the city and surrounding low ground as a lens that captures a global turbulence. The storms are part of a shift in the weather that makes a man leave his barren and dry field in southern Mexico, that expels people from the villages of Central America. The dying bayous are but a signature of centuries of human tinkering with the soil and water and sky all over the planet. The continued rise of human numbers is like the rise of the sea itself, predictable and irrevocable. The treaties, such as NAFTA, which were touted as solutions to poverty, bad governments, and stalled economies, have become part of the forces hurling people into migration. The legislation entertained by Congress to deal with illegal immigration has that look of the woman with a broom who tries to sweep back the incoming tide.

Reverend Jesus Gonzales is still feeling fine as he leads his flock of migrants at the Iglesia Luterana Monte de los Olivos. His church feeds them, helps them find housing, clothes them, offers a clinic (for among other things the prevalent Katrina cough resulting from the mold, asbestos, and general filth of demolition work), teaches English, and holds services. Gonzales worked in the oilfields of west Texas and then felt the need for some more meaningful work. His congregation is largely Honduran (refugees from the hurricanes of the 1990s) and now is absorbing Mexicans.

Basically, his congregation is undocumented and after Katrina, the Hondurans came right back to the New Orleans area because they were not eligible for any aid from FEMA. Like the Mexicans, they had to work to survive and use their wits to find shelter.

He has coyotes in his church. Most bring people up from the villages they initially fled. When Gonzales walks New Orleans he mainly sees some upscale whites walking big dogs, Mexicans and Central Americans. At Mardi Gras this year, he was stunned that half the conversations around him were in Spanish.

He is a sunny man and takes the new Latin city in stride.

"Most of these Mexicans," he offers, "know more about the border than the Border Patrol does. They've done their homework. And it's a big border."

His congregants are making $12 to $15 an hour. Their employers keep an eye peeled for the Border Patrol—some have reconfigured their small plants so that no one can enter without warning. One of his congregants, a Mexican, was assigned an Arabic name by his employer and wears his new identity on a tag. Local Spanish radio issues alerts in code on Border Patrol movements in the area. Gonzales sees no end to the migration to the New Orleans area so long as there is a need for labor.

In Richie's Café in St. Bernard Parish, the water came up to mid-thigh. About a third of the parish population has returned. David Johnson, fifty, is a crabber and was one of 200 locals who rode out Katrina.

He's a big man and soft-spoken and he sees hurricanes as "part of living here."

He rescued old people, lost both of his boats, and is ready for whatever comes next.

He says simply, "I was living part of history. It took fishermen to get people out. Someone has to stay to get it open again. It won't get going on its own."

We are in the future now and we might as well enjoy it. There is a reality made clear here that is denied elsewhere. The real energy now is in the sea and sky. The nations that face these elements are ebbing,

just as the land in this particular region is washing away. An American city has vanished and there is no will to restore it. The cheap energy that fueled the fantasies of nations is vanishing. The turbulence caused by carbon loading of the atmosphere is said to be a reality for the next hundred thousand years, with most of the hyper-weather coming in the first thousand.

We must learn this new language and abandon our dead language. The migration is not an adjustment of the global marketplace that will grow our economy: it is an exodus by the doomed who, in the case of New Orleans, find even a ruin to be a better future. The proposed walls and pathways to citizenship are almost vanity devices that enable us to pretend we have a handle on events. Like the war on terror or the war on drugs, they help us believe we are in command of things.

I'll cast my lot with the David Johnsons of the world who accept hurricanes as part of living and who insist someone has to face reality and get things going again. People are clambering on the train of death in southern Mexico at this moment and riding north. Men and women are slipping through the wire into the volcanic heat of the desert summer. Some taste the edge of death this very minute. A group of migrants are stripping down to their bare skin, putting on the garments of their new life, all this while coyotes say hurry, hurry and hustle them into vans and onward toward cities scattered about the nation. There is no quick fix for the failed nations of this hemisphere. There is no magic chant that will instantly remedy 500 years of corrupt government in Mexico.

The Border Patrol will grow. There will be a wall. Tougher laws on illegal immigration will be passed by Congress. And the people will keep coming.

la gente

The peasants are said to tell a tale of how the General lost his soul. There is said to be a mountain with a very odd shape where young men go to find their destiny. Here the devil lives. The General entered here, it is said, and made a bargain with Satan where he gave up his soul for personal bravery, the ability to dominate people, the eyes of an eagle, the strength of a beast. It is said he entered a cavern lined with jewels and gold. Fierce heat belched from the depths. The devil sat surrounded by generals, popes, cardinals, kings, loose women, and wise men. None of this frightened the General, nor could the devil dogs and the fiendish goats restrain him.

He cut his deal and left without uttering a regret. They say his soul remained, weeping in a corner of this hell.

(42) *He wandered for days and failed*
and now he eats a meal given him by U.S. humanitarians . . .

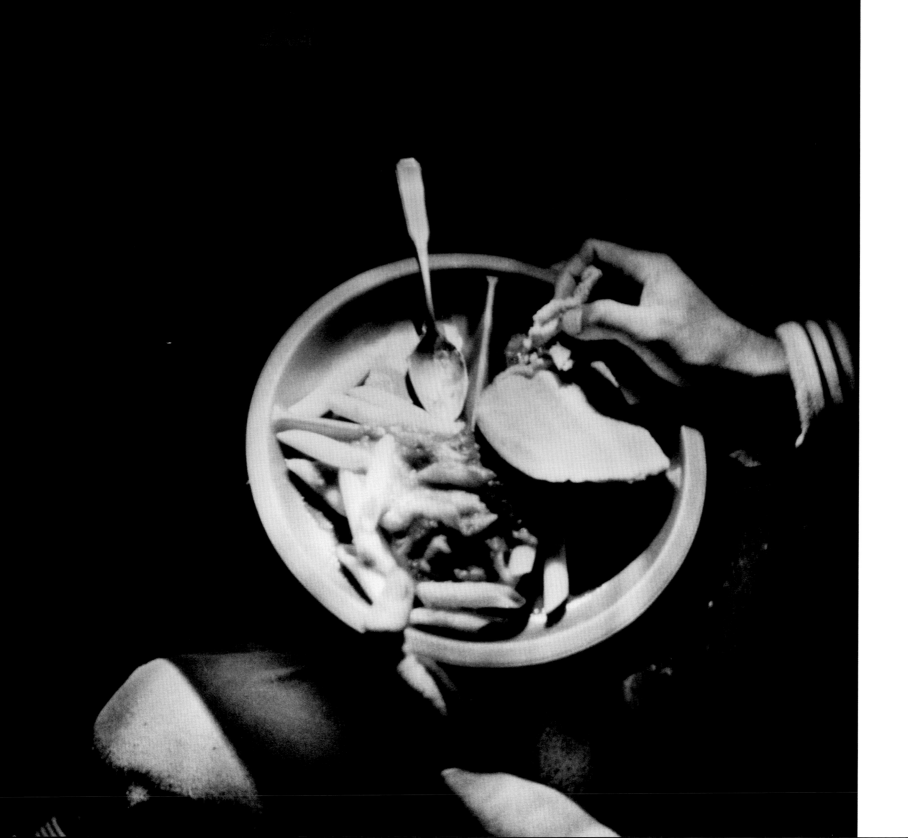

(43) *and in southern Louisiana illegal workers raise houses after the flood . . .*

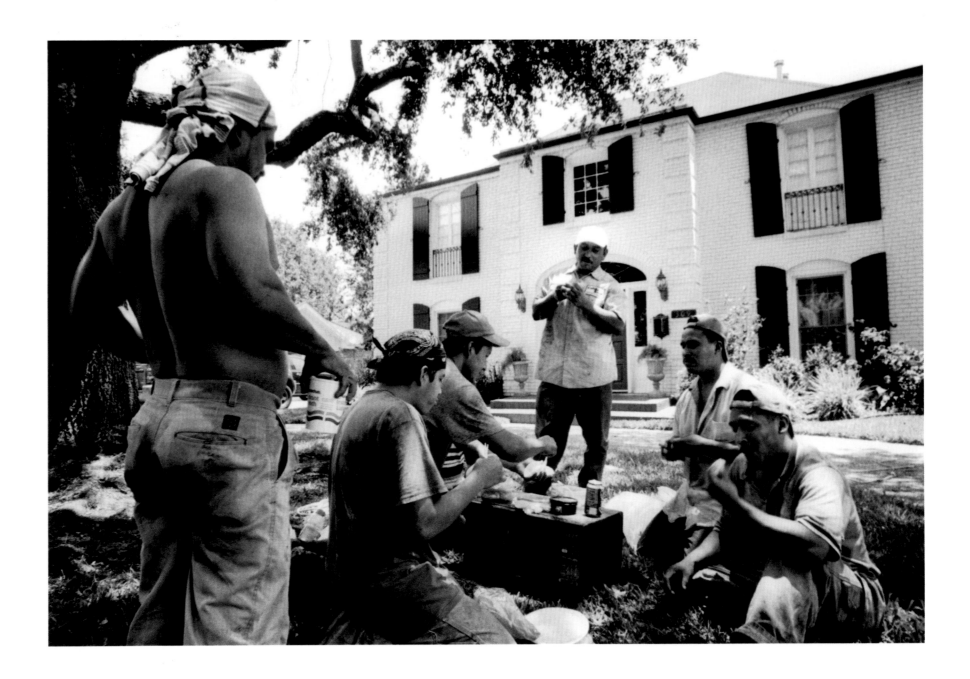

(44) *or in Mississippi they haul away the trash of Hurricane Katrina . . .*

(45) *or in the Central Valley of California*
a Mixtec American tastes the past and the future . . .

142

(46) *or in North Carolina Americans enjoy a street café . . .*

(47) *or in Humboldt County, California, Mexicans get prenatal care . . .*

(48) *or fix a car in North Carolina—a man who paid $5000*
to a people smuggler now works on his own car . . .

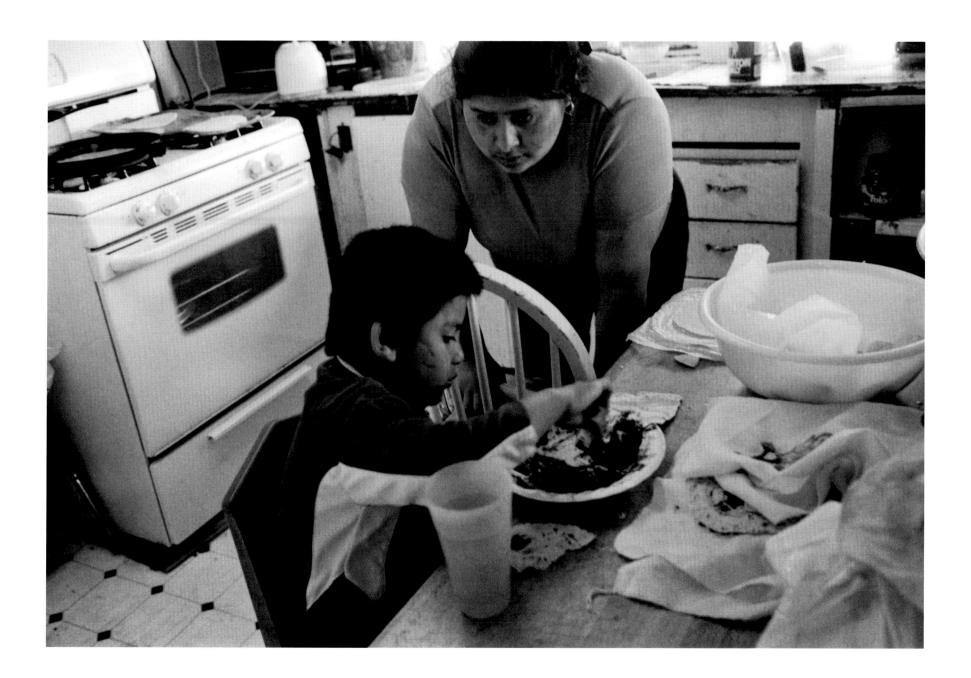

(50) *while three American citizens in California*
are tended by their Mexican mother and aunt . . .

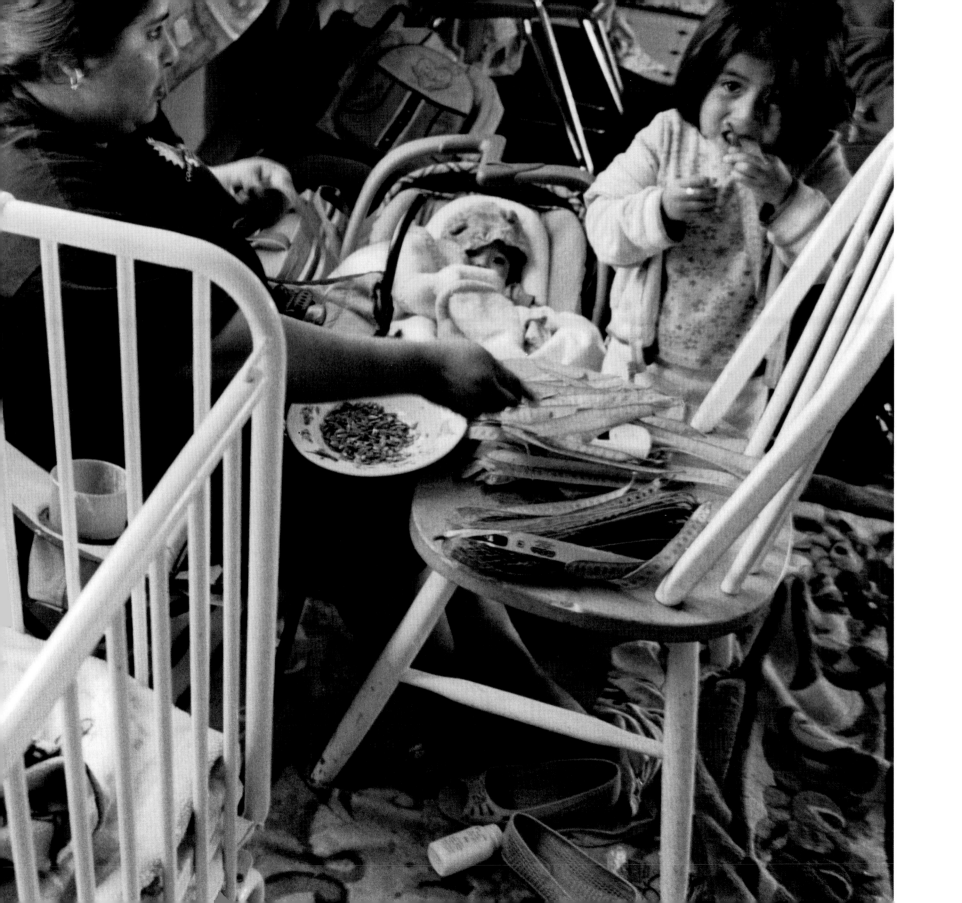

(51) *and a child who walked the Arizona desert in July feeds her American sister . . .*

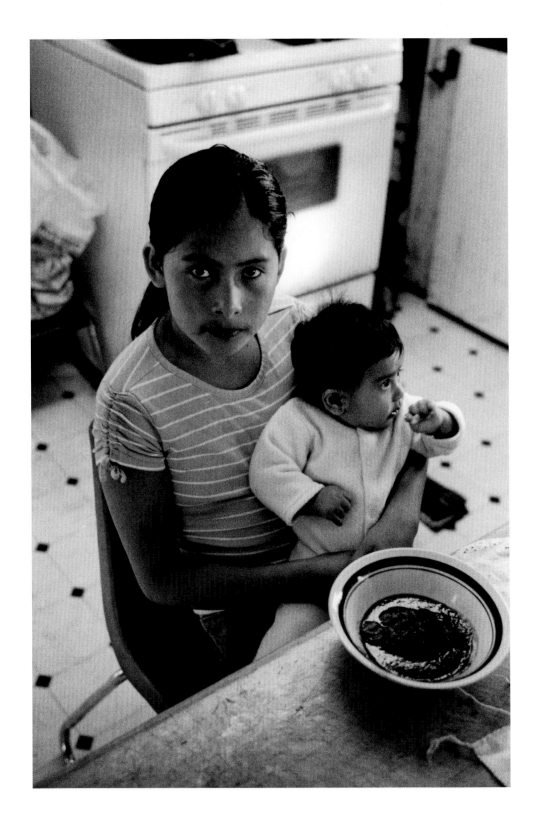

(52) *and they live in trailers, sometimes feeling like prisoners of U.S. law enforcement . . .*

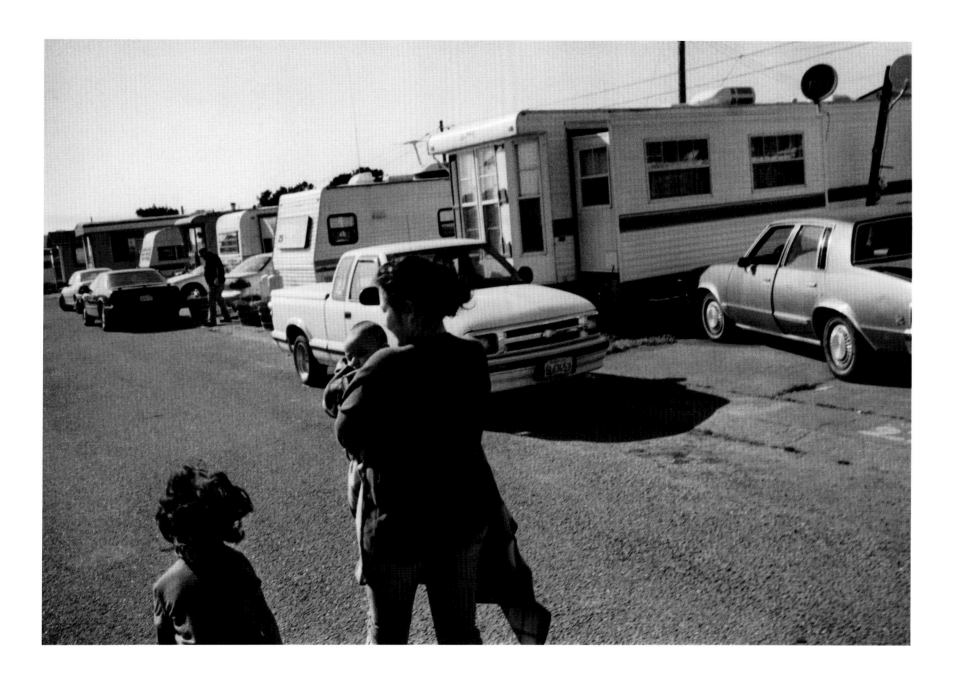

(53) or wait in line in North Carolina for driver's licenses . . .

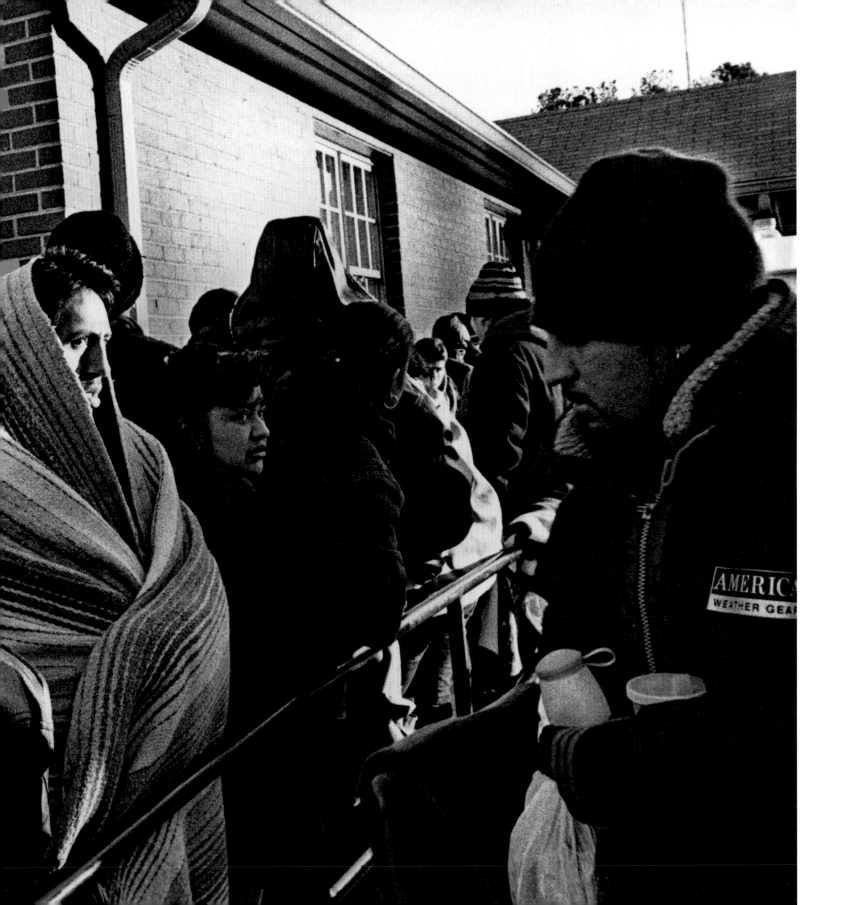

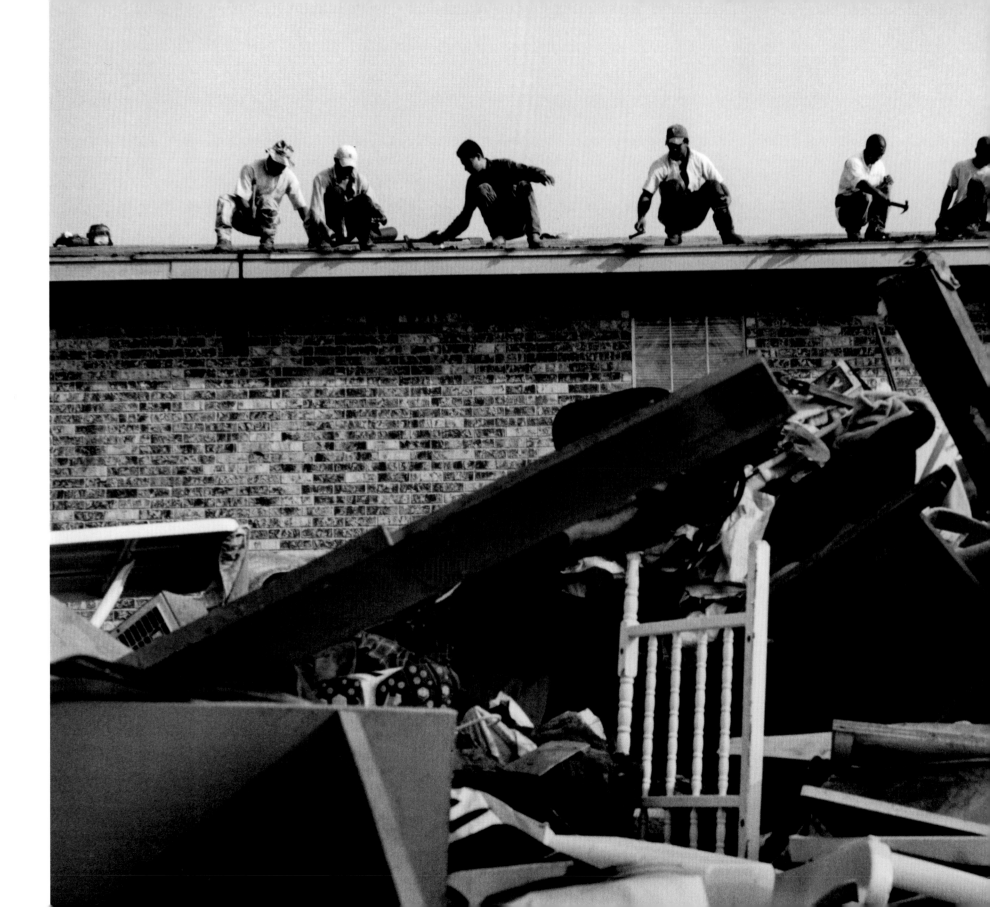

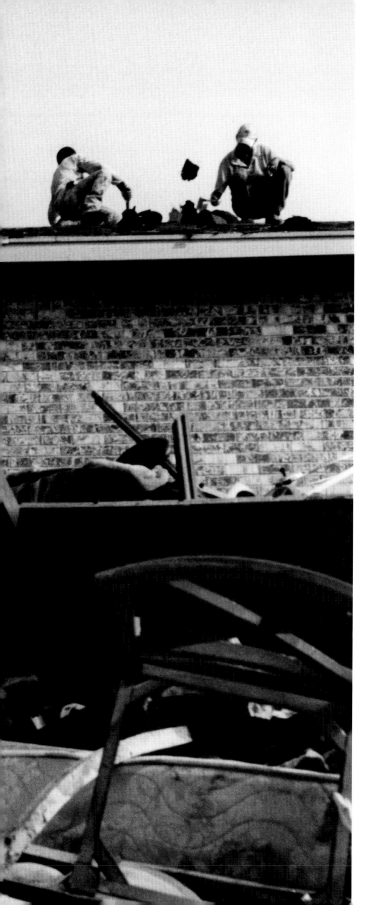

(54) *fix roofs on the Mississippi Gulf Coast . . .*

*(56) are cheated by contractors at a U.S. naval base
in Mississippi but keep going . . .*

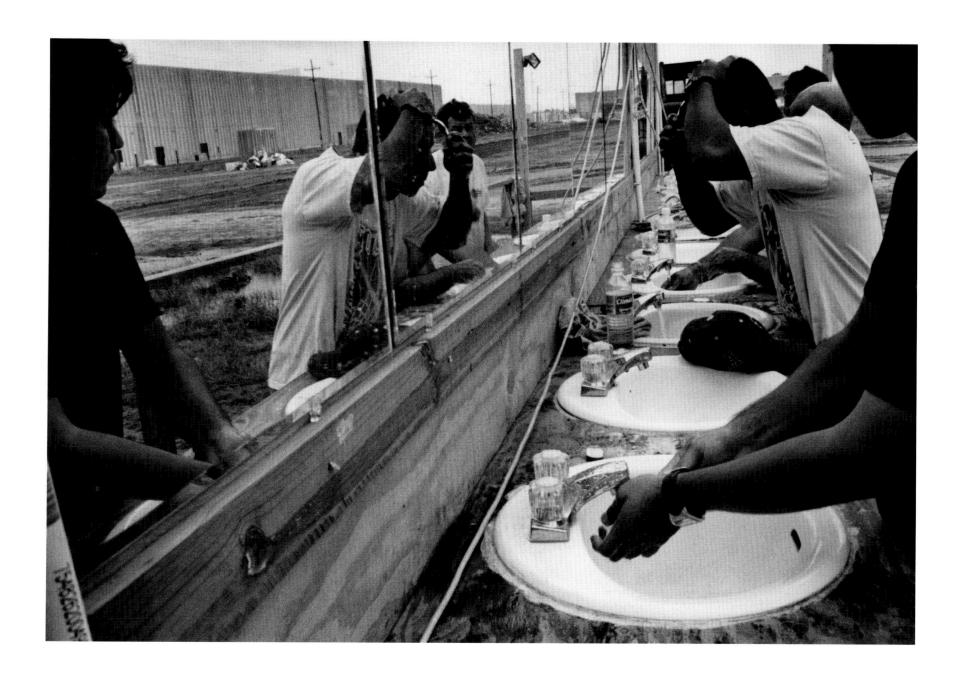

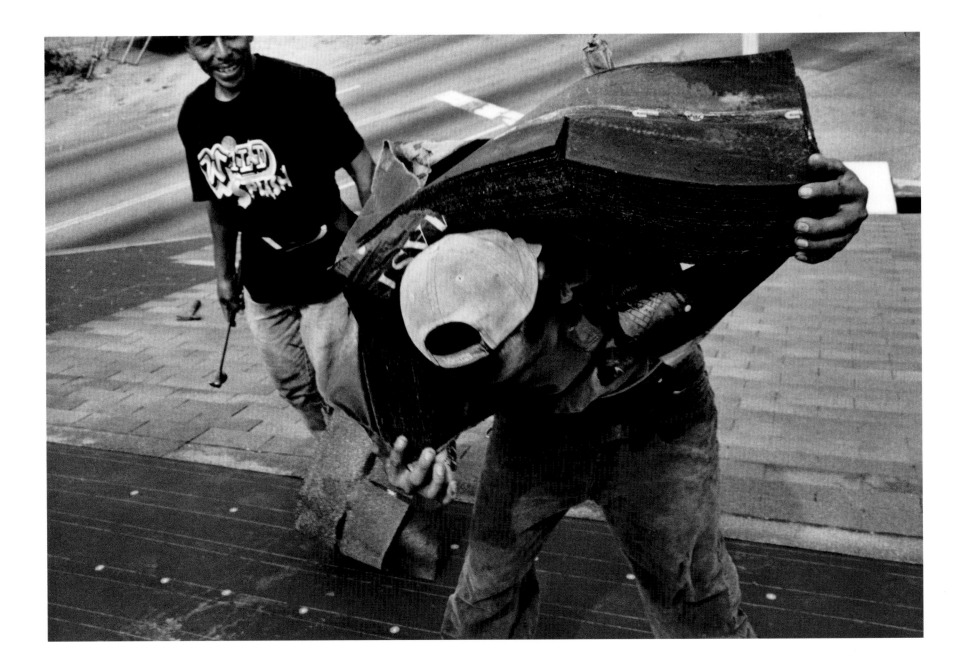

(59) *dig holes in New Orleans . . .*

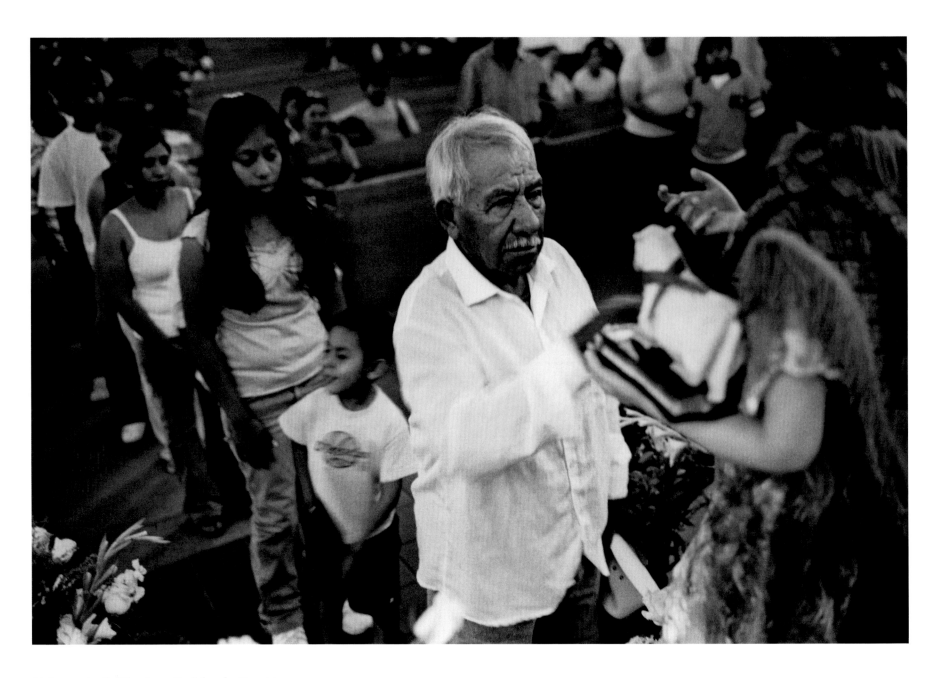

(60) *pray in California to St. John the Baptist,*
the saint of the Mixtecs . . .

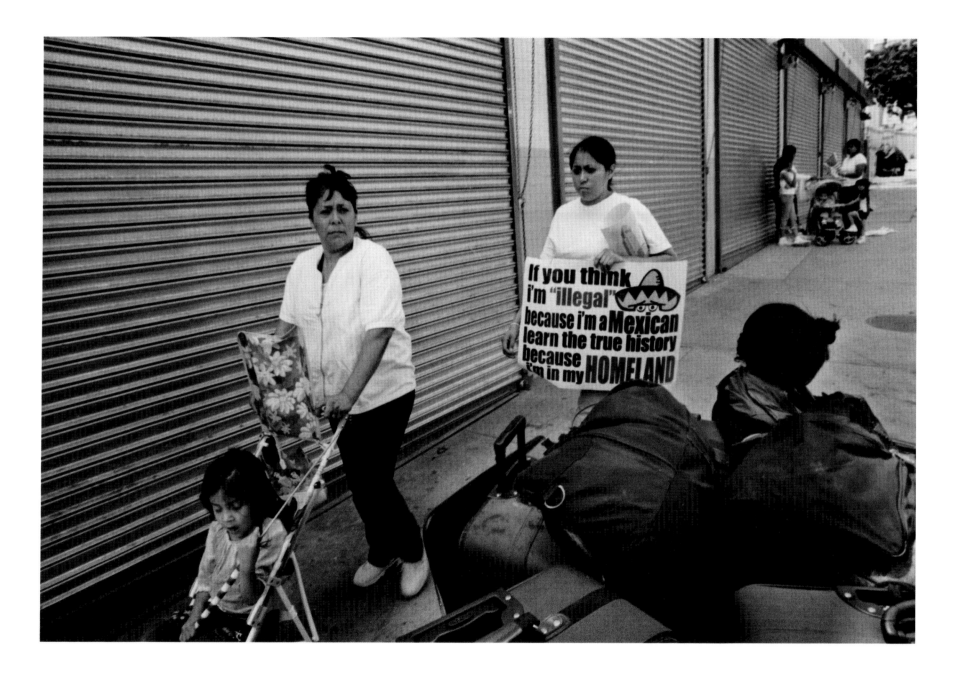

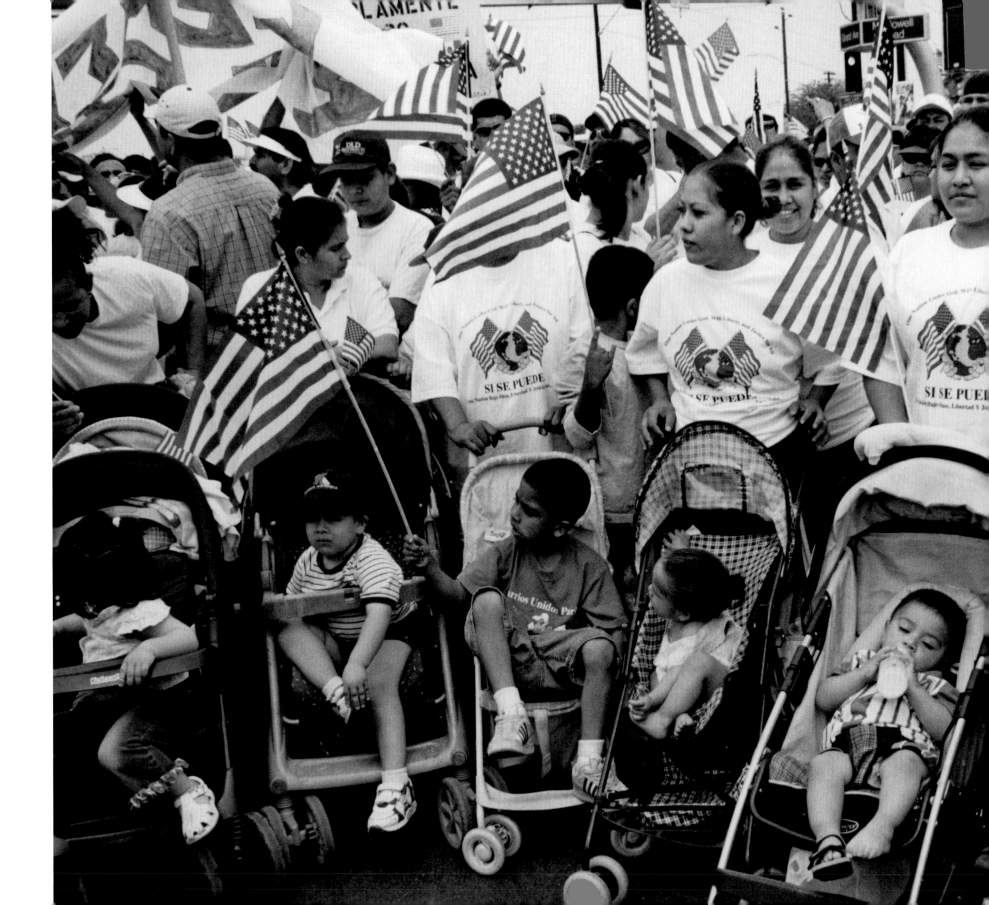

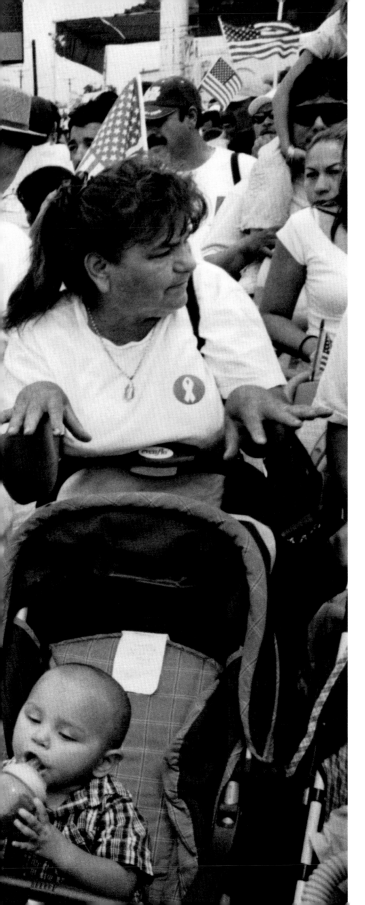

(62) *march in Phoenix . . .*

165

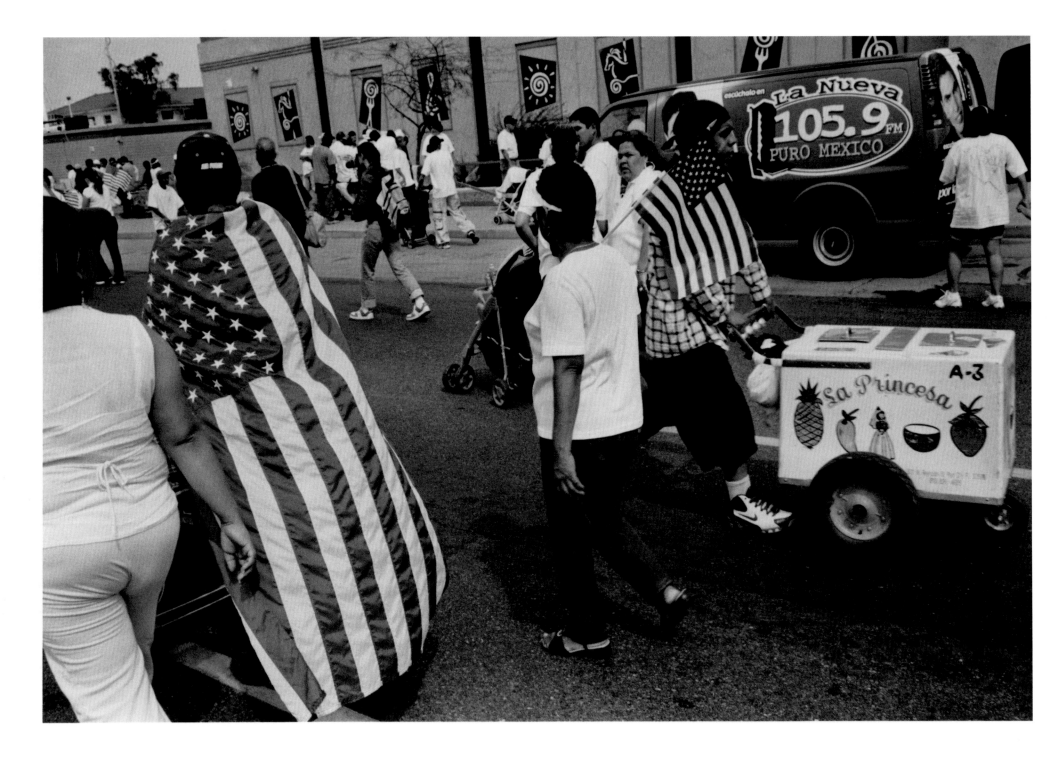

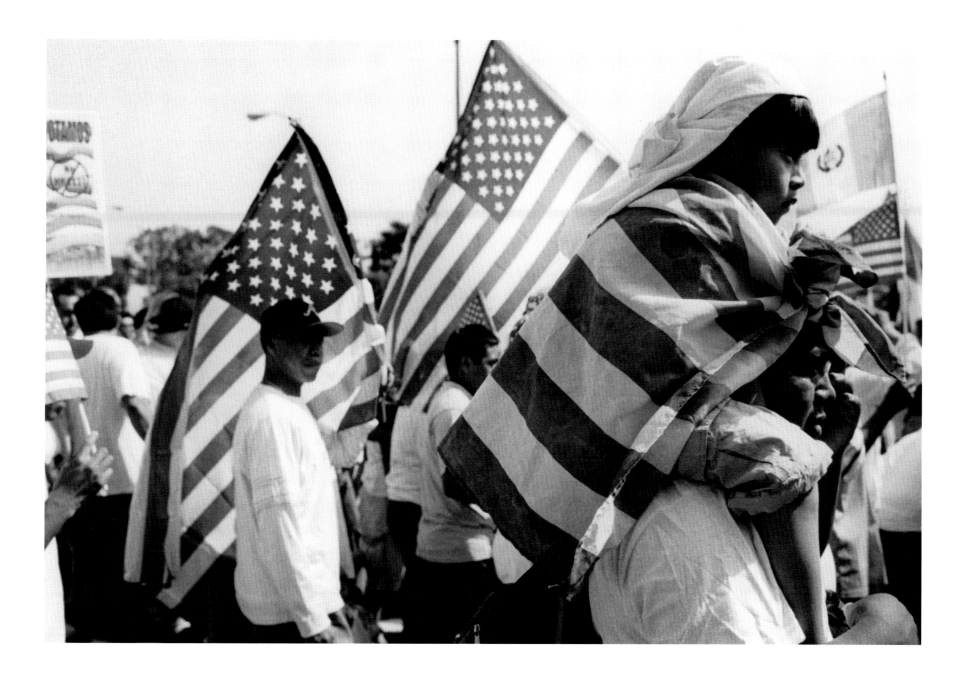

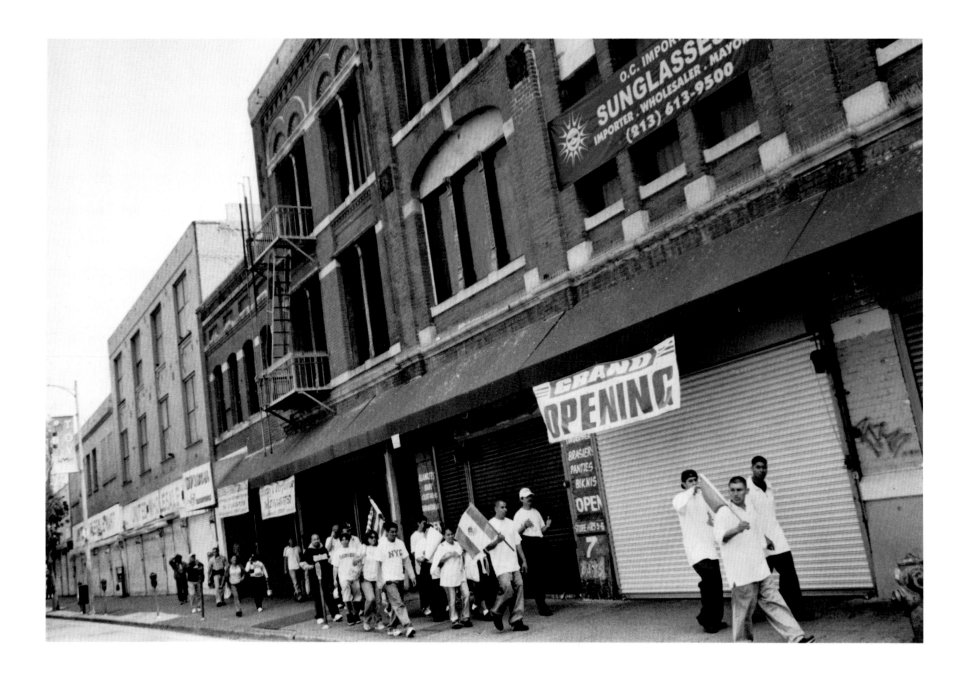

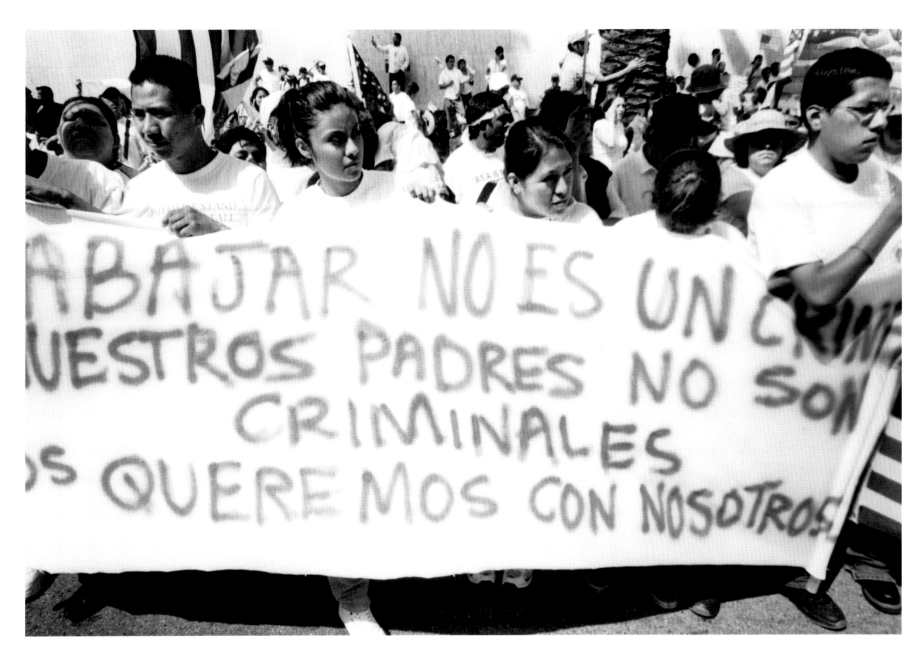

(66) *Los Angeles, "Working Is Not a Crime,*
Our Fathers Are Not Criminals" . . .

(67) Los Angeles shuts down for the march . . .

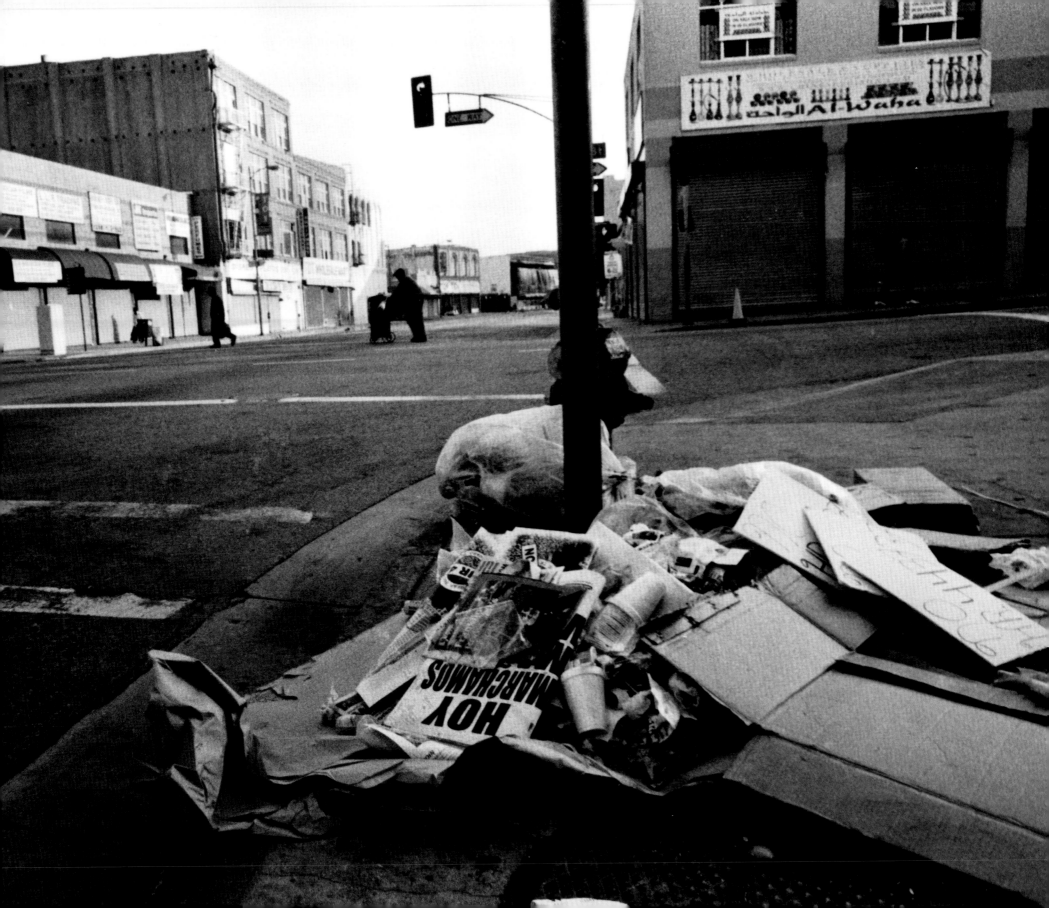

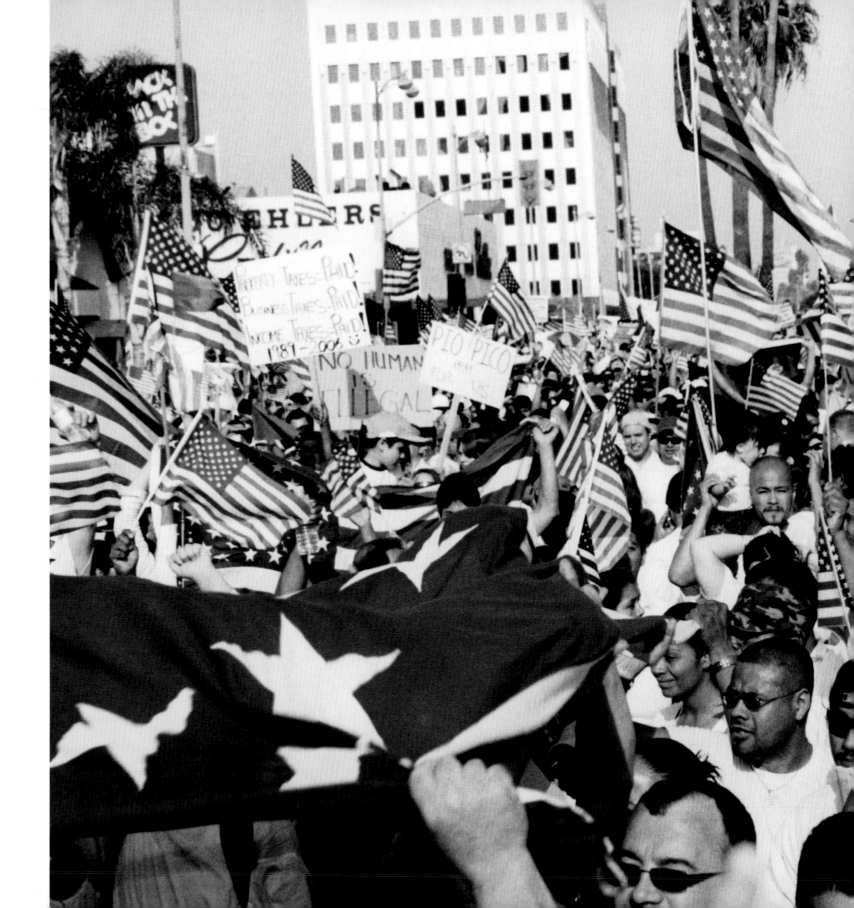

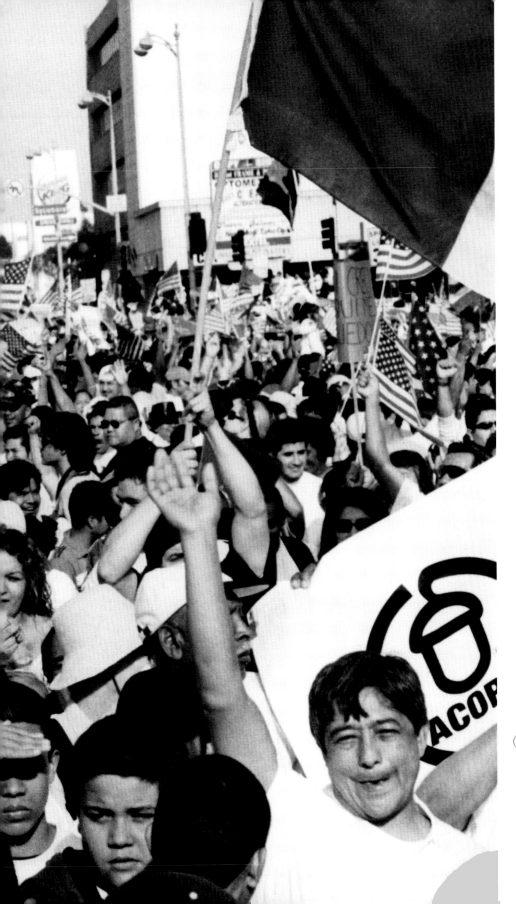

(68) *Los Angeles . . .*

173

(69) Phoenix . . .

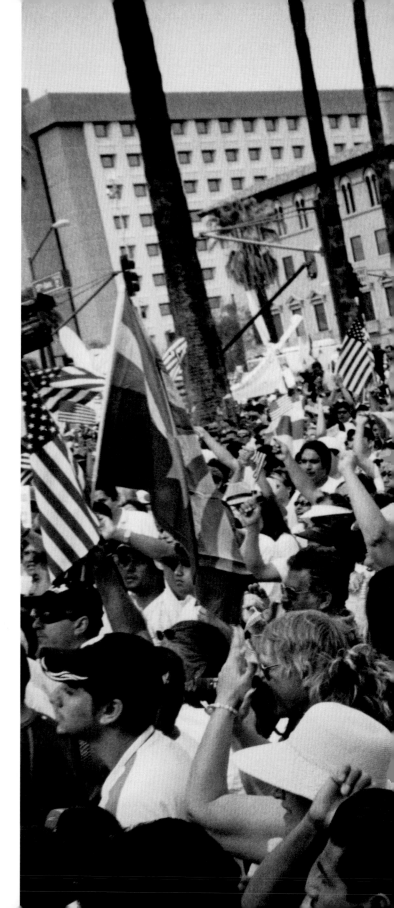

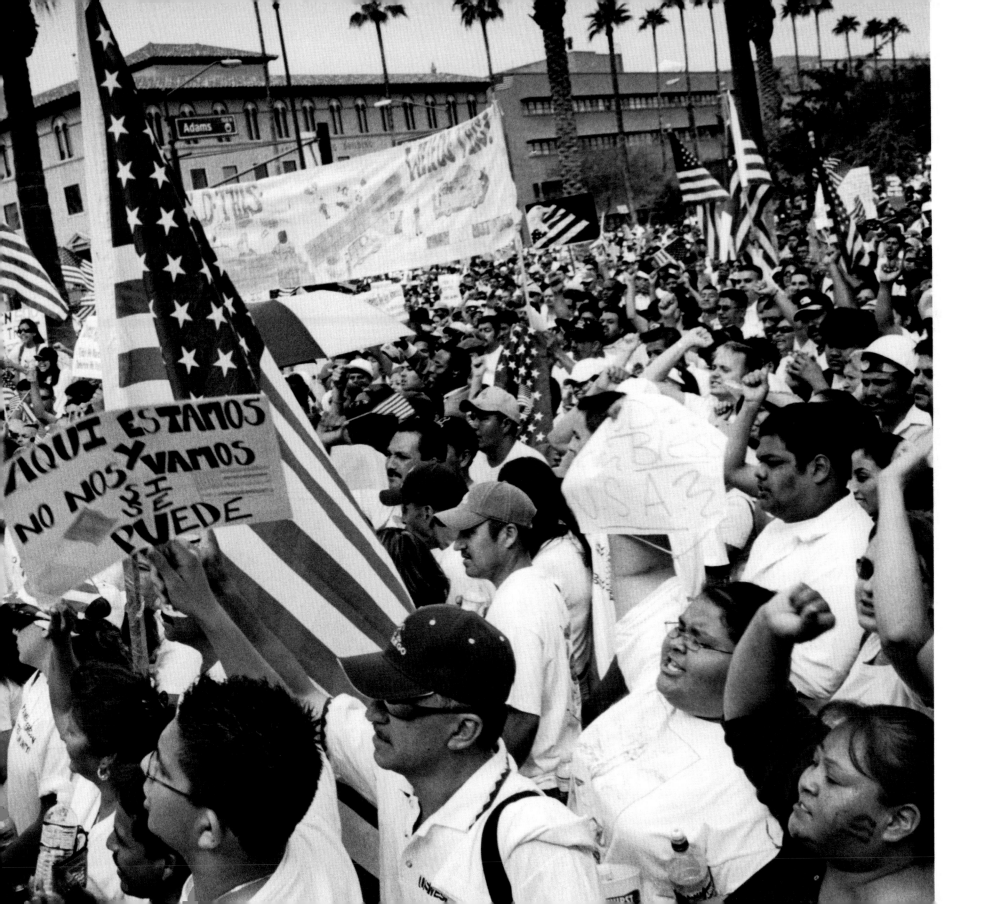

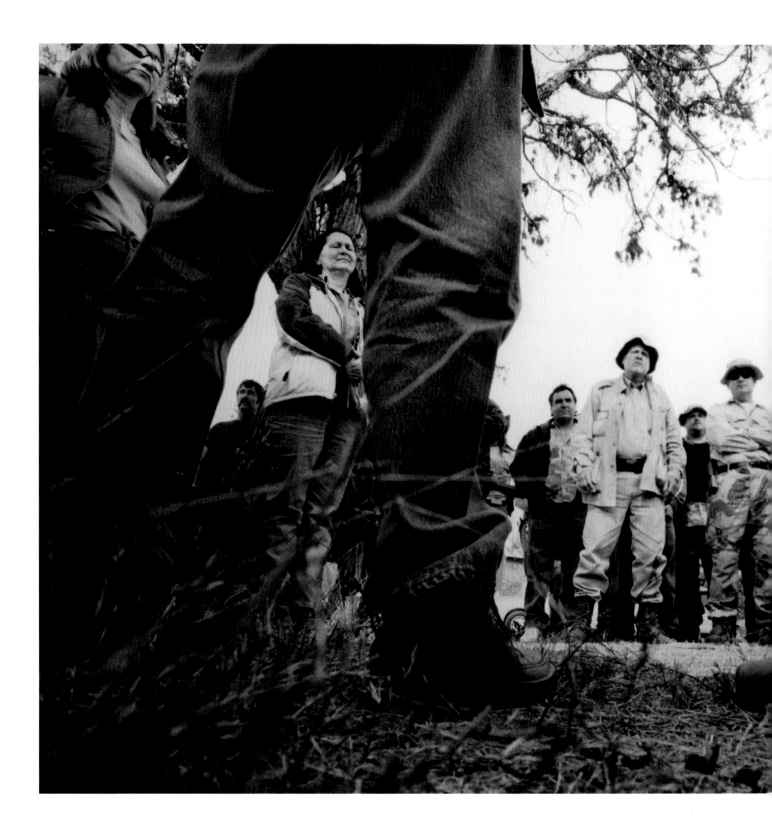

(70) *and Minutemen gather on the line in Palominas, Arizona . . .*

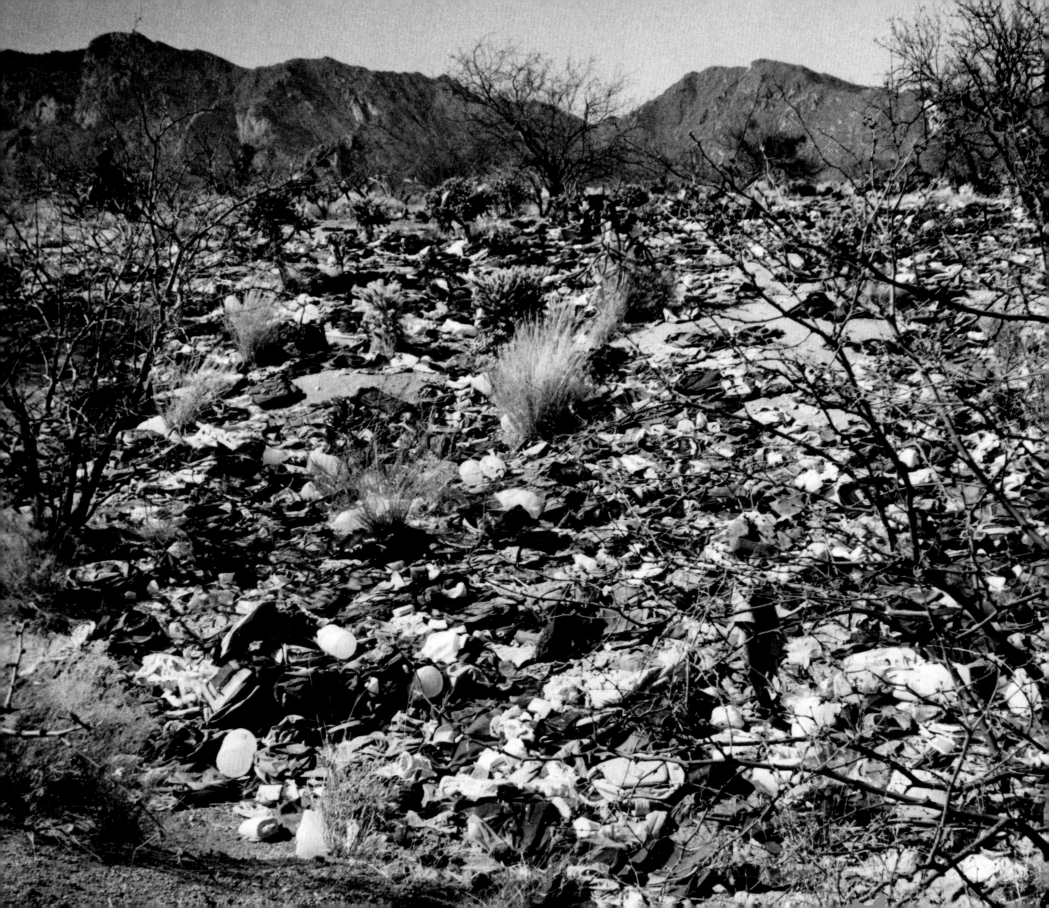

(71) *while migrants dump their clothes and packs
and change into a new life . . .*

(72) *after crossing a line open to the eye and closed according to law.*

part three

Motecuhzoma was so distressed that he could not calm his heart and was inclined to hope that the events that had been predicted would take place immediately and in this way he would know what the future held. . . . Because of these worries he called the chieftains of the barrios, asking them if they had dreamed anything. . . . The heads of the barrios told him they had dreamed nothing, nor had they seen or heard anything about this affair. Motecuhzoma answered, "Then I beg you, my friends, to tell the old men and women of the barrios to inform me of whatever dreams they may have had or will have from now on, be they in favor or against me. Also, tell the priests to reveal any visions they may see, such as ghosts or other phantoms that appear at night in the woods and dark places. Let them ask these apparitions about things to come. It will also be good to give this advice to those who wander about in the late hours. If they encounter the woman who roams the streets weeping and moaning, have them ask her why she weeps and moans. . . ."

FRAY DURÁN, 1581

a dream in the hole
in our hearts

THE GROUND IS POWDER, a fine reddish dust choking the lungs, clinging to the clothes and shoes. The mesquite cowers as low scrub, the fence sags and collapses from traffic. Everywhere sun pounds the earth. The safe ideas die here. I choke on the dust swirling in the air, eye the agents hidden in the brush. A bank of portable towers with powerful lights marches along the horizon. Out there, just past that thin line of battered wire, there, they are waiting for the day to fade. There are many names for them offered by agencies, groups, and politicians. There are laws to flog their brown backs. They wait and do not care. There is nothing left but the feel now, the hunger, the move. I stare at the soil and see thousands of footprints.

Julián stands beside me looking south with his camera. His eyes search for people. He wants that photo of *la gente* lunging north into the fine red dust. He lives and works in Ciudad Juárez. Right now, as we stand in the dust, death thrives in his city. In the past five days, there have been five executions, the killings of the drug trade. Two of the men were found buried, barely, in the desert, their hands tied, plastic bags over their heads, bullets carefully blown into their brains. Two workers strolling home noticed something amiss: an arm poking out of the ground, and then twenty feet away a forearm reaching for the sky.

We do not talk about the questions. The answer is right before our eyes and it walks. The questions are over now.

Across the wire is Agua Prieta, a muddle of 100,000 residents with thousands of Mexican migrants from the south waiting to cross the line. Something is broken down there, something that cannot be fixed and this thing, this broken thing, is hurling people at the wire.

On November 1, 1915, General Francisco Villa was crushed at this place, beaten by a singular failure: his trust of Americans. The General had always been careful about Americans and their property because he needed the United States as a source of arms. But while he was busy fighting his revolution, lost in the bloody sierras with his army, he had not learned that the United States had given up on him and sided with his enemies. He approached Agua Prieta on the line with his army and expected a token force. He met 6000 men in trenches with machine guns, men hiding behind barbed wire and seeing in the night with huge searchlights. They had been transported on U.S. trains across New Mexico to surprise the General. His army was slaughtered. Women, the soldaderas of his men, swarmed to the fence with buckets seeking water for the wounded. Villa himself comes to the wire to find out how this magical army had made it to this place. An American standing on the U.S. side tells him.

The General is unhappy at the news.

He says, "I want you to publish this. . . . I, Francisco Villa, will not feel responsible for the lives of Americans in my territory."

That American is shocked.

He asks, "What? Will you kill them?"

"Worse," Villa answers. And then he walks away.[1]

Something is broken. I know this in my bones. Villa, of course, is dead and gone and of no matter. It is in books.

In these books, after Agua Prieta comes Villa's raid on Columbus, New Mexico, and after that raid comes the Punitive Expedition, thousands of American soldiers hunting Villa in Mexico and finding nothing but dust and hatred. There are many songs, *corridos*, about all this and it is now like the dust swirling around my face. It is over. The revolution ended eighty years ago and the modern world began.

The General captures some American doctors after Agua Prieta. He plans to shoot them but first he tells them, "I will devote my life to the killing of every gringo I can get my hands on and the destruction of all gringo property."

The doctors kneel and pray and wait for death. The firing squad assembles but the General changes his mind. He does this constantly, wavers and falls under the spell of shifting moods. The General is not easy to predict. So the doctors live and Villa moves off into Mexico.

I tell Julián he is still out there, living under an assumed name, being ignored, living as a nobody, but out there. He smiles at me and then laughs.

We stroll the fence, see the broken wire, find empty water bottles under the bushes. See thousands of tracks heading north in the dirt. The searchlights that slaughtered Villa's army are back and stand for miles along the border, waiting for night. I am in a very good mood. There is nothing to do but wait for dark.

THE WOMAN STARES THROUGH BINOCULARS and she looks south. Her vehicle squats in the brush, the sides white with the insignia of the Border Patrol. I approach to talk and gently tap on the windows.

She jerks in surprise and then rolls down the window.

She says, "You frightened me."

Her face is thirty-something but the strain has taken over her eyes and they are much older. Gray strands shoot through her hair and creases are eroding her face.

I ask her if this is a good place to get a photograph of people crossing in the night.

She says yes, but it is very dangerous. Seven or eight migrant women have been murdered at this very spot.

The fear in her eyes.

Behind her is a searchlight on a tower. The lens stares south.

She tells me again it will be very dangerous here in a few hours.

I have to get out of here, I must leave behind illegal immigration, free trade, the global economy. I have to get this ringing out of my head, this buzz of words and policies and proclamations and commissions and solutions. I must go south. I must find the General. Something is broken. The General will understand.

In Agua Prieta, Julián met a man from Nayarit. The man wore a cap with a $ sign plus the outline of a naked woman. He fishes two months a year off the coast, then he is out of work for ten months. He has had enough. He said he was going north.

He had no direction, no relative to hook up with, no city to head toward. No destination.

I AM GOING SOUTH WITH JULIÁN.

He never knew his father, and his mother left him to the care of her parents, José Isabel and Rafaela. His grandfather was a farmer who formed an *ejido*, a collective, after the revolution. He tried to teach Julián the earth and its animals. When Julián was in his early twenties, he faltered after working for five years in a maquiladora, and with two friends decided to go back to that ejido his grandfather had helped found. The peasants agreed to let him join and have ground out of respect for his grandfather. It all came to nothing. His friends fell away from the scheme, Julián fell in love with a beautiful and rich woman. So it ends this way: He gives his patch of ground to another peasant and asks that, if possible, someday the ejido build a library or clinic and name it after his grandfather because, he says, "He was like millions of farmers treated by my country like animals. No one will ever know they existed and who they were."

The beautiful, rich woman marries someone else. Julián lives on the streets of Juárez for months. He does not explain this period except to make the point that he had it easy since he had money for food. Then he turns to photography, the beauty. He takes that first shot: two men dressed as clowns standing one atop the other's shoulders in traffic and begging for change. The man on top juggles.

He spends day after day haunting the central city, the market, the whores, the cathedral, the plaza. He is the thin, silent man, the one almost unnoticed. See him, right over there, in those shadows, that man holding a camera. These spells come and go but now he is in the midst of one. He will capture that eternity, that beauty amid the stench

and dust and dirt and broken glass and painted lips on the young girls soliciting in the doorways. And finally, as always happens, he becomes broken, worn out, and so he does what he must do. He goes to his aunt's house and leaves his camera with her. The house is teeming with cousins and their wives and their children. Everyone sleeps in shifts, everyone works in the maquiladoras. This is the safe house for Julián. So he leaves the camera for two weeks.

That is how he rests.

He creeps into the maquiladoras, a zone of work barred to the press except for company-controlled publicity shots. Julián has learned to shoot secretly in low light and so a flow of photographs begins—men and women looking blankly at the camera with eyes chastened by a five-and-a-half-day week. They are a nation of Mexicans from the interior suddenly meeting the culture of the machine and being broken to the habits of presses, drills, and assembly lines. Julián at night leans over the tiny light table in his room and stares at the images of the place he escaped, the dull grind he fled for the ejido, and then the streets and finally the marriage to his camera. No one wants these images. No matter. Julián is on his mission, and he takes his wife, the camera, with him into the mills.

FOR TWO DAYS, we've wandered the broken ground on the edge of the sierra where the General always found men and the government has always found trouble. The tacos and salsa verde before the second checkpoint, the sun eating our skin, all the eyes on us, flies buzzing, and the colonies, Mormons, Mennonites, and the villages of lean men with unshaven faces, the pines clinging to hills around the brown field, that girl in the tight black skirt and heels crossing the street at dusk, the air rich with promise of rain. The fat and happy couple in the café. The churches lonely on the old street.

Julián notices the willows green by the fields sucking off the ditches and the ditches fed by the streams of the sierra, cool, fat streams flowing eastward to die in the desert. When Julián was a boy, his city of Juárez was full of willows, and he would walk his barrio with these green hands stroking his shoulders, the long branches dripping leaves onto his life. Now the willows are gone, long dead, and the river, it is dry, channeled off on the American side. An entire water world he once lived and swallowed has vanished. Juárez is now dust, clouds of dust. No one swims in the river, the river of dust.

Julián says, "The city will have to create a dry culture."

He looks out at the oaks, the pines, the green fields, the willows, ah, they are weeping, weeping tears of green, and he says softly, "This is the Mexico of dreams."

He has never been here before. We are 150 miles from where he has spent his life.

The ground is rich with soldiers, long dead, wearing sombreros, riding hard, following the General. This was his pantry for gore. We drive for hours. Not a statue, not a sign, not a word about Villa.

THE COPPER WIRE SERVES as a guitar strap, and that somehow catches Julián's eye. He suddenly says stop, crosses the highway and waits for the bicycle. The man approaches on a beat-up old machine. He is dark, twenty-five, the clothes dirty, sandals on the pedals. The guitar is strung across his back. He looks puzzled, then slowly relaxes.

We are on the edge of Parral, the city where the General dies in a hail of bullets. The man on the bicycle knows nothing of such matters. He has heard the name but it has no meaning for him, he explains. He has never been to school, not a single day. His eyes are dark, the face a smooth mask, the words soft and careful. Slowly, he takes the guitar off, unhooks the copper wire, then untwines a second wire that holds the wooden body together. On the face of the instrument beams a smile decal. A foot away a scorpion symbol is glued on.

Julián crouches, he wants the fingers softly flicking the strings, the guitar spewing forth sounds, the man singing his song, wants it in one frame, but it won't work, the song is too long, too old, a howl coming from God-knows-where.

The guitarist cuts loose with his favorite song. The man says his song is about one thing—he wishes he'd never been born.

He cannot read, nor can he write. He says his name is Ismael.

He is finished, the song trails off. He has yet to smile. His voice, speaking or singing, hardly pushes past a whisper. In a moment, he rides off.

ON JULY 20 EACH YEAR IN PARRAL, the horsemen come. And they testify to the killing. There is a brass star on the sidewalk where the General died. A plaque on the wall. The building by the kill site is now a computer school for the children of the rich. The horsemen come for a duty. They take the General to the Campo Santo, this they do each year in Parral. The short, dark shoeshine man explains this as he toils over an expensive pair of boots and the Virgin smiles down on him from a banner pinned to his stall. The General is dying just 100 yards away, his body riddled with bullets and half sprawled out of his touring car. There is a silence on the street as the gunfire falls away. A fair-skinned man waiting for a shine offers that his uncle was a Villista. He got shot at Durango when he was eighteen and within four years the wound put him in a grave. The man explains that when he visited Paris, he read a book that said Villa was the Napoleon of the New World.

I listen, make notes, and feel the still of the afternoon.

I smell dust, hot air, the wax off the boots being polished, hear the motor car coming down the old street, heading toward that ninety-degree turn where it must slow, then the guns fire, Villa topples, and then the reenactments, the phrases, an old guitar with a copper wire for a strap, the sad song softly playing out in the morning light, the dream of never being born, and it goes this way: the revolution began in 1910, stuttered in triumph in 1912, then resumed when the leader was murdered, stuttered again in 1914, triumphed again, then Villa falters, talks across the wire at Agua Prieta, begins to kill the rich Americans, attacks the United States, becomes hunted by 10,000 soldiers, keeps living and killing, goes into the Bolsón and comes out of the fire to be spared by a government that cannot kill him with war so opts for the long death of peace, and once again the revolution triumphs, triumphs with one out of eight Mexicans dead, or one out of ten or one out of fifteen, who is counting?

Somehow the Mexican Revolution erupted and nothing happened except the dying. And now this does not matter.

History has become a briar patch we do not visit. We are of a different process and no longer must listen to sad-eyed singers crooning softly about their dream of never being born.

THE MIDNIGHT HOUR HUGS THE PLAZA in Durango as the red truck with the band in back slowly circles the last few taco vendors. Julián looks at the teenager driving the pickup and scowls, "Narco."

"How do you know?"

He looks at me with disgust.

Two hours before, we had hit an army checkpoint near a turn to a narco town in the sierras. The cool night air played against our skin as the soldiers rumbled through our suitcases. Then we drove on through a small pueblo and suddenly girls in twos and threes, all dressed well and with high heels, would poke through the night as our headlights ate their faces.

Then, Julián said, "There is a dance."

But now he says nothing. Now he just knows.

WE WALK UP THE HILL and away from the cathedral. Julián strides like a man on an errand. Zacatecas curls around us with its core of

colonial buildings. The air sags from car exhaust. He turns a corner and stops.

"It may be this street. Or the one just above on the hill," he says. "I don't know, but somewhere around here. Where I was born."

He is not smiling.

The last time I was here I went to a stall in the market and bought currency Villa had issued during the revolution. A cab driver told me he was a school teacher but survived by working six months each year in the slaughterhouses of Dodge City, Kansas. Just like the drunken Mexican on a train in the Sierra Madre once turned to me and said, "I am what you call a wetback."

Somewhere near here, Julián is certain, somewhere near here he was born. His face shows no emotion. His favorite book is a Mexican novel by Juan Rulfo, *Pedro Páramo*. In the book everyone is the son of Pedro Páramo and Pedro Páramo abandons each son and leaves him to eat the rock and dust of Mexico barred by hills from the rich hacienda of the father figure. "Páramo" means a harsh, dry desert, the kind of place like the Bolsón de Mapimí where General Villa in June 1920 eats fire and crosses with the ragtag band he has left, does this in order to prove he is still free and dangerous.

Juan Rulfo says, "There you'll find the place I love most in the world. The place where I grew thin from dreaming. My village rising from the plain. Shaded with trees and leaves like a piggy bank filled with memories. You'll see why a person would want to live there forever."[2]

Julián lectures me from time to time on Pedro Páramo, on how I must understand. For students of literature, Rulfo is the pioneer who inspired Gabriel García Márquez, who in turn unleashed clouds of butterflies, a century of solitude, and the velvet knife of magical realism. Rulfo wrote two books, one about Pedro, the other a loose set of stories, then he fell silent for decades and quietly died full of unspoken words. Americans find him unreadable. Or find him dull. Or find him toxic. We demand solutions. The world of Pedro Páramo offers no hope, not even as a hint—the world of Páramo is thronged with orphans wandering the hard stones looking for death.

"Have you asked?" I blurt out.

"It doesn't matter," Julián murmurs.

Then we go up the hill to the next street and there look also at the rows of doorways, one of which may have been the entrance to his birth.

THE TEATRO ACROSS THE STREET is very important because it is there in the fine lobby that Julián meets her. She is rich and she is beautiful and she is intelligent. He is in his twenties, has done five years slaving in a border factory and permanently damaged one eye from the work, and bought a camera. He has returned to Zacatecas, his birthplace, and now in an instant he finds love.

He rolls these words off his tongue, savoring each syllable and moment, as we sit in the café with espresso across the old street from the theater. Just up the hill is the house where he was born, if only he knew the house. Somewhere around here are his father's people, if only he knew the people. His father is a blank to Julián and he prefers to keep him that way. He is not discussed. Now he is dead and buried someplace. The father was and is an accident in the saga of yet one more son of Pedro Páramo.

All life for Julián begins with his grandfather and grandmother and he always calls them his mother and father. They raised him, fed him, and taught him. They supplied the piece he considers himself, the piece he feels is missing when he walks the streets of Zacatecas looking for his birthplace and then muttering that its location does not matter, does not matter at all. Election banners flutter overhead on the calles, cars go past with loudspeakers booming out the virtues of candidates, one has a beautiful young girl sprawled on the hood, she looks over at us and waggles her full breasts.

THE WOMAN HAS EVEN TEETH, and her broad body hosts a voice rich in passion. She teaches in Zacatecas and reads aloud one of her students' stories: Pancho Villa wanders Mexico looking for his shade, for that part of him killed when he ceased to be Doroteo Arango, his real name, fled into the hills as a bandit and became this legend. He kills here and there, and always he kills to find this shade, this part of himself left behind so long ago. He levels Zacatecas with cannon and then wanders the rubble now soaked in light trying to ferret out his shade. And then in Parral when the bullets finally find him and he spins into the warm arms of death, then at that instant his shade rejoins him and he is whole. Dead and finally alive.

I hear the rich Spanish of the woman's voice, she is holding the essay in her hands and the words burn as she reads. There is this piece missing in us, our shades, and we look for them, search everywhere. Julián sniffs the air.

Jesus, her voice is on fire, her fat body a volcano. And by her side, Julián stands, and I can hear the air rush up his nostrils as he searches.

ZACATECAS IS TAKEN BY THE GENERAL when Julián's grandfather, who of course he calls father, when his father is fourteen years of age. And he walks through the sacked city and he steps from one body to another, a carpet of bodies. Then came the plagues, strange diseases seeping from the bodies as they rotted. The Villistas try to draft him and make him bear arms but an uncle somehow prevents this act. And there is no food.

He looks down at the toddler he calls Julián and he says, *"Mi hijo,* my son, I lived *la pena negra,* the black sadness."

His grandfather walked north to La Laguna but there was no food. He entered the fire of Bolsón. He says it was terrible.

But my God, the old man loves Villa. Julián never asks why. Things simply are. The old man loves the corridos about the General, sings

them to himself. He tells Julián about the time the General takes Juárez through sly moves with the telegraph. He tells how a rich man raped the General's sister and how young Doroteo's revenge sent the General onto the outlaw trail.

The grandfather is known for his ability to weave rope, very strong rope. He teaches the boy that women are like horses, you cannot break them until they are full and ripe, until they are strong. Otherwise, they will seek revenge. Remember this, *mi hijo.*

His grandfather's eyes finally settle on a girl. This Julián learns from his grandmother, his mother. Neither one has ever been inside a school so they hire people to write letters for them. Each day they leave their notes under a rock by the spring near the village. Each has friends to read the letters to them. This way they feel their way into their love. Her father approves of the marriage because he sees her future husband as a hardworking man, though he smoked and drank. Years later, the grandfather quits these habits to prove that he is a strong man.

In the years when the Americans fight the Nazis, he goes to Canton, Ohio, to work on a railroad. He says little of these years in the strange land. Instead, the grandfather tells the boy Julián he must always work hard. And that he must consider eternity, because his grandfather is a man with his eye fixed on God.

"As long as I knew him," Julián says softly, "he wanted to die. He wanted to be with the saints."

He would say things like "Ah, Julio, I'm going to die. And then I will give you my hat, my pickaxe, my shovel, my hammer."

Julián tells him the Virgin is a fake story and the old man would get angry. But still, he is the father and he never wavers in his desire to leave his hat, his pickaxe, his shovel, and his hammer to his boy.

His mother, she feeds the boy, she tends to his clothes, always making sure he has clean clothes. She never argues with him about his lack of faith even though she is as religious as her husband. She hardly ever

corrects the boy, maybe three or four times in all those years. When he begins to disappear into photography she says nothing. Except when at twenty-two he takes a self-portrait of his face staring into the mirror with fierce eyes and what look to be holes from bullets. She likes the photograph and so he gives it to her.

Once, Julián takes a photograph of her. She is reading. She never really learned to read, but she kept trying.

Another caravan of cars comes by all decked out with banners endorsing a candidate. Each car this time has young and beautiful girls on the hood and they all have wondrous breasts and they share them with the people on the sidewalks as they slowly move past.

We never find the house where Julián was born or was not born. It does not matter, he tells me.

Once when he was showing me photographs, he turned and asked, "Have you ever noticed what sad eyes Mexicans have?"

When he was a boy living in the barrio with his grandfather and grandmother, he dreamed of being an architect. But with time this idea slips away. Julián explains simply that he is of the wrong class.

A car passes, another girl on the hood, the smile blazing with neat white teeth, the skin brown and glowing, eyes dark, blouse screaming against the breasts, not a worry in the world.

JULIÁN KEEPS INSISTING on the importance of *Pedro Páramo*. Without Juan Rulfo's novel, there is little hope of understanding. The book has barely begun before it explains, "The road rose and fell. It rises or falls depending on whether you're coming or going. If you are leaving, it's uphill; but as you arrive it's downhill."[3]

He sees it as the map to the thing called the Mexican mind despite the fact that almost no Mexicans have ever heard of the book, much less read it. The father is a desert that consumes everything and leaves his offspring nothing. And to leave, you must travel uphill.

We go into a student bar and I start drinking. And then Julián decides I must taste a special cactus that grows in Zacatecas and we move to a small café that features the dish stuffed inside tortillas. The woman toils patting the tortillas and frying the stuffings while a television flickers absentmindedly on the wall. The woman patting the dough has a dark face, the woman on the screen is fair-skinned and wears a tight sheath and lights a long, slender cigarette.

Julián explains that all Mexicans want to be the hero so that their names and lives will not be lost to history. That is why they do not care what works or does not work, if a project is sound or unsound. They merely want to be the hero and the hell with the rest. By his count, he rolls on, only five heroes have appeared in 500 years. Cuauhtémoc, the Aztec prince who endured torture and refused to tell the Spaniards where the treasures were hidden. Father Hidalgo, who launched the first revolution in 1810, and of course, was slaughtered. Benito Juárez, who cast out the French. Emiliano Zapata, who fought the dictatorship and of course was slaughtered. And Villa, but not quite. Villa, he explains, is only half a hero because the rich and powerful hate him and fear him and only the poor love him.

All the other Mexicans, he says in a clear voice, a voice full of comfort, are dead, including the ones that are alive. I bite into the *gordita*, the cactus pad is smothered with chile. The walls of the café scream yellow, blue, and pink. The woman on the screen lights another cigarette, and the smoke curls from her red lips.

"All Mexicans," he intones, "want to be the hero, the leader. Nothing else matters. Being the hero is the only protection from death."

Once, Julián covered a Mexican presidential candidate when he visited Juárez. Normally, such a personage only moves within a diamond of security, with guards and supervising generals at each of the four points of the diamond. But this candidate had no such belt of safety. And he moved freely and plunged into crowds. Julián was stunned. The

man seemed very relaxed, absolutely at ease. There could only be one explanation for such behavior: The man knew he was already dead. Twenty-three days later, he became officially dead when bullets mowed him down at yet another campaign swing in yet another city.

THERE IS AN EXCHANGE IN RULFO'S *Pedro Páramo*. It is simple and clear, a few lines tossed back and forth between friends.

"And your soul? Where do you think it's gone?"

"It's probably wandering like so many others, looking for living people to pray for it. Maybe it hates me for the way I treated it, but I don't have to worry about that anymore. And now I don't have to listen to its whining about remorse."[4]

THE EJIDO SLUMBERS in the morning hours. It is on the edge of Zacatecas, a community founded in the 1920s in the aftermath of the revolution. Julián's grandfather was one of the original members. But that was then. Now the ejido slumbers, sleeps so soundly that some of the people who dwell within it do not know its name, *La Escondida*, which means hidden. Nor is there much memory of its founding and Julián only knows the scraps his grandfather told him as a boy. He has hesitated in coming here and gets out of the truck with reluctance. I go into a small tienda and buy some Cokes. Outside, we sit on a board propped up on two milk cases. The streets in the ejido are dirt and old bedsprings work here and there as fences around the small homes. On the wall of the beer store, someone has spray-painted the outline of a man but this man is headless.

Julián broods. In a while, we must go and pick up a $2000 color processor that he has stored for years with his family members in Zacatecas, and I suppose crating up this machine is what occupies him. I am at ease in the dust and flies and busy absorbing the new geography of the huts trailing up and down the banks of the arroyo that knifes through the hamlet. The fields are off half a mile, near a stream. There is no whiff of work in the air this morning. A small child plays with a toy army truck in the dirt, radios blare from various households and there is no shade.

Julián points across the arroyo, past the *noria*, or well, where his grandmother and grandfather secretly placed letters under a rock when they were young and full of lust, letters they could neither read nor write. He points almost feebly with a languid air to a church squatting across that arroyo and says his grandfather's house is over there. This is the house he occupied years ago, returned to when he fled Juárez and its mills, the place he was going to return to the Mexican earth, get square with himself and the planet, raise cactus and live simply, become the essence of that vague word: Mexican.

He says, "I don't want to go there."

I say nothing. We have traveled in a desultory way for 1000 miles, dropping in here and there on the haunts of the General, but still ambling toward a place, and the place we both knew was this ejido and that house, the house of dreams and mud and the past and the revolution, the place where the walls held his grandfather's shade and this shade could whisper to us about crossing the city the morning after the General's successful siege and stepping lightly from body to body in those bloody hours before the plagues came and the black sadness.

I look at the small church, a pale green thing rising slightly above the adobes of the houses. The adobes, like the ground itself, gleam a rich red in the morning light. Some chickens scratch across the road and the rest is silence. I can feel everyone in the pueblo watching us.

Julián came here with friends from the city to find the floor of life.

"We wanted to have a part of the ejido," he says softly, "to raise cactus, to save certain species of *tunas* because the tunas, the types of prickly pear, are dying out here. No one protects the tunas. I don't know why. They have abandoned the tunas."

Two scraggly dogs come near and then sprawl under the shade of a truck. When Julián and his friends came here to raise tunas, the people of the ejido listened and traced out in their heads his blood links through his grandfather, and then they gave him a piece of land to work.

He sits by me on the board bench, his camera in its case by his side. He is all but frozen by the sight of the pueblo and cannot stir to make a picture.

"It took millions of years," he says suddenly, "to create the tunas and now in fifty years they are dying out. Now, my aunt says, they are hard to find. When I came here to work, my cousins in Juárez could not understand why I was doing this."

I go back into the small tienda for more Cokes. On the wall is a cheap poster featuring Spider-Man, Superman, Batman and Robin, and Wonder Woman. A rooster crows, the low rumble of trucks on the highway into Zacatecas rolls through the air. Flies buzz. And then more silence.

"When I was in my twenties," Julián begins yet again, "I thought the cactus, the *nopales* with their tunas, I thought they mattered. They only need water once or twice a year and there is little rain here. This land is easy for nopales, hard for *maíz.*"

A piece of paper blows lazily down the dirt lane, Julián falls silent as it passes.

"We told them," he says, "we were here to find nopales. Nothing more. No one cared. They were only interested in whether I had a legal right to be here. A friend came down with me once. He thought the city of Zacatecas was beautiful. I can't remember what he thought of the ejido. He saw my grandfather's house, took some photographs. He said it was okay. But he was sick, sick in his stomach. But he came here because he said the work in the border factories made him feel empty.

"This place was a fantasy for all of us. The fantasy was to not be in a movement, to not be in a factory, but to finally be trying to use the natural resources of your land and the intellectual resources of your land, to be free of external forces. But farmers are never independent.

"When did I surrender the fantasy? When my friend left, when he lost the will for this thing, I realized I was investing money in this dream and it would not be possible. The fantasy took help. It took money. When we began there were three of us. When it ended, there was just me."

We stare off at the little church across the arroyo and there just to the left is his grandfather's house, the building he took for his dream. The walls are broken, the roof gone. A woman is washing clothes nearby. She stares at us.

Julián suddenly says, "In Mexico, the dead are alive and the living are dead."

And that is when he finally gets up and we go to the truck and rumble down the dirt lanes to the house of his aged aunt.

Her home sits on the steep lip of the arroyo, just across the way from the *noria* where her parents exchanged those letters full of love. The front room is empty. Once the family used it to make tortillas for sale but then this ceased, just stopped, things have a way of stopping and there is no need of an explanation. The air buzzes with flies and then we enter the light of the patio with an old yellow dog looking warily and tubs green with flowering plants.

Julián disappears into an open door and then suddenly I hear his voice get louder and he is saying, "Julio, Julio, Julio." There is silence and then the soft moaning of another voice and this voice raises ever so slowly and then the voice fills with tears.

Julián returns and says his aunt did not at first recognize him.

I go into the room. She lies on a sofa, her hair gray and black, a blanket over her body. She is blind and almost deaf. In the corner, a television set babbles with a children's show. On the wall over her head, Christ watches, the Virgin also. The blanket on her body is purple, white, yellow, red, pink, blue and green. The cement floor has been painted blue. Family pictures stud the walls: there is Julián's grandfather

when he came back from Canton, Ohio, and his work during World War II. He is wearing a suit. The suit was painted on. Only his face is actual.

Julián leans over his aunt and shouts. She stares blankly. The walls of the room are pink, the roof a sheet of corrugated metal. A cartoon elephant is speaking from the television.

The old woman, lying there deaf and blind, her body shot but in good flesh, her breasts full, her eyes blank, she rolls off name after name and for a minute she and her nephew review the family members and catch up on news. Her voice is a low moan, a thin voice almost coming from the grave. Above her on the pink wall, someone has nailed a horseshoe. Beside her a tapestry displays a woman walking a tiger on a leash. Next to that is a real photo of Julián's grandfather, one also taken when he came back from Ohio. In this image, he wears no suit. His body is encased in blue overalls, his hat a torn straw sombrero, his shirt is also torn. I look out the window, a red rose blooms.

Julián turns to me and says quietly, "This place is worse than fifteen years ago. That is why I never want to come here."

The old woman slowly sits up, and her seventy-two years weigh heavily on her. She stares blindly. Food no longer interests her. Her stomach is now bad. She knots her hands in her lap.

She has spent every day of her life in the ejido. She says she does not know the name of the ejido. She says no one does.

Her life has been work. She swept. She carried water. She ground corn on her stone metate. She went to the fields with their red dirt. Her happiest times were when she was strong and could work. She did not work for money, just for food.

On the screen, children are singing to an old man.

The voice of the old woman seems to come from a well. Her father told her that he was in Zacatecas with his uncle right after the siege. His uncle took his hand and they walked. The streets were full of bodies and down at the train station there were even more bodies. The bodies were gathered, piled up and lit. As they burned the limbs twitched and moved about.

She falls silent here and stares out from her blind eyes.

Then, she continues, they went to the Bolsón de Mapimí to look for food. She says she does not know if the General was a good man. She can't remember. Maybe, who knows? Maybe he was bad? When she was a little girl, an old man in the ejido told her stories about the revolution. He told her that when he died he would come back to her as a ghost. That is all she remembers of the revolution.

She asks Julián if he gets cold living so far north on the border. He says no, *Tía*, I never get cold. And then the old woman falls silent again and returns to watching the world through blind eyes.

After an hour or two, we leave and as we drive up the dirt lane away from the house, it disappears, disappears absolutely and soon in a minute, maybe two minutes, it never existed at all.

Finally, Julián crosses the arroyo. We pull up to his grandfather's house, the one Julián returned to when he was going to save the cactus and save himself. It is a ruin. He refuses to get out of the truck. He cannot pick up his camera. Black pigs root around nearby. Dying nopales face the sun.

We go to the whores. On the edge of the ejido is the district of brothels for the city, a walled fortress with one entrance. In the center is a large parking area and this is surrounded by the clubs. They are idle now in midday, and only a few taxis come to take the girls into town on various errands. Fifteen years ago, his grandfather's ejido permitted the whorehouses to be built. Julián's uncle told him it would provide good work for the women of the ejido, that there would be many sheets to wash. We sit in the truck and stare at Club El Padrino, the Godfather.

Julián says nothing.

Then he repeats, "Now you know why I don't like to visit my family."

Juan Rulfo begins his novel in this way and his way is the way to go home: "I came to Comala because I had been told that my father, a man named Pedro Páramo, lived there. It was my mother who told me. And I had promised her that after she died I would go see him. I squeezed her hand as a sign I would do it. She was near death, and I would have promised her anything. 'Don't fail to go see him,' she had insisted. 'Some call him one thing, some another. I'm sure he will want to know you.'"[5]

WE GO INTO THE CITY to yet another aunt's house to pick up his color processor. We have bought wrapping material to protect the sensitive instrument. Julián disappears into the house. And then he comes out.

He says, "Let's go."

The color processor is gone.

"What happened to it?" I ask.

Julián says it is gone. There is no reason. Things happen that way.

He barely speaks for hours.

Finally, I ask why he took no pictures at the ejido.

"Pictures are for eternity," he murmurs. "I do not need pictures for my feelings."

I WAIT OUTSIDE THE HOLE. Julián vanished an hour ago. We drove into the hot wind of the Bolsón de Mapimí and came to this hole in the ground. A small road went off to the left and we followed it up the mountainside. The lane was one car wide and fell off to the side as we edged our way along the cliffs. Up high, the abandoned stone buildings suddenly came into view. We parked and then Julián vanished into the hole.

We are in the black sadness. The hole swallowed up his grandfather after the siege of Zacatecas, after the burning bodies writhed in piles.

He was fourteen or fifteen years old when he went into the hole and he was very hungry. The mountain is silver and the mine opened late in the nineteenth century. The investors were foreign, the men and boys in the hole were Mexican.

I look out into the Bolsón, a frying pan with a setting sun. Up the hill is the old stone casino where the mine's management played in the evenings. Just over the ridge is where the Mexicans were quartered. There were ten or fifteen thousand people here then to claw at the hole and to find a way out of the black sadness. It is a footnote in some book somewhere. A wooden suspension bridge crosses the canyon at my back and it is precisely 1.75 meters wide, 315 meters long, and 95 meters from the canyon floor.

Julián is deep in the earth looking for his grandfather whom he calls his father. Out in the Bolsón, the General is crossing in the June heat of 1920. The mine is dead now but there is talk of reopening it. Foreign investors are interested once again. It can all begin yet one more time.

The election, I forget which one, is going on down below. Earlier, when we left the highway, we had to wait for a funeral procession to reach the *campo santo*. A sign painter was finishing a candidate's message on a wall by the road. There is agreement among all the parties and candidates and they all stress the need for change. There is also a small cult of the General. People gather in bad rooms in poor places and hold séances to beckon the General's return. When he comes, he says, "You will not die of hunger, for it is not my wish." The people in response shout, "Viva Villa!"

Because, of course, my General is not dead but is alive. He is not like the empty living ones around me. He cannot really be killed. When a Mexican politician came to visit Villa at Canutillo, his retirement ranch after he survived the burning Bolsón that now stares me in the face, well, when this politician came, Villa showed him all around his property. They would sleep out on the land. But in the night, Villa would

vanish and go off by himself to sleep in a place no man could ever find. A newspaperman came about the same time to do a story on the retired General. He was walking with Villa and waited so the General could go ahead. Villa paused and then explained that no man ever walked behind him.

So do not tell me he is dead. He is in his grave and very much alive. We all know this in the night when we awaken, the sheets wet with sweat. We can feel him at the edge of our black sadness and he is marching.

I sit and wait for Julián. He is still in that hole, deep in the earth where they say there are riches. He took his camera, maybe he can finally open his eyes in the dark. His grandfather went into the hole a boy and came out a man. He told Julián it was very hard.

The General is out there in the Bolsón. I am certain. The desert is 700 miles wide and empty of water and they say no man can cross it with an army. They are quite confident of this fact. He is out there. I can hear him spurring his dying horse. The men grumble, the future looks like desert to them, the sun is setting, melting the mountains into pastels, the hot breeze caresses my face, a cold hand is on my shoulder, the horses of the army make clicking sounds as they stagger and their bones rattle against each other, skeletons sit astride rotting saddles, yet still they come, an army of skeletons heading toward the water and fat cattle said to flourish at the edge of the Bolsón.

The election, all the elections, I'm sure, will be flawless. Such events are essential to assure us that the General is dead. They must all be dead, it must all be over. This is our deepest wish. Still we worry. When Villa went to Canutillo with his men and ceased his war, he took things with him. He had caves in the mountains and they held thousands of arms and God knows how many rounds. No one has ever found them and surely by now they are rust and of no consequence. Besides, what can a headless man do? How can such a creature speak?

The stars are appearing here and there in the sky. The Bolsón is vanishing into the soft cloak of night.

Julián finally returns from the hole in the ground. He says nothing but numbers. He tells me how many shafts there are in the earth, how long each gallery is, how deep the probes go into the bones of the old mountain. He tells me his grandfather was a very fragile soul, that each time someone died he would be distraught for days. Yet he went into the hole as a boy and came out a man. He loved to talk of Villa. He knew all the songs.

Then silence. Julián has nothing to say. He looks into the Bolsón, into the impossible heat and empty ground no man can cross to get to the fat cattle and rich fields.

I hear the song the man sang by the road just outside Parral, the song in which he wished he had never been born. He said it was his favorite song. But of course he did not get his wish. They say one out of eight or ten Mexicans or fifteen died in what they called the revolution. They say the economy of Mexico did not recover for thirty years. They say it was all foolish and accomplished nothing. They say we know better now. They say the General is dead.

The stars flood the sky over the inferno of the land.

mist

THERE IS A MIST CALLED THE PAST and we only catch glimpses and then the mist swirls and we see nothing more of that ancient country. Fray Diego Durán writes *The History of the Indies of New Spain* in the sixteenth century. He knows the ancient language, Nahuatl, and puts on paper the culture of a lost world. He also knows its destruction since one of his mentors had been a soldier under Cortés.

His manuscript vanished into the dust of a library in Madrid and was not known to the world until the late nineteenth century.

As a seal of his friendship, King Achitometl gives his daughter to the newly arrived Aztecs so she can become a goddess and the wife of the Aztecs' god Huitzilopochtli. The Aztecs accept her early, take her home, kill her and flay her and have one of their young priests wear her skin.

Then the king comes with his court to celebrate the marriage. He enters their temple, a dark place, because the Aztecs tell him, "Lord, if it pleases you, you may enter and see our god and goddess who is your daughter, and make reverences to them and give them offerings." The king sacrifices birds, wafts incense into the air. Finally, he sits in this murk beside a priest and then realizes the man is wearing his daughter's skin.

He reacts with horror and rage and the Aztecs are driven into the lake that then dominates the Valley of Mexico. They are puzzled by this reaction. They wander the water and finally come to the place promised by their god, and they cry out with joy and say, "We have found the promised land."

That is how one story begins in the mists of time.

If Mexico really has a beginning, since, as the good priest Durán notes, there are peoples and legends leading into deeper mists and they came to this ground long before the Aztecs.

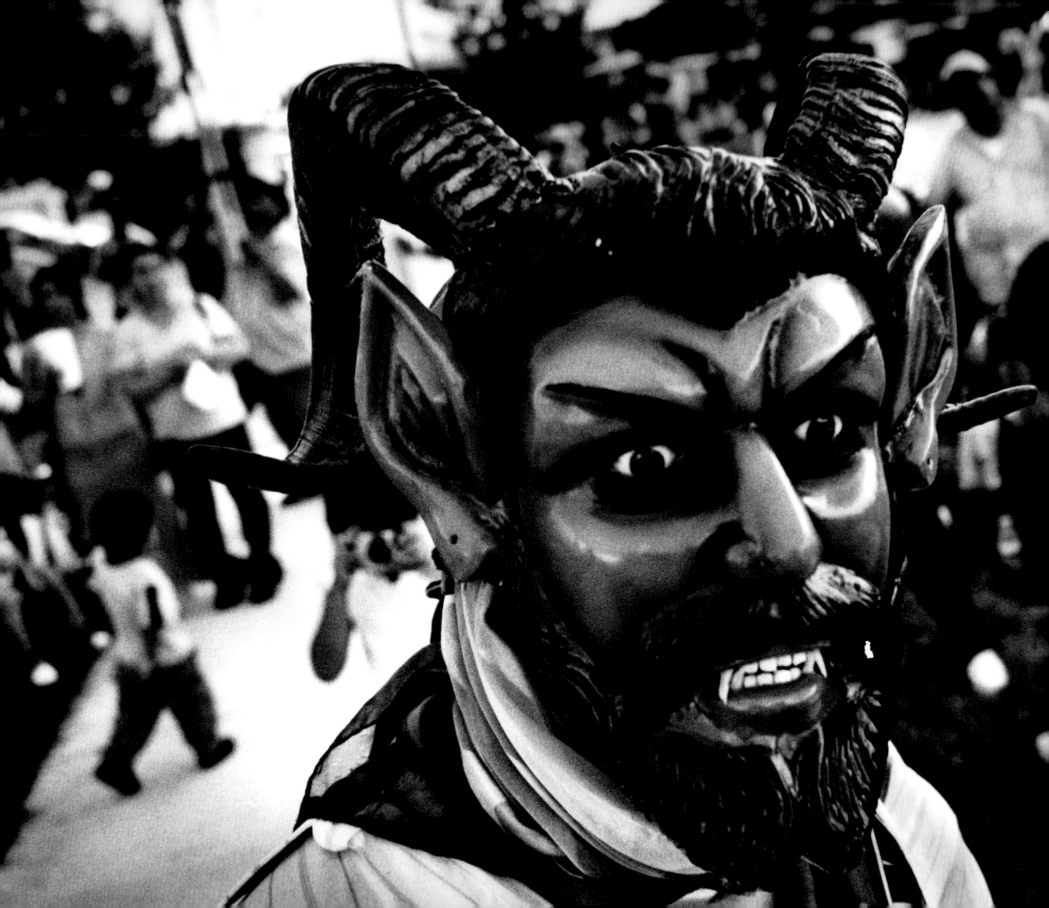

(73) The dance to the god Ruja,
a request to end slavery, in Arvin, California . . .

(74) *Mixtecs dance in Arvin . . .*

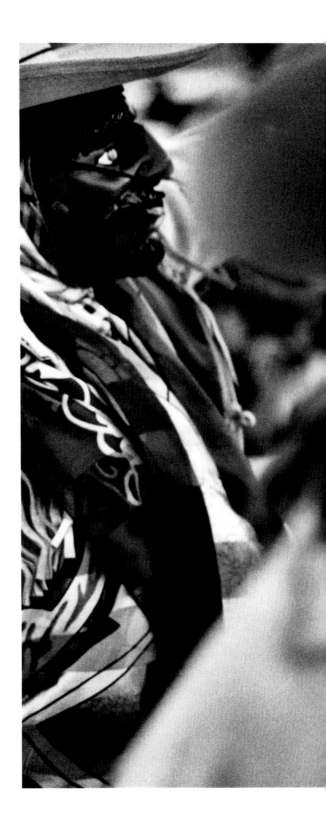

(75) and migrants go through the wire near Douglas, Arizona . . .

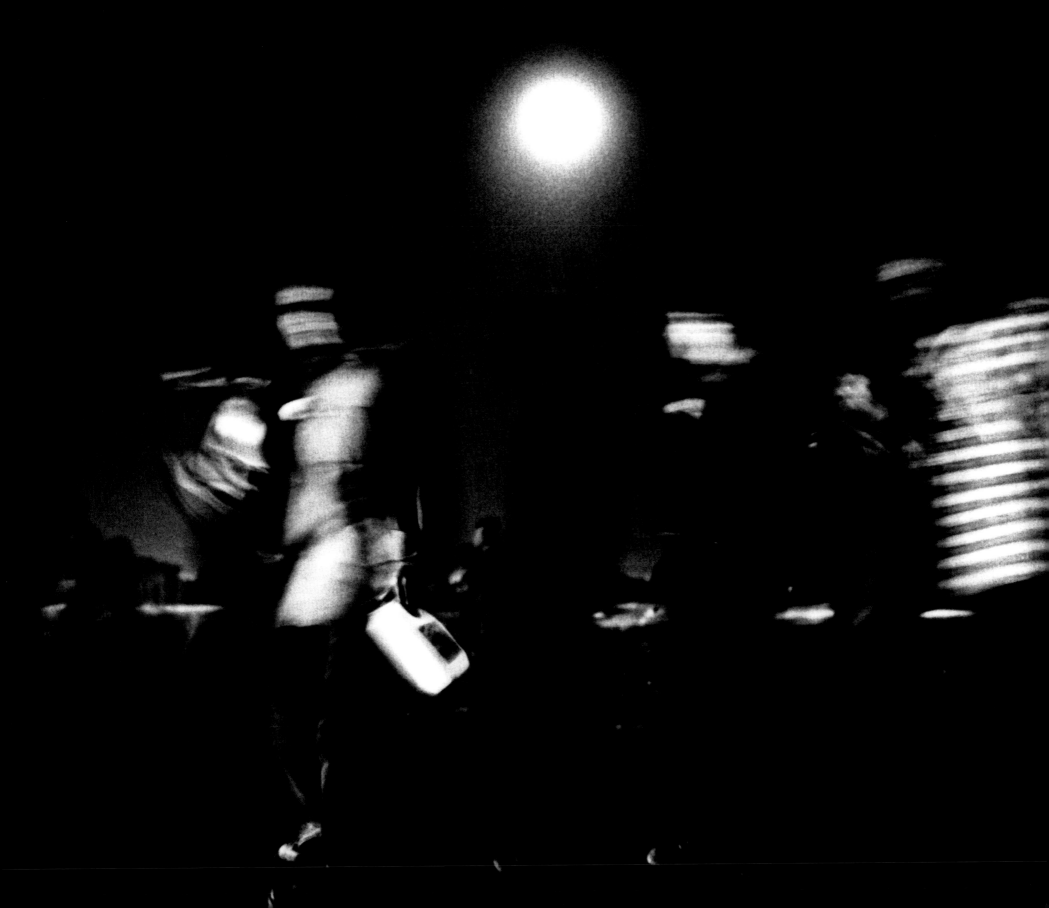

(76) while an Aztec Eagle Warrior dances in Los Angeles . . .

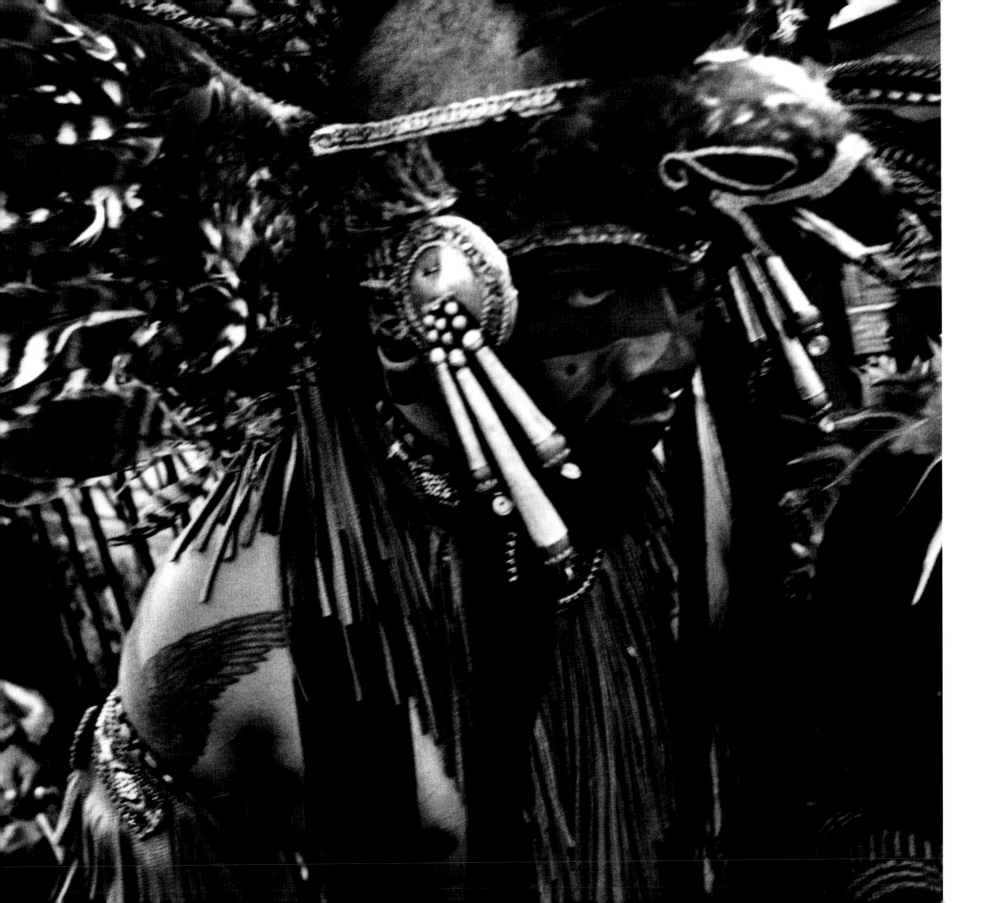

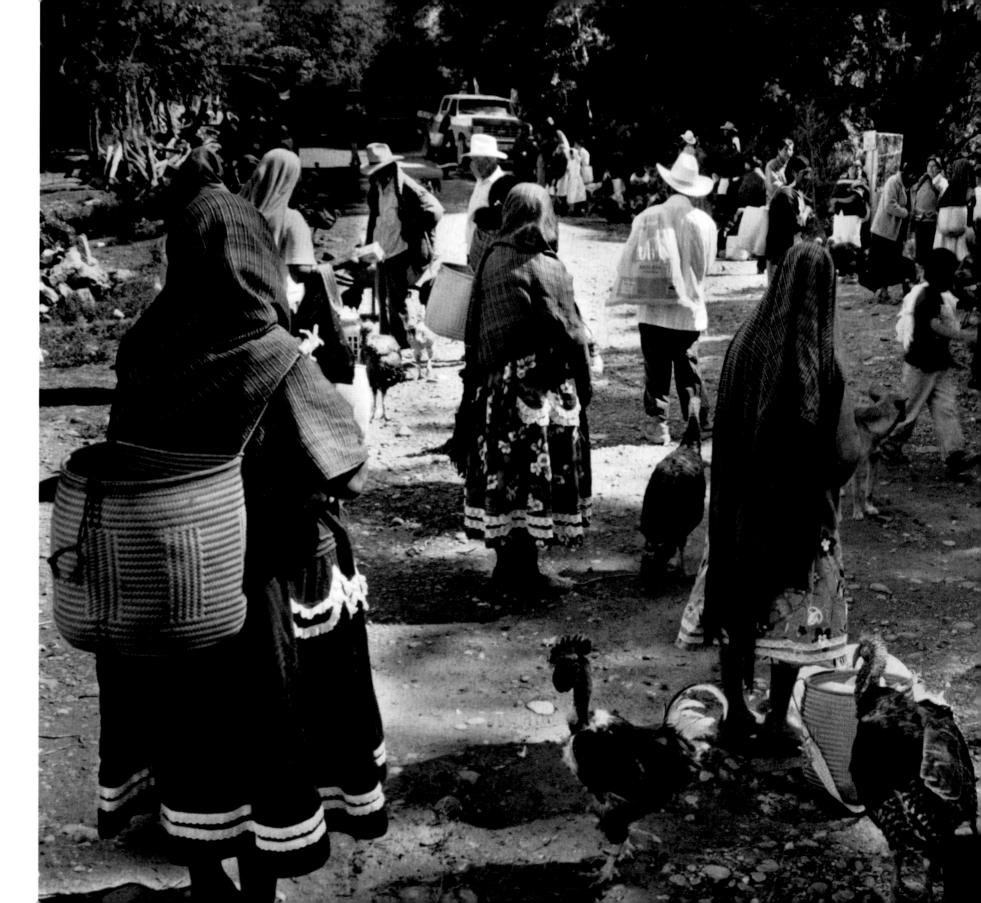

(77) *and in San Juan Mixtepec, a traditional market takes place . . .*

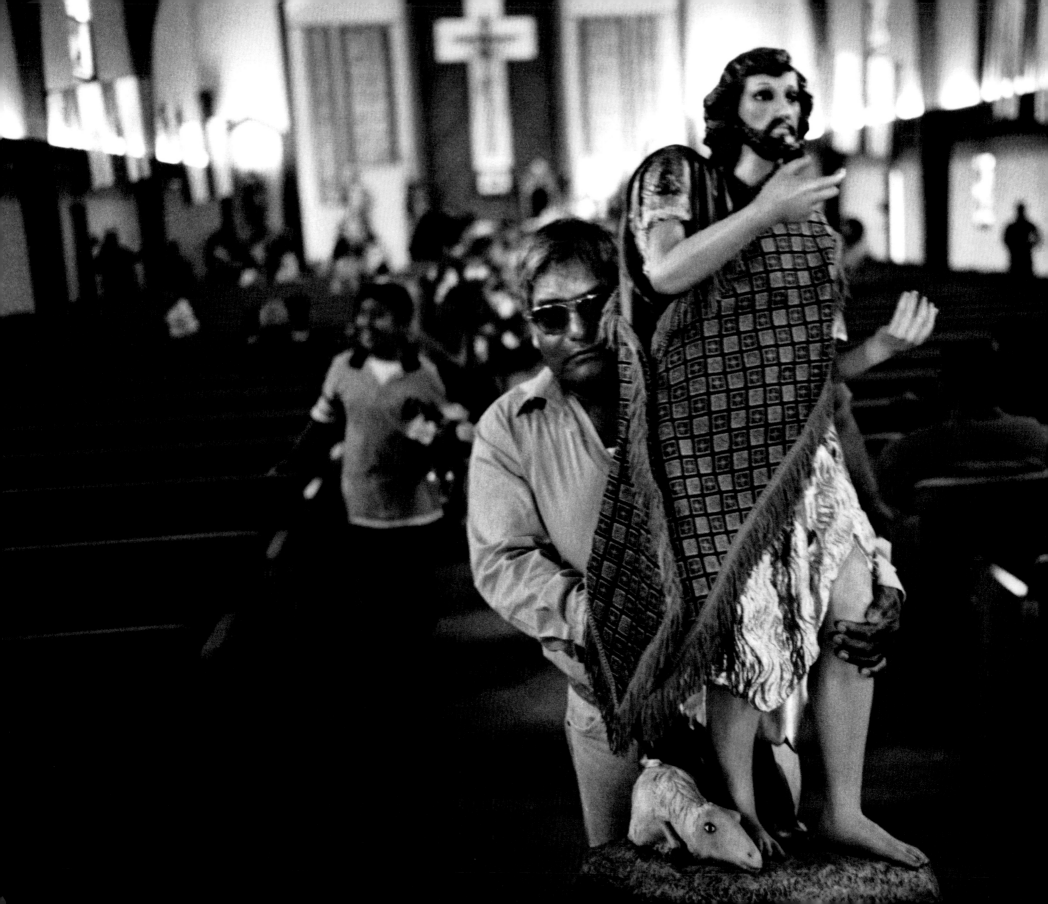

(78) and St. John the Baptist, an exact replica of the one in Oaxaca, enters the church in California . . .

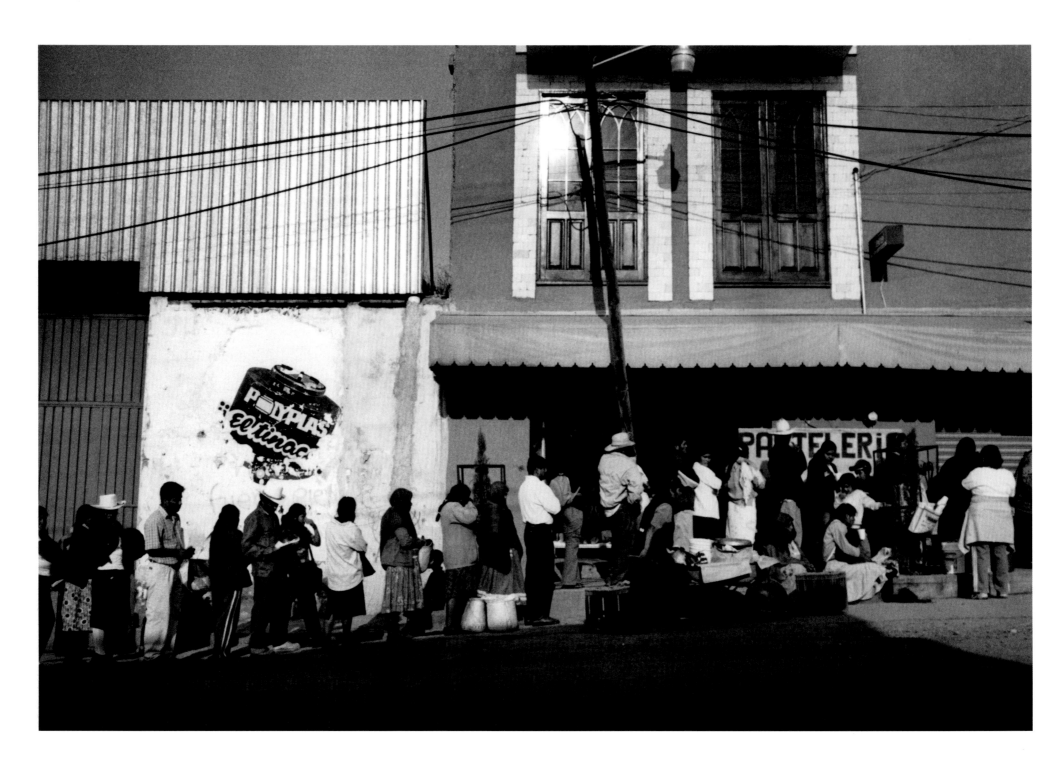

(79) *and in Tlaxiaco, Oaxaca, relatives line up for money wired from the U.S. . . .*

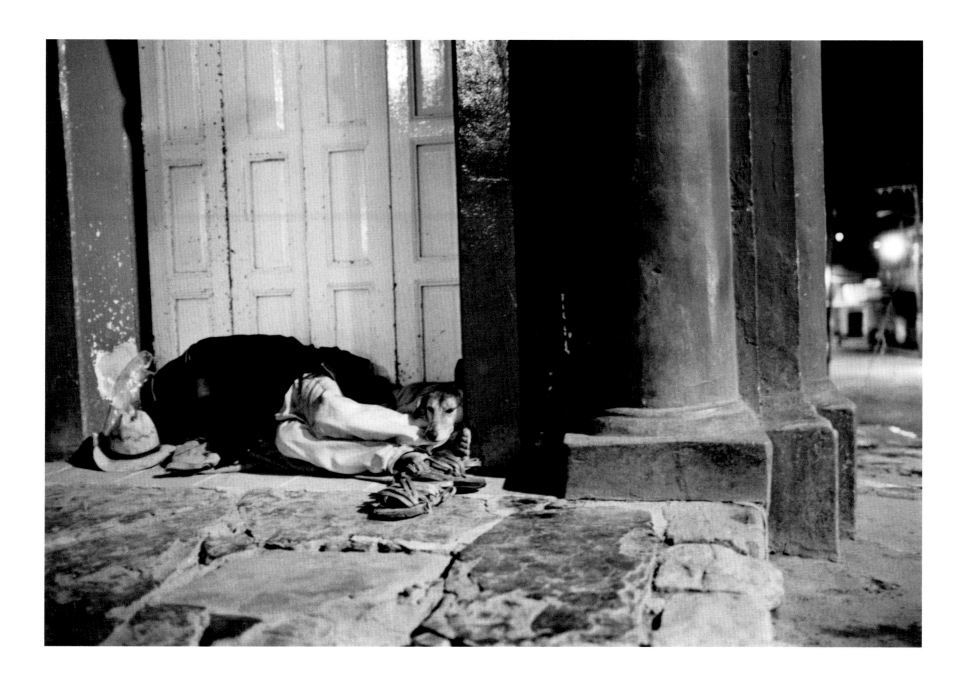

(81) while mansions paid for by illegals in the U.S. rise from the hills . . .

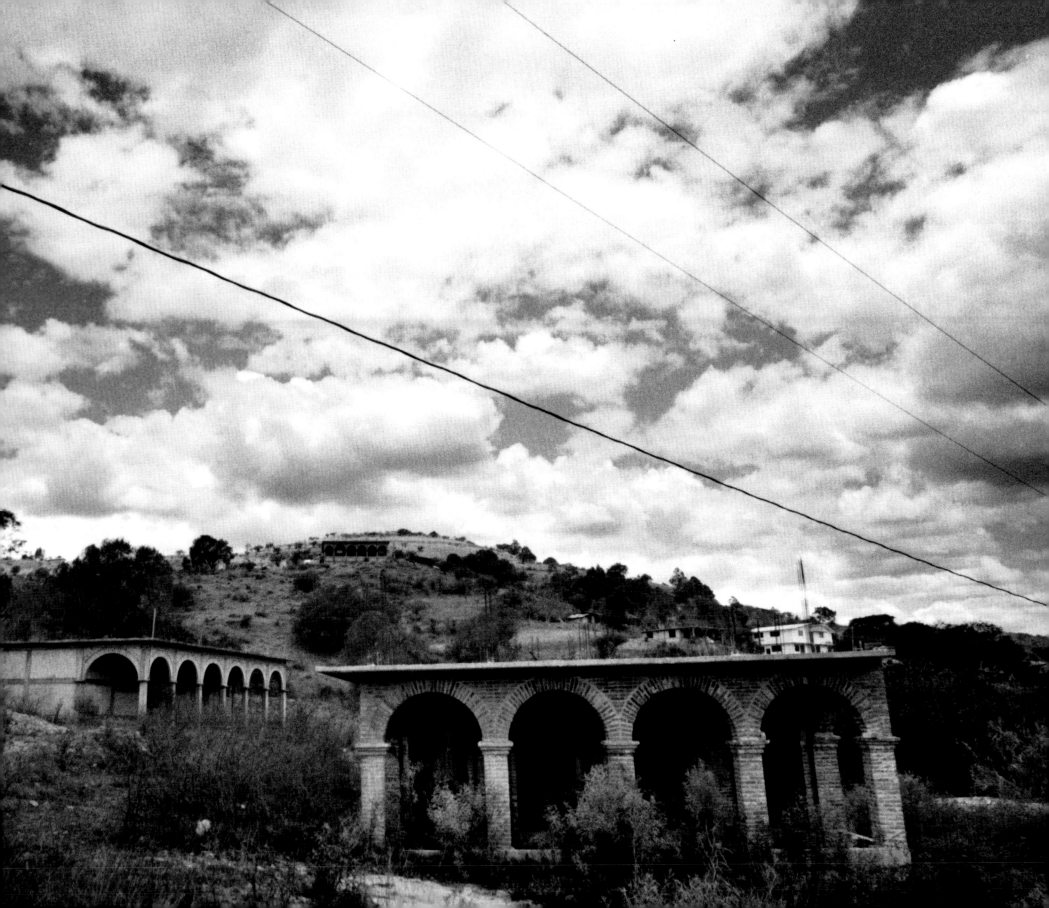

(82) . . .

(83) *such as Esperanza's house . . .*

(84) *or this one with the old house in the foreground . . .*

(85) and the mother of the absent owner walks past a dream . . .

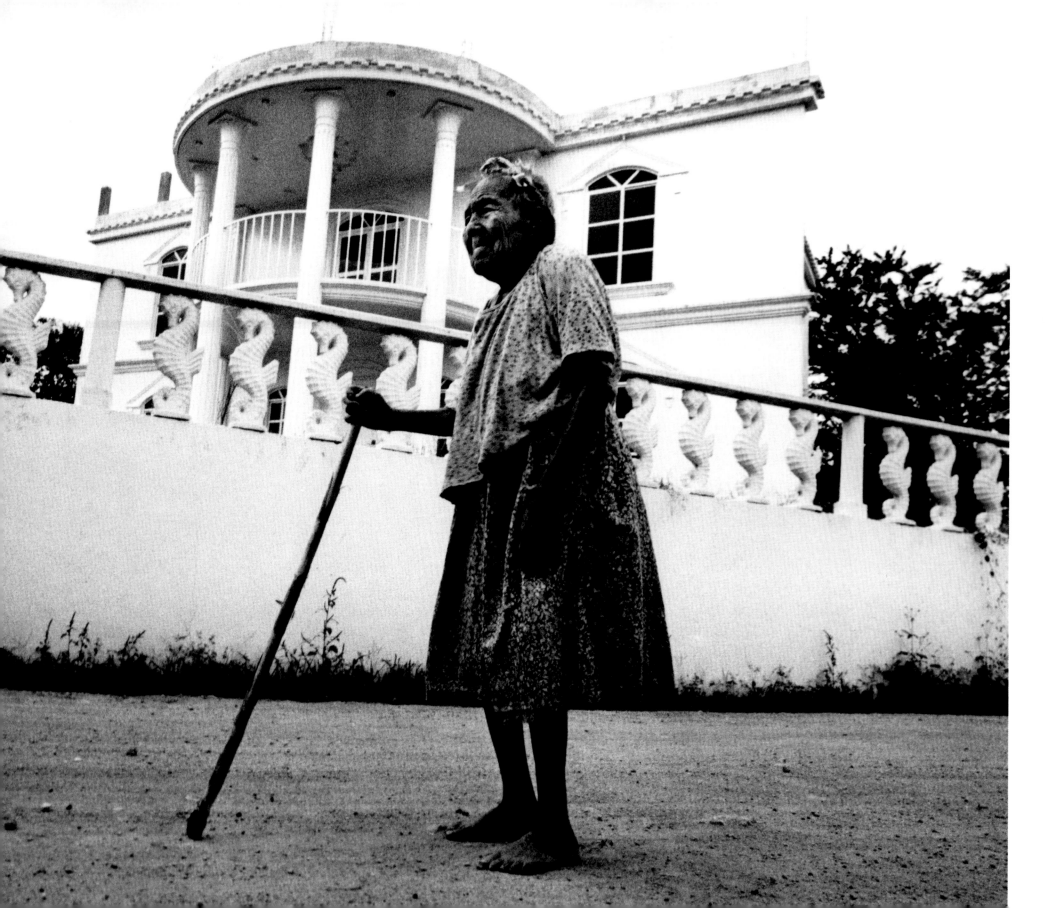

(86) *and Fox News interviews the Minutemen . . .*

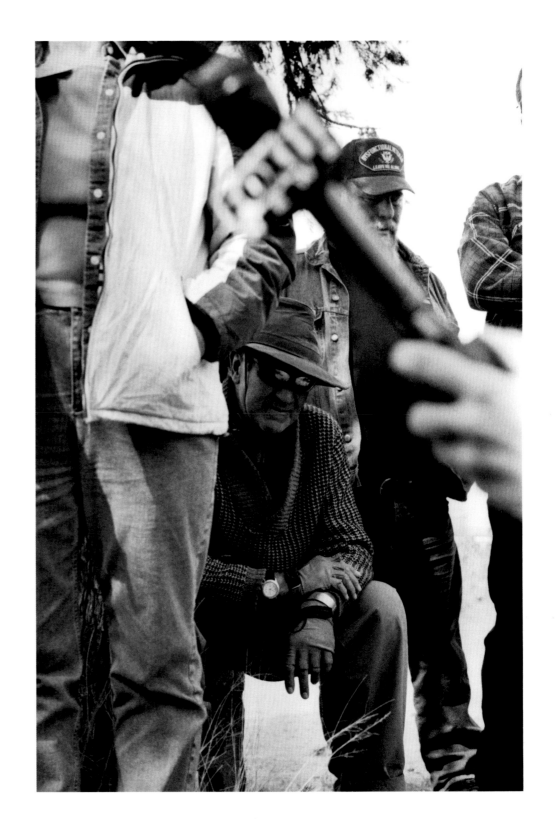

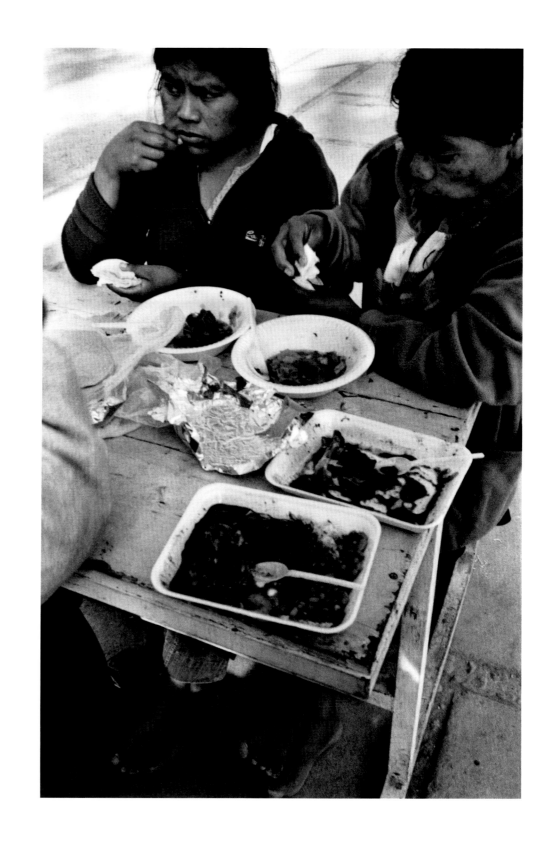

(87) *Mixtec women eat before crossing . . .*

(88) *a Minuteman gathers bras at a migrant dump site in Arizona*
as evidence of crimes he can imagine but never really know . . .

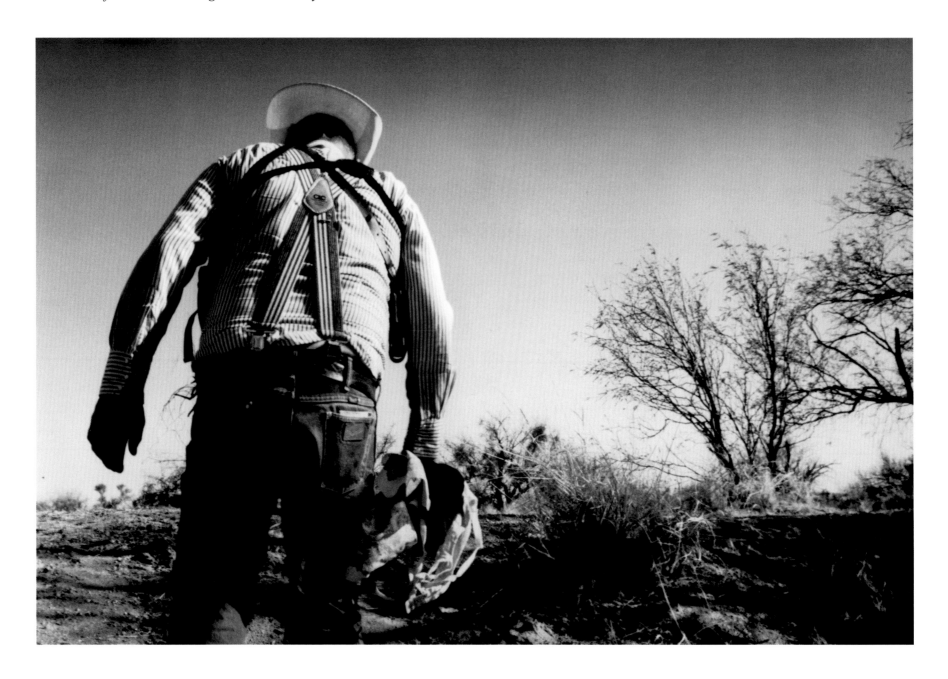

(89) *the brassieres hang off bushes near Sásabe on the line*
at a place where guides are known to rape women coming north . . .

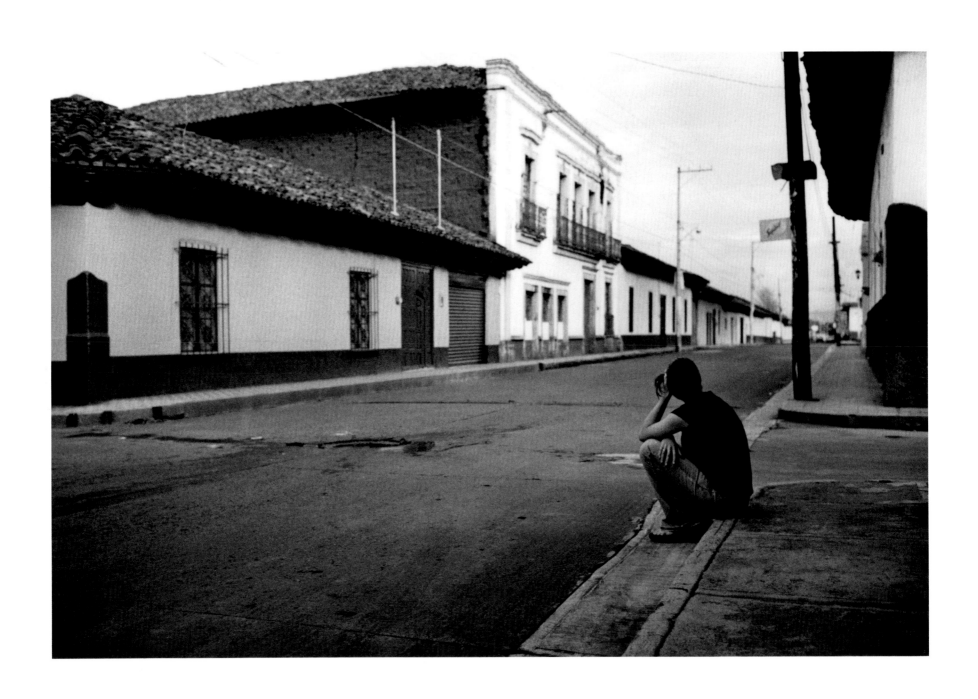

(90) *and a lonely woman in Michoacán sits in a town*
where all the men have gone to the U.S. . . .

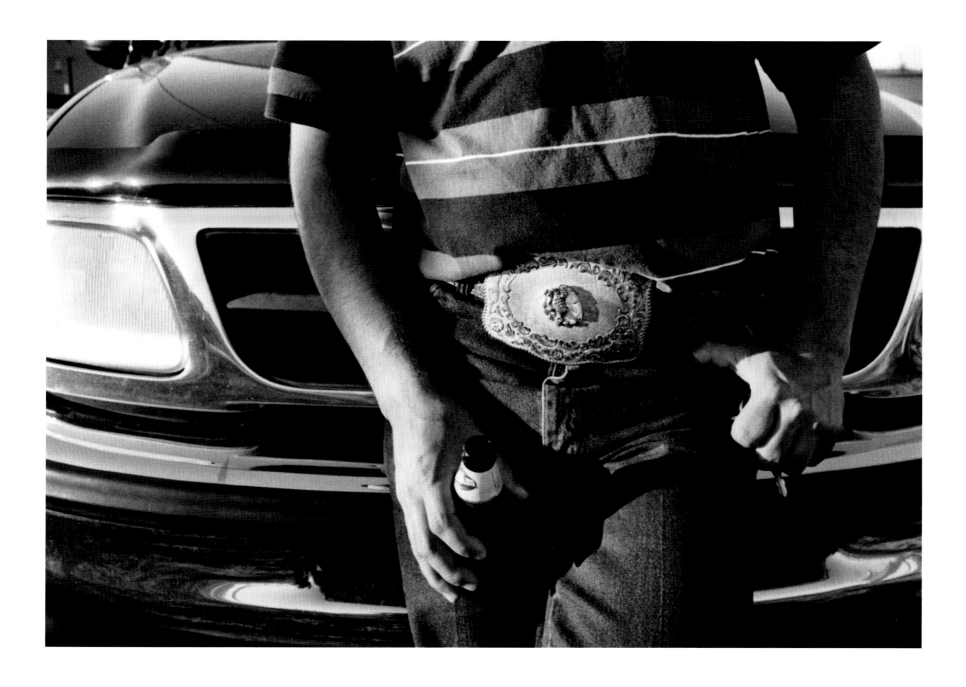

(92) *the train of death broke this arm . . .*

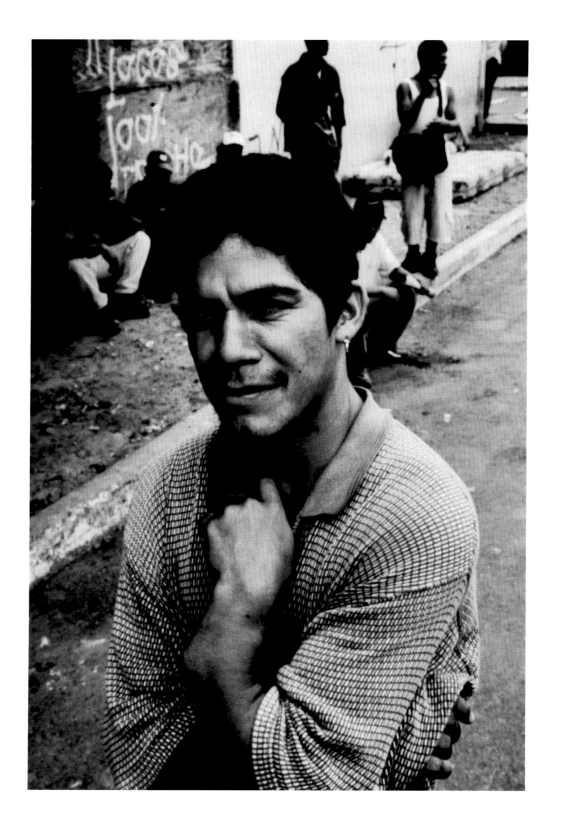

(93) *he was doing construction in Houston, fell from the roof*
and had a blade almost sever his hand . . .

(94) *shattered his knees, shoulder, and neck . . .*

(95) *chopped off these fingers . . .*

(96) *and so this man in Dodge City wants a union . . .*

(97) *and this man wants his fingers back . . .*

(98) *and Katrina cleanup workers rest between shifts . . .*

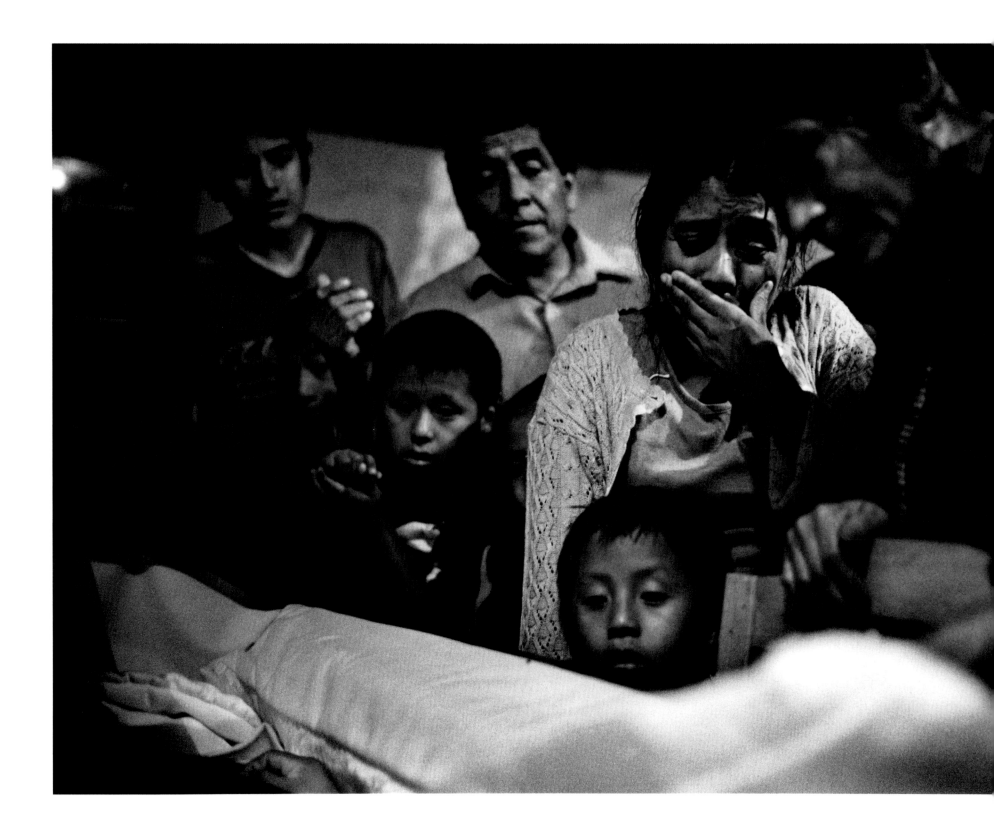

(99) *a migrant killed at work in California returns home to Oaxaca . . .*

(100) *his face at peace . . .*

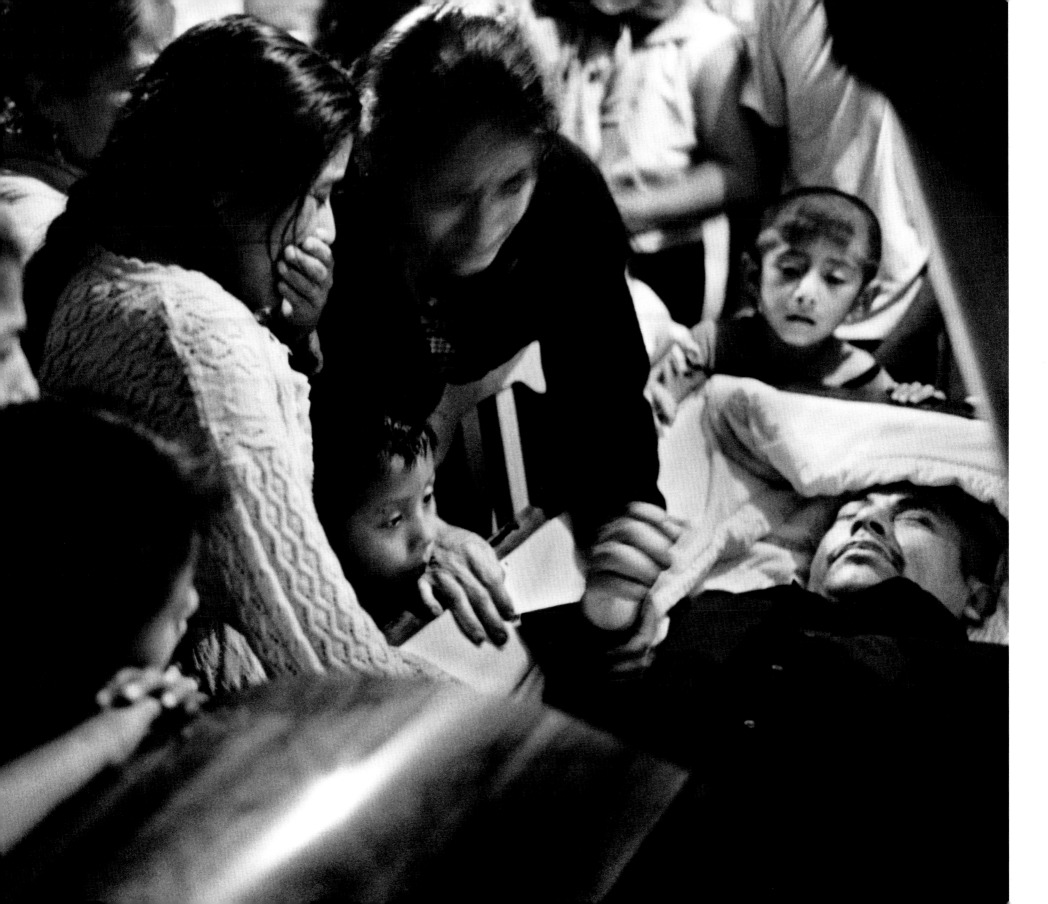

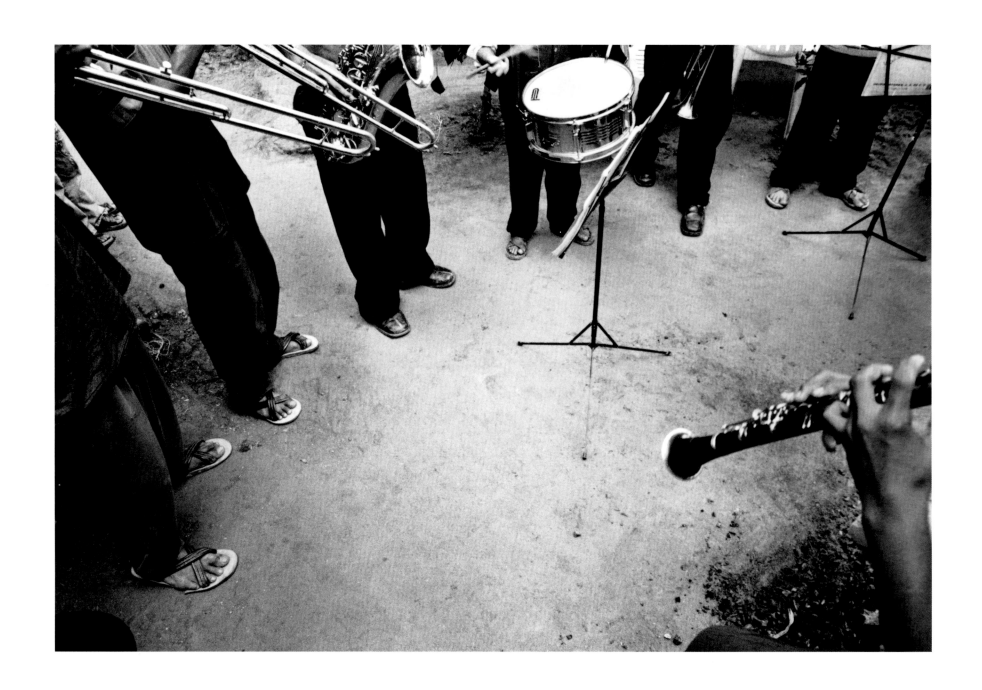

(101) *and the band plays "God Never Dies" . . .*

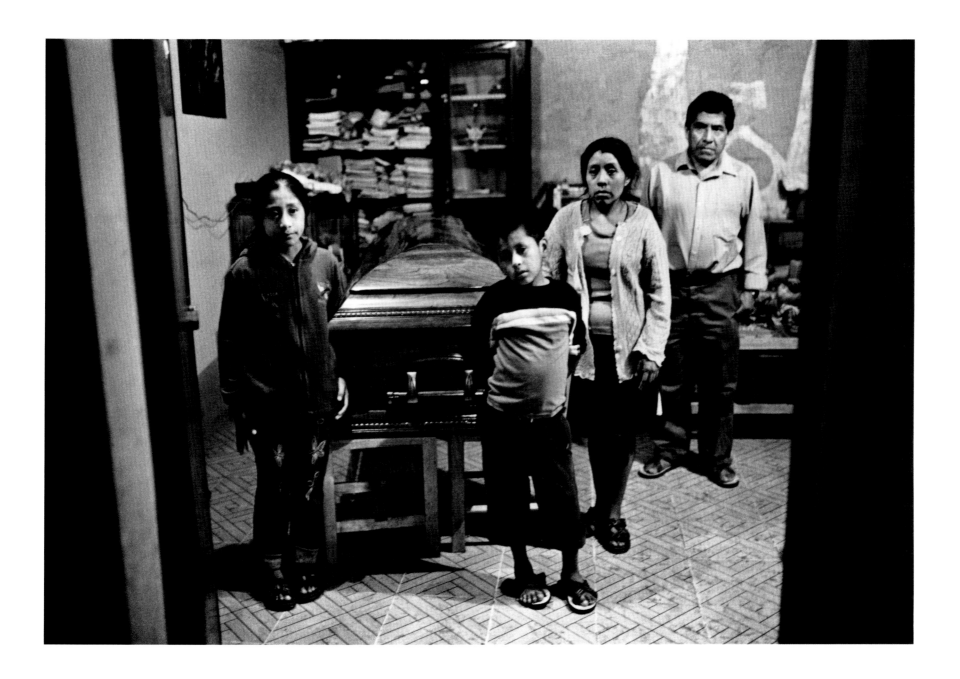

(103) *then the procession . . .*

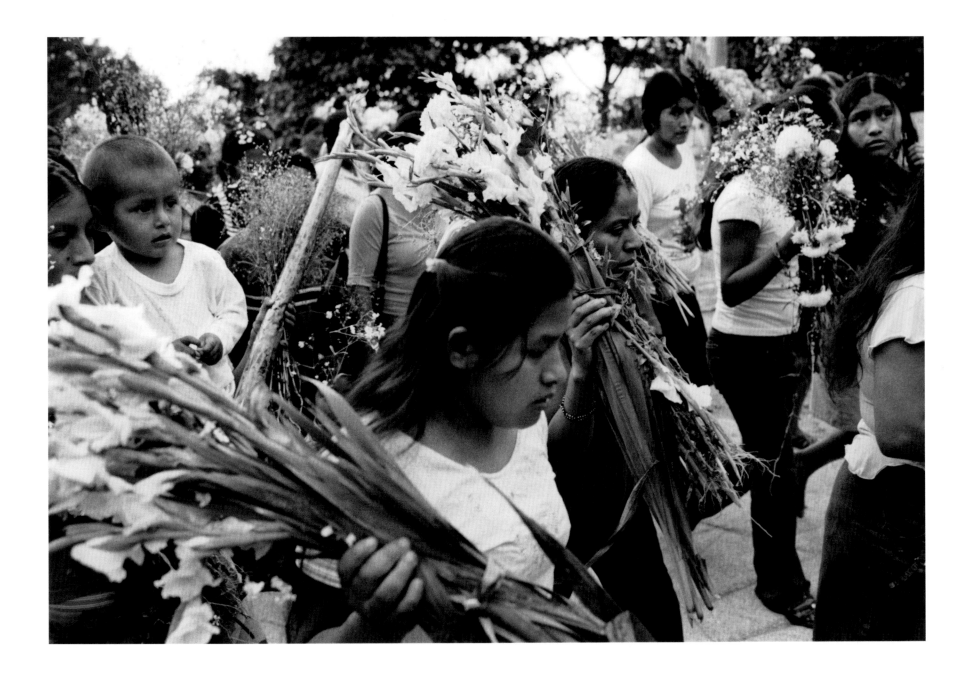

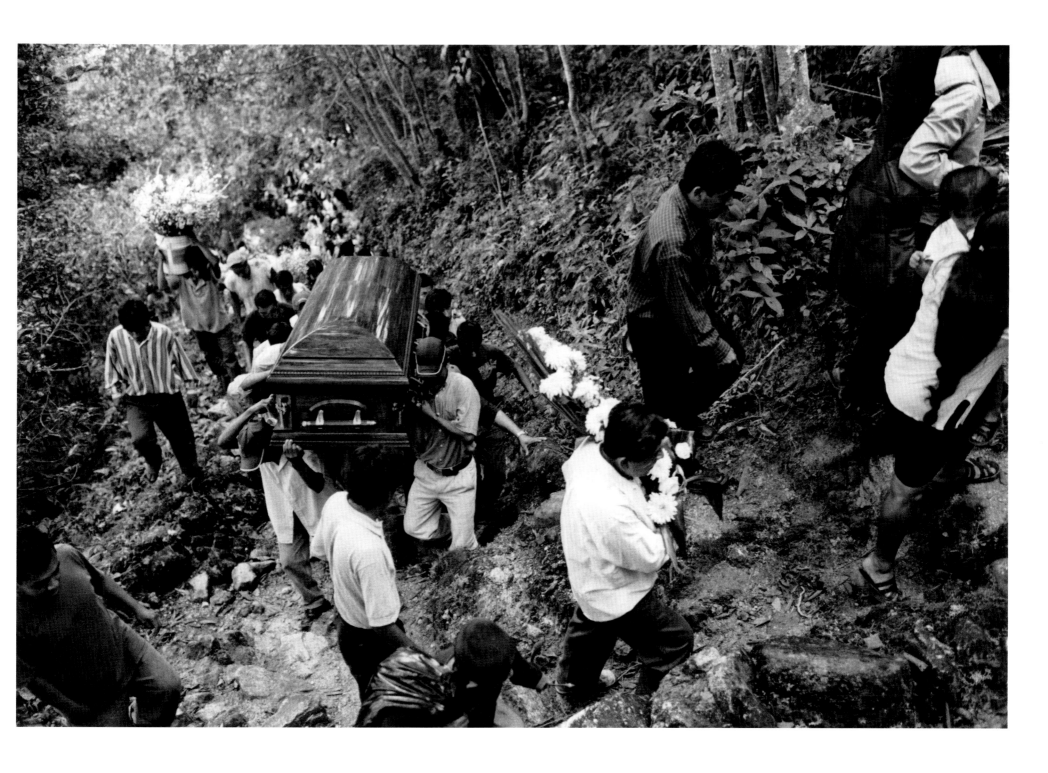

(104) *up the mountain to the Campo Santo, Holy Ground . . .*

(105) and Guadalupe, a first-generation Mexican American guards the line for the Minutemen . . .

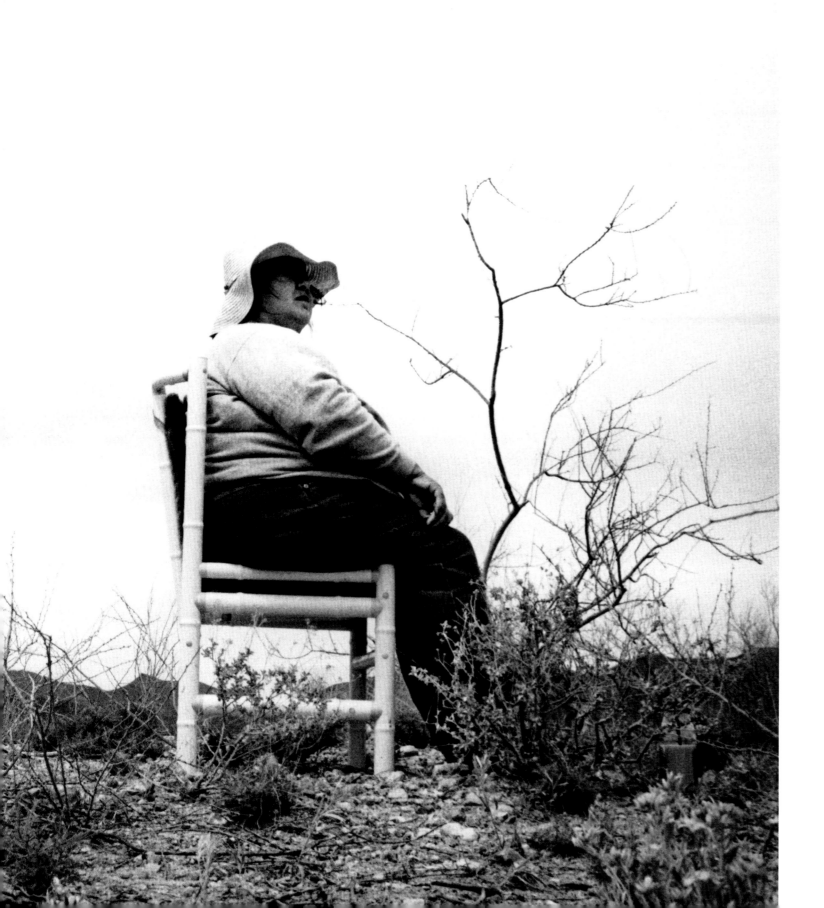

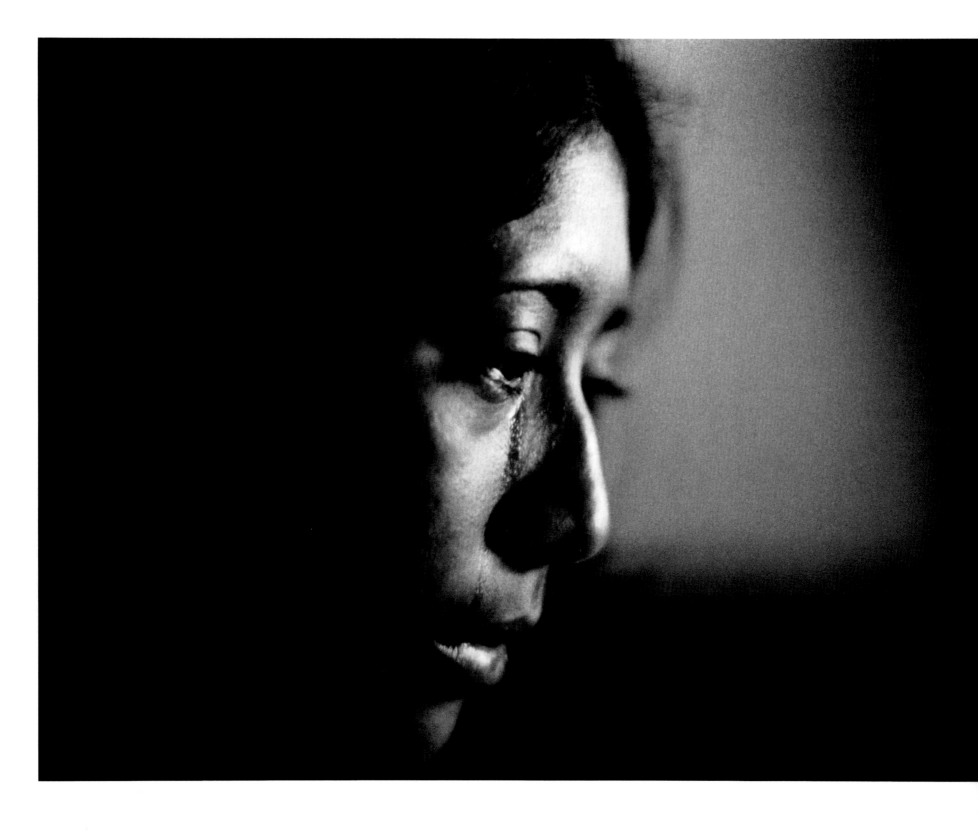

(106) *she is a teenager trying to join her parents in the U.S.*
and almost dies in the desert of New Mexico . . .

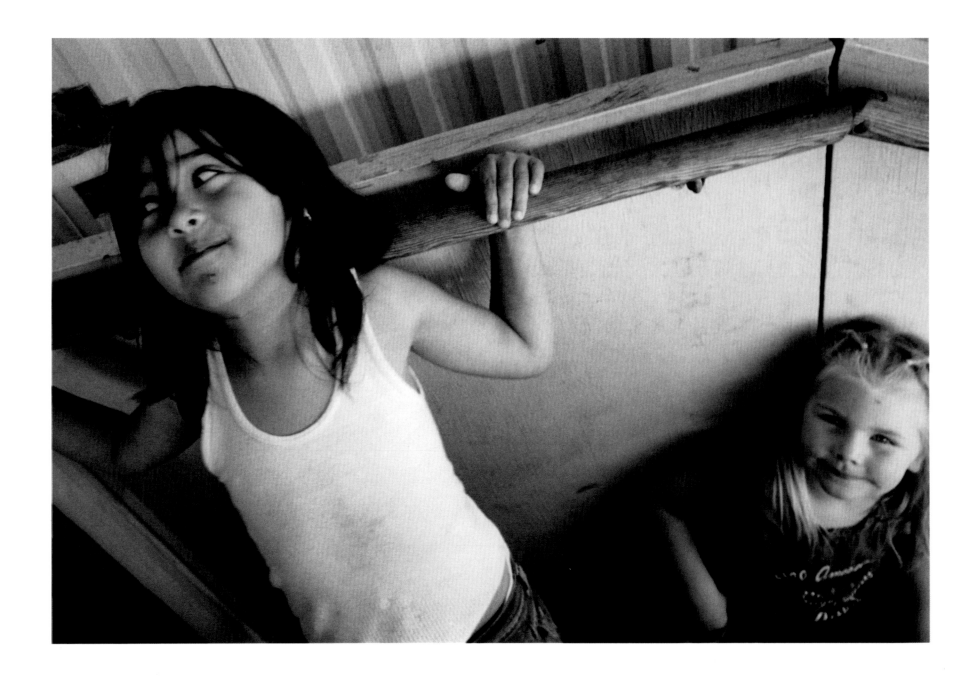

(107) *and one was smuggled in a car, the other is a U.S. citizen,*
and now they are friends in California . . .

(108) *and one was in a flower nursery in Eureka, California,*
with his American son . . .

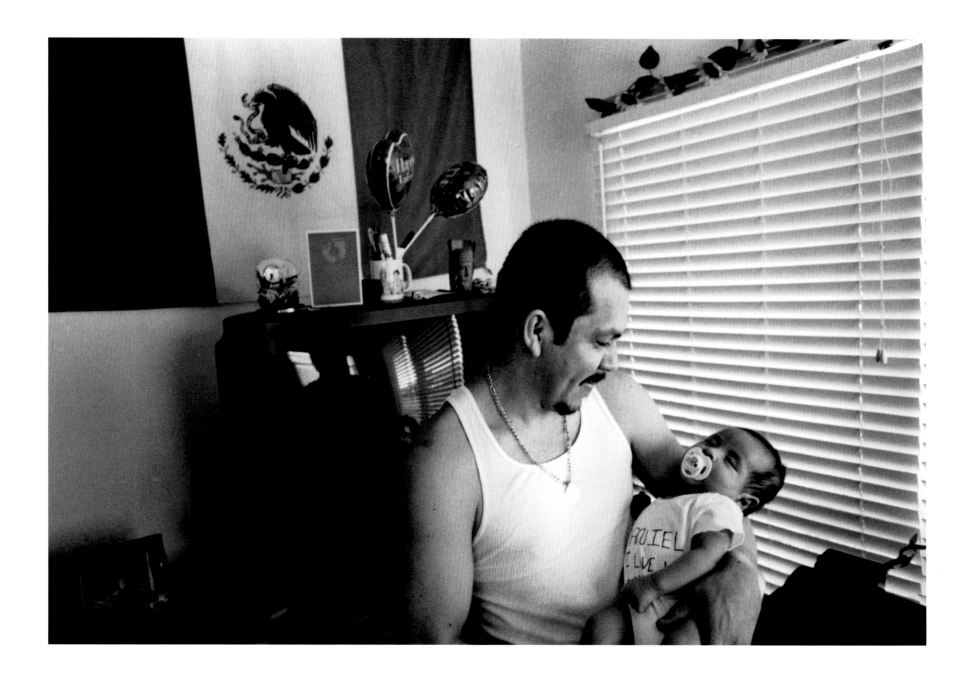

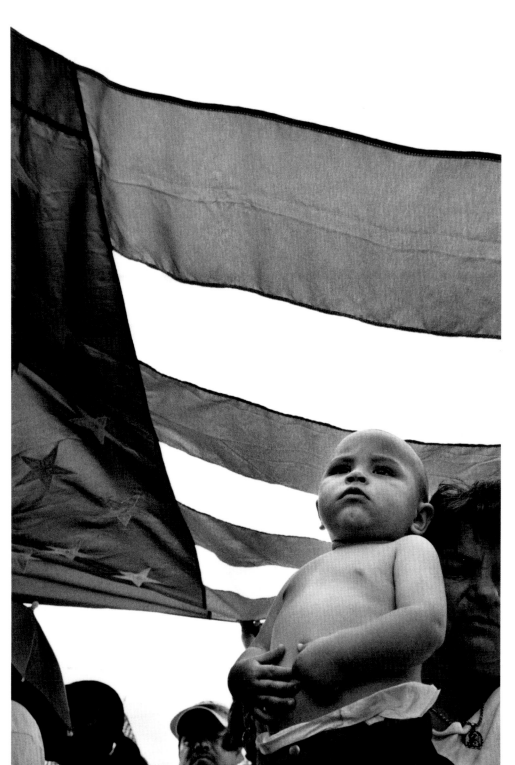

(109) *his father is in Iraq while this 17-month-old American marches in Phoenix . . .*

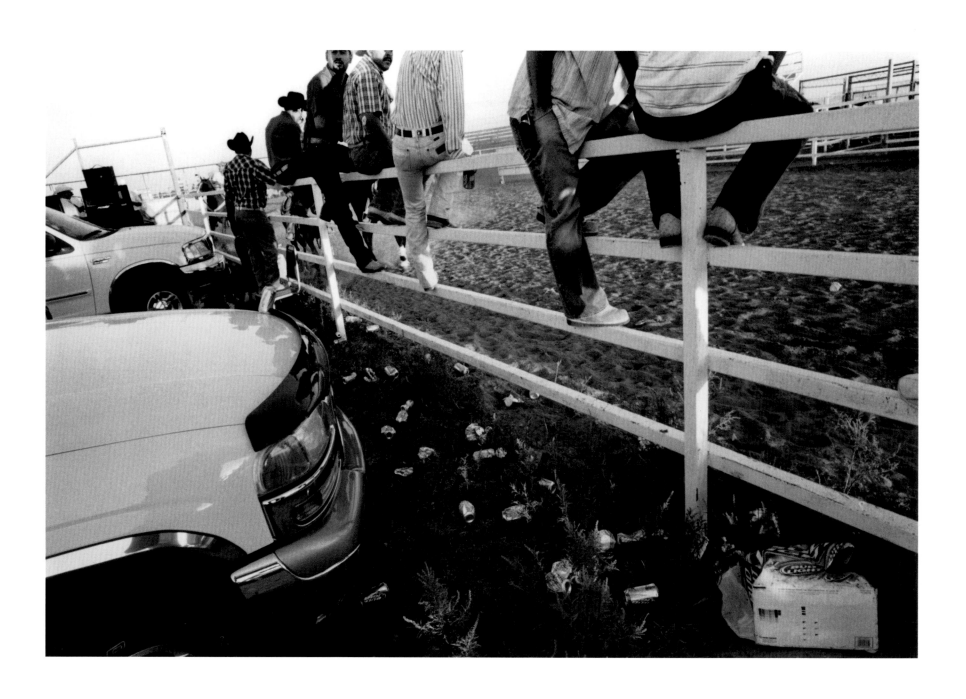

(110) *and Mexican Independence Day is celebrated in Dodge City . . .*

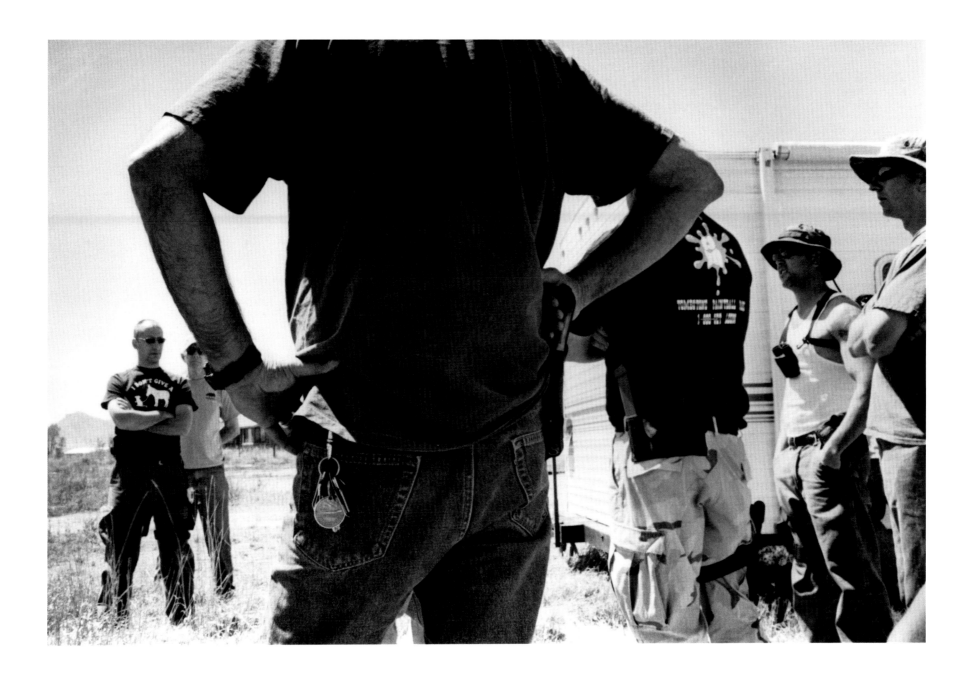

(112) *and the old man in North Carolina moves into a world*
he never imagined . . .

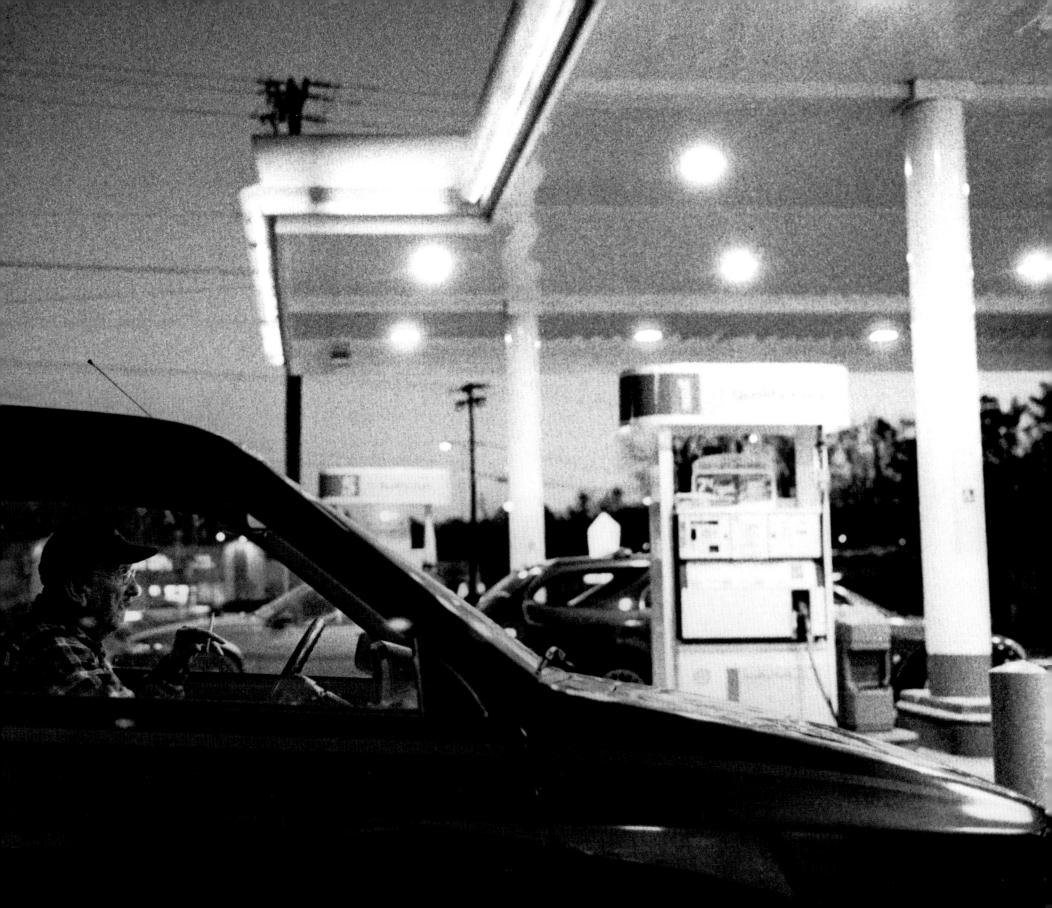

(113) while a dead city called New Orleans waits . . .

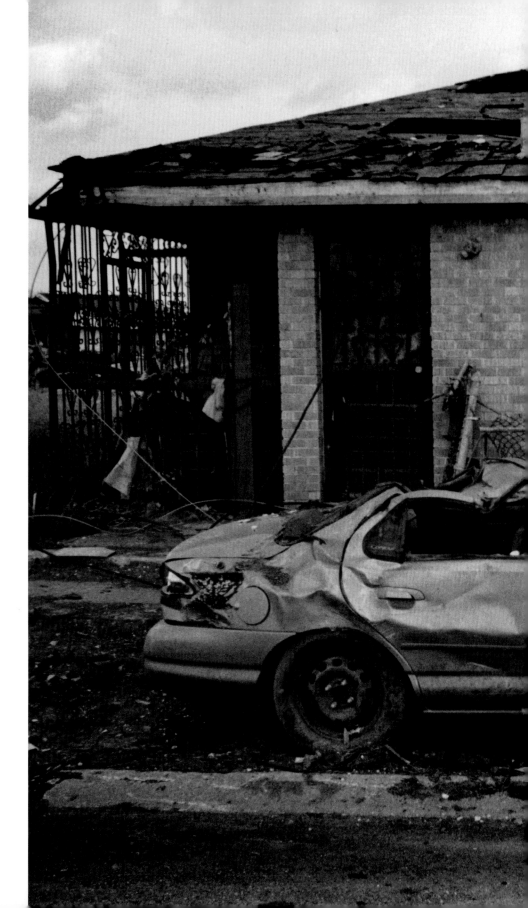

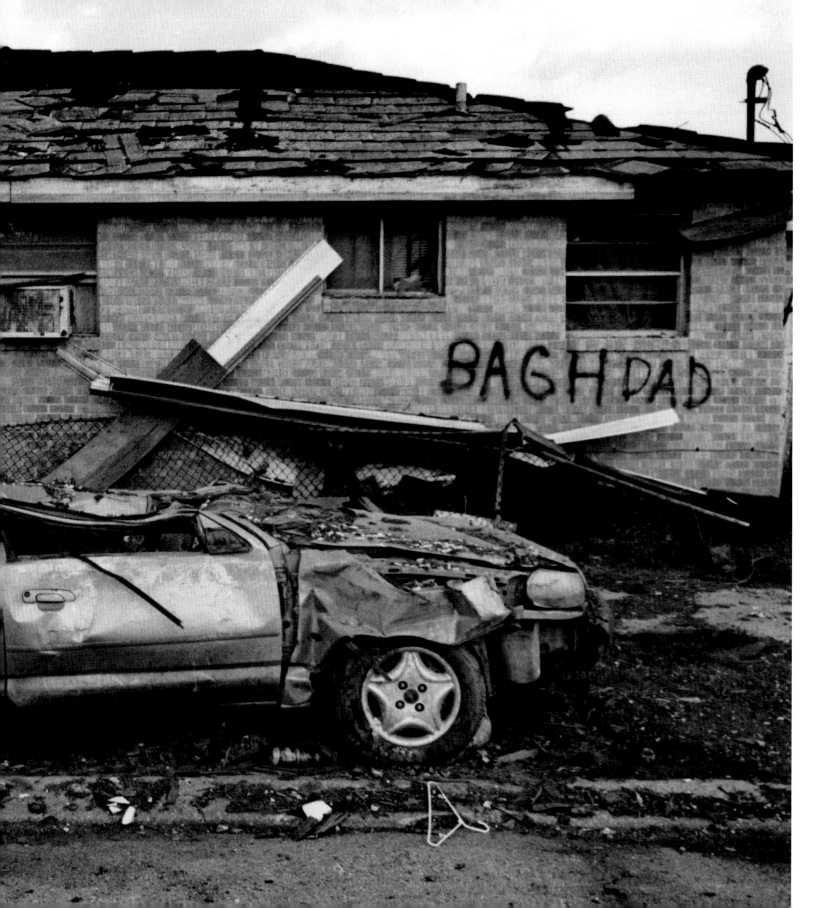

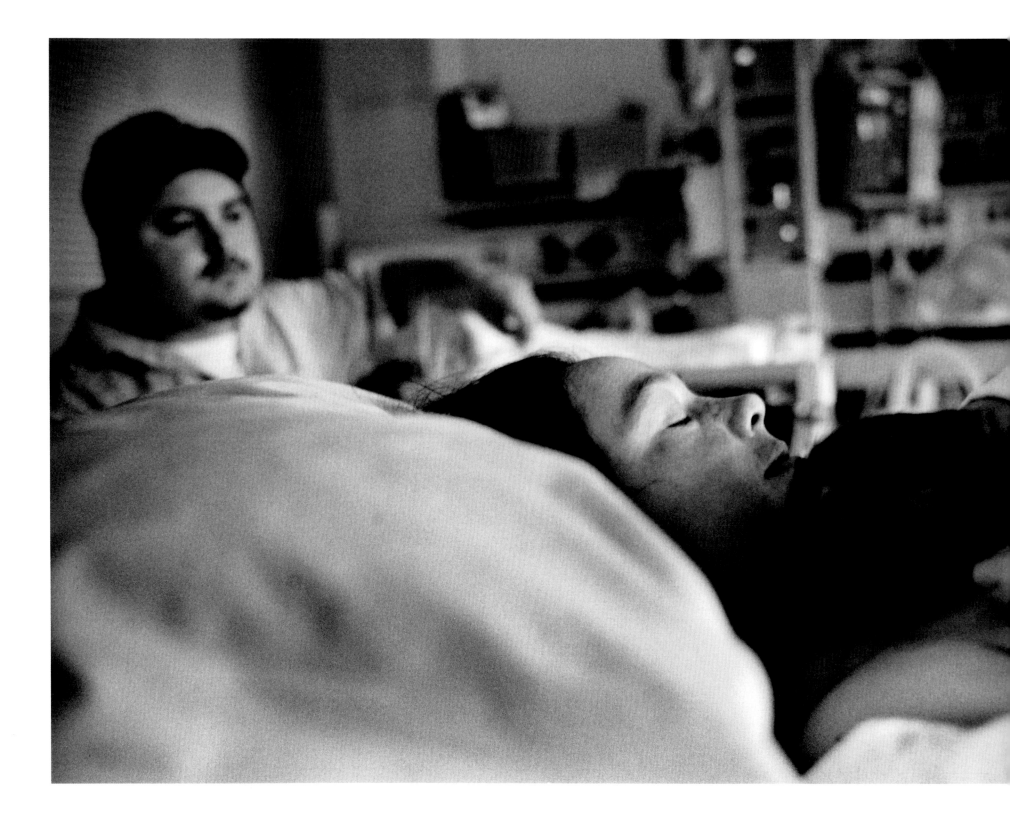

(114) and a new American, Miguel, is born on Cinco de Mayo in California . . .

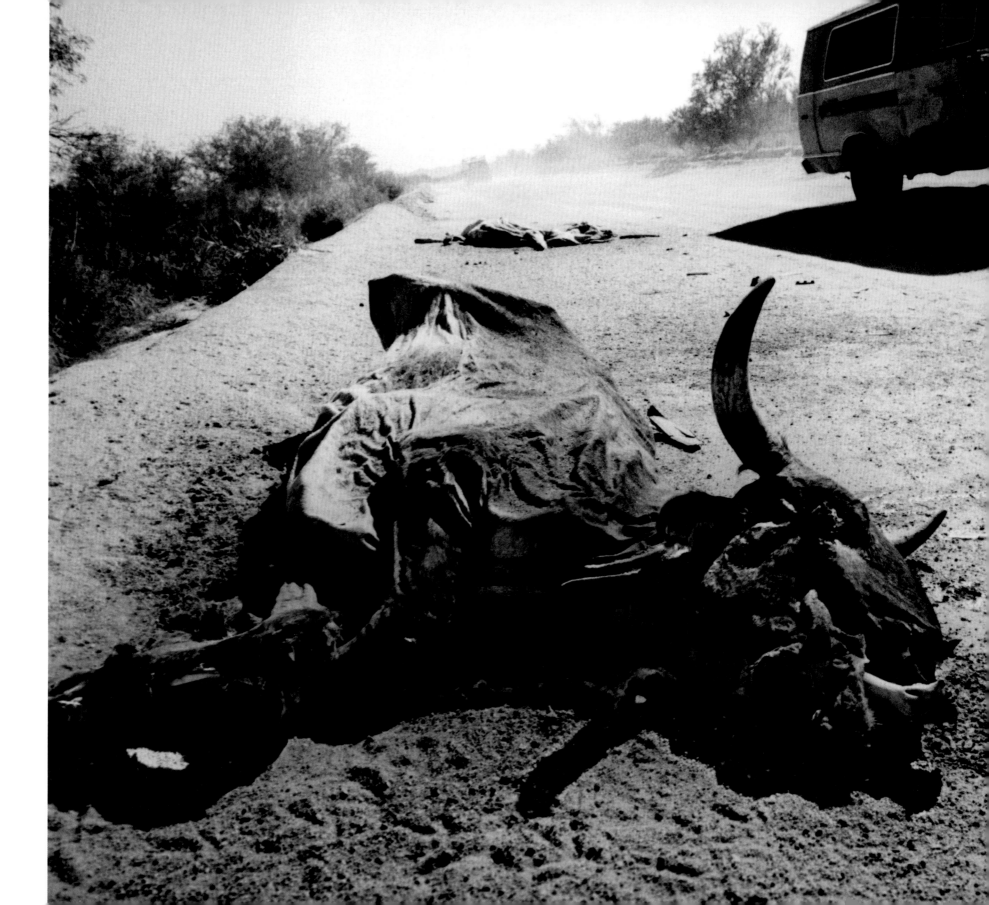

(115) *and the road with vans of migrants coming north near the border is dust, death, life, and our future.*

afterword

JULIÁN CARDONA *baghdad*

WALKING IN NEW ORLEANS, I get the feeling of a provincial city of the Roman Empire in its decadence, democracy nothing but a pleasant memory among the people now at the mercy of the emperor and his cabal, who squandered the resources of the state and its citizens on costly private wars. Katrina pulled back the curtain on a new American Gothic—the immigrant barbarians and their many children populate a new frontier, forever locked out of the American dream. The power of government has yielded to crime and corruption, a smell that hangs in the air. Like Juárez, New Orleans is another border city where gangs patrol the streets, willing to kill and be killed in order to profit from the only market left within their reach: drugs. Like Juárez, addicts troll the neighborhoods stealing copper pipes and anything else of value they might sell to feed their habits. New Orleans, laid waste in a few hours by the flood, remains in ruins months, a year, later. Here, daubed on the walls, the name of a city once the richest in the world, a center of learning and of an ancient civilization that nourished the Greeks, the Romans, and ourselves: BAGHDAD. I shoot. And I know that the boy who scrawled the word has never heard of ancient Mesopotamia. He screams against the power that destroys a distant city in the name of homeland security and yet abandons his American hometown. The poor people of New Orleans add another thread to the tapestry of migration. The devastated and still half-empty city signals a bad prognosis for the empire whose economy, power, and eventual fall depend upon oil, industrial agriculture, global warming, and migration on a biblical scale: EXODUS.

Noon, September 19, 1993. Manuel Sáenz and I, photographers for *Diario de Juárez*, wandered along the Río Bravo, from downtown Juárez west along the border road. Illegal crossing was easy and routine. Weekend nights, girls in party dresses and high heels would climb through a hole in the fence on the "free bridge." Heavy metal fans thought nothing of crossing for an El Paso concert—Van Halen, ZZ Top, Ozzy Osbourne, Judas Priest, Loverboy, the Cars, and more—and returning home to Juárez to sleep. A trip across the river on an inner tube cost two dollars.

But this day, things changed. Border Patrol trucks parked every third of a mile along the river and helicopters patrolled overhead. The next day, our newspaper proclaimed: *Border Sealed!*[1] Operation "Border Blockade" was underway (after a short time, the program was renamed "Hold the Line").

Men who had crossed daily to work construction, farm, or gardening jobs now tossed rocks at Border Patrol agents clad in gas masks and riot gear on the Santa Fe Bridge. A week into the blockade, the price to get smuggled into the United States rose from $20 to $100. Immigrants found more secret and dangerous routes, like the sewer tunnels under the river into El Paso. Three and a half months later, NAFTA came online and similar blockades were deployed in urban areas along the entire U.S.-Mexico border.

The images in this book date from the late 1990s—the beginning of the post-NAFTA massive wave of migration along the Sonora-Arizona border—through October 2006 at the funeral of Hermelando Ramírez, a tree-cutter from Oaxaca, killed on the job in Eureka, California. The images document the Minuteman Project on the Arizona border in April 2005, immigrants cleaning up the Gulf Coast after Hurricane Katrina, and protest marches in April and May 2006.

During the same period, cities on the frontlines of globalization erupted in waves of violence that still rage along the border. For decades, growth and development in Ciudad Juárez was distorted to meet the needs of the maquiladora industry and the greed of local bosses. Juárez has become synonymous with narco-trafficking; murders and disappearances; women raped, murdered, and dumped in the desert; and extreme violence against children. Tijuana, Nuevo Laredo, and other border towns suffer similar fates.

Agua Prieta, Sonora, in the early 1980s was a dull and dusty town where nothing ever happened, but when I arrived in May 2000, crowds of migrants from southern Mexico were showing up there and at other small border towns. One afternoon, the phone rang in my hotel room and a voice asked if the *pollos* (chickens) were ready. Perhaps not as strange as it seems. The hotel was filled with guys drinking beer and blasting *norteña* music in the hallways, marking them as *polleros*: people smugglers. The guy was calling to check on his merchandise. I told him he had the wrong room and he hung up with an apology.

As I walked through town carrying my camera in a black nylon bag, I must have looked like a pollo, and so various polleros offered their services to cross me into the United States. The place buzzed with lawlessness—everyone was watching or being watched.

Migrants were packed into the downtown hotels near the border with Douglas, Arizona, but the people on the streets were mostly agents or guides. The migrants stayed out of sight until sunset, when they would come out in small groups here and there. Some got into vans or pickups; others walked in groups of twenty in any direction they figured would take them to a place to cross the line. After dark, lines of immigrants, hiding, looking for their chance, spread out to the east and west of Agua Prieta, parallel to the seven strands of barbed wire that marked the line, stretching beyond the high metal wall near the official port of entry.

In the later years, I witnessed similar scenes in Altar, Sásabe, Las Chepas, and Nuevo Laredo.

Immigrants regularly fill the airline and bus seats from Mexico City to Hermosillo, Sonora; their shabby clothes, caps, and backpacks contrast sharply with laptop-laden businessmen in suits.

Sásabe, Sonora, an anonymous border settlement of about 1000 inhabitants, has become a legend in the world of illegal immigration.

Altar, the larger town a few dozen kilometers to the south, has become the hub where immigrants from Mexico and Central America gather before making the final jump to the line. Both towns are important stops on the migrant trail to the border.

People in Altar recall a time when there were three people smugglers in the town, the kind of small business that has always existed on the border. The local economy depended on agriculture and marijuana smuggling. In 1999 things changed drastically: thousands of migrants began to arrive, and with no housing available, they wandered the streets and slept outside on the plaza. In Sásabe, thirty brickmakers subsisted by exporting their wares to Arizona, but most of them are now gone. Today, the Lobo (Ford F-150 pickup) embodies economic power. Kids who make a lot more money than their teachers drive to primary school in their pickups. They buy snacks with $20 bills. On a bad day, a people-smuggler earns $2500; on a normal day, $6500.

I spent three days in Sásabe, staying for $8 a night in a little wooden room barely big enough for a foam mattress in back of a tortilla shop whose owner was cashing in on the new business. Many like him reacted quickly to the need for rooms. In Altar and other nearby places, construction of cheap hostels has boomed, as have other small businesses aimed at the migrants: restaurants, phone booths, supermarkets selling industrial quantities of bottled water and electrolytes. Street vendors provide jackets, caps, shoes, gloves, backpacks, and anything else perceived as necessary for crossing the desert. The town has never seen such prosperity.

Peasant farmers whose traditional methods make it impossible for them to compete with the low price of imported grain, men displaced from the sugarcane industry, and unemployed professionals, routinely pass through Altar. In my country, while the political class, some intellectuals, and pundits explain the benefits of NAFTA, millions of voiceless Mexicans express themselves another way: EXODUS.

In pre-Hispanic times, the Mexicas (Aztecs) built their empire on the economic engines of agriculture and war, fueled by trade and sustained by goods from different regions of Mesoamérica. The Mexicas exploited the legacy of the Olmecs and expanded their trade routes far beyond those of this earlier American civilization. The wealth earned in the Mexica wars was not paid by the nobles of the conquered peoples, but by the *macehuales*, the common people whose work and productivity maintained the lifestyle and privileges of the dominant classes. The *macehuales* planted crops on communal lands or on properties of the nobles; built roadways, temples, and other buildings; and manufactured clothing and weapons from feathers, metal, stone, and other raw materials from conquered regions of the empire. Merchants were a separate class involved in trade, diplomacy, and espionage. Their kings declared wars to avenge their losses or to protect the interests of the empire. At the time of the conquest, the Mexicas ruled over 370 towns in thirty-eight provinces throughout the region, surrounded by twenty-three distant client provinces, isolating their subjects and guaranteeing the security of the empire.[2]

Throughout Mexico's history, there is no rest for the weary poor majority. Spanish conquistadors used the same method of tribute set up by the Mexicas—with new masters. The colossal cathedrals and colonial edifices much admired in Mexican cities today are monuments to the exploited labor of centuries of poor people. Independence brought successive wars and crises. During the Reforma, the 1856 "Lerdo Law" required ecclesiastical and civil groups to sell communal lands and properties to private owners. Although intended to limit the wealth and power of the church, the law also forced Indians to sell their ejidos and become laborers on the estates of new private landowners—the speculators and foreigners who acquired the church and communal lands.

The government of Porfirio Díaz ushered in large-scale economic penetration by the United States. U.S. investors and corporations helped Díaz rise to power and benefited from policies that fostered U.S. ownership of land, railroads, ports, mines, and natural resources. Díaz was the United States' first "son-of-a-bitch" in Latin America,[3] until the revolution expelled him from power after thirty years of dictatorship. The revolution answered the campesinos' demand for the return of their communal lands, but despite the high cost in blood, it did nothing to change the equation of power. To the contrary, the revolution legitimized the political and economic machinations of subsequent governments. In 1910, John Kenneth Turner vividly portrayed the slave economy created by Díaz and his American capitalist financiers in the book *Barbarous Mexico*. After nearly a century, the portrait remains true to its subject: "The people were the sacrifice."[4]

Under the NAFTA regime, proposed and adopted under the post-revolutionary PRI government of Carlos Salinas, U.S. companies are back in full. Today, 14 percent of Mexico's workforce is embedded in the U.S. economy, the vanguard of the biggest migratory phenomenon in the world.[5] Mexico's elites, in partnership with transnational corporations and political bosses, maintain their privileges on the backs of the modern-day *macehuales*—the migrants who send their tribute from abroad.

Before and after Mexico's defeat by the United States in 1848, members of Congress—mostly southerners trying to expand the power of the slave states—made various proposals to annex Mexican territory. On May 31, 1860, the U.S. Senate refused to ratify the McLane-Ocampo Treaty through which the government of President Benito Juárez had agreed to cede the perpetual right of transit to the Isthmus of Tehuantepec, to grant free transit through Mexican territory to U.S. citizens and military personnel, and to reduce or eliminate customs duties—all for $4 million cash that Juárez and the liberals desperately needed to fight the War of the Reforma. The treaty would have turned Mexico into a

military "protectorate" of the United States, allowing intervention in regions plagued by extreme poverty and violence. The treaty favored the economic and political interests of the slave states, but southern senators could not muster the votes to ratify it. Secession and civil war came less than a year later.

For more than a century and a half, the poor people of Mexico have played a role in the foreign and domestic policies of the United States. Mexico's surplus of cheap labor was imported during the Bracero program and lured to border cities to work in U.S.-owned maquiladoras. Now, after thirteen years of NAFTA's disastrous impact on the Mexican countryside, these same poor sectors of the Mexican population stream into the U.S. illegally[6] through the border towns of Los Algodones, San Luis Río Colorado, Sásabe, Agua Prieta, Las Chepas, Nuevo Laredo, Reynosa, etc.

The destiny of Mexico—the country that exports its people—continues to be bound tightly with that of the United States—an imperial republic on the threshold of empire.

In January 2003, I spent two weeks in North Carolina, one of the recent migrant destinations with a booming Hispanic population. Mario had arrived not long before, after a friend settled in the town of Carrboro and helped him get work. After saving some money, Mario brought his girlfriend, Angélica, to join him.

Just outside of Sásabe there is a big tree where immigrants dump their old clothes and put on new ones that make them look more "American." Mario and I realized that we had both stopped under that same tree. I was doing a story for a magazine in Mexico City; Mario was crossing the border to meet his friend in North Carolina. At their new apartment in Carrboro, Mario and Angélica talked for a long time about the details of their journeys. Mario worked for a construction company and Angélica had a job cleaning apartments. When visitors showed up, they always asked where I had crossed and were surprised to find out

that I was in the U.S. legally—I was the only person they knew with papers. From them I learned that the illegal activity of the coyotes is governed by market forces. Mario paid $1500 to cross and walked three days through the desert. Taking this knowledge into account, he paid $2500 dollars for Angélica's trip, with only one day walking over an easier route.

Mario and Angélica say that as working-class people, they encountered more discrimination in Mexico; they don't feel mistreated in their daily interactions with Americans. They can buy better clothes, food, and household goods in the U.S.; they even found a microwave oven for only $5! On the other hand, they are terrified at the possibility of getting sick.

During the time of my visit, the massive influx of Mexican immigrants to North Carolina was getting a lot of attention in the press. Stores selling traditional goods and open-air flea markets served a mostly Mexican clientele. Many came from the states of Guanajuato and Chiapas and many, like Mario, worked in construction. Immigrant communities were growing rapidly as men arranged for their wives and children and even their parents to make the illegal journey to settle permanently in the U.S.

In northern California, increasing numbers of immigrant families are the focus of "Paso a Paso," a prenatal care project of St. Joseph's Hospital in Eureka, headed by Carol Cruickshank. The program began in 2001 with only two clients and has now served more than 300. From July 2005 to May 2006, when I visited Eureka, fifty-eight new mothers had registered with the program.

The Hispanic community in Humboldt County numbers about 8000, the majority immigrants from Oaxaca, followed by groups from Michoacán, Sinaloa, Guanajuato, and Hidalgo. They carry on their traditions of having large families. Elvia Saavedra, director of the program, said that "nearly all of the mothers have arrived recently and have on average

four children, at least one born in the United States." At most, they have attended six years of primary school and the majority cannot read or write. Elvia says she hasn't found anyone who wants to have more than six children, but the reality is "we don't know how many kids they will have here."

They name their little girls Kimberly and Ashley; boys are called Kevin and Brian. According to Elvia Saavedra, 13 percent of the births in Humboldt County are Mexicans; the place with the highest rate of Mexican births is the town of Fortuna, California, with 20 percent. Women work in the flower farms in the area, in Mexican restaurants, in the fish-packing plants, or as hotel maids, generally earning no more than $6.75 per hour.

Hermelando Ramírez, a Zapotec Indian from Tierra Blanca, Oaxaca, also found his way to Eureka. He worked for two and a half years at a sawmill during his first stay in the U.S. He went home and then returned again, working for about one year at the same job, with the idea of earning money to build a house for his family.

Small waterfalls cascade along the road to Hermelando's village just off the highway to Pochutla, about five hours from Oaxaca City near the Pacific Coast. The mountainous zone grows an abundance of bananas, avocados, guavas, and other tropical fruits, and "Café Pluma," one of the finest coffees of Mexico, but recent hurricanes and low coffee prices have diminished the local economy. Even though the coffee is grown organically, the small farmers in the region do not have the certification or outside contacts they need to find a better market for their product.

Hermelando's last stay in Eureka ended abruptly—after only six months. On October 21, 2006, he was killed on the job—crushed by a falling tree. I arrived in his village a few days later as mourners kept vigil through the night on the porch of a house shrouded in fog. Hermelando's body was flown to Guadalajara and then driven to his village in Oaxaca to be buried on a mountainside, the funeral procession accompanied by flowers and music. The logging company paid the funeral expenses, but since Hermelando was an illegal worker, his widow, Minerva Almaraz, received no economic compensation for herself and her three children: Ruth Nohemí, ten; Elías, eight; and Daniel, five.

I later contacted Carol Cruicksank in Eureka, who inquired among the Oaxacan families in the community, but no one had known Hermelando and local media did not report the accident that killed him.

Immigrants often take on high-risk jobs. Death may come from a falling tree, or heat stroke while picking crops in the fields or repairing roofs, or falling from a building under construction. Or, in the case of Alejandro González, crushed under the weight of a house being raised in the 400 block of East Louisiana State Drive in Kenner, a suburb of New Orleans, March 4, 2007. Alejandro was from Mexico but had lived in Louisiana for several years, was married to a woman from the New Orleans area, and worked as a foreman in his uncle's business. I searched the article in the *New Orleans Times-Picayune* for the names of some of the workers I met in May 2006, recent immigrants attracted to the cleanup and reconstruction jobs after Hurricane Katrina.

Hermenegildo Sánchez and his co-workers reported each morning to the construction company, where they would then be sent to various job sites. Their supervisor told me that if it were not for the immigrants, he would not have personnel to handle the jobs. The work of raising houses involves digging under the house with shovels, then installing jacks under the structure—temperatures often rise to 100 degrees in May in Louisiana. The holes would fill with water almost immediately. Sometimes the crew would have to dig tunnels under the houses to place the jacks and then carefully synchronize the raising and leveling of the structure.

Dirty and brutal work. Best kept out of sight, and those who do it often remain anonymous, even in death.

Gildo generally drove his co-workers to the job sites. Police commonly suspected that cars with four or more people might be carrying illegal immigrants and they were often stopped for traffic violations. Gildo is from Veracruz; he walked three nights in the desert near Sásabe, Sonora, and paid $1600 to get to Jackson, Mississippi, in September 2005, just after the hurricane hit the region.

As in Eureka, the post-Katrina influx to New Orleans has resulted in a noticeable growth in the immigrant population and birth of Hispanic children. The U.S. Census Bureau estimates that 100,000 Hispanics have arrived in the Gulf Coast area since September 2005. As the U.S. population approached the 300 million mark, it seemed likely that the 300 millionth person would be born to immigrant parents. And sure enough, the baby given that honor is Emmanuel Plata, son of Mexican parents, born at 7:46 a.m. on October 17, 2006, in Queens, New York.

While drinking coffee with Santiago Cruz, founder of the Latino Net of Eureka, I thought of the parades of baby strollers during the massive immigrant marches in Phoenix and Los Angeles. Santiago is middle-aged, dresses well, and is the publisher (with his wife) of the only Spanish-language newspaper in the region and lobbies in Mexican diplomatic circles. He has recently distanced himself from the majority position among immigrants' rights activists; for instance, he chose not to attend the May 1 march in Eureka. It seemed like a good idea to ask his opinion on possible outcomes of the recent pro-immigrant activities—the marches and demands to legalize millions of illegal immigrants. Santiago, now an American citizen, sat quietly for a long time and then responded: "The United States will do what best suits the United States."

The meatpacking industry exemplifies the convenience to—and dependence of—the U.S. economy on illegal immigration. Eric Schlosser, author of *Fast Food Nation*, calls meatpacking the most

dangerous job in the United States. A friend who worked in a plant in Dodge City, Kansas, told me that the workforce is 90 percent illegal immigrants. When an accident happens (and I heard of many during the week I spent there) and the worker returns to the factory after medical treatment, bosses usually ask for verification of their Social Security numbers. This results in many people getting fired after having lost their fingers or arms. They may get a small monetary compensation from the company, or they may not. Mexican Americans or legal residents do not fare much better. All of the injured workers—legal or illegal—are possessed by fear. A Salvadoran who lost two fingers and a Mexican who lost his left hand on the production line refused to be photographed or to talk on the record about their accidents. Both had no documents. Workers with legal status fear speaking out and want to avoid the consequences of filing claims against the companies.

There is no place for these workers in the "open economies" adopted by Mexico and other Latin American countries in recent decades. Starting in the 1980s—Latin America's "lost decade"—the World Bank and the International Monetary Fund, led by the United States, promoted free trade as the savior of the region. But what actually happened is that rampant emigration spurred by these free-market "reforms" now sustains a whole continent. Mexico received $23 billion in remittances in 2006 and the whole of Latin America brought in $62.3 billion in the same period, the largest amount of any world region.[7] For countries south of the United States, exportation of citizens is the only economic project that works.

Go to Oaxaca, or any other state in southern Mexico, to see the evidence. Oaxaca receives about $1 billion annually from immigrant remittances, eighth among the thirty-two Mexican states.[8] I visited the Mixtec region in June 2005—the place of origin for several generations of immigrants during the past century. Magnificent new houses line the road into the center of San Juan Mixtepec, and cars sport plates from

many different U.S. states. There are more grand houses beyond that town. And more and more. Similar developments can be seen in Guerrero, Tlaxcala, and Michoacán.

A year after that trip, I attended the St. John the Baptist Day celebration and the Mixtec Festival in Lamont and Arvin, California. I asked the organizer, Héctor Hernández, why the Mixtecs build these giant mansions back home in Mexico.

"We have a dream," he said softly.

"But why are the houses so huge?"

Héctor answered, "Because we have a really big dream."

CIUDAD JUÁREZ
JULY 2007

notes

a short note

1. Chris Hawley, "Long hours, low pay in Mexico heightens lure of opportunity in U.S.," *Arizona Republic*, December 10, 2006.

part two

The title is taken from the Zombies, "Time of the Season," 1969.

1. Lara Jakes Jordan, "Bird Flu Could Appear in U.S. in Months," AP, March 9, 2006.

2. Jerry Seper, "Guest-Worker Debate Boosts Alien Smuggling Business," *Washington Times*, May 9, 2006.

3. For nice tables on this muddle, see *Immigration Enforcement Actions: 2004*, issued November 2005 by Homeland Security.

4. David L. Teibel, "Sheriffs: Don't Make Us Immigration Cops," *Tucson Citizen*, May 11, 2006.

5. http://www.cis.org/articles/2002/back202.html.

6. Susan Ferriss, "Mexico's Fox Claims Lowered Poverty Despite No Growth Economy," Cox, June 7, 2004. Enrique Andrade González, "The Realities of the Mexican Migration," *Tulsa World*, January 22, 2006.

7. Robert J. Samuelson, "The Immigration Impasse," *Washington Post*, April 5, 2006.

8. "McCain Spars with Booing Union Chiefs," cnn.com, April 4, 2006. Jonathan Weisman, "Immigration Divides Allies," *Washington Post*, March 31, 2006. Julie Watson and Olga R. Rodriguez, "U.S. Employers Send for Immigrants," *Arizona Republic*, April 16, 2006.

9. For a sampler of this point, try http://nationalpolicyinstitute.org/, icirr.org, cis.org; also, alternet.org/story35733/.

10. George W. Grayson, "Mexican Officials Feather Their Nests While Decrying U.S. Immigration Policy," cis.org backgrounder, April 2006.

11. D'Vera Cohn and Tara Bahrmpour, "Of U.S. Children under Five, Nearly Half Are Minorities," *Washington Post*, May 10, 2006.

12. David Nasaw, *Andrew Carnegie* (New York: Penguin Press, 2006), 387.

13. For example, in John Mason Hart's *Empire and Revolution: The Americans in Mexico Since the Civil War* (Berkeley: University of California Press, 2002): "Lerdo's American and Mexican critics labeled him an 'obstructionist' and called him 'treacherous' and 'double dealing.' In contrast, the Americans saw in General Díaz a strong, decisive military leader capable of disciplining a fractious nation. A paraphrase of Franklin Delano Roosevelt captures the prevailing hope of Americans with interests in Mexico: 'Díaz was a Son of a Bitch, but he was our Son of a Bitch.' This was a critical juncture, the most critical yet for American enterprise in Mexico. Leading financiers and industrialists from the eastern United States joined elites from southern Texas to influence the course of Mexico's history. They participated in the overthrow of the Lerdo government by providing financial assistance to General Díaz and his band of rebels" (60).

Also, "When Lerdo defeated him in the 1875 presidential race, General Díaz and his military office corps once again attempted to overthrow the democratically elected Mexican government. They were known as 'the railroaders,' a sobriquet taken from the rallying cry used by Díaz supporters during his presidential campaign. The railroaders believed that American capital and technology would modernize and transform their nation. In 1876 Díaz and his followers succeeded, with important American help. Díaz had been a principal recipient of American arms shipments procured from the bondholders during the war against the French, and he used those connections to obtain weapons, which reached him from the port of Coatzacoalcos. He deposed Lerdo and seized control of the Mexican government" (61).

And finally, "In 1883 a group of the most prominent capitalists and politicians of the United States gathered with their Mexican counterparts in the banquet hall of the Waldorf Astoria Hotel in New York. The cabinet members and financiers took their seats at the long dining table. Facing each other at the left and the right of the head chair were General Porfirio Díaz and Ulysses S. Grant, both former presidents. Collin P. Huntington, one of the leading railroad industrialists and financiers of his time, took the head chair. In the meeting that ensued, the Mexican officials presented their case for pervasive American participation in the development of their economy, and the American investors bargained for access to Mexico's abundant natural resources. The program of free trade, foreign investment, and privatization of the Mexican countryside that they agreed upon that evening continues to resonate. The benefits and detriments of the agreements that they struck have influenced the relationship between the peoples and governments of the United States and Mexico to this day. It was the Americans' first step in a progression that has determined the relations between the United States and the nations of the Third World in the twenty-first century" (1).

14. Consider Charles Bowden, *Down by the River*. Or for a recent taste, "The Cocaine Clown Scandals," Leopoldo Ramos, *El Universal*, April 28, 2006.

15. Manuel Roig-Franzia, "Behind the Debate," *Washington Post*, April 17, 2006.

16. Leslie Evans, "Electoral Democracy Has Yet to Shake Mexico's Corrupt Bureaucracy," UCLA International Institute, March 16, 2005.

17. Mexico, naturally, is attempting to alter this reality. In Juárez, it has lured Electrolux from Sweden with free land in the hopes of building a cluster of new factories. Also, it has become part of the NAFTA corridor schemes where cheap new ports in

Mexico will drain off U.S. shipping and haul the Asian goods on new highways all the way to Canada. None of these schemes are likely to raise wages in Mexico, or stop the flood of poor people migrating north.

18. See Mike Davis, *Planet of Slums* (New York: Verso, 2006), for example.

19. Kevin Sullivan, "Africans Risk Death at Sea for New Life Abroad," *Washington Post*, April 1, 2006.

20. One-stop shopping on Simcox and other nativist groups: *Intelligence Report*, Southern Poverty Law Center, Winter 2005.

21. Jonathan Silverstein, "Racist Video Game Incites Anger," ABC News, May 1, 2006. See also resist.com/racistgames/index.

22. http://www.defenders.org/border/ontheline.html.

23. Brady McCombs, "Deaths Rise on Border along with Spring Heat," *Arizona Daily Star*, April 1, 2006; Tyche Hendricks, sfgate.com, "Mexican Migrants' Death Toll Sets Record," April 14, 2006.

24. For a provocative look at the history of American racism, see James W. Loewen, *Sundown Towns: A Hidden Dimension of American Racism* (New York: Simon and Schuster, 2005).

25. Source: Julián Cardona. In 2005, he lived in the Altar/Carborca area with drug and people smugglers. The payoff schedule for the state police in Sásabe came from them.

26. Marta Dickerson, "Mexico's Stubborn Lack of Choices," *Los Angeles Times*, April 16, 2006.

27. Arthur H. Rotstein, AP, "Minutemen Say They'll Erect Fence if Bush Won't Act," April 20, 2006.

28. Ibid.

29. Nadia Tate, "Paying Tribute to Death," *Business Mexico*, May 2004.

30. "One Year Later: Still No Justice for Mexican Journalists," *Human Rights News*, April 18, 2006.

31. "Asesinan a policía," *El Mañana*, April 26, 2006.

32. "Cornyn Says Mexico Should Help Find Missing Americans," AP, April 5, 2006.

33. See, for example, Marla Dickerson, "In Mexico, Farmers See Milk Profits Dry Up," *Los Angeles Times*, April 1, 2006.

34. Forrest Wilder, "South Texas Hold 'Em," *Texas Observer*, May 5, 2006.

35. Mark Stevenson, "Few Protections for Migrants to Mexico," AP, April 19, 2006.

36. Sam Quinones, "Migrants Find Gold Rush in New Orleans," *Los Angeles Times*, April 4, 2006.

37. Julie Watson, "Coyotes Openly Trolling for Clients," AP, April 20, 2006.

38. For example, in 2006 Mexico exported $38 billion in oil but imported over $11 billion in oil for a net of around $27 billion in oil exports. Remittances hit $23 billion—but this figure does not touch the enormous amount of goods and money carried home by Mexicans on their return visits. Any form of amnesty will almost certainly gut the flow of remittances—this happened after the 1986 amnesty. Also, as more Mexicans settle here, regardless of their legal standing, the flow of money home will decline. For numbers see elfinaciero.com.mx/portal/cfpages;print.cfm?docid=41066.

39. Victor Davis Hanson, "Mexico's Addiction to Remittances from Illegals in the U.S., Real Clear Politics," May 11, 2006.

40. Mark Stevenson, "Legalizing Immigrants Could Cut Flow of Money They Send Home, Mexican Economist Warns," AP, April 14, 2006.

41. An example of what they leave behind: Jonathan Roeder, "Mother's Own War Highlights Poor Policing," *The Herald Mexico*, April 18, 2006.

42. One flaw in any sense of control of migration is the counterfeiting of documents. See Dave Montgomery, "Cashing in on Illegal Immigration," *Contra Costa News*, May 8, 2006.

43. Alfredo Corchado and Laurence Iliff, "Mexico's Middle Class Heads North," *Dallas Morning News*, May 3, 2006.

44. *Harper's*, December 2006, "Readings," *The Boys From Brazil*, 18–19.

45. John Pomfret, "Despite Security and Dangers, Border Crossers Find Way North," *Washington Post*, May 18, 2006.

46. http://www.cpc.noaa.gov/products/outlooks/hurricane.shtml.

47. Mike Tidwell, *Bayou Farewell* (New York: Vintage, 2004).

part three

1. Friedrich Katz, *The Life and Times of Pancho Villa* (Palo Alto: Stanford University Press, 1998), 526–527.

2. Juan Rulfo, *Pedro Páramo* (Austin: University of Texas Press, 2002).

3. Rulfo, 12.

4. Rulfo, n.p.

5. Rulfo, 12.

afterword

1. Patricia Giovine, "Cercan la frontera," *Diario de Juárez*, September 20, 1993.

2. Alex Gudiño, *Los cimientos del cielo, Templo Mayor Mexico-Tenochtitlan*, DVD, directed by Alex Gudiño, Mexico City, 2006. Frances F. Berdan, "El imperio azteca y sus provincias," in *El Imperio Azteca* (Mexico City: Fomento Cultural Banamex, 2004), 264.

3. John Mason Hart, *Empire and Revolution* (Berkeley and Los Angeles: University of California Press, 2002), 60.

4. John Kenneth Turner, *Barbarous Mexico* (Austin: University of Texas Press, 1969 [1910]), 104.

5. Jane Bussey, "Remittances' benefits come at a price," *Miami Herald*, July 16, 2007, http://www.miamiherald.com/103/story/170203.html.

6. Laura Carlsen, "The Price of Going to Market," International Relations Center, Americas Program Policy Report, September 19, 2005, http://americas.irc-online .org/am/654.

7. "Aumentan 15.1 por ciento ingresos por remesas en 2006," *El Financiero*, Mexico City, January 31, 2007, http://www.elfinanciero.com.mx/ElFinanciero/Portal/ cfpages/print.cfm?docId=41066. "Las remesas para AL superarán los 100 mil mdd en 2010: BID," *La Jornada*, March 19, 2007, http://www.jornada.unam.mx/2007/03/19/ index.php?section=economia&article=027n3eco.

8. "Nuevo récord ingreso de remesas a Oaxaca," *Olor a mi tierra: El Sitio Web de Noticias de Oaxaca*, August 12, 2006. http://www.oloramitierra.com.mx/?mod=read& sec=migrante&id=8729&titulo=Nuevo_record_ingreso_de_remesas_a_Oaxaca.

bibliography

Abbas. *Retorno a Oapan*. Mexico City: Coleccion Río de Luz, Fondo De Cultura Económica, 1986.

Almada, Francisco R. *Diccionario de Historia, Geografía y Biografías Sonorenses, Gobierno del Estado de Sonora*. Hermosillo, 1983.

Anreus, Alejandro. *Orozco in Gringoland: The Years in New York*. Albuquerque: University of New Mexico Press, 2001.

Archivo Casasola, Jefes. *Héroes y Caudillos*. Mexico City: Fondo De Cultura Económica, 1986.

Arnold, Linda. *Bureaucracy and Bureaucrats in Mexico City, 1742–1835*. Tucson: University of Arizona Press, 1988.

Arreola, Daniel D., and James R. Curtis. *The Mexican Border Cities: Landscape Anatomy and Place Personality*. Tucson: University of Arizona Press, 1993.

Azuela, Mariano. *The Underdogs*. Fairfield, Iowa: 1st World Library, 2004.

Azuela, Mariano. *Two Novels of Mexico: The Flies, The Bosses*. Berkeley: University of California Press, 1972.

Barry, Tom. *Mexico: A Country Guide*. Albuquerque: Inter-Hemispheric Resource Center, 1992.

Barry, Tom, Harry Browne, and Beth Sims. *The Great Divide: The Challenge of U.S.-Mexico Relations in the 1990s*. New York: Grove Press, 1994.

Beezley, William H. *Insurgent Governor: Abraham Gonzalez and the Mexican Revolution in Chihuahua*. Lincoln: University of Nebraska Press, 1973.

Behars, Ruth. *Translated Woman*. Boston: Beacon Press, 2003.

Berdan, Frances F. "El imperio azteca y sus provincias," in *El Imperio Azteca*, 264–269. Mexico City: Fomento Cultural Banamex, 2004.

Berdecio, Roberto, and Stanley Appelbaum, eds. *Posada's Popular Mexican Prints*. New York: Dover Publications, 1972.

Brocklehurst, Thomas Unett. *Mexico Today: Country with a Great Future*. London: John Murray, 1883.

Cabeza de Vaca. *Adventures in the Unknown Interior of America*. Albuquerque: University of New Mexico Press, 1983.

Calderon de la Barca, Frances. *Life in Mexico*. Berkeley: University of California Press, 1982.

Camp, Roderic A. *Mexico's Leaders: Their Education and Recruitment*. Tucson: University of Arizona Press, 1980.

———. *Entrepreneurs and Politics in Twentieth-Century Mexico*. New York: Oxford University Press, 1989.

Castañeda, Jorge G. *Utopia Unarmed: The Latin American Left After the Cold War*. New York: Alfred A. Knopf, 1993.

———. *The Mexican Shock: Its Meaning for the U.S.* New York: New Press, 1995.

Chevalier, Francois. *Land and Society in Colonial Mexico: The Great Hacienda*. Berkeley: University of California Press, 1963.

Cockcroft, James D. *Mexico: Class Formation, Capital Accumulation, and the State*. New York: Monthly Review Press, 1990.

Corral, Luz. *Pancho Villa: An Intimacy*. Chihuahua, Mexico: Centro Librero La Prensa, Chihuahua, 1981.

Crumrine, N. Ross. *The Mayo Indians of Sonora: A People Who Refuse to Die*. Prospect Heights, Illinois: Waveland Press, 1988.

Crumrine, N. Ross, and Phil C. Weigand, eds. *Ejidos and Regions of Refuge in Northwestern Mexico*. Tucson: University of Arizona Press, 1987.

Day, James M., ed. *Morris B. Parker's Mules, Mines, and Me in Mexico, 1895–1932*. Tucson: University of Arizona Press, 1979.

Díaz, Bernal. *The Conquest of New Spain*. New York: Penguin Books, 1963.

Eisenhower, John S. D. *Intervention! The United States and the Mexican Revolution, 1913–1917*. New York: W. W. Norton & Co., 1993.

Flandrau, Charles Macomb. *Viva Mexico!* Urbana: University of Illinois Press, 1964.

Fontana, Bernard, and John Schaefer. *Tarahumara: Where Night Is the Day of the Moon*. Flagstaff, Arizona: Northland Press, 1979.

———. *The Old Gringo*. New York: Farrar, Straus & Giroux, 1985.

Fuentes, Carlos. *The Death of Artemio Cruz*. New York: Farrar, Straus & Giroux, 1991.

Galeano, Eduardo. *Memory of the Fire: Century of the Wind*. New York: Pantheon, 1988.

Gardner, Dore. *Niño Fidencio: A Heart Thrown Open*. Santa Fe: Museum of New Mexico Press, 1992.

Gentry, Howard Scott. *The Warihio Indians of Sonora-Chihuahua: An Ethnographic Survey*. Washington, D.C.: Smithsonian Institution, Bureau of Ethnology, 1963.

Griswold del Castillo, Richard, Teresa McKenna, and Yvonne Yarbro-Bejarano, eds. *Chicano Art: Resistance and Affirmation, 1965–1985*. Los Angeles: Wight Art Gallery, University of California, 1991.

Guillermoprieto, Alma. *The Heart That Bleeds*. New York: Alfred A. Knopf, 1994.

Guzman, Martin Luis, trans. by Virginia H. Taylor. *Memoirs of Pancho Villa*. Austin: University of Texas Press, 1965.

The Great Western Historian, No. 2. "The Many Wives of Pancho Villa: Who Killed Pancho Villa and Why? The Hanging of the Columbus Villa Raiders." El Paso, Texas: Bravo Press, n. d.

Hall, Douglas Kent. *The Border: Life on the Line*. New York: Abbeville Press, 1988.

Hall, Linda B. *Álvaro Obregón: Power and Revolution in Mexico, 1911–1920*. College Station: Texas A&M Press, 1981.

Hanrahan, Gene Z., ed. *Blood Below the Border: America Eyewitness Accounts of the Mexican Revolution*. Salisbury, North Carolina: Documentary Publications, 1982.

Hardy, Lieut. R. W. H. *Travels in the Interior of Mexico in Baja California and Around the Sea of Cortes, 1825, 1826, 1827–1828*. Glorieta, New Mexico: Rio Grande Press, 1977.

Harris III, Charles H., and Louis R. Sadler. *The Border and the Revolution*. Silver City, New Mexico: High Lonesome Books, 1988.

Harris, Larry A. *Pancho Villa and the Columbus Raid*. El Paso, Texas: McMath Company, 1949.

Hart, John Mason. *Empire and Revolution: The Americans in Mexico Since the Civil War*. Berkeley: University of California Press, 2002.

———. *Revolutionary Mexico: The Coming and Process of the Mexican Revolution*. Berkeley: University of California Press, 1987.

Harvey, Robert. *Liberators: Latin America's Struggle for Independence*. New York: Overlook Press, 2000.

Herrera, Celia. *Pancho Villa Facing History*. New York: Vantage Press, 1993.

Historia Gráfica de la Revolución, 1900–1946. Mexico City: Archivo Casasola, 1971.

Holden, William Curry. *Teresita*. Owings Mills, Maryland: Stemmer House, 1978.

von Humboldt, Alexander. *Political Essay on the Kingdom of New Spain*. Norman: University of Oklahoma Press, 1988.

Johnson, Kenneth F. *Mexican Democracy: A Critical View*. New York: Praeger Publishers, 1984.

Kandell, Jonathan. *La Capital: The Biography of Mexico City*. New York: Random House, 1988.

Katz, Friedrich. *The Secret War in Mexico: Europe, the United States, and the Mexican Revolution*. University of Chicago Press, 1983.

———. *The Life and Times of Pancho Villa*. Palo Alto, California: Stanford University Press, 1998.

Kennedy, John G. *Tarahumara of the Sierra Madre: Beer, Ecology, and Social Organization*. Chicago: AHM Press, 1978.

Kennedy, John G., and Raul Lopez. *Semana Santa in the Sierra Tarahumara: A Comparative Study in Three Communities*. Los Angeles: University of California Press, 1981.

Krauze, Enrique. *Mexico: A Biography of Power*. New York: Harper Perennial, 1998.

Ladman, Jerry R., ed. *Mexico: A Country in Crisis*. El Paso: Texas Western Press, 1986.

Lafaye, Jacques. *Quetzalcoatl and Guadalupe: The Formation of Mexican National Consciousness, 1531–1813*. University of Chicago Press, 1976.

Langewiesche, William. *Cutting for Sign*. New York: Pantheon Books, 1993.

Lewis, Oscar. *The Children of Sanchez: Autobiography of a Mexican Family*. New York: Random House, 1961.

Lister, Florence C., and Robert H. Lister. *Chihuahua: Storehouse of Storms*. Albuquerque: University of New Mexico Press, 1966.

Lumholtz, Carl. *Unknown Mexico*. 2 vols. New York: Charles Scribner's Sons, 1902.

Machado, Manuel A. *Barbarians of the North: Modern Chihuahua and the Mexican Political System*. Austin: Eakin Press, 1992.

Martínez, Oscar J. *Troublesome Border*. Tucson: University of Arizona Press, 1988.

McFeely, William S. *Grant: A Biography*. New York: W. W. Norton & Co., 1982.

Mills, James. *The Underground Empire*. New York: Dell Publishing Company, 1986.

Montes de Oca, Heriberto. *Frontera de Extremos/Frontier of Extremes*. Sonoita, Arizona: ALANTHIS, 1991.

Naylor, Thomas H., and Charles W. Polzer. *The Presidio and Militia on the Northern Frontier of New Spain, 1570–1700*. Tucson: University of Arizona Press, 1986.

Nugent, Daniel. *Spent Cartridges of Revolution: An Anthropological History of Namiquipa, Chihuahua*. University of Chicago Press, 1993.

Nugent, Daniel, ed. *Rural Revolt in Mexico and U.S. Intervention*. San Diego: Center for U.S. Mexican Studies, University of California, 1988.

O'Connor, Richard. *Ambrose Bierce: A Biography*. Boston: Little, Brown & Co., 1967.

Ortiz Monasterio, Pablo, ed. *Historia Natural De Las Cosas*. Mexico City: Fondo De Cultura Económica, 1983.

Oster, Patrick. *The Mexicans: A Personal Portrait of a People*. New York: William Morrow and Company, 1989.

Pagden, Anthony. *Hernan Cortes: Letters from Mexico*. New Haven, Connecticut: Yale University Press, 1986.

Paz, Octavio. *The Labyrinth of Solitude*. New York: Grove Press, 1985.

Pick, James B., and Edgar W. Butler. *The Mexico Handbook: Economic and Demographic Maps and Statistics*. Boulder, Colorado: Westview Press, 1994.

Poniatowska, Elena. *Massacre in Mexico*. Columbia: University of Missouri Press, 1991.

Ramos, Samuel. *Profile of Man and Culture in Mexico*. Austin: University of Texas Press, 1962.

Reavis, Dick J. *Conversations with Moctezuma: Ancient Shadows over Modern Life in Mexico*. New York: William Morrow and Company, 1990.

Reed, John. *The War in Eastern Europe*. New York: Charles Scribner's Sons, 1918.

———. *The Education of John Reed*. New York: International Publishers, 1955.

———. *Adventures of a Young Man*. Berlin: Seven Seas Books, 1966.

———. *Insurgent Mexico*. New York: International Publishers, 1969.

Robertson, Thomas A. *Southwestern Utopia*. Los Angeles: Ward Ritchie Press, 1947.

Roca, Paul M. *Spanish Jesuit Churches in Mexico's Tarahumara*. Tucson: University of Arizona Press, 1979.

Rosenstone, Robert A. *Romantic Revolutionary: A Biography of John Reed*. New York: Vintage Books, 1981.

Rothenstein, Julian, ed. *Posada: Messenger of Mortality*. Mt. Kisco, New York: Moyer Bell Limited, 1989.

Ruiz, Ramón Eduardo. *The People of Sonora and Yankee Capitalists*. Tucson: University of Arizona Press, 1988.

Salas, Elizabeth. *Soldaderas in the Mexican Military: Myth and History*. Austin: University of Texas Press, 1990.

Shadle, Stanley F. *Andres Molina Enriquez: Mexican Land Reformer of the Revolutionary Era*. Tucson: University of Arizona Press, 1994.

Shannon, Elaine. *Desperados: Latin Drug Lords, U.S. Lawmen, and the War America Can't Win*. New York: Viking Press, 1988.

Simpson, Leslie Byrd. *Many Mexicos*. Berkeley: University of California Press, 1967.

Smith Jr., Cornelius C. *Emilio Kosterlitzky: Eagle of Sonora and the Southwest Border*. Glendale, California: Arthur H. Clark Company, 1970.

Spicer, Edward H. *Cycles of Conquest*. Tucson: University of Arizona Press, 1962.

———. *The Yaquis: A Cultural History*. Tucson: University of Arizona Press, 1980.

Tompkins, Col. Frank. *Chasing Villa: The Story Behind the Story of Pershing's Expedition into Mexico*. Harrisburg, Pennsylvania: Military Publishing Company, 1934.

Tuck, Jim. *Pancho Villa and John Reed: Two Faces of Romantic Revolution*. Tucson: University of Arizona Press, 1984.

Turner, John Kenneth. *Barbarous Mexico*. New ed. Introduction by Sinclair Snow. Austin: University of Texas Press, 1969 [1910].

Vanderwood, Paul J. *Disorder and Progress: Bandits, Police, and Mexican Development*. Wilmington, Delaware: Scholarly Resources, 1992.

Van Young, Eric, ed. *Mexico's Regions: Comparative History and Development*. San Diego: Center for U.S.-Mexican Studies, University of California, 1992.

Vargas, Ava, ed. *La Casa de Cita: Mexican Photographs from the Belle Epoque*. London: Quartet Books, 1986.

Warnock, John. *The Other Mexico: The North American Triangle Completed*. Montreal, Canada: Black Rose Books, 1995.

Weisman, Alan, and Jay Dusard. *La Frontera: The United States Border with Mexico*. San Diego: Harcourt Brace Jovanovich, 1984.

Wright, Angus. *The Death of Ramón González: The Modern Agricultural Dilemma*. Austin: University of Texas Press, 1990.

extended captions

photo section one

1. Highway 50, Garden City to Dodge City, Kansas.
2. San Juan Mixtepec, Oaxaca.
3. Amadeo Moreno, 43. Metairie, Louisiana.
4. Backpacks, jackets, shoes, and gloves—on sale to immigrants in the main plaza. Altar, Sonora.
5. Immigrants are ferried to "La Línea" from a Sásabe stash house.
6. Checkpoint. Hermosillo, Sonora.
7. Buenos Aires Wildlife Refuge. Arizona.
8. Don Henry Ford, Jr., returns to Piedritas, Coahuila, several years after serving time in federal prison for marijuana smuggling. On September 19, 1986, a DC-6 loaded with eleven tons of Colombian marijuana landed on a secret airstrip near Piedritas. The man at right was one of the campesinos involved in the operation. The photo was taken from the entrance of the large cavern where the marijuana was stored.
9. Vicente Fox Quesada on his first day as president of Mexico. National Auditorium, Mexico City. December 1, 2000.
10. Colonia Estrella del Poniente. Ciudad Juárez, Chihuahua.

photo section two

11. Chapel Hill, North Carolina.
12. Saturday market. Tlaxiaco, Oaxaca, "La ciudad Mercado." Sellers of limestone used in making corn tortillas.
13. Workers displaced by NAFTA on hunger strike. El Paso, Texas. June 5, 2000.
14. Third-shift maquiladora workers. Ciudad Juárez, Chihuahua.
15. José Martínez, 37, from Francisco Villa, Nayarit, outside his hotel room in Agua Prieta, Sonora. Martínez can get only two months of work a year (September and October) at a fish cannery in his hometown. He hopes for a more stable job in the United States.
16. Central Americans stopped by officers of the Mexican National Migration Institute, Highway 15 from Guaymas to Hermosillo; buses packed with illegal immigrants stream daily to hub-towns like Altar, Sonora.
17. Molten Corporation, Juárez Plant. Ciudad Juárez, Chihuahua.
18. Telegraph office. Altar, Sonora. Immigrants line up to receive money from relatives in the United States to pay for the remainder of their journey.
19. Packed vans arrive at the border town of Sásabe from Altar, Sonora. Estimates of the number of people crossing through the area vary from 1000 to 3000 daily, depending on the season.

20. Main square in Altar, Sonora. Immigrants get cheap meals of fried chicken, tortillas, and beans.
21. Mario and Angélica in their new apartment. Carrboro, North Carolina.
22. Ezequiel Sánchez builds a house with money sent from the United States by his cousin Emeterio. The new house will accommodate Valeria and Elizabeth, daughters of Emeterio (at left) and his wife, now living in the cardboard shack in the background.
23. Ten immigrants (one out of the frame) who crossed the border illegally use pay phones to call relatives in the United States before boarding buses to Phoenix and Los Angeles. Their smuggler has advised them not to hang out in a large group. Greyhound Bus Station. Tucson, Arizona.
24. Interior of the House of Death, Parsioneros 3633, Las Acequias, Ciudad Juárez, Chihuahua. On January 23, 2004, Mexican Federal Police began a search for missing persons that led to the discovery of twelve bodies buried in the patio—at least one victim was a U.S. citizen. An undercover informant working for the U.S. Bureau of Immigration and Customs Enforcement (ICE) is implicated in the killings; the first murder here was transmitted to ICE agents in El Paso electronically, and a recording was made on tape at the agency. These events came to light when DEA agents in Juárez were mistakenly targeted by Mexican police working with drug traffickers.
25. María Esther García at the Juárez morgue, January 2004, looking for her brother Pedro García, who disappeared July 12, 2002. When twelve bodies were unearthed in Las Acequias, hundreds of relatives came to the morgue seeking news of their loved ones. The Association of Relatives of Missing Persons in Juárez had presented 196 cases to law enforcement authorities, but according to one ex-member of the Association, Lorenza Benavides de Magaña, the list of missing persons includes more than 914 cases. None of the twelve bodies found in the patio of the House of Death were in the list of missing persons maintained by the Association.
26. Relatives of the disappeared waiting in the Juárez morgue to identify bodies try to avoid media exposure.
27. Sixto Méndez Goyazo, 14, from Chiapas, has never attended school. He is illiterate, knows nothing of the U.S., nor where he is going to be taken to work after crossing the border at Sásabe. Sixto travels with his 32-year-old uncle Felipe Coyazo, a peasant who lost his livelihood in Chiapas due to uncompetitive Mexican corn prices under NAFTA. Sixto wants to work in the U.S. to support his parents.
28. Luis Gustavo Bernal Vázquez, 13, Cuenca, Azuai, Ecuador, enters his cell in Hermosillo, Sonora. He was arrested on a bus to Altar, Sonora, the hub-town for immigrants crossing illegally into the United States.

29. Checkpoint at El Tortugo, thirty miles south of the border in Sásabe, Sonora. From 10 a.m. to 6 p.m., Mexican federal officers count every passenger in vans packed with migrants going north. After dark, migrants, including many Central Americans, go uncounted.

30. Paula Flores, mother of 17-year-old Sagrario González, who was murdered in April 1998. On February 18, 2005, state police arrested José Luis Hernández Flores, a friend of Sagrario's brother, and charged him with homicide. Hernández told the police that he had asked Sagrario to be his girlfriend but she turned him down. Later, he and a smuggler and another man kidnapped Sagrario, attacked her, and disposed of her body in Loma Blanca, a desert area in the Juárez Valley. In 2006, Paula's husband, Jesús González, committed suicide.

31. Sisters of Sagrario González and friends of her church choir. May 1998.

32. Paula Flores and other mothers of the group "Voices Without Echo" search for Liliana Holguín de Santiago. May 2000.

33. Irma Pérez has searched the desert since September 1995, when her daughter Olga Alicia, 20, was found raped and murdered. Liliana's sister, Gloria Holguín, is at her side.

34. Three mothers and their children stop before crossing the desert. Daytime temperatures in the area reach 115 degrees. Sásabe, Sonora. June 2004.

35. Evangelina Arce pastes a flyer on the coffin of 15-year-old Liliana Holguín, June 2000. Evangelina's daughter Sylvia, 29, and her friend Fabiola were abducted in Juárez on March 11, 1998, allegedly by federal police officers. They are still missing.

36. Border Patrol agents detain eighty illegal immigrants near Bisbee, Arizona. May 2000.

37. Young men and boys from southern Mexico light votive candles and pray for a safe crossing before leaving the Sonoran town of Altar. Soon they will be loaded into vans and trucks and ferried north toward La Línea.

38. At sundown, hundreds of migrants march north in groups of twenty, hoping to cross the border. Each group is joined by a smuggler, whose identity is not revealed and who acts as a guide. Agua Prieta, Sonora. May 2000.

39. Six Guatemalan and two Honduran women are arrested at a checkpoint in Hermosillo (two out of the frame); three of them are pregnant. They were part of a group of sixteen from both countries who planned to reach the U.S.-Mexico border via Altar. August 2004.

40. Twenty-seven people, including women and children, leave Sásabe heading northeast into the Buenos Aires National Wildlife Refuge. Daytime temperatures in the area reach 115 degrees. June 2004.

41. Julia Caldera searches for her daughter, María Elena. In the background are the hills where Liliana Holguín's body was dumped. August 2000.

photo section three

42. Immigrant rescued after eight days in the desert by residents of Arivaca, Arizona. He was taken to the Ark of the Covenant shelter, built near Arivaca by the "No More Deaths" movement. June 2004.

43. House-shoring workers take a break to eat tacos. New Orleans, Louisiana.

44. Hurricane Katrina debris. Pascagoula, Mississippi. September 2005.

45. Angel Bautista, a United States citizen from a Mixtec family, born in Fresno, California. Arvin, California. June 2005.

46. Street scene. Carrboro, North Carolina.

47. Carol Cruickshank and the staff of "Paso a Paso" give prenatal classes to Mexican women. Eureka, California. May 2005.

48. Marvin, a Honduran who paid $5000 to a smuggler to be taken from his country to the United States. Carrboro, North Carolina.

49. Celerina Vargas makes tortillas and mole daily for her family, as she did in Oaxaca. Her husband, Dionisio Moctezuma, works in a flower farm. Her son, Ildeberto, sits at the table. Eureka, California. May 2006.

50. Celerina Vargas at her home in Eureka, California, with her American-born children Estrellita (far left), Odilia, and her five-month-old niece, Joselyn. Celerina has five children, three of them born in Mexico.

51. Celerina Vargas's daughters, Jessica Marisol and Estrellita. Marisol crossed the desert at age 5 with her mother and two brothers in July 2002; María was 3 and Ildeberto was an 18-month-old baby.

52. "I don't feel free in this country," says Ofelia Gutiérrez. She lives in Eureka with her children, Cristal, Tomás, and 4-month-old Alexander, an American citizen. Her husband, Inocencio Ramos, works in a logging company.

53. Every day, dozens of people spend the night outside the office of the Division of Motor Vehicles in Durham, North Carolina, trying to get their driver's licenses before new rules take effect. On February 2, 2004, Operation Stop Fraud will no longer allow IDs issued by the Mexican consulate or similar documents from other countries when applying for a North Carolina driver's license. January 2004.

54. Immediately upon arriving on the Mississippi Gulf Coast from Beaumont, Texas, thirteen roofing workers are employed to fix an apartment complex at W. Pine and Hill, in Gulfport. There is one Honduran in the group; the rest are from San Luis Potosí, in Central Mexico.

55. House-shoring worker. New Orleans, Louisiana.

56. Victoria Cintra (in the car), Gulf Coast Coordinator for the Mississippi Immigrants' Rights Alliance (MIRA), advises undocumented workers in Hangar 216 of the Naval Construction Battalion Center in Gulfport, Mississippi. Some of the 270

workers, including thirty women, contracted by a company in Richmond, Texas, accused the owner of imposing subhuman working conditions at the New Orleans Naval Base. They lived in tents with no water or electricity, food was scarce, and they were overworked and underpaid. They were evacuated to Gulfport when Hurricane Rita struck.

57. Undocumented workers try to evade the camera while they shave and wash their faces at the Naval Construction Battalion Center in Gulfport, Mississippi. In the aftermath of Hurricane Katrina, the Bush administration relaxed procurement, labor, and immigration rules, allowing subcontractors of KBR, a subsidiary of Halliburton, Inc., to abuse hundreds of illegal workers; many never got paid for weeks of dangerous cleanup work at U.S. military facilities along the Gulf Coast. Louisiana officials complained that local workers were being replaced with cheap, illegal labor, and in October 2005, immigration officials detained 100 workers who had spent several weeks cleaning up the Belle Chasse Naval Air Station. September 2005.

58. Guatemalan roofers repair a building on Pass Road and "H" Avenue, in Gulfport, Mississippi. September 2005.

59. Jacking up walls in damaged houses. New Orleans, Louisiana. May 2006.

60. St. John the Baptist Day. Lamont, California. June 2006.

61. Downtown L.A., "The Great American Boycott," also called "A Day Without Immigrants." May 1, 2006.

62. National Day of Action for Immigrants' Rights rally. Phoenix, Arizona. April 10, 2006.

63. National Day of Action for Immigrants' Rights rally. Phoenix, Arizona. April 10, 2006.

64. "The Great American Boycott." Los Angeles, California. May 1, 2006.

65. Downtown Los Angeles, "The Great American Boycott." May 1, 2006.

66. "The Great American Boycott." Los Angeles, California. May 1, 2006.

67. "Today we march, tomorrow we vote." Downtown Los Angeles. May 1, 2006.

68. La Brea Avenue, Los Angeles, California. May 1, 2006.

69. Protesters in front of the state capitol, Phoenix, Arizona. Marches for immigrants' rights took place in more than 100 cities and towns nationwide. April 10, 2006.

70. Minuteman patrols receive instructions on the rules of engagement at morning orientation near Palominas Trading Post before traveling to border watch stations. Palominas, Arizona. April 2005.

71. A massive dump site in the Upper Altar Valley, Arizona; illegal immigrants meet representatives of their smugglers (coyotes) after a forty-mile walk through the desert; they are told to strip; dump their old clothes, packs, and jugs of water; and put on new, more "American"-looking clothes before traveling on to an urban stash house. April 2006.

72. A shovel marks the U.S.-Mexico border: on the left is the road to Las Chepas, Chihuahua, a haven for smugglers; on the right, the road to Columbus, New Mexico. September 2005.

photo section four

73. Mixtecs perform the "Danza de los diablos" (Dance of the devils), traced to African slaves in Oaxaca who worshiped the god Ruja after the Spanish conquest of Mexico. The dance is interpreted as a spiritual quest for freedom, asking for an end to slavery. The best-known version of the dance is from Santiago Collantes, Oaxaca. Arvin, California. June 2006.

74. "Danza de los rubios" (Dance of the blonds). Arvin, California. June 2006.

75. A group of immigrants walks toward the border west of Agua Prieta, Sonora. May 2000.

76. Aztec Eagle Warrior. Los Angeles, California. May 1, 2006.

77. Market at San Juan Mixtepec, Oaxaca, population 30,000. Mixtepec has a long tradition of migration to the United States; an estimated 80 percent of its people reside abroad in California, Oregon, Washington, Arizona, New Mexico, Colorado, Wyoming, Texas, Alabama, Georgia, Florida, Virginia, North Carolina, South Carolina, Ohio, Michigan, and New York, but county officials still include them in the census statistics. Old men, women, and children remain in the town. June 2005.

78. In June 2005, an exact replica of St. John the Baptist was sent from San Juan Mixtepec, Oaxaca, to the Mixtec migrant communities in Lamont and Arvin, California. After mass, the saint is carried to the home of one of the migrants. Lamont, California. June 2006.

79. People line up at "la casa de cambio" Intermex, in Tlaxiaco, Oaxaca, to receive remittances from the United States. The small town has twenty-two such offices to cash money sent from abroad. June 2005.

80. Every Friday, people arrive in Tlaxiaco, Oaxaca, from surrounding villages and spend the night in the plaza to cash money wired on Saturday from relatives living in the United States. June 2005.

81. Five new houses on a hill in San Juan Mixtepec, Oaxaca. Land prices have risen to $100 to $150 per square meter or more due to the construction boom. Most of the migrants' houses, some luxuriously furnished, remain uninhabited. In the native language, *Mixtepec* means "in the hills of the clouds." June 2005.

82. New house, California-style. San Juan Mixtepec, Oaxaca.

83. Interior of Esperanza's house in Santa Cruz Guendulain, Oaxaca. Esperanza has worked for nine years as a waitress in California and has not been to her hometown

since she left. She married an illegal immigrant and has a 4-year-old American son, Brian. Her mother, Clara (center), keeps the doors locked, waiting for her daughter to return. June 2005.

84. Immigrant's house in San Juan Mixtepec, Oaxaca. Remittances to Mexico from immigrants in the U.S. rose to a then-all-time-high of $16.6 billion in 2004; $20 billion in 2005; and $23 billion in 2006. In Oaxaca, which ranks eighth among the thirty-one Mexican states in receipt of remittances from the U.S., relatives use the money to build houses in the grand style shown in this photograph; most remain uninhabited.

85. Felicitas Ruiz Ramos, 88, stands in front of the house built by her son Gerardo Pérez Ruiz, who lives in the United States. San Andrés Ixtlahuaca, Oaxaca. November 2006.

86. Minuteman. Palominas, Arizona. April 2005.

87. Migrant women from Tlapa, Guerrero, share a meal in Altar's main square. They are Mixtec Indians who barely speak Spanish. March 2005.

88. Minuteman Bob Kuhn carries a fistful of brassieres collected at a dump site on the King Ranch in the Upper Altar Valley, forty miles above Sásabe, Sonora. April 2006.

89. Brassieres hang from bushes near the border, east of Sásabe. When migrants leave populated areas, women are frequently raped by *polleros* (smugglers), sometimes in front of their parents, their husbands, or their children.

90. Santa Inés, Michoacán, known as "the town of the lonely women." November 2006.

91. Mexican Independence Day. Dodge City, Kansas. September 2006.

92. Salvadoran Luis Ángel Ramírez waits to swim the Rio Grande in Nuevo Laredo, Tamaulipas. He broke his arm in a fall from the "train of death" in San Luis, Mexico, and has been pursued by police in three countries on his journey north. Luis worked in the cleanup of New Orleans after Katrina devastated the city. May 2006.

93. Construction worker Feliciano Martínez fell from a roof in Houston, Texas, and his arm was almost severed by a metal blade. After five surgeries to repair the tendons, he has not recovered mobility in his fingers. Dodge City, Kansas. September 2006.

94. Luis Castañón was known on the job as "the Champion" due to his fast pace on the production line. After twenty-three years of repetitive work in meatpacking plants in Garden City, Kansas, Luis can barely move. He has had three surgeries for metal implants in both knees, and other surgeries on his left shoulder, his left hand, and his neck. Garden City, Kansas. September 2006.

95. Steve Vilaysing, from Laos. Accident in a meatpacking plant. Dodge City, Kansas. September 2006.

96. Juan Viurquez. Accident in a meatpacking plant. An employee of Tyson Foods in Garden City, Kansas, Juan is supporting the United Steel Workers pro-union campaign at the company. Garden City, Kansas. September 2006.

97. Ignacio Leyva lost five fingers cleaning a meat-processing plant that produces ground beef for hamburgers. Lakin, Kansas. September 2006.

98. Dormitory for undocumented Mexican workers in the Biloxi Regional Medical Center in Mississippi. In the aftermath of Hurricane Katrina, Mexicans did most of the cleanup at the hospital, working twelve-hour shifts, seven days a week. September 2005.

99. Hermelando Ramírez died after a tree crushed him, October 21, 2006, while on the job for a logging company in Eureka, California. Tierra Blanca, Oaxaca. November 2006.

100. Hermelando Ramírez.

101. A band of young Zapotecans plays "God Never Dies" at the funeral of Hermelando Ramírez; his daughter, Ruth Nohemí, plays saxophone.

102. The logging company paid to ship Hermelando Ramírez's body to Mexico, but his widow, Minerva Almaraz, did not receive any monetary compensation. As an illegal worker, he had no life insurance. Now she must raise her three children alone: Ruth Nohemí, 10 (left), Elías, 8 (center), and 5-year-old Daniel. According to a 2004 AP report, a Mexican worker is four times more likely to die than the average U.S.-born worker, in part because "Mexicans often take the most hazardous jobs." In California, 725 Mexican workers died on the job between 1996 and 2002.

103. Women and children carrying flowers accompany Hermelando Ramírez's body to the cemetery.

104. Hermelando Ramírez is carried up a steep road to the top of the mountain where his body will be buried.

105. Minuteman Guadalupe Morfin, a first-generation American citizen from California, at her post along the Border Highway near Naco, Arizona. Her father immigrated to the U.S. from Mexico during the Bracero program. April 2005.

106. Dulce Yolanda Gálvez, 19, from Jonacatepec, Morelos, tried to reunite with her parents and two brothers, who migrated to Minneapolis, Minnesota, over an eight-year period. Her aunt and cousin were in the same group attempting to cross through Las Chepas, near Palomas, Chihuahua. She almost died after being left behind by the group; a Border Patrol rescue team saved her life. September 2006.

107. Cristal (left) plays with her friend Shailynn. Cristal and her brother Tomás were smuggled into the United States on May 2005; she was 3 and her brother was 7. Her mother's relatives delivered the children to an unknown couple in Tijuana who charged $3400 for the service. They were given names to match those of the American

documents provided by the smugglers, but Cristal refused to use the name assigned to her. She was taken to the International Port of Entry at night, while asleep. Tomás crossed easily during the day. Eureka, California. May 2006.

108. Daniel Lemus, from Colima, Mexico, and his newborn American son, Daniel Jr. Daniel works in a flower farm. Eureka, California. May 2006.

109. Jimmy Frías, aged 17 months, U.S. citizen. His father is a soldier serving in Iraq. Phoenix, Arizona. April 10, 2006.

110. Mexican Independence Day. Dodge City, Kansas. September 2006.

111. Minutemen waiting for a meeting with Tombstone project organizer, Chris Simcox, near Palominas Trading Post. Palominas, Arizona. April 2005.

112. Durham, North Carolina. January 2004.

113. Lower Ninth Ward, New Orleans, Louisiana. May 2006.

114. Miguel Ángel Vázquez, born May 5, 2006, in Eureka, California. His parents, Miguel and Lidia Lucía, are from San José de Gracia, Jalisco.

115. On the road from Altar to Sásabe, Sonora/Arizona—the main northern route for vans packed with immigrants and the occasional truckload of marijuana. All who use the road are charged a $3 fee. August 2004.